THE BRIDE
STRIPPED BARE

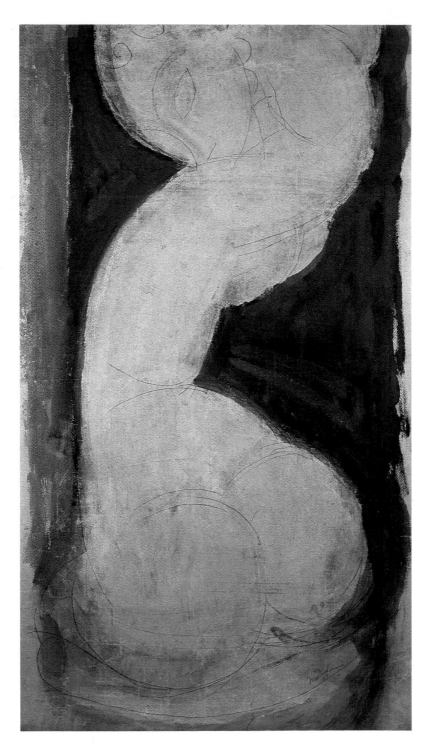

MODIGLIANI, *Green Caryatid*, 1913–14, gouache, courtesy of Perls Galleries, New York

THE BRIDE STRIPPED BARE

The Artist and the Nude in the Twentieth Century

JANET HOBHOUSE

JONATHAN CAPE

THIRTY-TWO BEDFORD SQUARE LONDON

by the same author

EVERYBODY WHO WAS ANYBODY: A BIOGRAPHY OF GERTRUDE STEIN
NELLIE WITHOUT HUGO
DANCING IN THE DARK
NOVEMBER

First published in Great Britain 1988
Copyright © 1988 by Janet Hobhouse
Jonathan Cape Ltd, 32 Bedford Square, London WC1B 3EL

British Library Cataloguing in Publication Data

Hobhouse, Janet
The bride stripped bare: the artist
and the nude in the twentieth century.
1. Nude in art 2. Women in art 3. Portrait
painting—20th century
I. Title
757′.4′0904 ND1290.7
ISBN 0-224-02011-0

Portions of the chapters on Bonnard, Schiele, Lachaise, Modigliani,
Matisse and Picasso have appeared in *Connoisseur* magazine.

Printed and bound by New Interlitho, Italy

CONTENTS

For Rose Lee and Dakota
and for Maggie
with love

PICTURE CREDITS

The author and publishers are grateful to the many institutions and individuals who have provided photographs for reproduction in this book.

The following list acknowledges photographic sources *other* than the owners specified in the captions, and also works where an additional credit is due:

ARISTIDE MAILLOL Pl 1, – Photo: Paul Rosenberg & Co., New York; Pls 2, 3, 5 – Photo: Bruno Jarret; Pl. 4 – Marquand Fund, 1951, from the Museum of Modern Art, New York, Gift of the Sculptor, 1955. All Rights Reserved; Pl. 6 –Mildred Anna Williams Collection; Pl. 7 – Photo: Robert E. Mates; Pl. 8 – Gift of the Artist; Pl. 10 – Gift of Maurice Wertheim, 1950. All Rights Reserved; Pl. 11 – Gift of Stephen C. Clark; Pl. 13 – Photo: Giraudon, Paris; Pl. 15 – Justin K. Thannhauser Collection (Photo: David Heald). All works by Maillol are © DACS 1987.

PIERRE BONNARD Pls 19, 29 – Photo: Courtesy of Acquavella Galleries, Inc., New York; Pls 24, 25, 26 – Photo: Musées Nationaux, Paris; Pl. 27 – Photo: Lefevre Gallery, London; Pls 31, 32 – Photo: Bulloz, Paris; Pl. 33 – Photo: Courtesy of Wildenstein & Co., New York; Pl. 34 – Photo: John Webb; Pl. 37 – Photo: Giraudon, Paris; Pl. 38 – Photo: Galerie Beyeler, Basel; Pl. 39 – Acquired through the generosity of the Sarah Mellon Scaife family, 1970. All works by Bonnard are © ADAGP, Paris and DACS, London 1987.

EGON SCHIELE Pls 40, 41, 49 – Photo: Courtesy of Fischer Fine Art, London; Pls 45, 51, 58, 61 – Photo: Fotostudio Otto, Vienna; Pls 55, 57, 59 – Photo: Courtesy of Galerie St Etienne, New York; Pl. 60 – Photo: Courtesy of Phaidon Press, Oxford.

HENRI MATISSE Pl. 63 – Chester Dale Collection; Pl. 64 – Tompkins Collection; Pl. 65 – Kay Sage Tanguy and Abby Aldrich Rockefeller Funds; Pl. 66 – Photo: © 1987 by The Barnes Foundation; Pls 67, 77 – Photo: Musées Nationaux, Paris; Pls 68, 82 – Photo: Hans Peterson; Pl. 71 – Mrs Simon Guggenheim Fund; Pl. 75 – Given by R. Sturgis and Marion B. F. Ingersoll; Pl. 78 – Gift of Saidie A. May; Pl. 79 – Photo: Bridgeman Art Library, London. All works by Matisse are © DACS 1987.

PABLO PICASSO Pl. 88 – Acquired through the Mrs Sam A. Lewisohn Bequest (by exchange) and Mrs Marya Bernard in memory of her husband, Dr Bernard Bernard, William Rubin, and anonymous funds; Pl. 89 – Photo: John Webb; Pl. 90 – Gift of Hanna Fund; Pls 91, 110, 111 – Photo: Museum of Modern Art, New York; Pl. 92 – Gift of the W. Averell Harriman Foundation in memory of Marie N. Harriman; Pl. 94 – Bequest of Gertrude Stein, 1946. © Metropolitan Museum of Art, New York, 1983; Pl. 96 – Gift of G. David Thompson in honour of Alfred H. Barr, Jnr; Pl. 97 – Acquired through the Lillie P. Bliss Bequest; Pls 98, 100, 101, 102, 103, 104, 106, 109, 112 – Photo: Musées Nationaux, Paris; Pl. 99 – Photo: Galerie Louise Leiris, Paris; Pl. 107 – Photo: Mirko Lion; Pl. 108 – Purchase Fund. All works by Picasso are

7

ERRATA

The following plates have been laterally reversed: 85, 112

Picture Credits

© DACS 1987.

AMEDEO MODIGLIANI Pls 113, 120, 121, 128 – Photo: Courtesy of Perls Galleries, New York; Pl. 114 – Given by Mrs Muriel J. Speisel in memory of her husband; Pl. 115 – Photo: Robert E. Mates; Pl. 116 – Gift of Joseph and Enid Bissett; Pl. 123 – Photo: Courtesy of Acquavella Galleries, Inc., New York; Pl. 124 – Gift of Mr and Mrs John McAndrew; Pl. 125 – Photo: IFOT; Pls 126, 131 – Chester Dale Collection; Pl. 129 – Photo: Bulloz, Paris; Pl. 130 – Louise and Walter Arensberg Collection. © ADAGP, Paris and DACS, London 1987; Pl. 132 – Schenkung and Gertrud Hadorn; Pl. 133 – Mrs Simon Guggenheim Fund.

JULES PASCIN Pl. 135 – Given by Richard Davies; Pls 138, 140, 142, 143 – Photo: Courtesy of Perls Galleries, New York; Pls 139, 141, 145, 147 – Photo: Bulloz, Paris; Pl. 144 – The Edwin and Virginia Irwin Memorial; Pls 146 – F. M. Hall Collection.

GASTON LACHAISE Pl. 153 – Photo: Robert Schoelkopf Gallery, New York; Pl. 154 – Alfred Stieglitz Collection, 1949. All Rights Reserved; Pl. 156 – Gift of Joseph H. Hirshhorn, 1966; Pl. 157 – Gift of Stephen Bourgeois, 1923; Pl. 162 – Gift of Spencer Kellogg, Jnr; Pl. 164 – Photo: Frank J. Thomas; Pl. 165 – Gift of Mr and Mrs Edward M. Warburg.

STANLEY SPENCER AND LUCIAN FREUD Pls 170, 171, 179, 190 – Photo: John Webb; Pls 172, 173, 174, 180, 181, 182, 183, 184, 185, 186, 187, 189, 191, 192 – Photo: Courtesy of James Kirkman, London; Pls 176, 177 – Photo: John Neal, Maidenhead; Pl. 188 – Photo: Courtesy of Marlborough Fine Art (London) Ltd; Pl. 194 – Photo: The Stanley Spencer Gallery, Cookham. All works by Stanley Spencer are reproduced by permission of the Stanley Spencer Estate.

BALTHUS Pl. 195 – James Thrall Soby Bequest; Pl. 196 – Felton Bequest, 1952; Pls 197, 201, 209 – Photo: Courtesy of Pierre Matisse Gallery, New York; Pl. 198 – Photo: Michael Cavanagh, Kevin Montague; Pls 199, 206 – Gift of Joseph H. Hirshhorn Foundation, 1966; Pl. 200 – Robert Lehman Collection, 1975. © Metropolitan Museum of Art, New York, 1981; Pl. 202 – The Ella Gallup Sumner and Mary Catlin Sumner Collection; Pl. 203 – Photo: Courtesy of The British Library; Pl. 207 – Photo: Giraudon, Paris; Pl. 208 – Photo: Courtesy of Marlborough Fine Art (London) Ltd; Pl. 210 – Photo: Courtesy Galerie Claude Bernard, Paris. All works by Balthus are © DACS 1986 and 1987.

WILLEM DE KOONING Pl. 211 – Jointly owned by The Metropolitan Museum of Art and Muriel Kallis Newman, in honour of her son, Glenn David Steinberg, 1982. © Metropolitan Museum of Art, New York, 1982; Pl. 212 – Photo: © The Art Institute of Chicago. All Rights Reserved; Pl. 214 – Gift of G. David Thompson, 1955; Pl. 215 – The Lauder Foundation Fund; Pls 216, 217, 219, 225, 227 – Gift of Joseph H. Hirshhorn Foundation, 1966 (Photos: John Tennant/Lee Stalsworth); Pl. 220 – Gift of Mr William Inge; Pl. 222 – Photo: Otto E. Nelson; Pl. 224 – Friends of Art Fund, 57.11; Pl. 226 – Purchased with funds from the artist and Mrs Bernard F. Gimbel; Pl. 229 – Photo: John Webb; Pls 230, 232, 233 – Photo: Courtesy of Xavier Fourcade, Inc., New York; Pl. 231 – Photo: Courtesy of M. Knoedler & Co., New York.

PHILIP PEARLSTEIN Pl. 234 – Photo: Courtesy of Allan Frumkin Gallery, New York; Pls 235, 236, 238, 239, 240, 241, 242, 243, 244, 246, 247, 248, 249 – Photo: Courtesy of Hirschl & Adler Modern, New York; Pl. 245 – Wilson Fund; Pl. 250 – Museum Acquisition Fund.

8

PREFACE

This is not a book about Marcel Duchamp. Nor is it a survey of the female nude in the twentieth century. It does not by any means include all the important artists who have painted or sculpted naked women during the past ninety years. Renoir, Rouault, Derain, Laurens, Magritte, Giacometti, Henry Moore, Wesselmann and many others are here missing and unaccounted for. What the book is, I hope, is a study of thirteen erotic and affective sensibilities as expressed in the work of thirteen artists: Aristide Maillol, Pierre Bonnard, Egon Schiele, Henri Matisse, Pablo Picasso, Amedeo Modigliani, Jules Pascin, Gaston Lachaise, Stanley Spencer, Lucian Freud, Balthus, Willem de Kooning and Philip Pearlstein; thirteen complex ways of feeling by men about women; thirteen selves contemplating the other and projecting on to that abstraction a range of feeling from dread to desire, even detachment, under cover of a technical artistic preoccupation. ('I do not create a woman, *I make a picture*,' said Matisse; 'Content is not interesting,' says Pearlstein. But they both chose *this* content and no other, and that is what is interesting.) The range of these feelings and the form through which they have been expressed — in some of the most famous and beautiful images of this century: Matisse's odalisques, Picasso's *demoiselles*, Bonnard's bathers, Modigliani's madonnas, Balthus's Lolitas, de Kooning's harpies, all the venuses, courtesans, caryatids, street urchins, whores, virgins, nymphs and dancers in these pages — are the subject of this book.

This is a book about the bachelor as much as the bride, the artist as well as the nude, because art comes not just from other art but from lives as they are actually lived, and affected by weather and illness, money and politics, sexual excess and domestic strife. At times the life of the nude is so close to the life of the artist that her form becomes his involuntary autobiography; at times a confession, a description of self in the form of the ideal other. At other times the nude may be a refuge from the facts of the artist's life, what he creates *instead*. At such times she is born not out of what is there but out of what is missing.

Behind the isolated image of the nude there is always a crowd scene. In this crowd are elements from the artist's present (his anxieties and aspirations), ghosts from his past (memories), fantasies of his future

(desires or nightmares). In the crowd are other women from the artist's life (his wife, mother, sister, mistresses or landlady) — all those female beings that collectively create his feelings for the female on the canvas. And there are other images of women, from films, posters, advertisements; and other nudes, those made by his contemporaries or perhaps the great nudes of Western art, the Titians, Giorgiones, Rubenses, Goyas, Manets, which the artist may intend to challenge. Lastly, there may be the real model herself, whose appearance is incorporated selectively into the painting or may simply be used as a catalyst for the idea of the nude the artist holds in his mind.

The nude is a fantasy of another human being, conjured out of memory and desire and fabricated by a process of subtractions and additions. What may be subtracted are the specifics of the model: her appearance and personality, allowing the artist to treat his unreal being freely — chop her up if he's a cubist, colour her green if he's expressionist, bend her, inflate her, multiply or dissolve her as he imposes his vision on his subject. Yet he must never lose her altogether, for no matter how abstract the nude becomes she remains related by complex kinship (through memory, desire) to real beings who must not be abused. (Duchamp's descending nude was shocking not only because of the radical style of the painting but because the subject of his radical treatment was recognisably human.) Instinctively we feel that what an artist does to the image of the nude has bearing on what he intends for her kind: she is the metaphor of their relationship. The struggle between the expressive needs of the modern artist and the moral and social constraints imposed by the subject make the nude a primary object of anxiety in an anxious century.

The instinctive reverence for the human image may account, as with portraiture, for the relative unadventurousness of most nude painting in this century. Yet many of the best and most advanced artists of the twentieth century have painted or sculpted nudes, often obsessively. No other subject addresses as directly or as fundamentally the question of who we are and how we love. Because buried in the notion of nakedness is the notion of candour (uncovering), the nude is a self-issued invitation for the artist to speak intimately, about himself, about desire and distance. The artist who paints a nude announces that he has something particular and private — no matter whether the expression exists in cubist, surrealist or neo-realist form — to say about this subject: the entity that stands (or refuses to stand) between himself and his solitude, the soft-skinned edge of the rest of the world.

In the years during which this book was written I have been helped by many people. I would like to thank particularly the staffs of the Museum of Modern Art Library, New York, the New York Society Library, and the New York Public Library; of the Victoria and Albert Museum Reading Room and the Courtauld Institute in London; of the Musée Rodin and the Beaubourg in Paris; of the Musée Matisse in Nice; and of the Albertina in Vienna. Philip Diotallevi of the

Wildenstein Gallery, Barnett Owen of the Perls Galleries, and Robert Schoelkopf of the Schoelkopf Gallery in New York were especially helpful. Above all, I would like to express my gratitude to all the patient and talented editors, designers and other staff, past and present, at Jonathan Cape who worked so hard and generously for this book: Liz Calder, Frances Coady, Valerie Buckingham, Alison Mansbridge, Cathie Arrington, Rowan Seymour, Ian Craig, Tim Chester, Polly Samson, Mon Mohan, and Patsy Metchick, and who over the seven years of my association with Cape have made visits to Bedford Square a real and special pleasure. This is their book as much as mine.

LACHAISE, *The Mountain*, 1920–1, black sandstone, Worcester Art Museum, Dial Collection

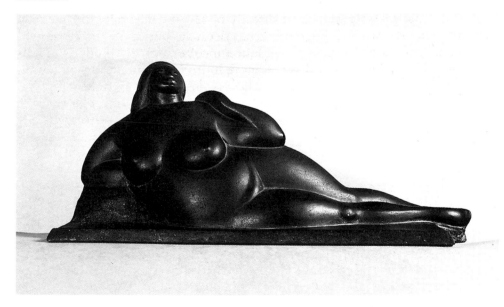

ARISTIDE MAILLOL

In 1902 Octave Mirbeau wrote to Maillol about a small statue he had recently purchased from Maillol's dealer, Vollard:

Rodin came here. He picked up your Léda, just as I had done, and looked at it intently, examining it from every angle, turning it round in every direction.

'It is most beautiful,' he said. 'What an artist!'

He looked at it again, and went on: 'Do you know why it is so beautiful and why one can spend hours looking at it? It is because it makes no attempt to arouse curiosity.'

And to make sure Maillol took this as the praise intended, Mirbeau continued: '. . . There was a look of melancholy in [Rodin's] eyes. "I do not know, I swear I do not know of any modern piece of sculpture that is of such absolute beauty, an absolute purity, so evidently a masterpiece." '[1]

Whatever caused Rodin's melancholy, it was unlikely to have been envy. No two contemporary sculptors ever had a more different conception of art, nor of their shared source of inspiration. For Rodin the body signified as metaphor, as an expression of intelligent spirit[2] and of feeling. His sculptures were empathetic extensions of himself. Maillol's statues have absoluteness because they speak of nothing beyond themselves, beyond the abstraction of flesh as flesh (its weight, its geometric volumes, its gravity) which Maillol called 'pure beauty'. They are utterly contained and finished works, hence, perhaps, their inability to arouse 'curiosity'. Above all, they are works entirely discrete from the hand and personality of their maker. They are among the first works of the twentieth century to have broken free of the artist, without the least trail of afterbirth, the least sign of derivation. Not belonging to him, they seem to belong to no time, no culture. Their very lack of provenance renders them curious.

Whereas Rodin ruffled the surfaces of his works with his own heavy breathing — whereas he fragmented, sliced, and left on his finished sculptures the marks of their contingency and making (factory seams, armature gashes, ruptures, bubbles, evidence of violence and ownership), and in some cases used the cast of his own hand in a composition

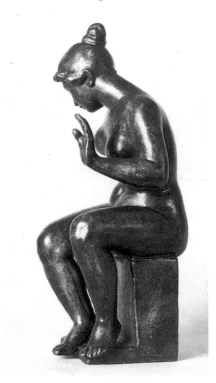

1 *Léda*, *c.*1900, bronze, Portland Art Museum, Oregon

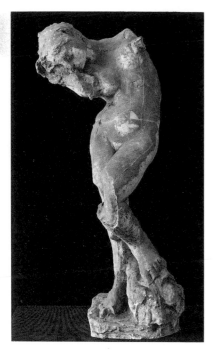

2 RODIN, *Meditation (Without Arms)*, 1896–7, plaster, Musée Rodin, Paris

to insist how these figures were his creatures — Maillol's sense of limited connection with the work, his sense of art as service, was exceptional. 'I consider that I make statues as an apple tree gives apples,' he once said. 'I am neither proud nor sorry to be a sculptor. It is in me and I give what I have. It is simple and natural. That's all.'[3]

In Maillol's work,★ not only are there no marks of the human (or mechanical) touch, but there are no signs either of any feeling warmer than devotion, not the least sensuality in the finished works (compare, for example, his sculpture with that of his friend Renoir), nothing remotely boastful even of knowledge, let alone ownership, of flesh. For all their undeniable power, these are chaste and coolly rendered icons. In the sculpture of this century, their kinship seems to be not only with the cubist work of Henri Laurens, but also with the abstractions of Brancusi — like Laurens, once Maillol's assistant. In the work of each of these artists, art and maker are utterly distinct; the artist exists for the sake of the work, not the work for the sake of expressing or replicating the artist. Above all, the work never provokes speculation about, or invites intimacy with, the personality of the artist.

But Rodin's twentieth-century offspring are a different matter. Not only Matisse, but Giacometti and de Kooning are heirs to his sense of art as direct expression of the hand and emotion of the artist.

It is clear that Rodin, like Matisse after him, conceived of beauty in art, as in nature, as part of a process, a first step, above all, a signal, an invitation to come closer, to hear, to mix, to join. That is why there is so much arousal in his art, so much preliminary love-making, so much evidence of connection and exchange. That is why response to Rodin's work, both negative and positive, is so immediate. The work is pushed up close to us, pulls at us, irritatingly or touchingly, like a crowd of street urchins.

But with Maillol the presentations are formal, and seem never to move beyond the declaration of distance, affirmation of godliness rather than humanity, the constant assertion that beauty is a divine attribute, an end in itself. The sculptor's attitude is pagan, exotic, utterly remote, ice in the guise of hedonism: 'In my work I look for beauty above all things . . . [We] try to do what pleases us; and what pleases us is beauty . . . ' and 'I believe that sculpture should be primarily decorative.'[4] Maillol wrote this in 1925. Even in that surrealist era, his attitude must have been shocking. Who still believed in such pure and functionless beauty? Even for Matisse, who might otherwise seem to share Maillol's outlook, beauty had its uses: to comfort, seduce, or provoke contemplation of God. 'What I dream of is an art of balance, of purity and serenity . . . an art which could be for every mental worker . . . a soothing, calming influence on the mind, something like a good armchair which provides relaxation from

★ I am speaking here not of the smaller works, but of the life-size and larger, major pieces. In the smaller studies there is often great tenderness in the rendering of flesh and gesture, as the sculptor subordinates expression of the ideal to the facts of observation.

physical fatigue.'[5] But Matisse's art, unlike Maillol's, seeks also to arouse, to communicate beyond itself: 'What I am after above all is expression,' he wrote in 1908. 'What interests me most is neither still life nor landscape, but the human figure. It is that which best permits me to express my almost religious awe towards life.'[6] Maillol's notion of motiveless, absolute, uncommunicating beauty seems, in contrast, as antique and hypothetical as the subject of his friend Bourdelle's ill-received *Dying Centaur* (1914). 'He is dying,' the sculptor said bitterly, 'because no one believes in him.'[7]

Part of the reason there is so little of the personal in Maillol's work has to do with the artist's sense of the proper relations between art and life; namely, that they should keep as clear of one another as possible. His figures are as abstract as the artist could make them while yet continuing to work in so figurative a tradition. 'Details don't interest me,' Maillol said, 'the important thing is the general idea . . . I am seeking beauty not character.'[8] 'What I want is that the young girl depicted in a statue should represent all young girls, that the woman and her promise of maturity should represent all mothers.'[9]

3 RODIN, *Hand of Rodin with Torso*, 1917, plaster, Musée Rodin, Paris

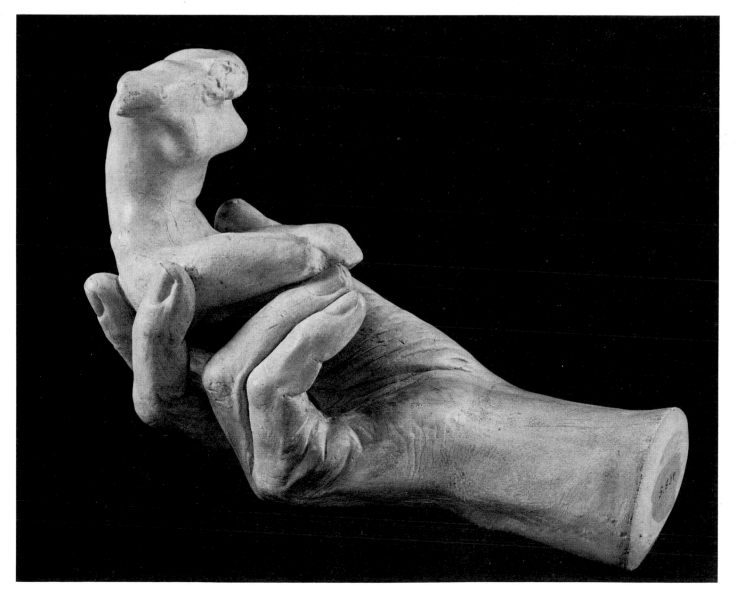

There is no suffering in Maillol's figures, and no happiness because, with the notable exception of the dramatic monument to Blanqui, *Action in Chains*, of 1906, there is no narrative — no sense of real persons frozen in a symbolic moment of life. Maillol took his work out of time to regain a sense of the eternal. He reconnected his art with that of the ancient world — not through pastiche, but through thorough analysis of its simplest geometric components (when he toured Greece in 1908 he used Cézanne as his spectacles) — and made his art eloquent of its part in a continuum. Rodin's art, by contrast, is, however immortal, fixed in its time, in its romantic conviction of human heroism, in its sense of the tragedy, above all of the transience, of life. 'More beautiful than a beautiful thing,' he once said, 'is the ruin of a beautiful thing.'[10] Rodin desired for himself an art descriptive of time, because of its greater affective power, its expressed compassion for bodies that age and suffer; but he also embraced the effects and haphazardness of temporal life in order to keep his own art buoyant. Where Maillol's work, in its courtship of the timeless, risks deadness, a kind of sterile monumentality, Rodin's sculptures retain life to the degree to which they imitate its processes. So his art plays with the effects of light on surface, courts movement, glimpses, expresses the whole with the part, repeats itself, recombines its own elements, reduces and enlarges, splices and severs, like some hymn to creation itself, a special kind of creation, not the seven-day miracle, but one that works in time and through seasons, with its endings and re-beginnings exposed.

Rodin's passionate art comes out of a voracious love of human life, from the experience and feel of life rather than from mere knowledge of its appearance. In this respect, he felt himself to be not at the beginning but at the end of a tradition and philosophy: 'I am one of the last witnesses of a dying art', he wrote in 1914; 'the love that inspired it is spent.'[11]

Matching Maillol's sense of time as a spoiler of ripe fruit was his conviction that nature was a bad influence on art. He told the critic John Rewald in 1941: 'The further one gets away from nature the more one becomes an artist, the closer one sticks to it, the uglier the work becomes.'[13]

There was no compassionate acceptance of, let alone revelling in, life *as is* for Maillol. He was choosier, epicurean; not just the art but its models had to be perfect. No beautiful ruins: 'It isn't women I love,' he said, 'it's young girls. I love the rosy freshness of girls who have in their eyes that faith in life, that confidence no melancholy can mar.'[12]

Maillol first began to sculpt in his mid-30s, around 1895, when the group known as the Nabis, with whom Maillol was closely associated, was most influential. Their prime theoretician, Maurice Denis, is probably most famous for his declaration of the flat earth of painting, which was revived in the criticism of the 1960s and 1970s to give old credentials to an art of drips and stains and ruthless anti-illusionism: 'It

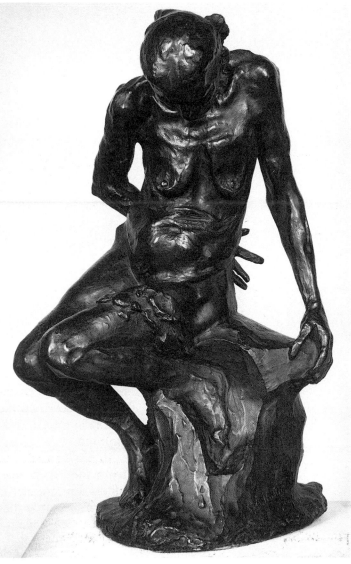

is well to remember that a picture — before being a battle horse, a nude
woman, or some anecdote — is essentially a plane surface covered with
colors assembled in a certain order.'[14]

Denis's definition of a new non-narrative, non-psychological art was
one which Maillol retained for his own work over the next fifty years.
In the aggressive language of the manifesto, Denis proclaimed:
'Universal triumph of the imagination of the aesthetes over crude
imitation; triumph of the emotion of the Beautiful over the naturalist
deceit.'[15] His definition of great art serves well as a description of
Maillol's aims in sculpture: 'What is great art,' Denis asked, 'if not the
disguise of natural objects with their vulgar sensations by icons that are
sacred, magical and commanding?'[16]

Dina Vierny, Maillol's last and best-known model, who posed
for the sculptor from 1934 until his death ten years later, describes
how even in his last years the sculptor conceived of art as a form of

17

struggle between the real and the pure:

> It was a confrontation. He didn't have very many models in his life; his wife, some others. This confrontation with nature was so important that when a visitor came to the house he would say, 'Madame, lift your skirt, show me your knee'. It was a matter of confrontation between life and his art. It didn't really matter who the model was . . .
>
> . . . Maillol worked principally alone. He had a great need for solitude. The model was indispensable, that was the necessary consultation with nature. Sometimes, three hours with the model was sufficient. Whatever he did with the model he would then undo, and begin again. Because his ideas were inside him and not in nature.[17]

Maillol's defensive posture was by that time, as Dina Vierny suggests, more a matter of habit: 'He was so full of his own idea, his internal image, that, in truth, he didn't really need nature. But the confrontation with nature was important to him.'[18]

Dina Vierny herself had been sent to Maillol by a colleague who recognised in her the Maillol ideal of face and figure. In taking Dina as his model, Maillol further ensured his art would be impervious to the dangerous effects of nature. Dina was already part of Maillol's *oeuvre* when she arrived, aged 15. Her resemblance to the girls in his paintings and tapestries of the 1890s, for example, is extraordinary.

Maillol's wariness about the reality of the model also found expression in the kinds of titles he gave his work. Allegorical, full of period sentiment, they disguised as best they could the facts of specific derivation, an aesthetic, and then later, perhaps, a more domestic concern. John Rewald has described the tragi-comic goings-on *chez* Maillol in 1938:

> Now she [Mme Maillol] looked with a sour face at many of the photographs I showed her. Although at the beginning the majority of her husband's works had represented her, she had been slowly dislodged from his creative activity. *La Nuit, La Méditerranée, L'Action enchaînée* had been posed for by her, and so had innumerable drawings that he still used. Probably more acutely than most married women, she had helplessly watched her man lose interest in her and, what is worse, had also been *replaced* in his work. The many pieces not representing her did not — as far as she was concerned — carry the titles under which they had become famous (titles often provided by Maillol's literary friends): *Île de France, Flore, Pomone, Les Trois Nymphes*, but were merely the bodies of rivals, and she would spit out designations such as *'une Parisienne', 'une gamine de Banyuls', 'une voisine de Marly', 'Marie'*, etc.[19]

But perhaps Mme Maillol's obstinate spade-calling was necessary in

6 Torso of *Île de France*, 1921, gilt bronze, Fine Arts Museums of San Francisco

an atmosphere where even the most alluringly real could be understood only in terms of art: describing his first passion for his wife, Maillol told John Rewald, 'I lifted her chemise and I found marble.'[20]

Maillol's priorities were always a little ruthless, in life as in art:

It was true that Maillol did not help when he once tried to appease

19

7 *Pomona with Lowered Arms*,
1937, bronze, Solomon R.
Guggenheim Museum, New
York

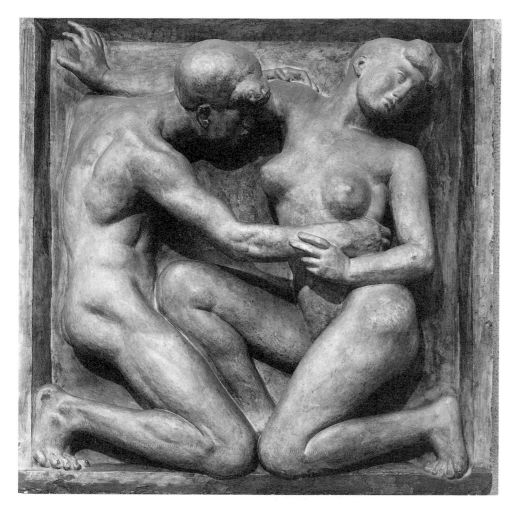

8 *Desire*, 1906–8, tinted plaster relief, Museum of Modern Art, New York

[his wife] by saying: 'But you can still pose for me . . . from the back!' She never forgave him for that.

So they lived side by side without communicating; she cantankerous, he withdrawn into his work, silent, avoiding to provoke her bad temper.[21]

Perhaps it was the memory of his early studies (1885–92 at the École des Beaux-Arts) under Cabanel, that academic near-pornographer, that led Maillol to flee from any notion of bodies as bodies and to geometrise and deify the erotic forms. His major works, for all the sexual power that remains in them, for all their unseverable connection with observed nature, are still exceptionally chaste. Mirbeau noticed that the Maillol ideal was a kind of triumph of functional design rather than an object of desire: 'Her perfect human shape destine[s] her rather for maternity than love.'[22] But there is something else. The confrontation between nature and the Idea of the artist, which Dina Vierny speaks of, was part of Maillol's sculpture from its earliest manifestations. Maillol was a proto-cubist in that he wished his art to translate what was observed into the language of what was previously known, to submit

whatever was before him to a ruthless mathematical scrutiny. While the early cubists met in Paris cafés and, under the influence of one Maurice Princet, breathlessly drew diagrams on napkins,★ Maillol with a similar intensity studied Cézanne and synthesised his analyses with those of the ancient Greek sculptors. Early in his work he began to square the nude, not as Picasso was to do, but more as Leonardo might have done, by literally putting his figures in boxes, measuring them in such a way as to proclaim not only human figures but nature, and above all human passions, containable, subordinable to analysis and art. In *Desire* of 1906–8 (Pl. 8), the analytic intention of the piece seems to outweigh simpler considerations. Had Maillol been born later, or come to sculpture even ten years after he did (he was all of 40 in 1900 when he gave up his career as a tapestry maker and began to work exclusively as a sculptor), he might have embraced a cubist solution in this instance — something along the lines of his disciple Laurens. Instead, the piece makes an inadequate synthesis of nature and analysis. Real life pops out of the square frame like a bawdy joke. The figures seem real people in stylised and awkward poses: he like some desperately gauche and hungry adolescent, she with her knee in his groin and her Christian-martyr expression. Together they mime grotesquely a tableau of the very conflict Maillol speaks of: passion and reason, nature and art, something which only the ancient world with its belief in gods as ideals in human form could do with conviction.

It was not just in the reliefs that Maillol forced the human body into

★ See page 119, footnote.

9 *Crouching Woman*, 1900, bronze relief, Dominion Gallery, Montreal

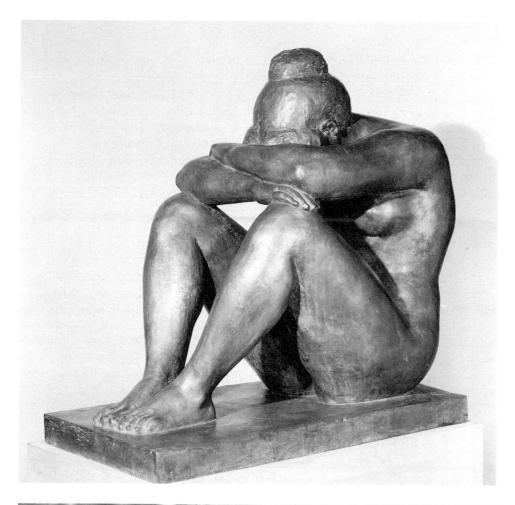

10 *Night*, 1902–9, bronze,
Metropolitan Museum of Art,
New York

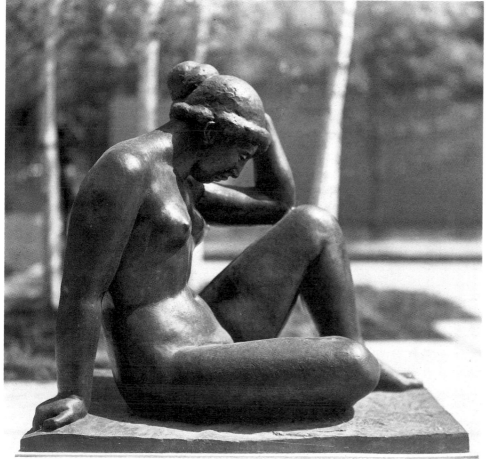

11 *The Mediterranean*, 1902–5,
bronze, Museum of Modern Art,
New York

geometrical shapes (see *Crouching Woman*, 1900, Pl. 9) but in the fully three-dimensional works as well. Small terracotta studies like *Thought* of 1902–5, and large bronzes such as *Night* of 1902–9 (Pl. 10) and *The Mediterranean* of 1902–5 (Pl. 11), are all tamed and housed by cubes. Maillol found geometry a tool for a certain kind of domination of subject by artist. Working in a figurative mode not only had the advantage of reconnecting his art with that of classical Greece, but, more enticingly, it allowed him in the game of entrapment a better prey, since the more lifelike the creature remained the more powerful the hunter-artist. 'That is how our figures must be,' he once said to a pupil. 'Full of life, only *mastered by style*.'[23]

The issue of mastery over nature is a significant part of cubism, certainly part of the drive in the art of its most famous adherent. Maillol's mature art, however, sought to be, not a demonstration of this mastery, but the result of it. Unlike the cubists, he did not want the analyses to show, did not want the inner workings of the machine visible to bear witness to the genius of the engineer. Only in rare sculptures like the dramatic and powerful Blanqui monument, *Action in Chains* (Pl. 13), is structural analysis of the human form made so explicit. The Blanqui monument is a description of the body struggling against constraints. Where the possibilities of the pose allowed trite derivation of one of Michelangelo's heroic captives or the porno-melodrama of Hiram Powers's sensational *Slave*, Maillol triumphs with a precise and rhythmical solution as intellectually rendered and as powerful as Boccioni's futurist masterpiece, the 1913 *Unique Forms of Continuity in Space* (Pl. 12).

In all of Maillol's monumental work, analysis of structure is present to the exclusion of any interest in inflected surface. There are no Rodinesque stormy seas of flesh, and not even much attention paid to the look of the body: few muscles, no valleys or ripples, characteristically only an unnatural smoothness and a minimum of articulated parts. Whatever interfered with wholeness and harmony was excised from the work. Maillol's women are monumentally simple: 'What I am after is architecture and volume,' Maillol said. 'Sculpture is architecture, is equilibrium of masses. This architectural aspect is hard to achieve. I endeavour to obtain it as did Polycleitus. My point of departure is always a geometric figure — square, lozenge, triangle — because those are the shapes that stand up best in space.'[24]

Dina Vierny says Maillol saw the forms of women as though they were parts of houses, '. . . more or less inhabitable. The legs were like the pillars of a temple . . . Maillol was an architect, he was completely abstract.'[25]

Where Maillol is not imposing architectural notions on his work, in the numerous beautiful life drawings and in the small studies of women crouching, kneeling, bathing — intimate studies that can be held in the hand — where the issue of subduing the idol is not present, the artist's full erotic and tender response is evident, not held in check but offered, realised, by the art.

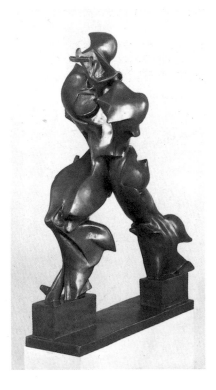

12 BOCCIONI, *Unique Forms of Continuity in Space*, 1913, bronze, Tate Gallery, London

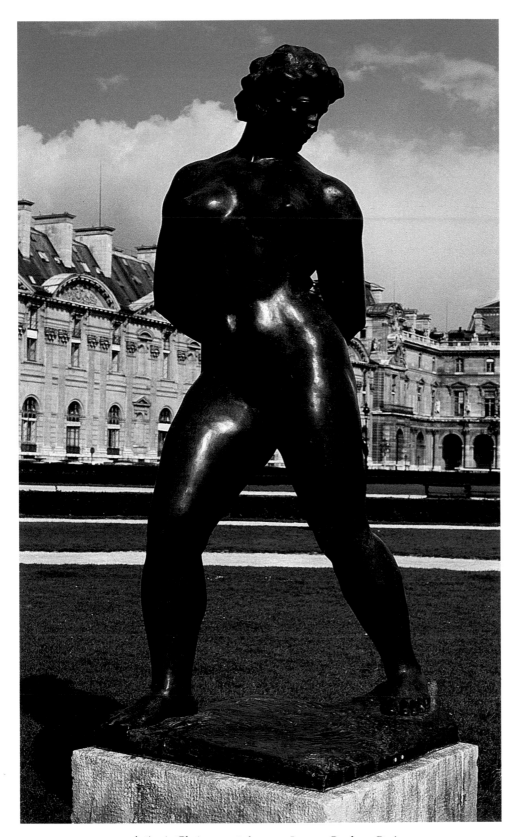

13 *Action in Chains*, 1906, bronze, Louvre Gardens, Paris

14 Study for *Action in Chains*, c.1905–6, bronze, courtesy of Paul Rosenberg & Co., New York

As far as figurative work can, Maillol's monumental art removed woman from her provenance in nature, denied the individual creature and subjected the type to the discipline of cylinders and boxes. It disavowed her intelligence[26] and emotions along with her character, while bestowing praise on outline and shape as absolutes of pure beauty.

Maillol took the Rodin nude, slowed her down, stripped her of metaphor and simplified her in order to contemplate her unified form. He made her body mute of things existing in time so that it might better express things of all time. He made the peasant type of his native Banyuls into believable forms of goddesses, and declared, rather than pride of technique and possession, the spirit of homage.

To a degree, Maillol's art was unfortunate in its time of birth. Being neither truly classical nor truly modern, it may seem to essay an

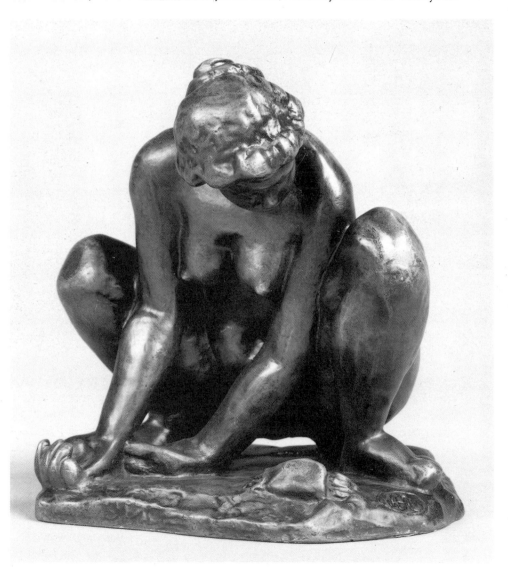

15 *Woman with Crab, c.* 1902–5, bronze, Solomon R. Guggenheim Museum, New York

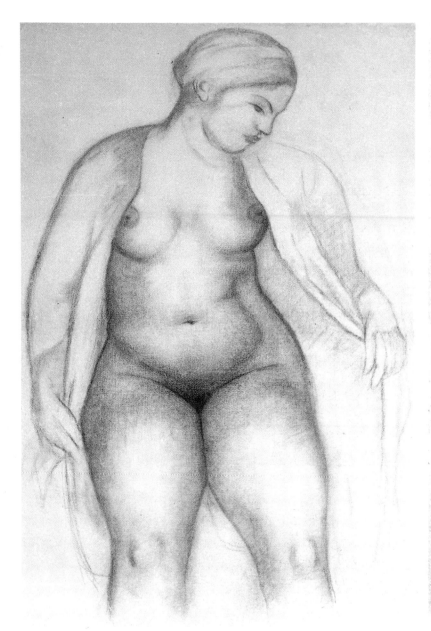

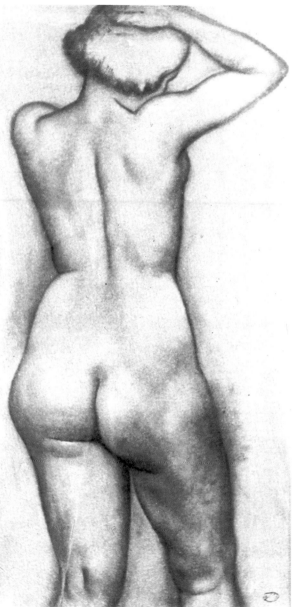

16 *Dina Seated, Facing Front,* 1939, charcoal, Collection of Dina Vierny, Paris

17 *Large Standing Nude, From Back,* 1930, charcoal and white chalk, Collection of Dina Vierny, Paris

advance by moving backwards. Like many of the decorative vacuities produced in the name of unsentimental new art, it seems in retrospect neither as bold nor as 'scientific' as it wished to be. Simultaneously embracing the look of antique art and the analyses of Cézanne, Maillol swept away the soul as well as the natural parentage of his subject, while leaving her all the vulnerabilities of a figurative presentation. Yet where the synthesis of observation and analysis is complete, Maillol's monuments have undeniable life. *Night, The Mediterranean,* the torsos of *Spring,* the *Île de France* and *Action in Chains* are among the indestructible icons of twentieth-century art.

27

NOTES

1 Octave Mirbeau to Aristide Maillol, quoted in John Rewald, *Maillol*, Hyperion Press, London, Paris, New York, 1939, p. 13.
2 'Le corps humain, c'est surtout le miroir de l'âme et de là vient sa plus grande beauté.' Auguste Rodin, *L'Art, entretiens réunis par Paul Gsell* (text 1911), Gallimard, Paris, 1967, p. 98.
3 'Maillol Speaks', *The Arts*, vol. 8, no. 1, July 1925, p. 37.
4 Ibid., p. 36.

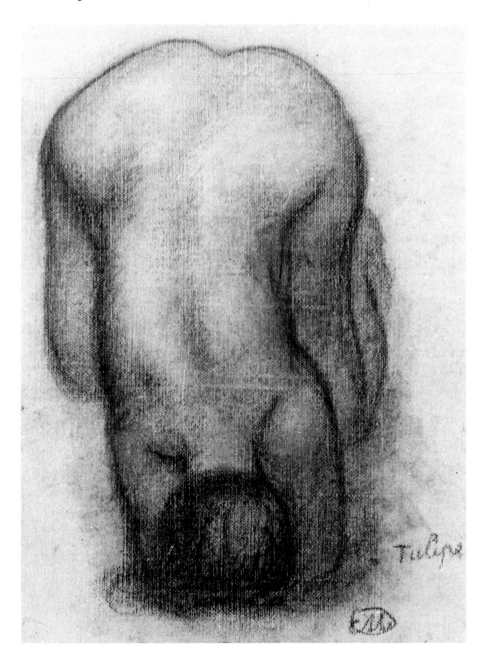

18 *Tulipe*, 1941, sanguine on hand-made paper, Collection of Dina Vierny, Paris

5 'Notes of a Painter, 1908', reprinted in Jack D. Flam, *Matisse on Art*, E. P. Dutton, New York, 1978 (paperback edn), p. 38.

6 Ibid.

7 Quoted in Albert E. Elsen's Foreword to *Pioneers of Modern Sculpture* (catalogue of an exhibition held at the Hayward Gallery, London, 1973), Arts Council, London, 1973, p. 27.

8 Maillol in conversation with the art historian Alfred Kuhn, quoted in Waldemar George, *Aristide Maillol*, New York Graphic Society, Greenwich, Connecticut, (n.d.) ?1965, p. 43.

9 Quoted in John Rewald, 'Maillol Remembered', Introduction to *Aristide Maillol: 1861–1944* (catalogue of a retrospective exhibition held at the Solomon R. Guggenheim Museum, New York, 1975), p. 22.

10 Quoted in Leo Steinberg, 'Rodin', in *Other Criteria: Confrontations with Twentieth-Century Art*, Oxford University Press, London, Oxford, New York, 1976, p. 385.

11 Rodin, *Cathedrals of France*, Eng. trans. by E. C. Geissbuhler from *Les Cathédrales de France* (1914), Beacon Press, Boston, 1965, p. 78.

12 Quoted by Jean Presson in *Occident*, no. 3, February 1948, p. 19.

13 John Rewald, 'Maillol Remembered', p. 27.

14 Maurice Denis, 'Definition of Neotraditionalism, 1890', in Herschel B. Chipp, *Theories of Modern Art, A Source Book by Artists and Critics*, University of California Press, Berkeley and London, 1971, p. 94.

15 Ibid., p. 100.

16 Ibid.

17 Wendy Slatkin, 'Reminiscences of Aristide Maillol: A Conversation with Dina Vierny', *Arts Magazine*, vol. 54, September 1979, pp. 164–5.

18 Ibid.

19 John Rewald, 'Maillol Remembered', p. 22.

20 Ibid.

21 Ibid.

22 Octave Mirbeau in 1921 (Eng. trans. by Diana Imber), reprinted in Waldemar George, op. cit., p. 214.

23 Arnold Ronnebeck, 'The Teachings of Maillol', *Arts Magazine*, vol. 8, no. 1, July 1925, p. 39.

24 John Rewald, 'Maillol Remembered', p. 16.

25 Dina Vierny, loc. cit., p. 165.

26 'The women Maillol met, with few exceptions . . . were imbeciles. He had a very poor opinion of women, of course, a beautiful *derrière* was an extraordinary thing for him. But he never had women as intellectual companions.' Dina Vierny, loc. cit., p. 165. And cf. Rodin's remark: 'La beauté, c'est le caractère et l'expression.' Rodin, *L'Art, entretiens réunis par Paul Gsell* (text 1911), Gallimard, Paris, 1967, p. 97.

PIERRE BONNARD

No commentator on Bonnard's work has failed to respond to the sweetness of Bonnard's world, or to the unmodernness of his sensibility: its lack of anxiety, of irony or doubt. From the evidence of the paintings it is hard to imagine that Bonnard lived through the privations of two world wars, or that he died at the beginning of the atomic age. The art that began by recording scenes of the *belle époque* seems fixed in some conviction of life as good and gay and innocent — in fact the imagery of the work becomes progressively so, until in the late canvases colour and light and joy seem themselves the whole subject of the art. Looking at the life's work we are likely to imagine Bonnard a fortunate, possibly even a simple man, one with an infinite capacity for pleasure, at peace with the world as he finds it, at home there and with himself.

But that is to confuse the art and the man, to assume that the life Bonnard painted was the one he led, easily done given the documentary style of much of his work, with its freeze-frames and half-anecdotes, the apparent off-handedness of the setting down, with its gestures caught and its strange perspectives, the scenes viewed as though from the corner of an eye and, as from this angle, not always perfectly legible. In a Bonnard 'slice of life', the subjects themselves may be sliced: a head may sit in a remote bottom corner of a huge canvas, or the blur of peripheral vision may make unreadable the goings-on at the edge of the painted world.

'I want to show all one sees upon entering a room,' Bonnard said, ' . . . what the eye takes in at first glance.'[1]

Bonnard's art may well be, as some critics have said, about this process of seeing, its vagueness and confusions, happy coincidences of forms, explosions of colour by light, but it is important to know what it was that Bonnard actually saw, the degree to which the scientific or 'factual' manner of his painting was at the service of his fabrications. The great achievement of Bonnard's art was to perpetrate the most seductive of lies, to make images of a private paradise where all the evidence shows there was none. He painted throughout his life a world of enormous comfort and gaiety, populated by dogs, cats, cousins and children. His record is of days regulated by the arrival of guests, large meals in brightly coloured rooms or in sunshine out of doors. And at

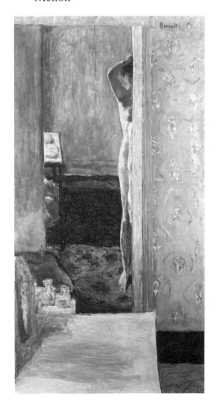

19 *Nude in an Interior*, 1912–14, oil on canvas, Collection of Paul Mellon

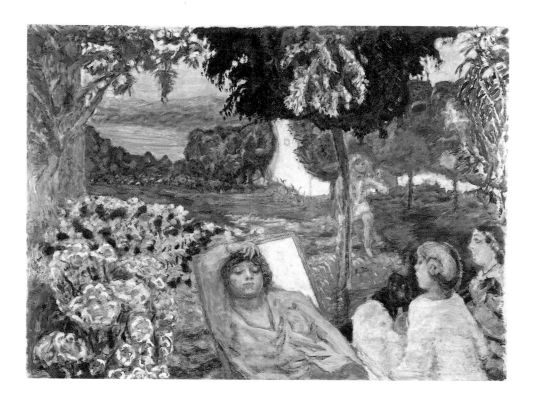

20 *In a Southern Garden*, 1914, oil on canvas, Kunstmuseum, Bern

the centre of this world, the woman he painted again and again, and in the titles sometimes named, there was Marthe, Bonnard's wife. We see her among friends, as hostess, or alone in numerous scenes of bathing, dressing. Slender, elegant — even without clothing, she conveys by stylish haircut and slippers a definite chic — we imagine her to have been bright, sexy, worldly, both sophisticated and good-natured, rather like Claudette Colbert in a comic romance of the 1930s.

That the truth was significantly different says something about the nature of Bonnard's art, and the look of it, its intensity of vision, its abstraction, its poetic inventions of colour and form.

Even Bonnard's closest friends admitted that his life, away from the hours spent painting, could only be described as a sad one. In contrast to those scenes of affluence and hospitality, those tables literally tipping under the offerings, surrounded by contented faces, was the almost ferociously spartan nature of his domestic world, protected by his notoriously bearish and inhospitable manner.[2] In later life, after 1925, when he and Marthe moved permanently to the South of France, old friends saw him rarely, and then only at their own invitation, at nearby hotel restaurants, to which Marthe, resentful and self-absorbed, obedient as always to the faddish regimes of her doctors, brought her own food: large slabs of uncooked meat, which she unwrapped and consumed under the outraged gaze of fellow guests and restaurant owners.

The charitable view of the Bonnards, taken by the locals in the South of France and at the various gloomy spas to which Marthe's ill-health or hypochondria (it is not quite clear) led them regularly, was that they were 'characters' (*originaux*): Bonnard with his rumpled clothes, his

21 *The Breakfast Room*, *c.*1930–1, oil on canvas, Museum of Modern Art, New York

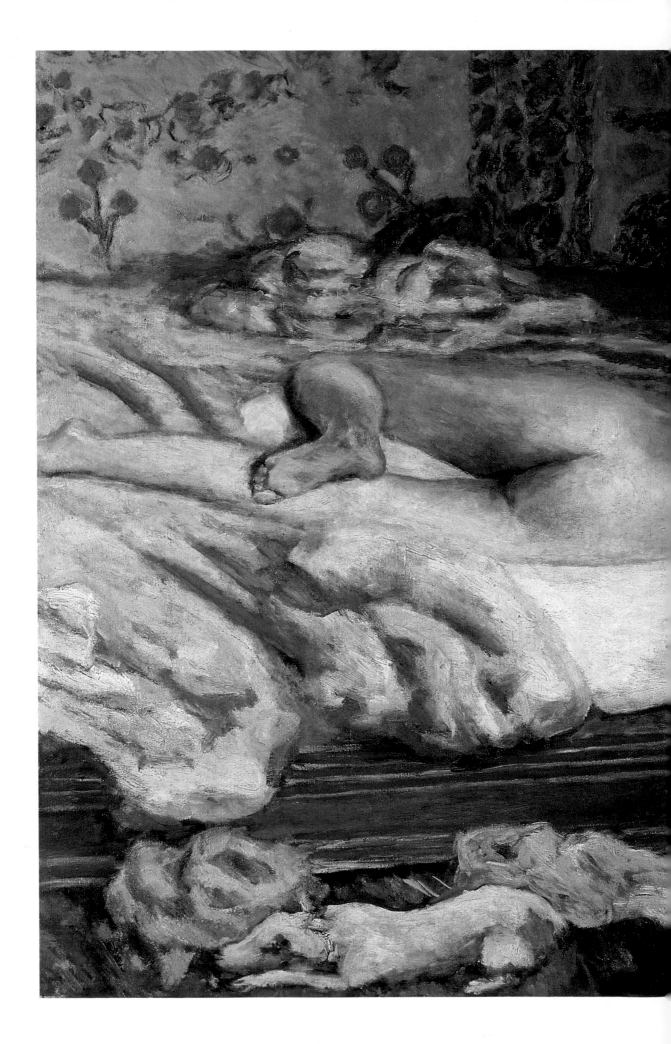

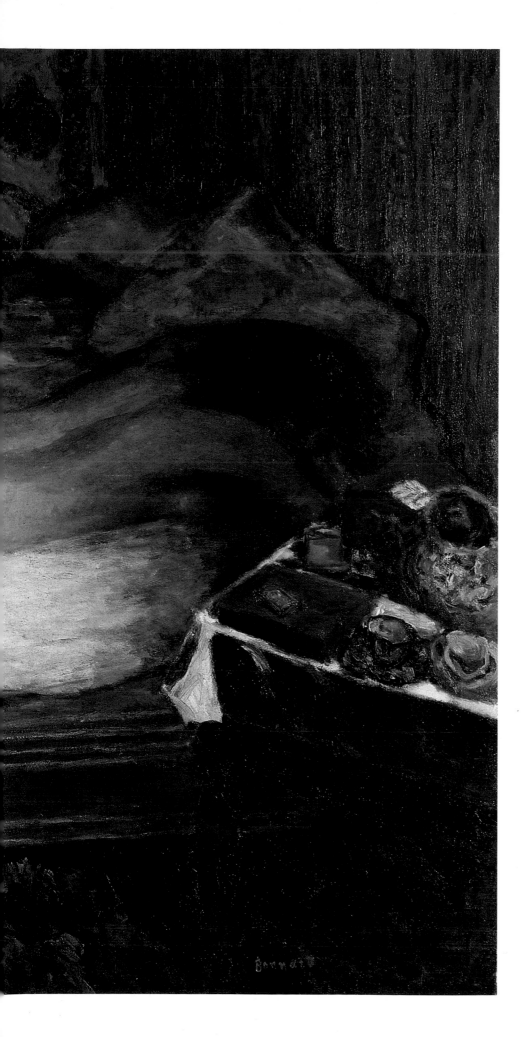

22 *Siesta*, 1900, oil on canvas,
National Gallery of Victoria,
Melbourne

bespectacled stares and long silences; Marthe with her loud, rude, 'savage and harsh', always complaining voice, her garishly coloured clothes and 'cheap finery'.[3]

Painters' wives are often treated roughly by memoirists, but Marthe has been exceptionally ill-viewed by Bonnard's friends. Contrasting the painter they knew from the early days when, as an illustrator of the *Revue blanche*, Bonnard led a busy and gregarious life in the Paris of the 1890s with what he became once he settled down with Marthe, former friends blamed the changes on her. Jealous to the point of mania, resentful of his friendships, a public nag, it was her fault, they said, they saw so little of him.[4] But, some of them allowed, it was out of the deprivation of this henpecked and lonely life, led in cheap hotel rooms and in various provincial homes, each one uncomfortably and banally furnished and extraordinarily unpretty (*dépourvue de confort . . . d'une laideur rare*[5]), and the regime of what they described as his unthanked martyrdom, that the idealising art was made. And, generously, some admitted that their loss was art's gain.

Still, the contrast was startling. 'Seldom was décor more lamentable than that of the rooms where he lived. They showed the most common taste, a petit-bourgeois slovenliness in such contrast with the art that the ugliness seemed not only engrained but a question of breeding.'[6] (Dauberville goes on to note that there were no trees in the garden, either.) When, no doubt more tactfully, Dauberville enquired how Bonnard was able to live in such a place, the artist replied, 'I have everything within me. Those who don't possess such inner wealth as I have need the help of beautiful works made by people like us.'[7] Beauty, Bonnard says, is something carried inside the head. A delusion of mind, his friends might have added, like love.

The Bonnards were not poor but spartan, austere, miserly, mistrustful of the money that the paintings brought. It was as though Bonnard sought to deprive himself of beautiful things in his life all the better to put them in his work. His art was one of transformation of what was seen into what was felt, or what was poetically signified by things seen or remembered or desired. Just as in his art Bonnard remade the neurotic bathing of Marthe (many times a day, for hours at a time, and involving an extraordinary preoccupation with soaps and scrubbing cloths[8]) into an image of luxury and peace, almost to the point of kinship with the Golden Age scenes of bathers by Puvis de Chavannes and Cézanne, so he remade the imprisonment of their life into a convincing image of domestic bliss and social harmony, complete with children they never had, friends they hardly saw, flowering gardens and harmonious, luxuriously comfortable and highly decorated houses in which they never lived.

'Painting from Nature is not copying the object, it is realising one's sensations,' Cézanne said, and it was along these lines that Bonnard's art developed, away from what he early on called 'vulgar naturalism' towards an art eventually so divorced from object as to seem to parallel his wife's solipsism with his own. (The most obvious instance of this

34

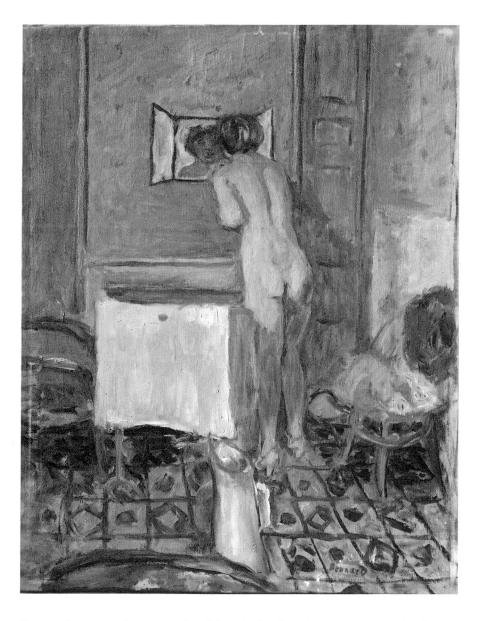

23 *Nude in Front of a Mirror*, 1915,
oil on canvas, Kunstmuseum,
Basel

divorce between image and subject is the fact that over a period of some
fifty years the paintings continue to depict Marthe as a young woman.
Where most painters would have turned to increasingly younger
models to keep their images beautiful, Bonnard has only to refer to his
memory. But that world of memory demanded an almost ruthless
protection from intrusion by fact, and Bonnard developed strong
powers of dissociation to keep it safe.)

With the exception of his drawings, Bonnard never worked directly
from his subject. 'I personally am very weak,' he once wrote. 'I find it
difficult to keep control of myself in front of the object . . . I do
everything in my studio.'[9] He was always more interested in what he
called the 'Idea' of the painting than in the reality of the model.[10] Over
the fifty years that Bonnard painted Marthe, his nudes changed in
nature from explicitly and almost exclusively sexual beings to chaste

35

apparitions, objects of the painter's eye, often equal in value to other objects in the domestic space. Marking these changes of feeling is the manner in which the images become less and less sculptural, corporeal (perhaps as the real Marthe moves away, in time, from her first physical manifestation), until they flatten into surface and skin. The final nudes are almost transparent: osmotic, coloured ghosts that allow passage of light and sensation around and through them, and seem to act as signs only, triggers of the artist's remembered feelings.

And the related role of the artist changes accordingly: in the early nudes, he is the enticed object of the nude's seduction; in the next, the observer and ostensibly impartial recorder of appearance; and in the last, one whose responses outweigh, overpower and eventually obliterate what he sees.

Bonnard's modernism lies, I think, in the achievements of this last stage of his art, and not, as is sometimes claimed, in his discoveries as observer, recorder of the way one 'actually sees' — not in that all-overness of his work: the equal pictorial value given to everything, whether wife or shadow, that comes into the undifferentiating snare of vision. His modernism lies rather in his priorities: the greater value he gives to his own sensibility over what it is he sees. Turning his back on the subject, deriving his art from private sensation, and acknowledging the distance between self and the world, Bonnard in his work has affinities with abstract expressionism. It is an art that ultimately celebrates feeling for itself and depends on a ruthless isolation to do so.

Bonnard met Marthe in Paris in 1894, a street encounter on the boulevard Haussmann. She was 16 and he 25. He had been a painter for six years and was just beginning to make his way as an illustrator for the *Revue blanche*, a fashionable avant-garde publication among whose contributors were both artists like Lautrec and writers such as Verlaine, Mallarmé and Proust.

Bonnard made his first portrait of Marthe in the year that they met. Although she came to live with him not long afterwards, they were not married until 1925, the year of their permanent move to the South of France, the beginning of their 'exile'. Marthe remained with Bonnard until her death in 1942. Over the nearly fifty years they were together (and until Bonnard's own death in 1947) she was the subject of his most important work.

The early nudes of Marthe are the most explicitly sexual of all Bonnard's work, and familiarity with the later paintings leaves us unprepared for the effect of these, their directness and impact. They refer unequivocally and almost exclusively to sex, invitation and enticement, firmly within the traditions of erotic art. (*Siesta* of 1900, Pl. 22, a legs-splayed back-view, is reminiscent of eighteenth-century boudoir painting such as Boucher's *Mademoiselle O'Murphy*.)

In *Blue Nude* and *Indolence* of 1900 and 1899 (Pls 24, 25), the woman lies legs apart, sheets cast aside, her body willingly exposed to the painter. There is almost no colour in these first works; the light shines

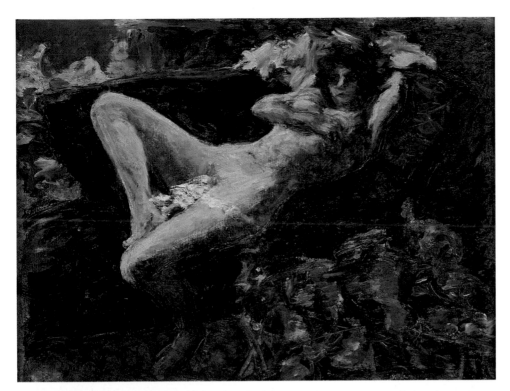

24 *Blue Nude*, 1900, oil on
cardboard, Galerie du Jeu de
Paume, Paris

25 *Indolence*, 1899, oil on canvas,
Musée d'Orsay, Paris

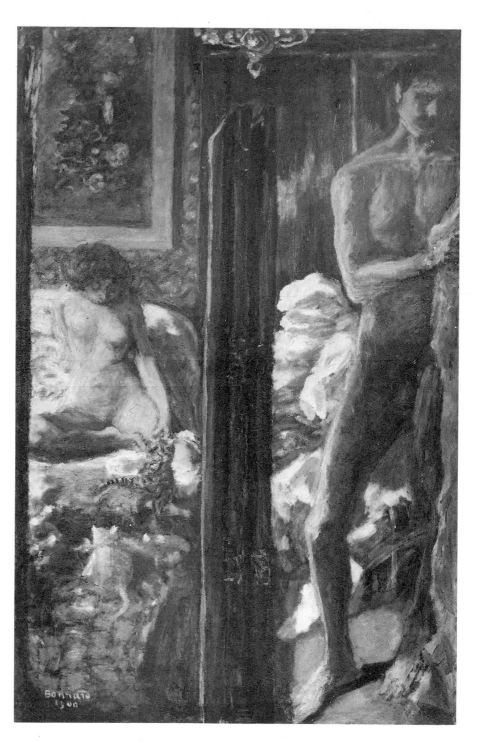

26 *Man and Woman*, 1900, oil on canvas, Musée d'Orsay, Paris

entirely from the flesh, a blue light in *Blue Nude*, a golden light in *Indolence* and in *Nude with Black Stockings* of 1900 (Pl. 27). Around the body, darkness, and the art-nouveau undulations of sheets and couches, lines and rhythms that reverberate from the presented forms of the female nude as these twist and curve inside the picture plane in a markedly different manner from the stiff horizontals and verticals of Bonnard's later work. These are beautiful and worldly images, full of

38

sensuality, conveying the feel of sheets and skin, the airlessness of near bodies in closed rooms. Thickly, darkly painted, they are about touch (and knowledge) the way the later work, with its air, light and re-learned innocence, is about sight. But here, clarity is subordinated to the sexual intent of the images, as Bonnard uses chiaroscuro, a romantic lighting that casts into shadow, the better to arouse and engage the imagination.

One of the few paintings that Bonnard made depicting a couple is *Man and Woman* of 1900 (Pl. 26). The picture (rather like similar scenes in the work of Sickert) suggests a moment out of domestic narrative. The man has just risen from the bed and is about to dress; the woman stares downwards, longing, perhaps resentful. Her desire for him, his indifference, is almost a reversal of the implied relation between Marthe and Bonnard as suggested in the later works: she cut off, unapproachable, wanting only to be left alone; he contemplating her, recalling her again and again, summoning her through his painting.

In 1908 Bonnard painted what in this respect seems a transitional work between the first and the later nudes: the *Nude Against the Light* (Pl. 28), an image of a standing woman seen from the side as she arches her back and exposes her body to the light that floods through lace-curtained windows. It is a glimpse of Marthe after her bath (there is a tub to her left in the bedroom: the Bonnards did not have a real bathroom until many years later). As in the later works, Marthe is alone and preoccupied with herself. But here, as in the early nudes, she exudes sexuality rather than containment, seduction rather than distance. Her invitation is to the light, and there is a joy in the painting which is not only the artist's. It is a rare picture of Marthe's contentment in herself and in her body. And, as Bonnard shows us, by the way the light throws the colours of the room about her, the way her body curves harmoniously with the decorative patterns on the walls, curtains and chaise, she seems, too, to delight in her surroundings, the body integrated with the place.

The period of erotic early nudes coincided with a time in Bonnard's life when he was working as an illustrator for the *Revue blanche*, designing sets for Jarry's *Ubu Roi* and in all respects leading a full and successful life in the capital, and it may be that the gradual changes in his nudes (of which *Nude Against the Light* seems to mark a stage of transition) reflected the gradual pressure of Marthe's increasing demands on his time and affections. While there was everything else in his life — Paris, theatre, friends, professional esteem, even celebrity of a sort — the women in his pictures represent sexuality alone. Later, as his life with Marthe separated him from other people and other settings, the nudes lose their exclusively sexual nature and take on a wider, and more neutral, meaning. As, progressively, Marthe became Bonnard's world, the art steps back to analyse it. In the paintings of his middle period, there is more air, more light, discreter forms inside each space. The artist begins to appraise the body of his companion in a cooler fashion, begins to look at Marthe as stiller life. And yet, less sexual, she

27 *Nude with Black Stockings*,
1900, oil on wood, Private
Collection

28 (opposite) *Nude Against the
Light*, 1908–9, oil on canvas,
Musées Royaux des Beaux-Arts
de Belgique, Brussels

is more powerful: her presence is everywhere, the implied source of
Bonnard's high, joyful colouring of the rooms she inhabits, his reason
for loving them, and for wishing to re-create them in his art. As the
images of Marthe lose sensuality and intensity, those qualities seem to
leak from her into her surroundings. In some paintings, Marthe is no
more than a ghostly presence, passing through (and indifferent to)

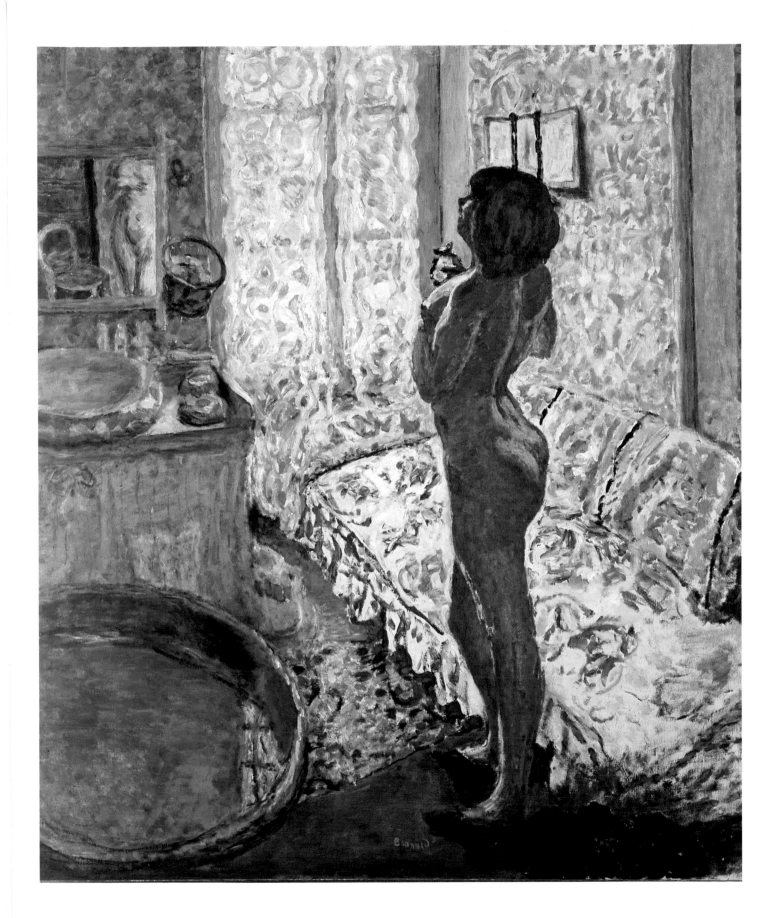

of his art, the fact of Marthe remains a kind of control, her appearance affected by the light explosions around her, at times herself a catalyst for the surrounding optical events. Yet she is always recognisably herself and psychologically described: consistently remote, self-enclosed, solitary. Inside the wildest, most frenzied storms of the artist, she is the gloomy anchor, the depressive inside Bonnard's mania.

The grounding effect of the real Marthe is clear if one compares a Bonnard landscape with a nude of the same period. Next to *The Garden* (*c.* 1937, Pl. 31), for example, an ecstatic outdoor scene with near frenzied colouring and wild expressionism, the painting of Marthe in *Nude in the Bathtub* (1937, Pl. 32) is almost constrained, chilly, as though some aspect of the subject blocked the feelings of the artist. And the landscape is by far the sexier painting, with its trees and leaves pulsating in the wild, emotive colouring of Bonnard's palette. Nature is voluptuous, enticing, opulent, beckoning the painter in the same manner as did his early nudes. It is not quite pantheism, but it is a rapt view of the world and of the painter's fusion with it (his colouring, his responses, adhere to and alter what he 'sees'), which he never altogether rises to, or wishes to re-create, in his paintings of his wife. In Bonnard's nudes, there is always a conflict between the drive in his art to express fusion with the object and his response to what that object tells him. Those intense feelings of the artist could not altogether force through the fact of Marthe's implicit rejection; in that sense Bonnard's paintings do not lie. Nature seduces him, light and colour seduce him, his own feelings seduce him, but Marthe refuses. Although his paintings of her express the enticements of place and the memory of their first life together, the realities of their life in the present, its unease and disconnectedness, lie at the heart of his images of her, hold him back

31 *The Garden, c.*1937, oil on canvas, Musée d'Art Moderne de la Ville de Paris

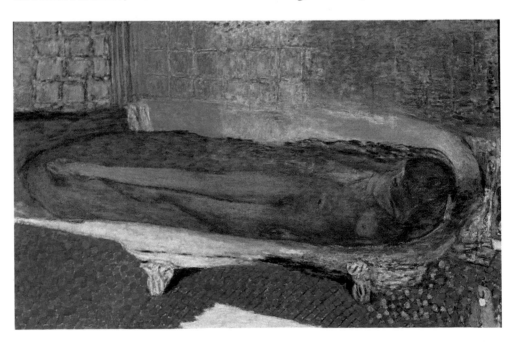

32 *Nude in the Bathtub*, 1937, oil on canvas, Musée d'Art Moderne de la Ville de Paris

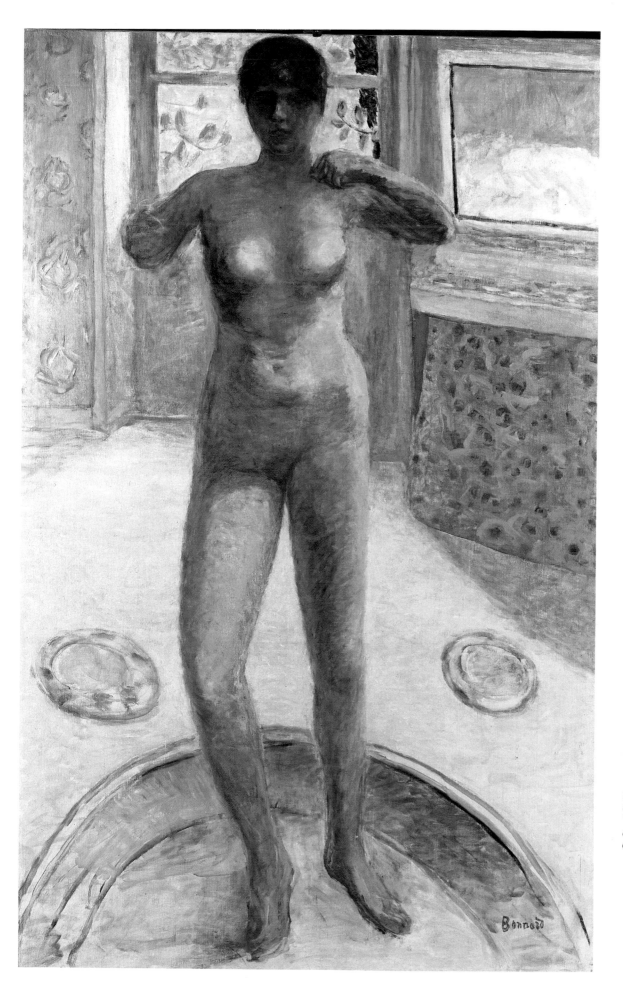

33 *Nude
Standing in a
Tub*, 1924, oil on
canvas, Private
Collection

from the total escapes and flights of the landscapes, while more powerfully engaging us by the mysterious ambivalence at their centre: her calm, perhaps sorrow, versus his joy; her solid presence versus the wild life and changeability of form and colour around her.

Bonnard did once (and in several versions) paint an image of paradise that brought the beloved into his enchanted landscape. He put himself in the picture too, with something that looks very much like an artist's easel. In *Earthly Paradise* of 1916–20, while the gardens and foliage surround and enthral the painter, a woman lies, arms open, breasts exposed, in a posture of welcome and peace. In the scene, the painter does not join her but remains at a distance, noting the affinity between woman and setting, recording the *luxe, calme et volupté* which seduces him and inspires the extreme responses of his art. Like those lunch parties that Bonnard likewise imagined, *Earthly Paradise* is a fantasy, but here, though the depicted artist is recognisably Bonnard, the woman is not Marthe.

Bonnard did occasionally paint Marthe as a goddess, but that was almost an accident of his art, a side-effect of his method of re-creation in a state of high feeling. In the beautiful 1924 *Nude Standing in a Tub* (Pl. 33), the image of Marthe as a young woman (although she was then actually 46) rises from the tin bath like Venus from her shell. Her right foot hovers precariously off the ground (Bonnard re-worked the original weight-supporting pose), defying gravity. In a sunlit room, she is herself a source of light, tall, large and radiant. Leaf-vines in the window-frame behind her, flattened by Bonnard's perspective, seem, like the delicate and sensuous patterns on the walls, to flow from her. Objects in the room hang weightless in magic space; the material world behaves un-really. The features of Marthe's face are shadowy, and the image becomes both a portrait and a hymn to a deity.

Bonnard's nudes were conceived in the space between, on the one hand, his daily life with Marthe together with his observations of light and objects, his great and constantly re-thought-out technical knowledge of painting, the crowd behaviour of colours and lines — all the things that made up Bonnard's known world; and on the other, a world he refers to again and again and regarded as distinct, the world of his own feelings. Between these two worlds Bonnard refused to choose, and consequently his art preserves an ambivalence which some have seen as a kind of fear, at best a nervous conservatism that kept him from taking greater risks. Picasso called Bonnard's art 'a potpourri of indecision':

> That's not painting what he does . . . He never goes beyond his own sensibility . . . He doesn't know how to choose . . . Painting isn't a question of sensibility; it's a matter of seizing the power, taking over from nature, not expecting her to supply you with information and good advice.[12]

But Bonnard sought the information in nature, or reality, because his

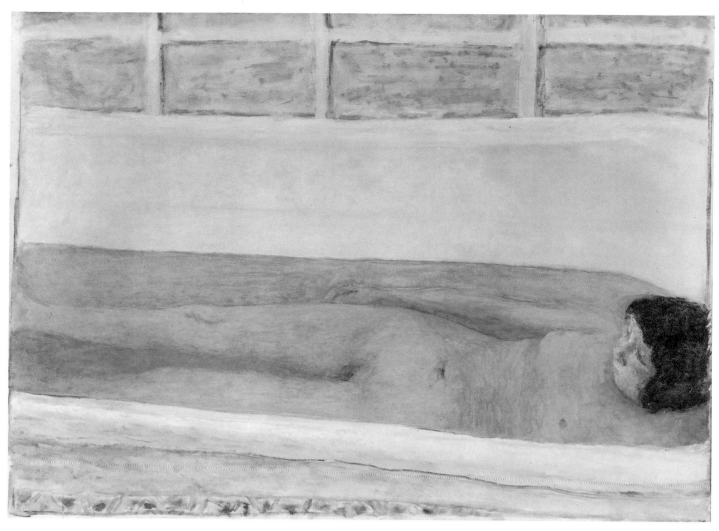

34 *The Bath*, 1925, oil on canvas,
Tate Gallery, London

art was his way of dealing with it. His art made polite, joyful and earnest conversation with his life. It demanded respectful listening as well as assertion. In a kind of perpetually monitored exercise in negative capability, Bonnard invented an art for himself that hugged the edges of both realms of his experience, refusing to abandon the empirical world in pursuit of pure sensation. ('If you let everything go, you are left only with yourself, and that is not enough. One must always have a subject, no matter how insignificant, in order to keep a foot on the ground . . . '[13]), and refusing equally to refrain from expression of self the better to record the nature of appearance (as may be said to have been the aim and manner of early cubism, for example). 'I think that when one is young,' Bonnard said, 'it is the object, the outside world that fires one's enthusiasm; one is carried away by it. In later life it is something within himself, the need to express an emotion, that leads a painter to choose his point of departure, one form rather than another.'[14]

The method of painting which Bonnard developed enabled him to join these two spheres of experience, and thus unite an otherwise

47

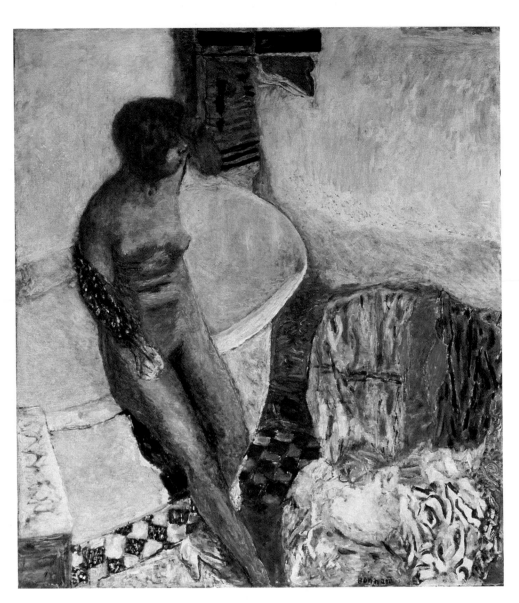

35 *Nude Bathing*, 1931, oil on canvas, Musée National d'Art Moderne, Paris

fractured world. Turning his back on the 'seductions of the subject', he would re-create it alone in his studio in a state of controlled and prolonged intoxication. Or, rather, his method was to inhale it deeply, hold his breath, record and incorporate the effects of his dizziness while he took a long time letting it out. The slowness of exhalation, the long hours, often extending over several years, devoted to each painting, were an important part of Bonnard's developed technique:* the artist's

* Bonnard was notoriously unwilling to finish his paintings. He is said to have continued retouching even after a painting was sold and hanging in the buyer's house. On one occasion he was arrested and held for two hours after tampering with one of his canvases as it hung in the Musée du Luxembourg. Working always, as he said, 'with a brush in one hand, a rag in the other', he retouched his work with the same voluptuous obsession with which Marthe soaped and bathed. (It is curious to think of him accumulating layer upon layer of paint for images of her scrubbing off layer after layer of skin. There is also a Mr-and-Mrs-Jack-Sprat aspect to the fecundity, opulence and banquet of his colorations next to her devotion to cleanliness, order and diet.)

48

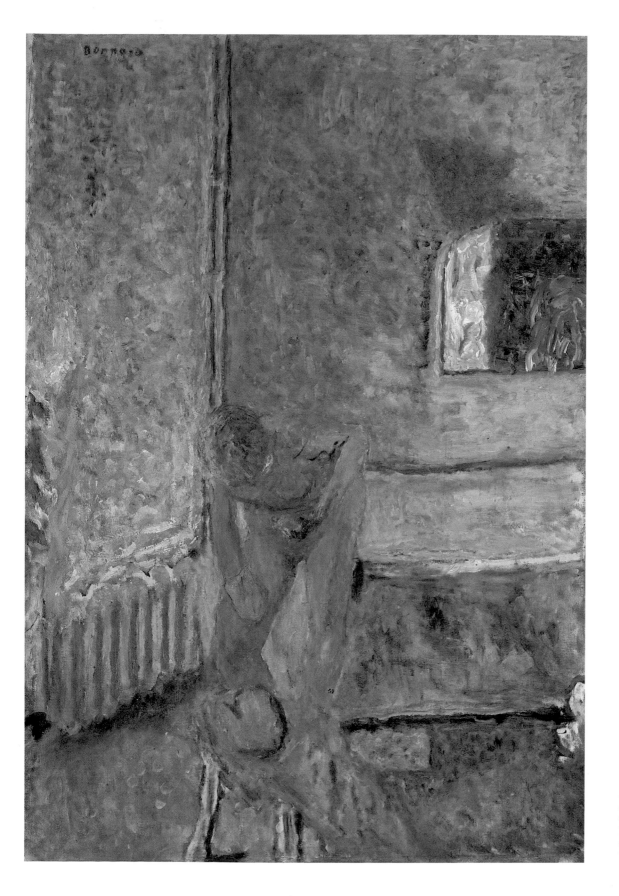

36 *Nude in an
Interior*, *c.* 1935, oil
on canvas, The
Phillips
Collection,
Washington

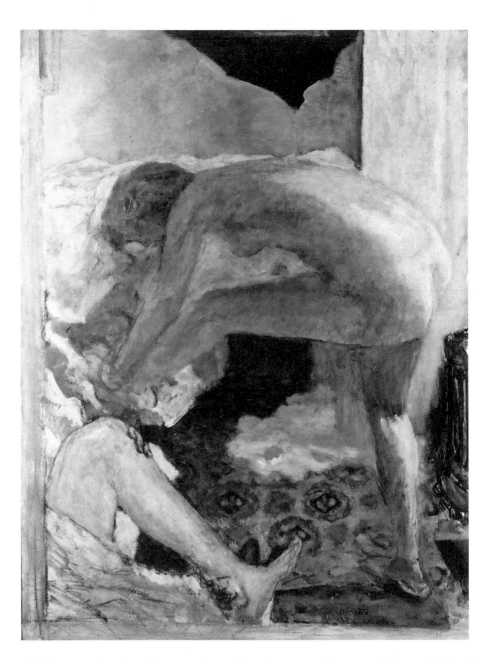

37 *Large Blue Nude*, 1924, oil on canvas, Private Collection

relation to time in the act of creation bears on the gestation period of much of his imagery, its source in manipulated and distant memory. And the prolongation of the act of painting had affinities, in the holding-off of conclusions (deaths), with his 'prolongation' in his nudes of the youth of Marthe.

'When you cover a surface with colours, you must be able to keep the game going indefinitely,' Bonnard wrote, 'continually to find new combinations of forms and colours which will answer to the demands for emotional expression.'[15] These complex surfaces of Bonnard's painting, minute spots and wilder strokes of colour, bumping into one another, creating and abandoning alliances, setting up and knocking down harmonies, keeping alive and in motion, made a kind of

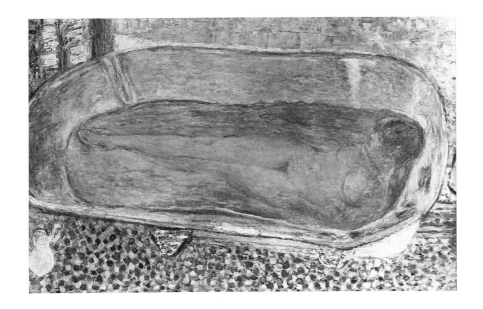

perpetual creativity, a continual disruption in the face of finality. As Bonnard grew closer to his own death, his art no longer sought after eternal images, the monumental and static forms that characterised his art prior to the 1920s, with its almost Seurat-like still figures, its demarcations between solid bodies and unstable surroundings. In the late art, colours and edges explode and fizz in a continually germinating, changing universe of forms.

In the late nudes, Bonnard pushes through the reserve of his earlier work, passes beyond the ambivalence towards his subject, overtakes the caution of his previous sensibility with a reckless new swaggering. Developed in the greatest isolation of his 'exile', his art becomes progressively freer of the facts of observed life, bolder in the assertion of his own emotion. In his late 60s and 70s, Bonnard drives his art on. There is no guarding of secrets, re-statement of principles, revaluation of a lifetime's work; instead, one painting after another that ferociously and joyfully breaks the artist's own rules.

In this last period, it is the world of his own feeling that dominates. If you look at anything long enough it will disappear, and this was the last effect of Bonnard's claustrophobic absorption in and isolation with Marthe. The late nudes seem to leave Marthe behind, or to overtake her, as though Bonnard has finally allowed her to disappear, age, wither and disintegrate. Limbs come apart, or distend into indistinction; bodies bloat and burst their outline. Forms and colours seem to decompose as though Bonnard at last feels free to play with notions of death and decay, as once he had denied these forces by an art that kept his invalid young, sound and out of time. Again and again in the late work the image of Marthe disintegrates or fades to no more than spirit life, while the artist's sensibility, his presence, becomes correspondingly dominant, louder, clearer — as though in that long domestic struggle carried on over the distance between bathroom and studio the artist has finally won. It is his voice we hear now, his sensibility, his joy, not her

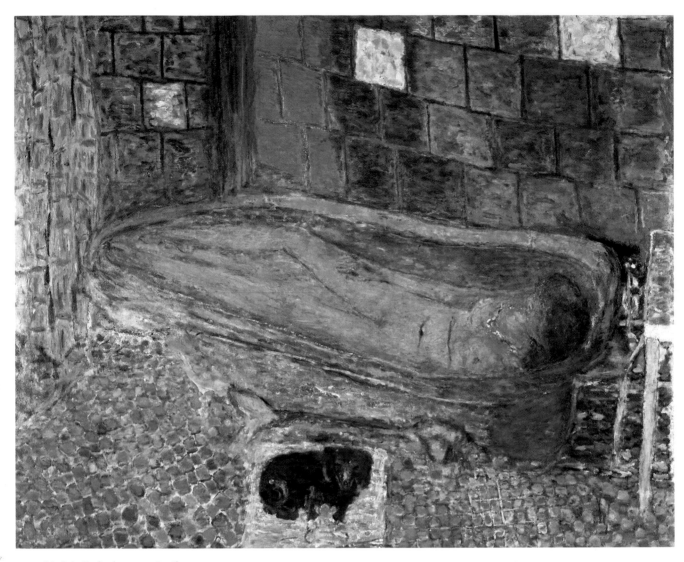

39 *Nude in Bathtub*, 1941–6, oil on canvas, Carnegie Museum of Art, Pittsburgh

self-absorption, as Bonnard at last becomes the hero of his own fable.

After Marthe's death in 1942, Bonnard locked the door of her room and allowed no one to enter. The last painting of Marthe, *Nude in Bathtub* (Pl. 39), was begun in 1941, and Bonnard continued to work on it for the next five years. Like many of the late nudes, the body is decomposed and featureless (it could be a painting of a drowned woman in her bath). But something of the living Marthe remains in the character of the little dog who lies near her on a mat. It is a different animal from the one that kept its mistress company in the sensual sleep of *Siesta*, painted nearly fifty years earlier. But like that animal, this one seems to sense and express the feelings of its mistress towards the painter. Fifty years on, no longer in peaceful contentment, the dog guards Marthe's image, staring out of the canvas as though to challenge all intruders, among whom Bonnard, almost in homage to Marthe, now gallantly acknowledges himself.

NOTES

1 Quoted in Preface to *Bonnard: Drawings from 1893–1946*, exhibition catalogue with an essay by Patrick Heron, American Federation of Arts, New York, 1972, p. 78.

2 Thadée Natanson, editor of the *Revue blanche*, remembers how in the country when Bonnard received a letter he would respond, 'Now I'll have to write back.' Natanson writes, '. . . la parcimonie spartiate de la vie que menait Bonnard usait ses forces et altérait ses humeurs.' ('The spartan parsimony of Bonnard's life depleted his strength and affected his disposition.') Natanson, *Peints à leur tour*, Éditions Albin Michel, Paris, 1948, p. 318. Here and elsewhere, the English rendering is mine.

3 Annette Vaillant, *Bonnard: ou Le Bonheur de voir*, Éditions Ides et Calendes, Neuchâtel, 1965, p. 78.

4 Ibid., and in Jean Dauberville's Preface to Jean and Henry Dauberville, *Bonnard: Catalogue raisonné de l'oeuvre peint* (4 vols), Éditions J. et H. Bernheim-Jeune, Paris, 1965, vol. 1, p. 21.

5 Henry Dauberville, Introduction, ibid., vol. 1, p. 18.

6 'Rarement décor fut plus lamentable que celui des pièces où il vivait. Elles étalaient un goût des plus médiocres, un laisser-aller de petit bourgeois, un tel divorce avec l'art que leur laideur paraissait non seulement native mais héréditaire.' Ibid.

7 'J'ai tout en moi. Ceux qui n'ont pas cette richesse intérieure qui est la mienne ont besoin de l'apport des belles oeuvres créés par des gens comme nous.' Ibid.

8 Annette Vaillant, op. cit., p. 142.

9 Bonnard's notes quoted and trans. in *Bonnard*, Éditions Beyeler, Basle (n.d.), n.p.

10 'La présence de l'objet, du motif, est trés gênante pour le peintre au moment où il peint. Le point de départ d'un tableau étant une idée — si l'objet est là au moment où l'on travaille, il y a toujours danger pour l'artiste de se laisser prendre par les incidences de la vue directe, immédiate, et de perdre en route l'idée initiale.' ('The presence of the object, of the theme, is very burdensome for the painter while he is painting. The starting point of a work being a conception ['idée'] — if the object is there while he's working, there is always the danger for a painter that he'll let himself be taken up by the incidentals of what is immediately in front of him and lose sight of the first conception.' Bonnard, quoted ibid.

11 'Il la soigne, la craint, la supporte, il l'aime, moitié confondue à lui dans le souci perpétuel qu'elle lui cause; présence, qu'il fixe au centre de son oeuvre . . .' ('He looked after her, feared her, supported her; he loved her and was half-crazed by the constant worry she caused him — that being whom he made the centre of his work . . .') Annette Vaillant, op. cit. p. 78.

12 According to Françoise Gilot in her *Life with Picasso*, quoted in Hilton Kramer, *The Age of the Avant-Garde: an Art Chronicle of 1956–1972*, Secker & Warburg, London, 1974, p. 198.

13 In Bonnard's notes; see *Bonnard*, Éditions Beyeler.

14 Quoted in Antoine Terrasse, *Bonnard* (Eng. trans. by Stuart Gilbert), Éditions d'Art Albert Skira, Geneva, 1964, p. 73.

15 In Bonnard's notes; see *Bonnard*, Éditions Beyeler.

EGON SCHIELE

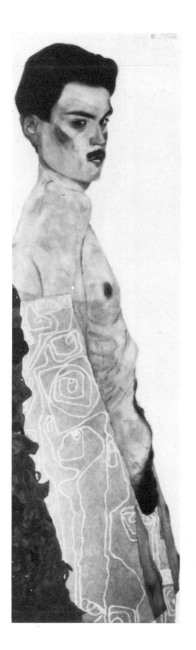

It was a short career, begun around 1907, and ending in 1918 with the artist's death from influenza at the age of 28. For all the technical brilliance, it remained for the most part a young man's art: defiant, boastful, cocksure and cock-alarmed, sometimes almost hysterical in the insistence on its own view of the truth, its declaration of the body's humiliations: sexual longing, deprivation, repression, fear as often as lust, obsession, and desperate narcissism. Schiele's work expresses impatience, not just with the fin-de-siècle idiom, the decorative and stagey tradition into which his art was born and which for a short time it honoured, and not just with the pomp and hypocrisy of Viennese society; but the urgency is in the drive of the art, in the feverishness — a quality common to both sickness and sex — the speeded-up metabolism, intensity, awareness of physical sensation, as though all the work were under physical pressure, as though Schiele knew he had not much time.

Real sickness gave factual basis to Schiele's work, rooted its metaphors of extremity and madness. Its shadow, legitimate and poeticised, darkened his art and shaped his sense of his own body and its needs. His father's syphilis, transmitted to his mother, caused the stillbirths of three brothers and the death, at 10 years, of a sister. His father died of the disease, insane, in 1904, when Schiele was fourteen. That sex should be the first act of a process of which the end is death and madness was not some remote and modish Decadent conceit but the central fact from which Schiele's art sprang, and it was to express and resolve the contradiction of fatal sexual need that his art developed. The direction of his work moves from a fear of his sexuality, expressed in the very declaration of it, to acceptance of Eros as a force of life rather than death.

Schiele's early art shows the overwhelming influence of Jugendstil, and a discipleship to Klimt's work in particular. It is, like Klimt's, ornate, decorative, declarative, its sensuality heavy and indirect. Klimt expressed the erotic as though it were one of the remaining joys of a jaded palate, an aesthetic pleasure, whose force could be multiplied and refracted in exquisite fabrics, lines, precious metals, rich colours, as though it was a form of wealth, something you could own. Schiele's view may be said to be the reverse of this: physical desire being

40 (opposite) *Self-portrait, with Decorated Drapes*, 1909, oil on canvas, Private Collection

41 *Danaë*, 1909, oil on canvas, Private Collection

something that owned you. His eroticism was far more raw, far less gracious, less proclaimable to a public. Both artists expressed, as indeed the time and place required them to, sexuality as a secret; both used the imagery of wrapping, clothing, hiding to evoke it. But Klimt's art is suggestive and sensual. He loves the wrapping as much as the nakedness, and implies that what is wrapped is precious, unseen because it should be rare. For Schiele, on the other hand, sexuality was secret because it was terrible, powerful, imprisoning. The effort of his art was to unwrap this dirty secret, expose it and investigate. If his art never unreservedly celebrates the human body, it did eventually come to forgive it.

There wasn't enough urgency in Klimt's work for Schiele to use its inventions for long. Around 1909, his art began to pull away from that of his friend and mentor and to concentrate with obsessive fascination on the subject of himself. A strange, hybrid self-portrait of 1909 (Pl. 40) indicates the direction in which Schiele's art begins to go, away from static formalism towards exposure. The formality of the pose, the abstract design on the cloak, the odd importation of landscape greenery on curtains (complete with Klimt-like blossoms) are all quotations from the work of the older artist. But the psychological portraiture and the deadpan and bravado display of genitals belong to Schiele's art. In this painting Schiele retained the look of Klimt's work while beginning to develop within it what was implied by Klimt's body/decorative-wrap juxtapositions. From this point, Schiele begins, literally, to expose his subjects and to develop what are to be the characteristic themes of his work: emergence, coming into being. The self emerges from its hiding place, the truth from hypocritical cover; the artist Schiele emerges from the influence of other artists' work, the soul from (deadly) mortal bonds. All these themes were eventually developed in Schiele's art from the hint he took from Klimt. Even on the least

55

42 *Female Nude with Green Drapes*, 1913, pencil and watercolour, Graphische Sammlung Albertina, Vienna

43 *Young Woman, Head Resting on Left Hand*, undated, pencil, Graphische Sammlung Albertina, Vienna

symbolic level, he was to use and alter the clothing/nakedness contrast for his own purposes, making a near-fetish in the post-1910 work of women's shoes, underwear, skirts that ride up over pelvic bones and uncovered genitals. Klimt's provocative but merely suggestive striptease is thus heated up in Schiele's work and begins to look like something real.

In Schiele's early art, exposure seems still a dangerous business,

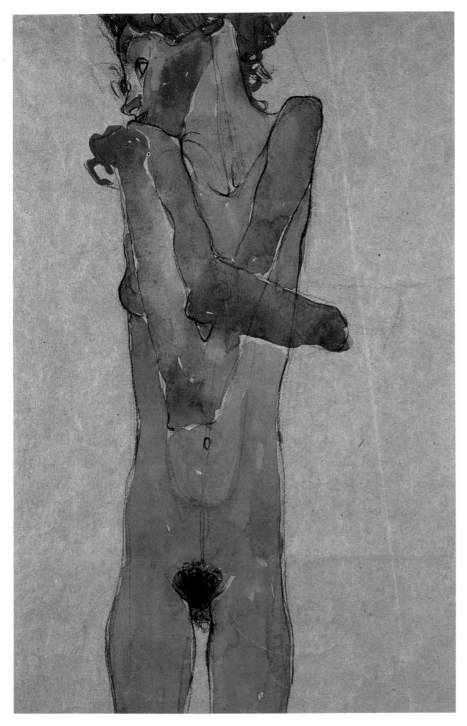

44 *Standing Nude Girl with Crossed Arms*, 1910, black chalk and watercolour, Graphische Sammlung Albertina, Vienna

undertaken nervously. You can see the artist's wariness even in the apparently bold 1909 self-portrait. In his first female nude, a portrait of his sister Gerti done in 1910 (Pl. 44), Schiele describes not just a naked body, but a frail one. His sister hugs herself as though she were cold, turns her head, flinches as though caught in her nakedness, a little helpless. It is less a 'nude' than a picture of someone who has just removed her clothing. The painting places its subject in a real world of

cold air and social inhibitions; for all its lack of props, setting, it is no idealised contemplative study.

There is some evidence that Schiele and his sister were more than ordinarily close, that there was some incestuous feeling between them. Even so, it was not to be in his portraits of any female that Schiele at this stage began to investigate his sexuality. Compassion, which is clear in the study of his sister, interfered with his artistic intentions. It was with himself as subject, in 1910, that he began a ruthless scrutiny and exposure of his sexual self.

His own appearance obsessed him. He posed in front of the large mirror which he took with him wherever he moved, and drew or painted himself grimacing, screaming, masturbating, squinting, with his trousers down or his shirt pulled up, with his arms chopped off or jutting upright from his belly like an erection. (See Pls 46, 48.) He used wild, unnaturalistic colours to indicate states of mind, to make himself ugly, to draw attention to genitals, nipples, to make them appear as wounds. He drew or painted himself coiled as a fighter, a dancer, a man in agony, crouching, always in bondage to the facts of the body, and, as again and again emphasised, its (for Schiele) pathetic sexual needs. He made studies of himself with hermaphrodite features, with female sex or female head, as though there were no other gender — no 'other' apart from that enclosed, despairing, Eros-driven self. He distorted the length of his fingers or limbs to indicate dislocations of the spirit, yearning for release.

This view of himself and his suffering extended to other subjects.[1] A work like *Sunflower* (1909–10, Pl. 45) is almost a self-portrait, with its jagged, febrile edges, exposed, pathetic rib-cage-foliage, its dragged limbs of leaves, its blackened, sunless face. Even his townscapes express this bleak view, speak of claustrophobia, where dark skies or striated mountains hover above, lean upon and oppress a frail human habitation. In his work of this period, no thing or being exists without knowledge of pain. His studies of new-born infants emphasise their writhing, wizened, exhausted appearance, and imply their imprisonment in life. His portraits of little girls show them without innocence, lascivious, corrupt, in masturbatory poses. In such works Schiele's compassion and projected self-disgust merge. Man is a sexual, dependent being: that is his doom and bondage. His art speaks defiantly of this truth, of his right to name the secret and the pain. And yet these images of bodies out of harmony, writhing, coiled, nervy, strung, are themselves balanced, harmonious, graceful as much as powerful, as though the seeing is the saving, as though Schiele's art were a kind of rescue. And he begins to take greater formal liberties with his truth-telling, to adapt what he sees to the demands of his art, his overriding sense of the beautiful. The emphasis in the work shifts from what is expressed (moving away from symbolism, and away from the element of horrified documentary of the 1910 self-portraits) towards the manner by which it is expressed. The artist's understanding of his gift, as increasingly emphasised by the work, changes, as Schiele comes to

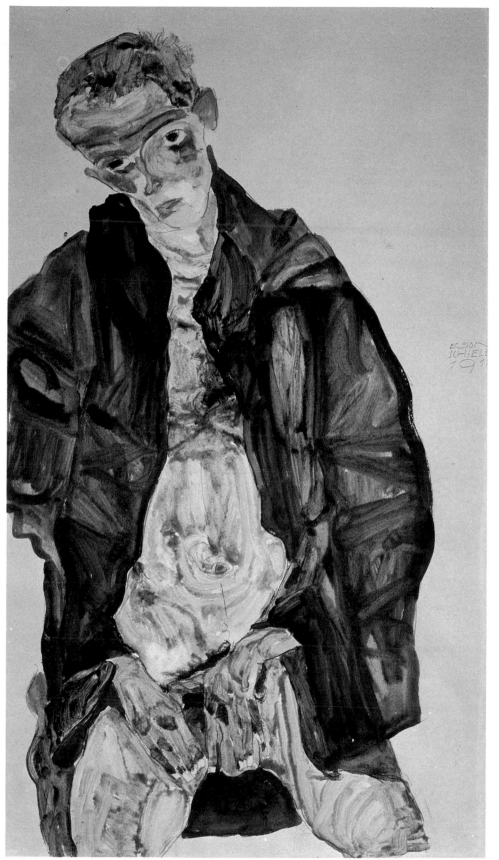

45 (opposite) *Sunflower*,
1909–10, oil on canvas,
Historisches Museum der
Stadt Wien

46 *Self-portrait Nude,
Masturbating*, 1911, pencil,
egg-tempera and
watercolour, Graphische
Sammlung Albertina, Vienna

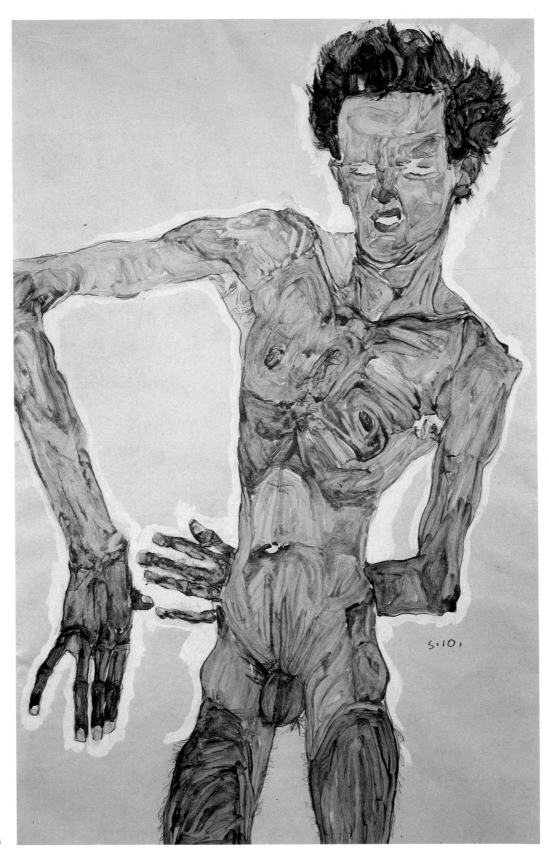

47 *Standing Male Nude (Self-portrait)*, 1910, pencil, watercolour and white body-colour, Graphische Sammlung Albertina, Vienna

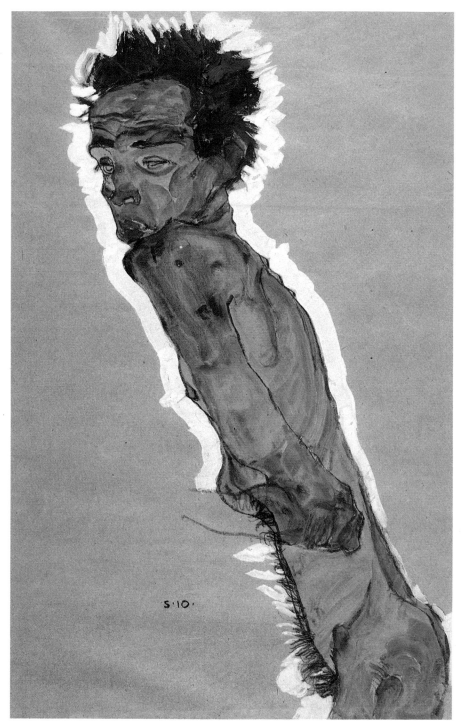

48 *Leaning Male Nude (Self-portait)*, 1910, black chalk, watercolour, gouache and white body-colour, Graphische Sammlung Albertina, Vienna

value his art less for its ability to reveal than for its power to transform. That grace is the contradiction in this work about pain, and I think that in gradually recognising this, the power he had *as an artist* over this suffering, Schiele began to reconcile himself to the facts of existence.

In 1912, Schiele was brought before a court and charged with corrupting a minor, an accusation deriving from his use — in the small provincial village where he lived with his companion and model Walli

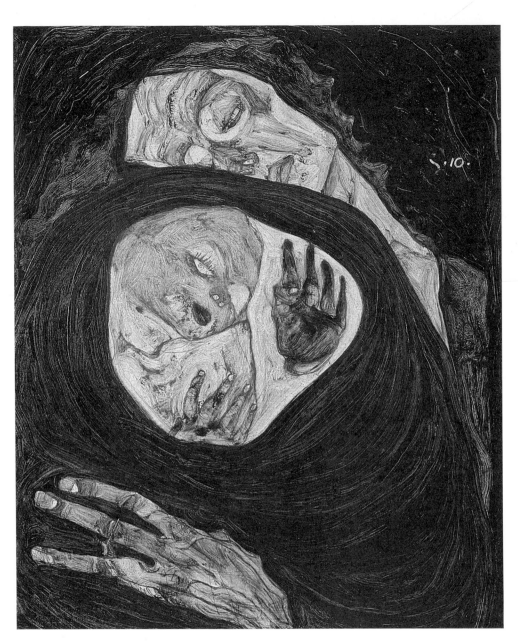

49 *Dead Mother*, 1910, oil and pencil on wood, Private Collection

— of local children as models for his work. Though the specific offence was never proven, the more general charge of obscenity stood and, after a trial in which the judge publicly burned one of his drawings, Schiele was sentenced to an extra three days in gaol in addition to the twenty-one days he had already served while awaiting his hearing. Here was real imprisonment to add to the artist's more abstract sense of human torment — the confinement of the spirit by the body — and Schiele suffered greatly its real humiliations. But the charge of obscenity baffled him: 'I certainly don't feel erotic when I make [such drawings],'[2] he wrote to a friend. Schiele called the judge's destruction of his work a 'castration', and declared, 'He who denies sex is a filthy person who smears in the lowest way his own parents who have begotten him.'[3] Elsewhere he wrote, with altogether different emphasis:

'Certainly I have made pictures which are "horrible", I do not deny that. But do they believe that I liked to do it or did it in order to act like a "horror" of the bourgeois? No! this was never the case. But yearning too has its ghosts. I painted such ghosts. By no means for my pleasure. It was an obligation.'[4]

The kind of suffering that Schiele underwent in prison added to his view that as an artist he had been set apart from an ordinary fate. One of his prison drawings is entitled 'I Feel not Punished but Purified' (20 April 1912), and another, 'Hindering the Artist is a Crime, It is Murdering Life in the Bud!' (23 April 1912). Between 1912 and 1917, the year of *The Embrace* (Pl. 58), Schiele did not paint himself naked. He became less interested in himself as an apparitional phenomenon than as something beyond mortality: the Artist, the Genius. It was a theme he had begun as early as 1910 with *Dead Mother* (Pl. 49), a gruesome, stylised work showing a dead woman holding a very pink infant inside her black, womb-like cloak. In 1911 a second version of this painting was subtitled *Birth of Genius*. The theme of Schiele's emergence from the fate and rules of ordinary mortality and, by analogy, from the corrupt (syphilis-tainted) flesh of his mother, was developed in works such as these and in later images, where he invites comparison between the birth-struggles of the infant and the artist's fight against social and physical constraint. The title of the second prison drawing cited above clearly indicates the newborn/artist analogy, as does the drawing of 25 April 1912: 'For My Art and for My Loved Ones I Will Gladly Endure to the End!' (Pl. 50) Here, a foetally-coiled Schiele tries to claw his way out of his confinement, his body wrapped in prison/swaddling clothes and contorted like an infant's on its way through the birth canal.

The notion of birth and separation from the mother was important to Schiele, not just because he was declaring himself free of his father's disease, but because with it he could replace a sense of dependence on the body with the conviction of his own immortality. In 1911 a series of self-portraits with Doppelgänger — for example, *Self-Observer II: Death and Man* (1911) — show to what degree Schiele felt shadowed by death and disease. But gradually the Doppelgänger changes character and begins, gently, to hint at immortality rather than death. Death had to do with the physical body and its genetic limitations; immortality was connected to art, genius, a proposition first vaunted in heavy symbolist works like *Dead Mother II*, and later more convincingly expressed, and confirmed to Schiele every time he painted. His later work no longer discusses immortality but seems simply to know it. To get to this point, Schiele's art went through a transitional phase when his theme became emergence of the individual, and dissociation — from the mother, from the prison environment, from his spiritual father, Klimt.★ By 1913, Schiele could announce this feat

★ Klimt is depicted in works like *Conversion*, *The Hermits*, *Agony*, all of 1912, all painted in a style which uses veils and wrappings, evoking the womb-cloak of *Dead Mother* of 1910.

50 'For My Art and for My Loved Ones I Will Gladly Endure to the End!', prison drawing of 1912, pencil and watercolour, Graphische Sammlung Albertina, Vienna

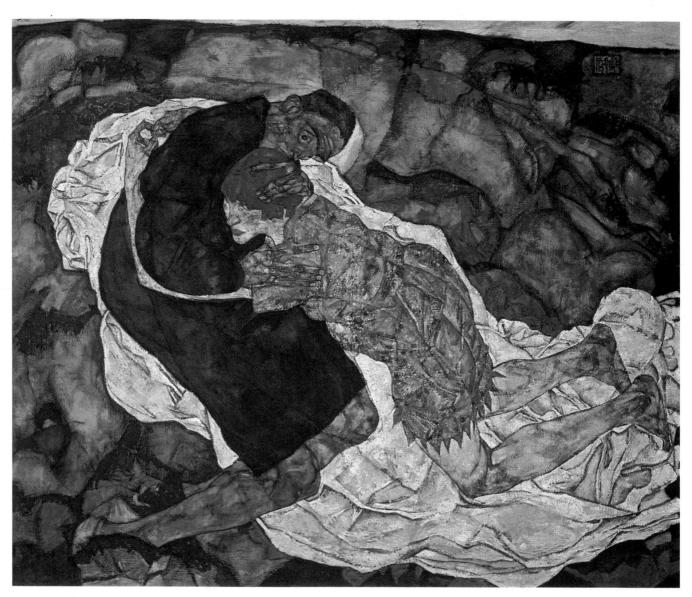

51 *Death and the Maiden*, 1915, oil on canvas, Österreichische Galerie, Vienna

of separation in a letter to his mother:

> You are at the age when, I believe, one has the driving desire to want to . . . rejoice in the fulfilled and revealed fruits — whose wilfulness is innate and grows independent roots. This is the great separation. Without doubt I shall be the greatest, the most beautiful, the most valuable, the purest, and the most precious fruit . . . I shall be the fruit which after its decay will still leave behind eternal life; therefore how great must be your joy to have borne me.[5]

Art is the eternal life, and this poor Mary must find solace in her incidental role as corrupt bearer of the godhead.

Given such convictions, and such a biography, it is not surprising that there are no madonnas among Schiele's female nudes, no icons and (unlike Klimt's work) no abstraction-bearing virgins. But, except for

64

the deadly mothers, there are few *femmes fatales* in Schiele's oeuvre either. His symbolism tells the story of his own spiritual and artistic journey, but his non-symbolic work describes real women, on to whom he projects his real, physical, longing. He describes these women in images of instant, transitory desire. Need is his theme, not devotion.

For all the poeticising instinct of the larger canvases, in this (for him) secondary line of work — the numerous quick drawings of women he made from life — he relates no dreams, but catches sexuality on the edge, in the moment, describes a nervy, living, felt connection between artist and model. But the drawings are also struck through with the artist's ambivalence: towards what he both desires and resents dependence upon. In certain works the women are doll-like, with the marks of manufacture in seams down torso or abdomen, or they are near-corpses, fallen rather than reclining, mutilated by a violent cropping of limb. Genitals are distorted, emphasised, as are the bones of the spine. The eroticism is tactile, urgent, twisting, often compassionate, but always up close — rarely, for example, at a Klimt-like remove — nor are the forms ever simply intellectually comprehended.

The image of breaking through cover was not just an expression of Schiele's own rejection of bondage and dependency, but takes on, in these drawings of women uncovering, self-revealing, a more positive aspect as a sign of sexual force. The coiled body, which in the self-portraits speaks of confinement and agony, now seems more and more to indicate a tightly sprung sexual energy. The private parts of the model are no longer private, neither sneakingly glimpsed nor extravagantly exposed as the dirty secret, but shown by non-

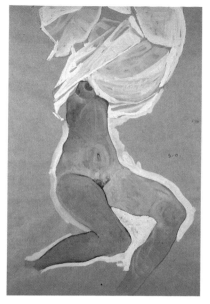

52 *Seated Female Nude, Undressing*, 1910, pencil, watercolour and white body-colour, Graphische Sammlung Albertina, Vienna

53 *Female Nude, Facing Right*, 1914, pencil and gouache, Graphische Sammlung Albertina, Vienna

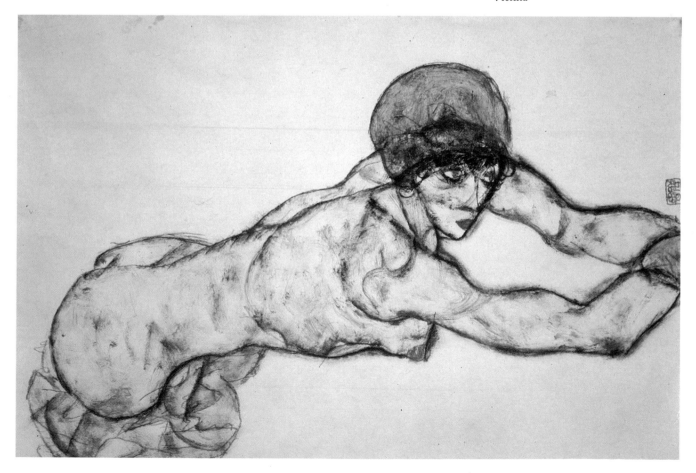

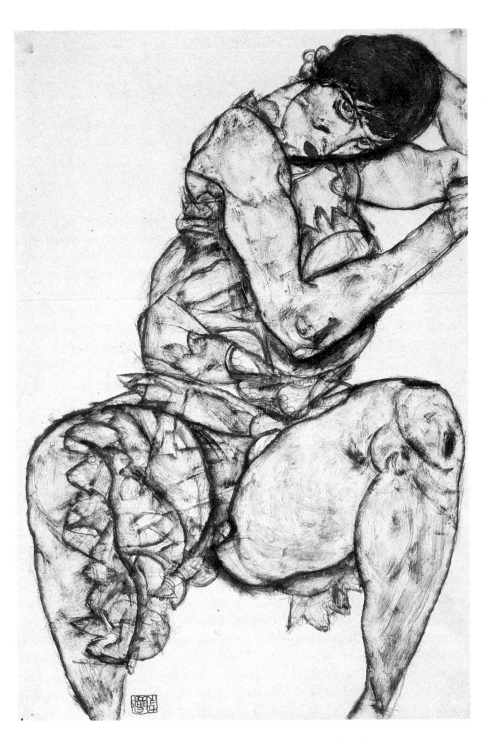

54 *Seated Woman with Left Hand in Hair*, 1914, pencil and gouache, Graphische Sammlung Albertina, Vienna

naturalistic colouring or peculiar distortion, with a different conviction: less as a provocation to conventional sensibility than as a declaration of the source of life and power of the body. Characteristically, too, Schiele often surrounds his subjects' forms with a band of white, in occult symbolism an indication of the aura, the unseen life-force, of the human being.

Just as Schiele's earlier landscapes had expressed his overwhelming conviction of human pain, in the post-1915 work it is a sense of

55 *Mountain Torrent*, 1918, oil on canvas, Private Collection

physical energy in nature which dominates. Even the specific image of hidden parts emerging from clothing in Schiele's studies of women has its echo in his late landscapes, in *Mountain Torrent* of 1918 (Pl. 55), for example, where waters gush between the banks of a valley river. The emphasis here is on breaking through, on the great physical force of the stream rather than on the banks that confine, and might have been shown to confine in the earlier work. In the late work, birth, the breakthrough, is seen as the universal goal of natural and particularly human energy. It is almost an optimistic view of things, a radical change in any case from the earlier fearfulness when exposure (as in the first nude, showing his sister Gerti) was depicted as something dangerous and chilling.

The wild, hurt, young man's intensity in Schiele's work, its narcissism and histrionics, have to do with the shocks of adolescence. As the artist matured and married, began to let go (of the influence of

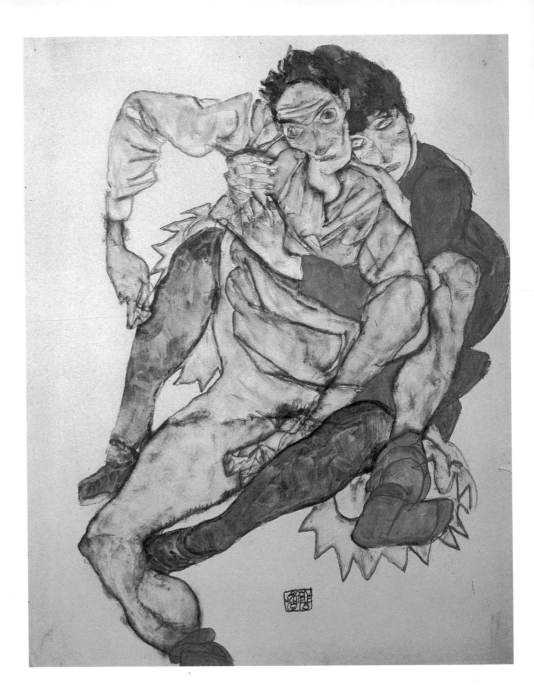

56 *Embrace: Egon and Edith
Schiele*, 1915, pencil and gouache,
Graphische Sammlung Albertina,
Vienna

Klimt, of his actual mother, of his sense of outrage), there is a letting go
in the work; forgiveness (together with a sense of the outside world)
creeps in; there is renunciation of the former conviction of doom. The
change is as marked as between Picasso's Blue and Neoclassical
periods, and there is a not dissimilar progression of imagery. Gone is
the obsessive, starved sexuality of the early work. In its place are
images of power, satiety, harmonious coupling; peaceful, notably
plumper nudes; elegant and confident declarations — as, with Picasso
— of a new-found freedom from want. *Three Women* (Pl. 59), Schiele's
last nude study, unfinished at the time of his death in 1918, is positively
Picassoesque (of the Iberian and also late-Neoclassical period), with its

three plump, squat graces of Grecian feature and Mediterranean build, idling, content, harmonious, utterly placid.

What happened? No exposure to the Spaniard's work, but something Schiele's own art documents: in 1915 Schiele met and married Edith Harms, a young, respectable and sexually inexperienced woman from the district of Vienna where he was then living with his companion Walli. In works of this period he describes both relationships: the parting from Walli and the first days of marriage to Edith. (See Pls 57, 58.) In both he uses the image of a woman clinging to a man. Where he depicts himself with Walli, there is some dignity to their separation, but where he describes the newly married couple he shows himself lifeless or raddled, a rag doll, held on to by an unhappy, helpless and (by implication) unsatisfying woman. In *Embrace: Egon and Edith Schiele* (Pl. 56), for example, the vacant stares of the couple might imply post-coital alienation but, given the other works from this time, seem rather to suggest misconnection and sexual incompatibility. By 1917, however, Schiele is making remarkably different images of himself as husband. *The Embrace* (Pl. 58) is, for all its chastity, an extraordinarily erotic painting, a straightforward description of copulation without boastfulness or pathos, one which, despite its specificity, is neither dated, nor seems — as most attempts at direct sexual description do

57 *Embracing Couple*, 1914, black chalk, Private Collection

58 *The Embrace*, 1917, oil on canvas, Österreichische Galerie, Vienna

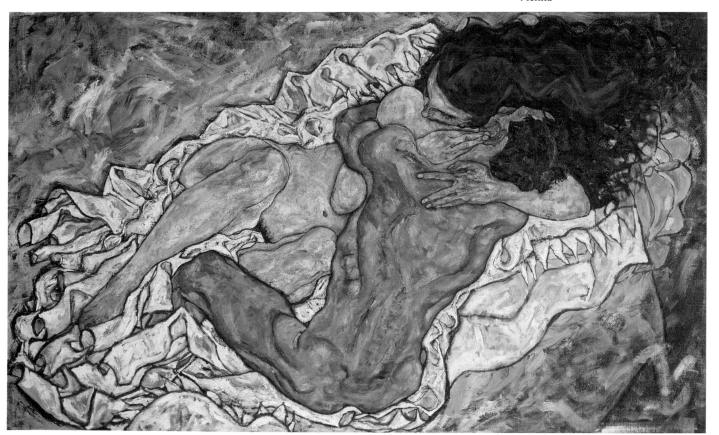

59 *Three Women*, 1918, oil on canvas, Private Collection

seem — either dead, or pornographic, or simply misjudged. In this painting, and for the first time in five years, Schiele depicts himself naked, but without rhetoric or irony, not on display, but with his back towards us as he embraces the woman. He is interested in her, not in himself, and not in us as audience. Indeed, he allows himself to be seen as though without his knowing, without demanding to set the terms. Likewise, the erotic centre of the work is no longer obsessively located in the sexual parts. The charge of the painting lies in the whirling tooth and wave shapes of the rumpled sheets, which seem to undulate from the central point of energy, the red ear of the man which, naturalistically rather than expressionistically coloured, indicates the degree of arousal, the temperature of the bodies. Next to the ear, the woman's long fingers are held taut in a gesture familiar from Schiele's self-portraits, where such stiff, separated fingers once suggested in his private symbolism both longing and sexual knowledge. But this painting is not about longing or the pain of wanting. Instead, it expresses, and rather gratefully, the joy of having.

The theme of possession is a characteristic of Schiele's late work, and not even his participation in the war seems to have affected its near light-heartedness. The work of the last months suggests a surprisingly cheerful acceptance of private life, a non-Gothic, almost Renaissance affirmation of the flesh (particularly in the nude drawings of 1918,

showing heavier women whose solid outlines and physical strength interest Schiele far more than their bones or nerves or states of mind — see *Reclining Woman*, 1917, Pl. 60), and an affirmation, too, of the real world. In the late portraits his subjects are no longer lost in space, but sit in fully described environments. The objects of the world, so long kept out of Schiele's view of what is significant in human life, now come flooding in. Chairs, and particularly books, are tenderly described, 'humanised', as Van Gogh humanised a pair of shoes by emphasising the form of the feet that shaped them;[6] so the sitter's world in late Schiele appears benignly and significantly connected to the inner life of its subject.

The changes in the late work seem to relate to Schiele's different perception of himself as a man and an artist. In *The Family* (Pl. 61), a work unfinished at the time of his death in 1918, Schiele painted himself with woman and infant. (He used a professional model for the work, as he had earlier for *The Embrace*.) In this self-portrait with (projected) family, Schiele shelters the woman with his body as he squats, his naked knees and arms framing hers, just as hers frame and shelter the child. Both parents are shown naked, while the child, in a strange reversal of the *Dead Mother* images, is clothed. Their nakedness suggests, rather than vulnerability, their sexual relationship, equality and harmony. Schiele paints himself with a long left arm, thrown back and dangling from his knee, a gesture which he used in earlier work,

60 *Reclining Woman*, 1917, oil on canvas, Private Collection

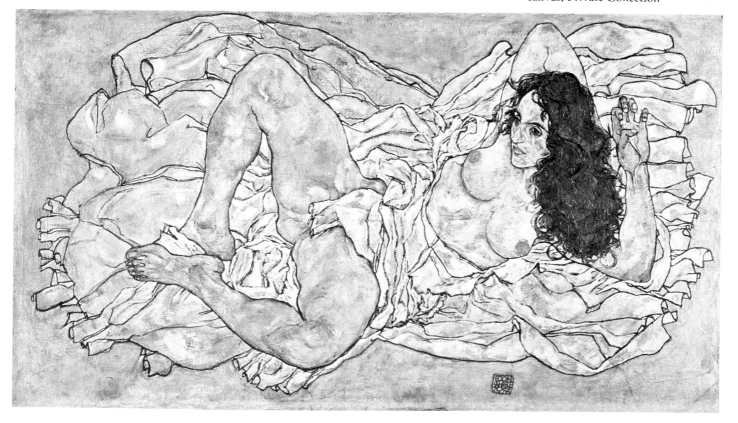

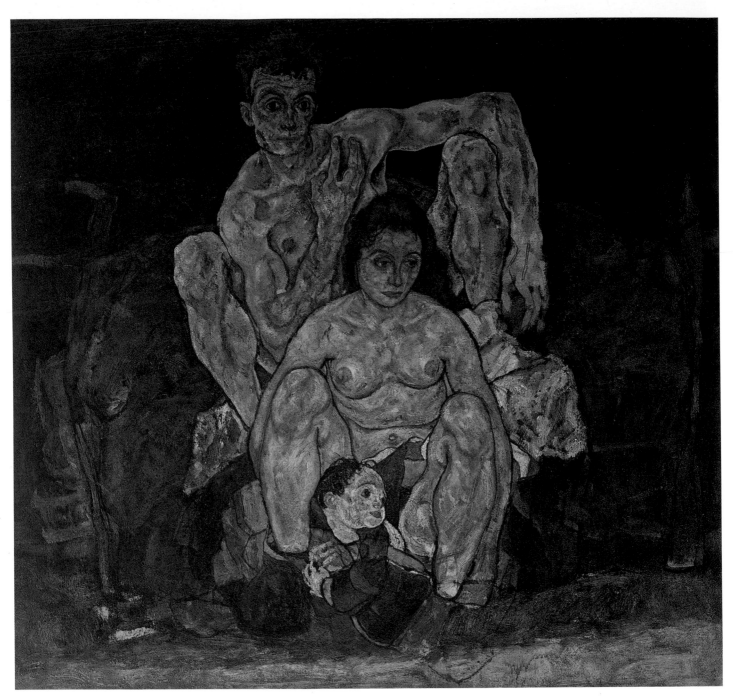

61 *The Family*, 1918, oil on
canvas (unfinished),
Österreichische Galerie, Vienna

and which he derived from Rodin's *Crouching Woman*. But here he
adapts the pose for a different purpose. That distorted, set-back arm no
longer speaks of body dislocation, of the spirit that flies from the flesh,
but evokes something new: breadth of shelter, capacity and willingness
to look after, anticipation of the role of father and protector. No longer
self-portrayed victim of others, the artist sees and shows himself as
responsible creator, of real not merely artistic progeny, and with this
late work, in particular, marks his own progress from blighted infancy,
deprived adolescence, to achieved man- and fatherhood.

NOTES

1 In a letter of 25 August 1913, Schiele wrote: 'At present, I am mainly observing the physical motion of mountains, water, trees and flowers. One is everywhere reminded of similar movements in the human body, of similar impulses of joy and suffering in plants.' Quoted in Erwin Mitsch, *The Art of Egon Schiele*, Phaidon Press, Oxford, 1975, p. 35.

2 Quoted in Peter Vergo, *Art in Vienna 1898–1918*, Phaidon Press, Oxford, 1975, p. 214.

3 Quoted in Alessandra Comini, *Egon Schiele's Portraits*, University of California Press, Berkeley, 1974, p. 104.

4 Ibid., p. 92.

5 Quoted in Alessandra Comini, *Egon Schiele*, Thames and Hudson, London, 1976, p. 29, n. 17.

6 Schiele much admired Van Gogh's work, which he would have seen in 1906 at a large exhibition held in Vienna by Galerie Miethke; see ibid., p. 29, n. 6.

HENRI MATISSE

Few images in modern art would seem to be more about enticement, nor more enticing, than that of the classical Matisse odalisque in her characteristic setting: the naked or semi-naked body, languorously posed on a couch or chair whose undulations express and magnify her own, surrounded by the highly coloured planes and shadow-stripes of a sunlit room, itself further decorated by a Moorish screen or oriental rug, with striped or patterned textiles and oval tables bearing vases that swell or bend or twist like dancers under bouquets of brilliant flowers. Such a room is as full of sexual and decorative vibration as a field in June, where every sound, odour, colour, curve and pattern of flower, grass, bird and insect buzzes with the same intent, and where beauty has no other project than procreation. In the Matisse work, nature and artifact call to each other through the echoing of forms and colours in a language of declared affinities, what Matisse called 'rapport': 'Rapport is the affinity between things, the common language; rapport is love, yes love.'[1] 'I do not paint things,' Matisse said, 'I paint only the relationships between things.'[2] 'I marry objects.'[3]

So intense is the mirroring and conversation among still and living forms that these brightly lit rooms, with their balconied doors and windows, open often to the odours and breezes of the Mediterranean, can nevertheless come to feel nearly claustrophobic, and the odalisque image itself seem replete and exclusive, as fulfilled as completed thought.

It is this sense of completion and satiety that seems to belie the element of enticement in Matisse's work (as though in relation to us the artist were simultaneously playing the roles of procurer and bouncer). Invitation, by definition, welcomes the entry of the onlooker (via the artist) into the world of the picture, but where that world is presented as not only attractive, abundant and available, but also self-contained and complete, one is inclined to hesitate before an entry that may be intrusion. The world of the odalisque is a party (of objects) to which we are not invited. If Matisse is allowed in, it is because he has taught himself how to behave, studied the art of transparency so that his presence will not disturb, indeed will barely register. He penetrates the world of the odalisque with his eyes alone, together with an intellect

62 (opposite) *Nude Upside Down, I, with Table*, 1929, lithograph, Bibliothèque Nationale, Paris

which comprehends the concept (and the spiritual implications) of perfection. His response to all the blossoming sensuality he re-creates is a kind of chaste gratitude, a mysterious detachment, more like a Zen Buddhist in a brothel than (as, say, late Picasso in his watcher and sleeping nude series) the voyeur or eunuch in the harem. With Matisse in these pictures there is no yearning, not the slightest hint of remorse. It is as though his response, ecstatic as it is, were on a short circuit, as though it could move to the transcendent from the eye and intellect alone, bypassing the strictly physical and erotic, or as though Matisse's sensuality had something cold at its centre, a check in the midst of its very generosity, like a badly mixed shower where the cold water comes out simultaneously with, and yet still distinct from, the hot water.

Matisse's work is about the joys of looking rather than of making love, about the seductions of the eye, a kind of intoxication in which the room tilts and colours vibrate★ but which, as often with intoxication, can lead to no performance, and must be its own reward. Nor does this intoxication — a word Matisse himself used — preclude a religious response, any more than it does, say, in Sufism (of which, as a student of Islamic art, Matisse was aware), where disorientation is the route to sacred communion. 'Do I believe in God?' Matisse asked himself in *Jazz*. 'Yes, when I work.'[4] Loss of self was the shared religious and artistic experience, a constant goal of his art, and one at which he arrived slowly. It was that loss which guaranteed a free and undisruptive presence in the chambers of the odalisque.

'You wait outside while the bread bakes,' he said in 1949. 'This is really the way it seems: you provide the raw materials and then you discover the result. That's where you want to say it's God's work.'[5] Or, in 1942, 'I am driven. I do not do the driving myself.'[5] And in 1952, 'I have been no more than a medium, as it were.'[5]

It was through identification with the subject that Matisse achieved this loss of self, and the result — 'God's work' — derived from this union: 'From a certain moment on, what takes place is a kind of revelation — it is no longer me. I no longer know what I am doing. I identify with the model.'[6]

Transparency, invisibility through oneness with the subject, Matisse searched for all his life. Not self-denial, but union of self with other, was the goal. After his apprentice work, the task he set himself as an artist was precisely how to present pure beauty in its physical totality without subjecting it to the destructive or obtrusive force (in his fauve years, obtrusive coloration) of his emotions, to convey both the image and the ecstasy which that image aroused in him, to love without interfering, to leave whole and intact while still remaining what he called 'expressive', in short, to be a revolutionary artist without being

63 (opposite) *Odalisque with Raised Arms*, 1923, oil on canvas, National Gallery of Art Washington

★ Matisse once described a painting to Aragon as 'the happy interpretation of a feeling of love, a hallucination in front of certain objects. This hallucination, obviously, is love itself . . . ' (*Henri Matisse, a Novel*, vol. 1, p. 242).

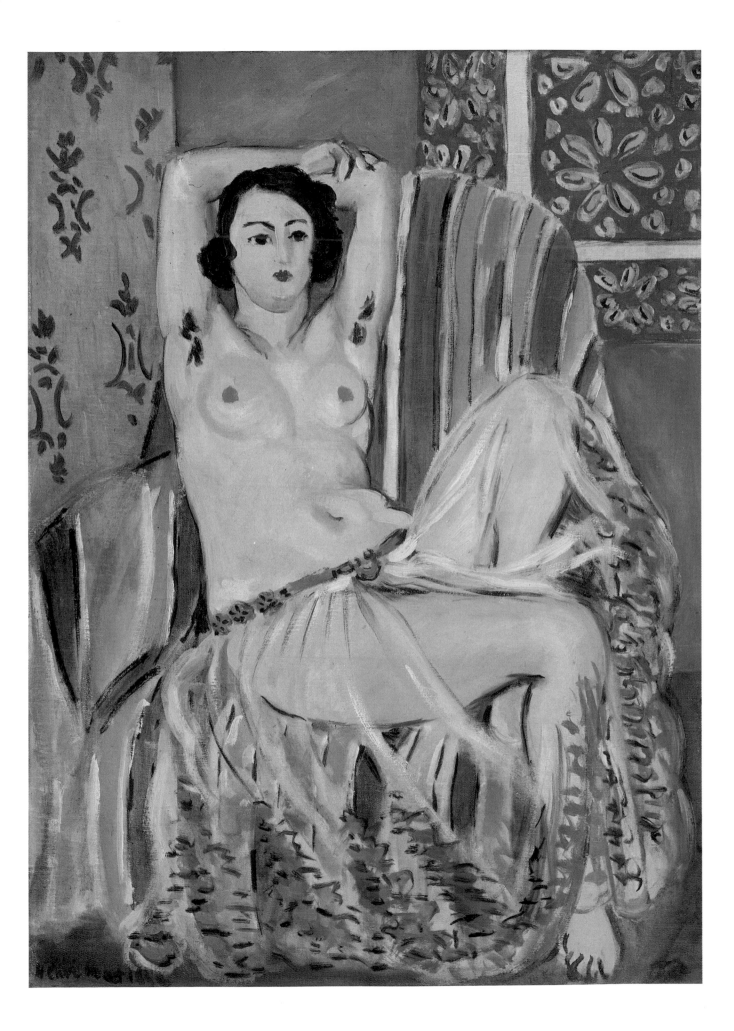

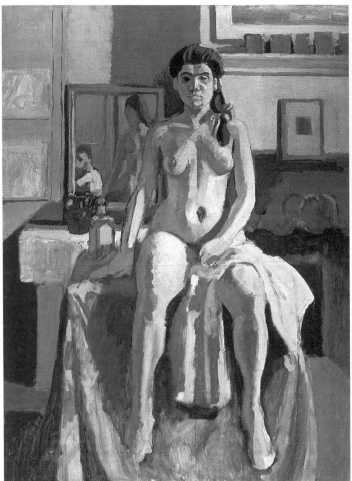

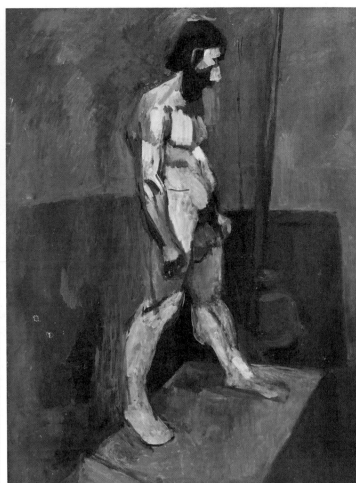

64 *Carmelina*, 1903, oil on canvas, Museum of Fine Arts, Boston

65 *Male Model*, 1900, oil on canvas, Museum of Modern Art, New York

Picasso. 'Picasso shatters forms,' he once said. 'I am their servant.'[7]★

'You know you have one idea,' Matisse wrote in an unpublished journal of 1949–50. 'You are born with it, and all your life you develop your fixed idea, you make it breathe.'[8] From the earliest work it would be hard to deduce that idea, or the inherent direction of his art towards radiance and transparency. The apprentice paintings are notable for their Cézannean, and possibly Moreauian, murkiness. From the symbolist painter Gustave Moreau, Matisse's first and long-cherished teacher, the artist may have developed not just the inner-Cathedral gloom and airlessness of his student work, but perhaps, too, his later

★ If Matisse's universe somewhat resembles a renouncing sage's paradise, Picasso often seems to inhabit a nightmare Kleinian nursery: all teeth and body parts, infant hungers and rages, sucking and dismantling aggression. But it is important to bear in mind their respective ages in the first years of what Gertrude Stein called the 'heroic age of cubism'. When, in his mid-20s, Picasso was tearing up the town with his young band of followers, Matisse was already a 'cher maître', head of a sizeable family, and director of his own art school; in 1907, the year of Picasso's *Demoiselles d'Avignon*, he was 37. Furthermore, he had arrived at his own maturity as an artist fairly late in life, having painted his first 'mature' work, *La Joie de vivre*, at the age of 35. He had thus something of a head start in detachment.

78

vocabulary of poetic signs and essences. More significantly, from Cézanne Matisse accepted a notion of darkness as weight and substance. In these early works we feel the artist striving to get the image down, to carve the body shapes like blocks from dark stone (see *Male Model* (*The Serf*), Pl. 65, and *The Model*, both of *c.*1900). Light, which was to be the foremost achievement and the great metaphor of spiritual radiance in the fully developed painting, seems nowhere on the agenda. Nor are these early figures blessed in any way with grace. They have a laboriously rendered presence, as if presence itself were in doubt. Darkness, weight, here become a form of insistence, and occasionally (as in *Carmelina*, 1903, Pl. 64) an expression of sensuality in a form Matisse later abandoned. (Matisse was not interested in earthiness, but in transcendence.) It has been said that there is no pain in Matisse's view of human life.[9] And that is nearly true. But if there is no pain in these closed and chunky early paintings, there is effort, a certain impenetrability that may be as indicative of a heavy spirit as the radiant later works seem to be of an untroubled one. Even in *La Joie de vivre* (1905–6, Pl. 66), that first astounding work from which Matisse dated his

66 *La Joie de vivre*, 1905–6, oil on canvas, The Barnes Foundation, Pennsylvania

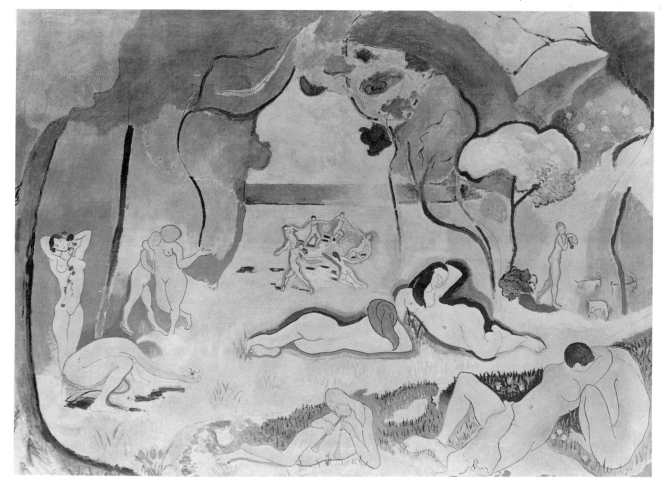

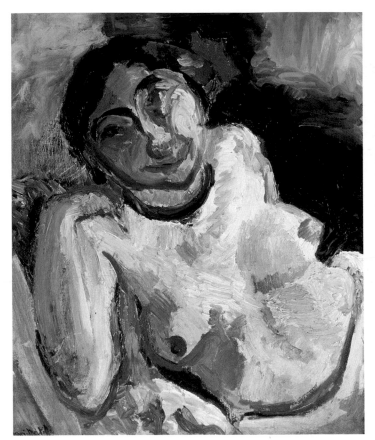

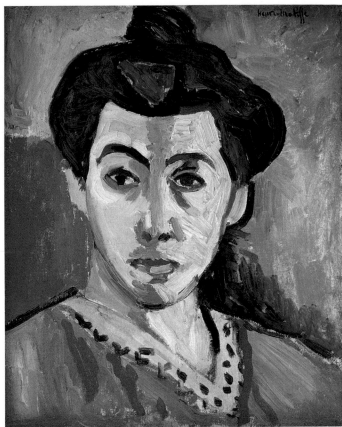

67 *The Gypsy*, 1906, oil on canvas, Musée de l'Annonciade, St Tropez

68 *Portrait of Madame Matisse*, 1905, oil on canvas, Statens Museum for Kunst, Copenhagen

maturity as an artist, the image of joy betrays a certain brute primitiveness. This is pastoral with a clumsier step than we might expect from its prominence in the canon of famous descriptions of Paradise, a little more post-Darwinian (closer even to Stravinsky's 1913 *Rite of Spring*) than we might infer from Matisse's own later sense of the work. The figures in the foreground, the solitary piper and the curiously single-headed embracing couple, are as shapeless as boulders, the mismatched lesbian pair on the left bloated, particularly the bubble-headed, single-breasted larger figure.* On the right, a shepherd plays to his goats, while tinier figures whirl in a circle across a vast distance deep in the centre of the image. Proportions and perspective are wildly disharmonious, and the crude stripes of colour, the Kandinsky-like, highly abstract and somewhat ferocious lines of force try but fail to unify the composition. Likewise, the lyrical colouring seems to sit on top of the canvas like a costume of cheerfulness or a second thought. *La Joie de vivre* is not a beautiful painting, but one of undigested and unequally intense parts lost in image-fracturing empty spaces (this is Paradise with barren and lonesome patches), and where the relationship among the figures is unheated to the point of tenuousness and

* Distortion at this stage of Matisse's work was still a question of physical deformation, a boneless shapelessness. Later what would be distorted was more likely to be that which pleases — the length of a limb or the twist of torso, as though it were pleasure in beauty itself that had the effect of close focus and exaggeration.

perspectival illegibility. Yet *La Joie de vivre* became a sourcebook for some of Matisse's most powerful works. Largely because the figures in the painting *were* undigested, he was later able to isolate them, to bring himself up close, and re-deliver the different groups and individuals whole and fully imagined. The circle of dancers lost in the background was extracted and enlarged for the Shchukin *Dance* decoration of 1909–10, and the large right-hand nude was recast as the beautiful sculpture *Reclining Nude* of 1907, itself reconceived, in the same year, as the two-dimensional *Blue Nude* (*Souvenir of Biskra*), a painting which in turn inspired a large family of painted and cut-out female arabesques.

In Matisse's fauve work, of which *La Joie de vivre* is an early example, colour, the sign of the artist's emotion, is laid on top of the image, rather than being integrated with it, and the effect of this layering was to seem at times a kind of hostility to the subject. The outcry which greeted the first exhibition of fauve works in the autumn of 1905, particularly *Woman with the Hat*, purchased by Leo and Gertrude Stein, was partly in response to what was interpreted as an artistic abuse of the model (Mme Matisse). The image seemed desecrated, all the more so given the formality of the pose, the bland ordinariness of feature and costume, above all, the clear presentation of the work as portraiture. Colour here seemed less an expression of feeling for the subject than an aggressive comment upon it.

In *The Gypsy* (1906, Pl. 67), the conflict between the image and its colourful presentation is even clearer than in the two 1905 portraits of Mme Matisse (*Woman with the Hat* and *Madame Matisse* ('*The Green Line*') (Pl. 68). Here the model naked to the waist, tilts with an

69 *Blue Nude (Souvenir of Biskra),* 1907, oil on canvas, Cone Collection, The Baltimore Museum of Art

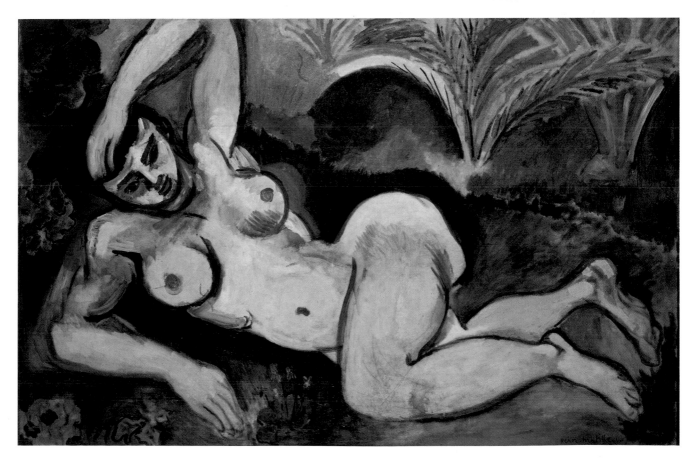

embarrassed smile towards the artist. Her pathetic expression is as disturbing as the green discolorations of face and body. In such a context, paint becomes further humiliation, along with the collar-necklace, drooping flower and depiction of sagging breasts and belly. The application of wild colour is less celebratory than somewhat derisive, or, if we give the image a Van Gogh reading (just plausible since Matisse admired the older painter and owned some of his work at the time), an act of peculiarly un-Matissean commiseration. The problem of *The Gypsy* and of the fauve technique in such a case is that there is a conflict between the real (the all too recognisable, emotive expression) and the abstract (the non-descriptive use of colour). The human image was too potent an icon for what, as a fauve, Matisse demanded of it, which was basically to remain quiet while he discovered the properties of colour. 'I was smashing everything out of principle,' Matisse said of his fauve summer of 1905, 'and I was working as I felt, by color alone.'[10] In his fauve experiments, Matisse freed himself from the laborious creation of image by structure which he had derived from study of Cézanne, and began to convey both the image and the emotion aroused by image through liberation of colour from natural description. ('It is not physical reality one renders but human emotion,' he told his students a few years later.)[11] But the style that worked for landscapes and still-lifes remained problematic when the subject was a living creature, and that of course was the prime

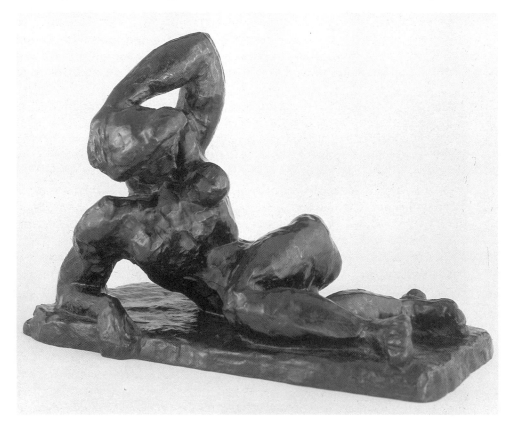

70 *Reclining Nude I (Aurore)*, 1907, bronze, Cone Collection, The Baltimore Museum of Art

image of Matisse's art: 'What interests me most is neither still life nor landscape, but the human figure. It is that which best permits me to express my almost religious awe towards life.'[12] Not until the extraordinary invention of the cut-outs late in his life would Matisse be able to achieve the absolute union of colour and form, so that the image itself would be created out of the mysterious expressive colouring, having ceased to argue with it. In the meantime, fauvism came to seem less and less a style in which to celebrate the sanctity of the human form.

In fact, it was by abandoning colour altogether that Matisse was able to arrive at a solution to the problem of how to create a modern image of the figure without seeming, by 'expressive', that is fauve, technique, to harm it. By working as a sculptor, and later by using that sculpture in place of the living model as the subject of his painting, Matisse discovered a way to have free, one might say guilt-free, use of the human form for his work.

For the *Blue Nude* (Pl. 69) Matisse used the image not of a living woman, but of one of his own sculptures, *Reclining Nude* (Pl. 70). Alfred Barr described the circumstances of the painting in his 1951 monograph on the artist: 'While modeling [*Reclining Nude*], he wet the clay too freely so that when he turned the stand the figure fell off on its head and was ruined. Exasperated, he began to paint the figure instead, putting in some palm leaves which he remembered from his fortnight at Biskra the year before.'[13] After *Blue Nude* Matisse was to use the finished version of the sculpture again and again in his paintings as emblematic of the female form. Using sculpture in place of the living model freed Matisse of the responsibility he felt to convey human dignity (what he called the universal 'gravity') while experimenting with colour and form. Sculpture, being an object, can be treated with relative laxity while yet continuing to bear a metaphoric weight as both human-made art and a referent of the human being. Later in his work, Matisse would reverse the process of reification (de-humanising the body image) and give emotional, indeed erotic, signification to objects ('I marry objects'). Eros was to be a substance he would make bleed from its human source to its non-human surroundings, creating in his later art his own categories: the female nude as still-life, and the still-life as a form of erotic (a 'sublimated' erotic) art. Removing himself from the living model, and using as inspiration both his own earlier painted nude (the large right-hand figure of *La Joie de vivre*) and its unfinished three-dimensional version, Matisse took a first step towards this later unifying and visionary art.

Blue Nude hovers on curious ground, midway between the erotic and the comic. Self-containment of the image in Matisse's painting — its contentment inside its setting, as well as its independence from the emotion of the artist (its icon sanctity) — has its beginning here, not only in the unification of shapes (the palm that sprouts behind the hip like futurist lines of force, for example) but, more important, in the twist of the body towards itself, the arm that touches the head and the

83

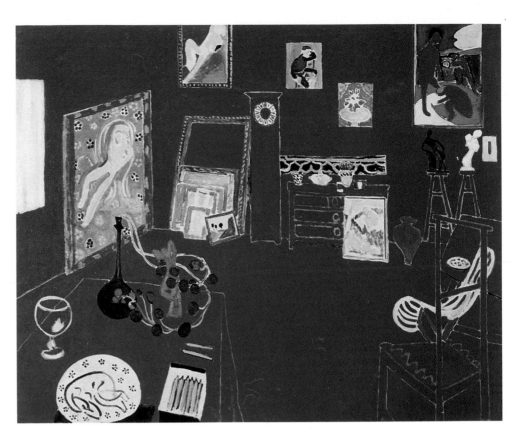

71 *The Red Studio*, 1911, oil on
canvas, Museum of Modern Art,
New York

arm that reaches to the knee. In this respect, the arabesque, the figure of
eternal return to the self, is the very symbol of content self-sufficiency.
Inspired by a sculpture, the image sits discrete in its setting like a
primitive god, while around it the environment seems to bend and
cradle its shape, like a flowery bed, or the ornate base of a statue. The
blue colouring, subordinate to the 'natural' flesh tone, is evident largely
as outline, as though the emotional pitch of the image were most
intense at its edges, and seemingly appropriately so, the edges of the
body being where lovers meet. And yet the mask head warns us not to
read this nude too naturalistically; despite the emphatically erotic
distortions of the torso, the exaggerated breasts and the tensions of hip
and thigh, the erotic force of the figure weakens at the extremities,
where grotesque feet and solitary paw float in the cartoon territory
which the image truly inhabits.

The finished sculpture *Reclining Nude* has none of the comic element
of the painting, but a precise and intellectual grace. Its distortion does
not detract from, but rather seems to emphasise, its dignity and beauty
('one can always exaggerate in the direction of truth,' Matisse said[14]),
and to proceed from an aesthetic logic which has no comment to make
other than praise. Matisse used the sculpture in nine paintings of studio
interiors as emblem of an ideal female presence. By using this and other
figurative artworks in the domestic setting, he was able to play with
relativities of scale and perspective (the human forms of *The Pink Studio*
1911, for example, are depicted as both flat and three-dimensional,
life-size and vase-size, suspended in air along a wall or grounded mid-

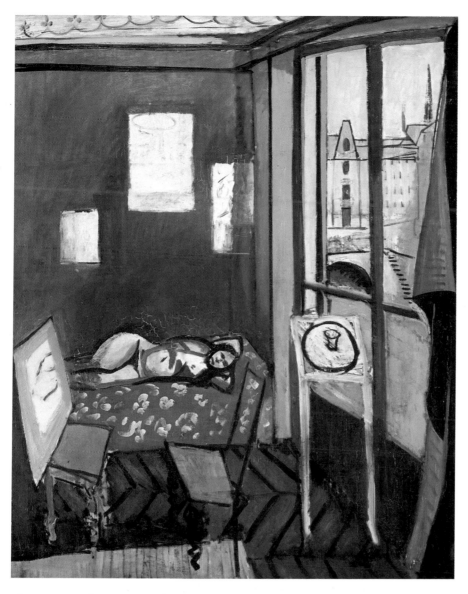

72 *The Studio, Quai St Michel,*
1916, oil on canvas, The Phillips
Collection, Washington

air on a sculpture-stand or on the floor of the room) in a way that
would be absurd, and, more important to Matisse, I think, almost
morally impermissible, had the figures related one step more closely to
their human sources. At the same time, by placing images of such
works as the *Reclining Nude* in the real but nevertheless sacred world of
his studio — the wildly ecstatic, 'unreal' colouring of *The Red Studio*
(1911, Pl. 71) is a clear indication that we are in a magic place — Matisse
was able to recast the composition of female figure in ideal setting
(Paradise) with more success than he had achieved in *La Joie de vivre*.
Nor in this case would there have to be any pretending, no faking of a
Golden Age, no references to Pan, nymph or satyrs. This literalness of
subject-matter (in the world of the studio and its contents) was
important to Matisse, just as later when he began to paint the
odalisques he claimed a 'right' to do so, having seen the real thing on
his trips to Morocco in 1912.[15] Matisse was at best an uncomfortable

85

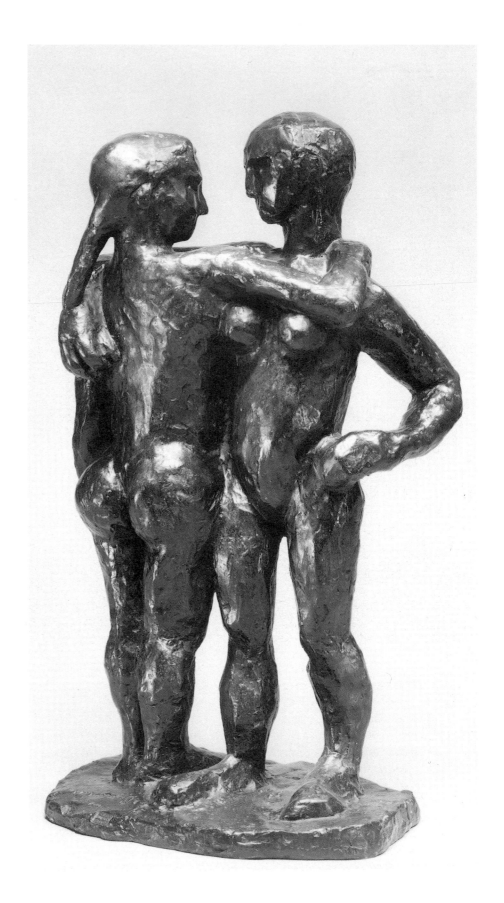

73 *Two Negresses*, 1908, bronze,
British Rail Pensions Funds
Works of Art Collection, on loan
to the Tate Gallery, London

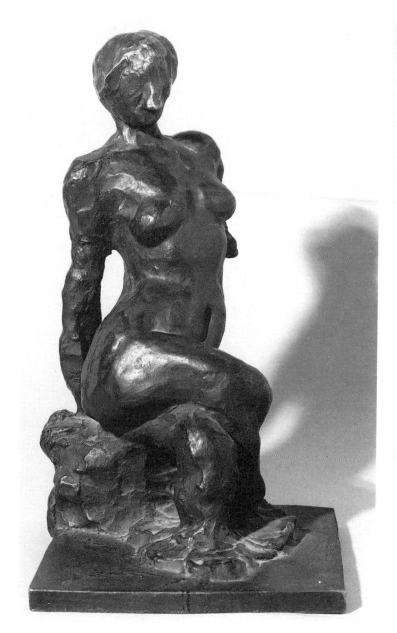

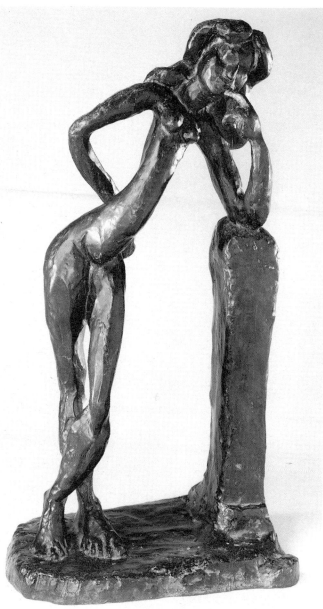

fabulist. Paradise had to be seen — and Matisse's art is a kind of document of its quotidian reality — to be believed.

When, around 1916, Matisse began once more to use living models for his nudes, a curious conservatism overtook him, an apparent inability to render what was seen in terms of what was felt. As with the Cézanne-related apprentice work, the presence of the image seems precarious and one can sense the artist's reluctance to impose upon it. In *The Studio, Quai St Michel* (1916, Pl. 72) the nude is a forlorn and sketchy figure, utterly without the exuberance with which Matisse conceived his earlier, sculptured women (*Two Negresses*, 1908, Pl. 73; *Seated Nude, Arms Behind her Back*, 1909, Pl. 74; or *Serpentine Woman*,

87

1909, Pl. 75) or the painted figures of *The Dance* (1909–10). ★ Another nude of this period, if indeed Barr ascribes it correctly to Matisse, is pure Giorgione via Modigliani (*Sleeping Nude*, ?1916). Such work as this is indicative of the hesitation Matisse still felt in the presence of the model. It would not be until his work in Nice, where he went in the winter of 1917 and returned every year thereafter, that Matisse would arrive at a triumphant form of presentation of the female nude. Turning once again to the female figure, and the theme of the model in the studio, Matisse ceased to work as a sculptor (he did no sculpture between 1918 and 1925) and dedicated his art to the painted image of an

★ The image of this painting was also used in the studio interiors to rework the failed vision of Paradise of *La Joie de vivre*. The circle of dancers, cut from the 1905–6 work, recast as the monumental figures of the 1909–10 Shchukin decoration, and then depicted from a distance as a component in *Still Life with 'The Dance'* (1909) and *Nasturtiums and 'The Dance'* (1912), was an important element in Matisse's re-definition of earthly Paradise in personal, domestic and professional — the sensibility in the studio — but no less ecstatic terms.

76 *Luxe, calme et volupté*, 1904, oil on canvas, Musée d'Orsay, Paris

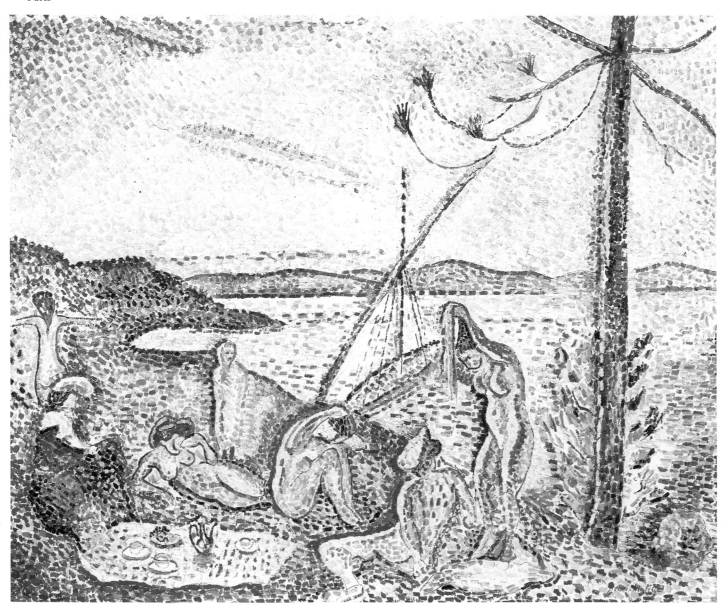

77 *Odalisque with Red Culottes*,
1924–5, oil on canvas, Musée de
l'Orangerie, Paris

actual, rather than replica, woman as the central figure of his studio/
Paradise.

Matisse's earliest depiction of earthly Paradise, his divisionist and
proto-fauve 1904–5 painting of female bathers, took for its title
Baudelaire's phrase 'luxe, calme et volupté'. When, in the Nice period,
he once more placed the living female body in the centre of his ideal
world, he let her express these qualities once more: languor (occasionally
to the point of near-invalidism), luxury and *volupté* in the sense of
erotic abundance and projected satiety, and above all, calm ('I believe
my role is to provide calm. Because I myself have need of peace'[16]), the
absence of anything more troubling than the vibration of colour and
form by which Matisse in his contemplative mode was characteristically
stirred. But 'luxe, calme et volupté' was an odd mixture of qualities,

89

necessarily self-cancelling if they were to create the balance and 'armchair' comfort Matisse said he intended his paintings to provide.★ Luxury (which he once defined as 'not communicable, being something more precious than wealth, within everyone's reach — a certain quality of love is what gives it, it means dressing or undressing the woman one loves in all the purity of one's love, without affectation or exaggeration'[17]) is as arousing an element in his work as *volupté*, and both had to be altered in order to create the desired calm.

The eroticism in Matisse's work is always checked, displaced, 'sublimated' or short-circuited. In the earliest examples it registers largely conceptually, by association with the subject. In the first painting of bathers, *Luxe, calme et volupté* (Pl. 76), Paradise is a curiously asexual gathering-place, much like a women's recreation centre where the presence of a male would certainly be intrusive and guaranteed to shatter the depicted calm. Both here and in *La Joie de vivre* a certain flavour of exhausted lesbianism adheres to the images, less erotic than supine, and somewhat literary. In the paintings of the Nice period, however, the character of the female model is emphatically heterosexual. Though her evoked relationship may be with the colours and objects around her, the artist's realisation of, and receptivity to, her are a part of the image. There is clear conversation between her body and the artist's eye and intellect; the connection, if not whole, is intimate.

Yet, why isn't it whole? Why such a paradoxically aesthetic and cerebral response to the undeniably erotic imagery? Some of the answer may lie in the artist's haphazard comments on his subject: 'I do odalisques in order to do nudes,' Matisse said to an interviewer in 1929 or 1930. 'But how does one do nudes without being artificial? And then, because I know that they exist, I was in Morocco. I have seen them. Rembrandt did Biblical subjects with real Turkish materials from the bazaar, and his emotion was there. Tissot did the Life of Christ with all the documents possible, and even went to Jerusalem. But his work is false and has no life of its own.'[18] From nudes to Christ is rather a short step, though perhaps no shorter than in his famous declaration of 1908: 'What interests me most is neither still life nor landscape but the human figure. It is that which best permits me to express my almost religious awe towards life.'[19]

There is something in such remarks, like those that insist he is only a 'medium' ('I am driven. I do not do the driving myself,' etc.[20]), that may seem to protest too much. He paints odalisques in order to paint nudes

★ Perhaps Matisse's best-known statement about his work is the apparently over-modest and often misinterpreted description of his artistic aims, given in 1908: 'What I dream of is an art of balance, of purity and serenity, devoid of troubling or depressing subject-matter, an art which could be for every mental worker, for the business man as well as the man of letters, for example, a soothing, calming influence on the mind, something like a good armchair which provides relaxation from physical fatigue.' (Quoted in Flam, *Matisse on Art*, p. 38.) It might be said that the most familiar and unchallenging art would fulfil this purpose sooner than any Matisse painting, particularly in 1908.

78 *Reclining Nude*, 1926, transfer lithograph, Museum of Modern Art, New York

that are real. But so are naked models real, and the local prostitutes (perhaps the most famous modern painting of prostitutes was Picasso's 1907 *Les Demoiselles d'Avignon*, a work which may have had indirect bearing on Matisse's choice of subject). And why insist on documentation when 'even Tissot' . . . ? It seems more likely that Matisse chose the odalisque as his subject not merely because he had seen her in Morocco, not at all because she was 'real' — though her literal existence was more comfortable for him than the fantastical origins of his previous inhabitants of Paradise — but because her reality was movable and relative. She was, if not an invention along the lines of the figures of *La Joie de vivre*, then certainly rare and exotic, and surrounded by the aura of sexual if not mythological fantasy. The odalisque is not only a highly decorative and somewhat theatrically costumed siren, whose pantaloons, scarves and bangles accentuate her bare arms and breasts; she is also a slave and a prostitute, and, as such, something of a passive screen on to which the owner of the hour, or the imagined owner, may project his desires and memories.★ She is real and not real at the same time, a historical fact and a mirage, the stuff of dreams in her very actuality. One may do with her as one likes, just as one may do what one likes with the painted image of a human if one is the painter. In both cases, ownership is crucial and moral responsibility limited.

★ 'Yes, I needed to have a respite,' Matisse wrote about his work in Nice, 'to let myself go and relax, to forget all worries far from Paris. The *Odalisques* were the abundant fruits at once of a light-hearted nostalgia, of a beautiful, living dream, and of something that I experienced almost ecstatically day and night, under the enchantment of that climate.' (Quoted in Schneider, *Matisse*, p. 496.)

When Matisse's descriptions do not insist on his purely 'religious' interest in his subject,★ they often protest the technician's: 'Above all,' he said in 1939, 'I do not create a woman, *I make a picture*.'[21] And Aragon reports, 'Matisse has affirmed that before the most voluptuous models his attitude is no different from what it is before a plant, a vase or some other object.'[22] But here is Matisse's full description of his subject:

> Look closely at the *Odalisques*: the sun floods them with its triumphant brightness, taking hold of colors and forms. Now the oriental décor of the interiors, the array of hangings and rugs, the rich costumes, the sensuality of heavy, drowsy bodies, the blissful torpor of the eyes lying in wait for pleasure, all this splendid display of a siesta elevated to maximum intensity of arabesque and color should not delude us. I've always rejected the anecdote for its own sake. In this atmosphere of languid relaxation, under the torpor of the sun washing over people and objects, there is a great tension brewing, a tension of a specifically pictorial order, a tension that comes from the interplay and interrelationship of elements.[23]

★ 'All art worthy of the name is religious. Be it a creation of lines and colors: if it is not religious it does not exist. If it is not religious it is only a matter of documentary art, anecdotal art, which is no longer art. Which has nothing to do with art.' (Matisse in 1951, quoted in Flam, *Matisse on Art*, p. 140.)

79 *Odalisque with Red Culottes*, 1921, oil on canvas, Musée National d'Art Moderne, Paris

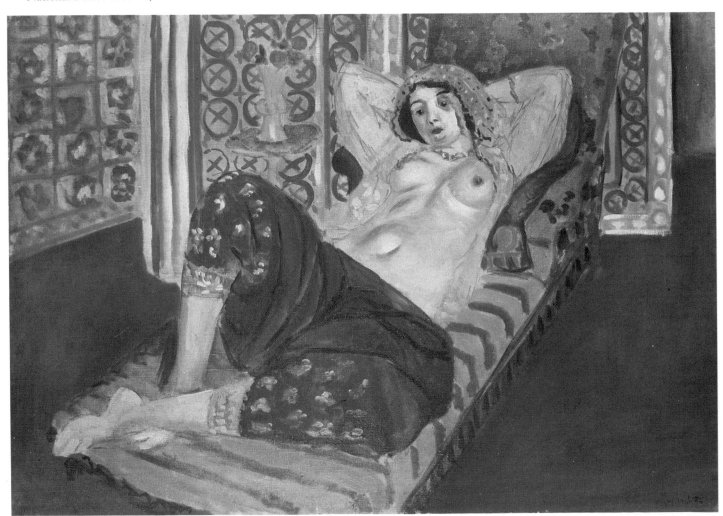

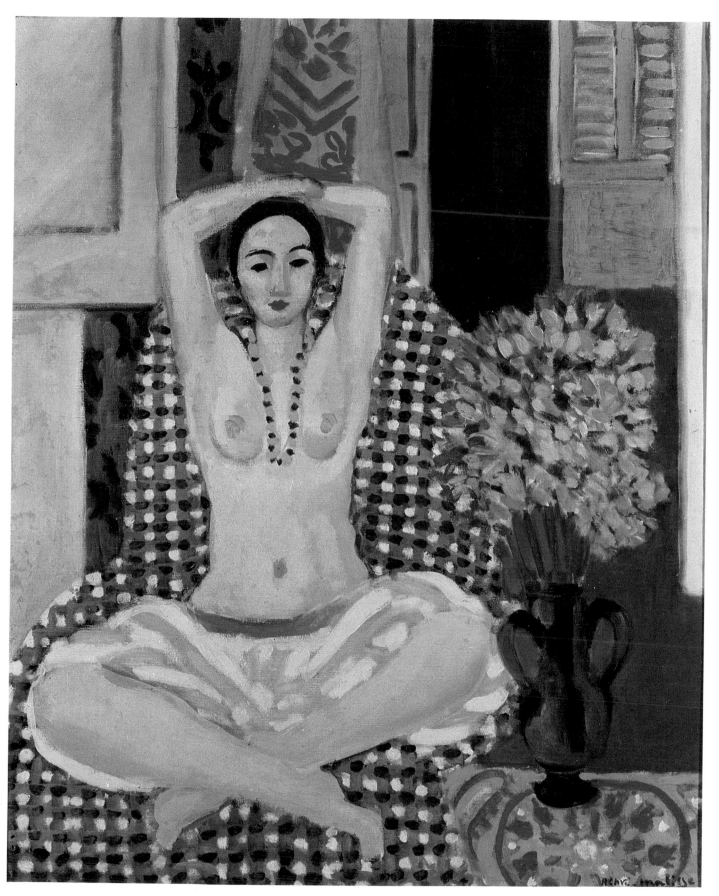

80 *The Hindu Pose*, 1923, oil on canvas, Private Collection

The description itself is quite rousing, until that curious definition of tension — which must surely be sexual — is shunted off to the sidelines of art-school jargon, as though butter wouldn't melt in the professor's mouth. And that 'lying in wait for pleasure' — from whom? one asks. But Matisse describes well. The painting itself balks at the erotic intensity, derails its own momentum, just as Matisse did verbally when dealing with this crucial aspect of his subject:

> The presence of the model counts not as a potential source of information about its makeup, but to keep me in an emotional state, like a kind of flirtation which ends in a rape. Rape of what: Of myself, of a certain emotional involvement with the object that appeals to me.[24]

I do not intend to suggest that Matisse was repressing a desire literally to possess his models, but that the issue of possession, and even of rape, is present in some of his works (in the very horizontality and passivity, not to mention theoretical occupation, of his reclining females), and that his tendency as an artist and an individual was to shy from it, or rather to disarm it by diffusing the eroticism throughout the work:

> My models, human figures, are never 'extras' in an interior. They are the principal theme of my work. I am absolutely dependent on my model, I watch her moving freely, and then settle on the pose that seems most natural to her. When I take a new model, it's from her relaxed attitude while at rest that I guess at the pose that suits her best, and then I follow it slavishly. I often keep these girls several years until I have exhausted their interest. My plastic signs probably express their psychological state (their *état d'âme*, a term that I don't like), in which (or in what else?) I take an unconscious interest. Their forms are not always perfect, but they are always expressive. The emotional interest they inspire in me is not shown specifically in my representation of their bodies, but often in special lines of values which are scattered over the whole canvas or paper and form its orchestration, its architecture. But not everyone notices this. It may be sublimated eroticism, which is not generally perceptible.[25]

For the act of painting itself, Matisse could acknowledge his lust ('. . . The paintings I want to do when I get back,' he wrote to a friend, 'I'm still boiling, an old stallion who has sniffed a mare,'[26]), but about the subject of that painting he was consistently indirect, and occasionally defensive:

> But my dear Rouveyre [he wrote in 1941, when at the age of 72 he began to illustrate an edition of Ronsard], if I let myself go, won't the book be licentious? . . . At my age! In my condition, what will they think of me? The unkind will say I'm a lecherous old driveler! And

why? Can't one keep a youthful and full-blooded imagination to one's dying day? I think I can do a better job of illustrating the *Amours* today than when I was twenty-five — for then there was no question of any imagination, I was right in the thick of it . . . [27]

Matisse was fully aware of the sexuality of his models. He used the power of it to drive himself in his work. The arousal was generalised, however, a flirtation which ended in a 'rape' of himself, or, as described in 1940 in a letter to his son Pierre, in an orgasm which was purely aesthetic:

I'm trying to stay wrapped up in my work. Before coming here I had planned on painting flowers and fruit — I even placed several arrangements of them around my studio — but this vague state of uncertainty we are all plunged into (for this country can be occupied under the slightest pretext) means that I am unable to bring myself, or perhaps am afraid to start working *en tête à tête* with objects that I have to breathe life into and fill with my own feelings. So I've arranged with an agency for film extras to send me their prettiest girls. The ones I don't use, I pay off with 10 francs. Thanks to this system I have three or four young and pretty models. I have them pose in shifts, for sketching, three hours in the morning, three hours in the afternoon. And this keeps me in the studio, surrounded by my flowers and fruit, and without noticing it I'm gradually brought into touch with them. Now and then my eye is caught by a particular motif, a corner of my studio which seems full of expression — even beyond my capacities, my energies: and I wait for the *coup de foudre* that is bound to come. This robs me of all my strength.[28]

This transfer of sexual response from the living source to her inanimate surroundings is characteristic of Matisse's images of the nude or semi-nude in his Nice paintings. The colour and description of setting has an intensity which often contrasts with the cooler depiction of the central subject. In *Odalisque with Red Culottes* (1921, Pl. 79) all Matisse's expressiveness is sunk in the colour and elaborate folds of the pantaloons, while the model herself gazes elsewhere, detached and contemplative, as removed from her own seductiveness as Matisse declares himself to be. It is her melancholy which checks our response to the image, splits it in two as it were, as though her physical beauty were merely incidental and not the primary subject of the work. In *The Hindu Pose* of 1923 (Pl. 80), the mask face and Yogic containment of the model cool her erotic presence, while the flowers in the vase beside her burst into 'expressive' bloom. And in *Antoinette, Nice* (1919) the sexuality of the image is similarly displaced, into the highly rhetorical feathered hat of the otherwise naked girl. None of these figures is half so intensely sensuous, nor so tenderly, passionately comprehended, as certain ecstatic objects in Matisse's work: *The Rococo Armchair* of 1946 (Pl. 81), for example, or the cobalt-blue lined, open violin case of

81 *The Rococo Armchair*, 1946, oil
on canvas, Musée Matisse, Nice

82 *Interior with Violin*, 1917–18,
oil on canvas, Statens Museum for
Kunst, Copenhagen

Interior with Violin of 1917–18 (Pl. 82). And which of the subjects in the title has greater femininity in *Dancer and Armchair, Black Background* (1946), a work in which Matisse seems to be demonstrating quite specifically this kind of impartiality?

But there is something else. Matisse spoke again and again of his need to identify with the model: 'When I paint or draw I feel the need for close communication with the object that inspires me, whatever it may be. I identify with it and this is what creates the feeling that is the basis of my art'; 'It is by entering in to the object that one finds oneself'; 'It demands . . . the possibility of an almost total identification [of] the painter with the model.'[29] The odalisques were to some degree self-projections for the artist, mirror images in their passivity, contemplativeness and, above all, solitude. Matisse's odalisques are notably iconic, single figures (though pairs do exist), often melancholy, half-abandoned, surrounded, like the artist, by beautiful objects, indeed inhabiting his space. The odalisque enters the painter's previously conceived solipsistic studio Paradise without fundamentally disturbing it. In fact the environment itself defines her ('The object is not interesting in itself,' Matisse once wrote. 'It's the environment which creates the object . . . '[30]). She is in that respect kindred to the artist when he contemplates his surroundings, when he is no longer present to himself, but when he feels the expressiveness of the beauty around

him. In her passivity, vacancy, solitude, in the poses that can suggest lassitude and near-invalidism, she is a reflection of the creator when he is most inclined to create, a state which Matisse once defined as beginning 'when the individual realizes his boredom or his solitude and has need of action to recover his equilibrium.'[31] If the odalisque as depicted by Matisse strikes us as erotically perceived, though herself unerotic, it may be because she is something of a negative element in the work, part decoration like the objects around her, part projection of the artist's sensibility. She is the fusion of himself with his immediate surroundings in a fantasy image of the 'other'.

While the sexuality of the odalisques tends to be bled into the depicted world around them,* or defused by the passive expressions of the subjects, who arc as unthreatening and comfortably welcoming as Matisse's 'good armchair' in his 1908 definition of his art, in the drawings of the period there is no ambivalence about the character of the nudes, or the artist's response to them. The drawings, sketches often, made as though from a state of unguardedness, are highly charged, as though the absence of colour gave the artist room to describe the erotic aspect more fully. The poses of the models are emphatically arousing, their faces alert, their bodies alive: arched or twisting, above all mobile in a way the painted odalisques are not, as though paint itself conferred objecthood, a kind of freezing monumentality. In the drawings, there is a felt connection to the living model, and an absolute union of erotic and formal responses: line expresses desire directly. These drawings convey the sense of skin on skin, the

* Three notable exceptions to this are *Recumbent Odalisque* of 1925, whose eyes engage the artist's directly, the irrepressibly erotic *Odalisque with Raised Arms* (1923, Pl. 63) and the unusually posed *Reclining Nude, Back View* (1927).

83 *Nude*, 1929, lithograph, Bibliothèque Nationale, Paris

presence of the artist's hand, and the wish to touch that follows immediately from the visual impression. Even the cartoon element in these drawings seems a half-hearted disavowal; the artist's intensity overwhelms it.

In the 1930s and 1940s Matisse worked primarily with fully dressed models, and here his pleasure in decorative textiles, in the contrast of flesh and fabric, and in the exuberance and transience of fashion, predominates. In the nudes of the period, however, the artist moved towards abstraction of forms and simplification of colours. The *Large Reclining Nude* of 1935 (Pl. 85) is as devoid of erotic content as any of his earlier renderings of his own sculpture in paintings of studio interiors. The figure is as cool and fundamentally comic a nude as those bombastic and ironic icons of Wesselmann's, say, proto-Pop in her flat monumentality and edible pinkness, and it is the artist's licence with

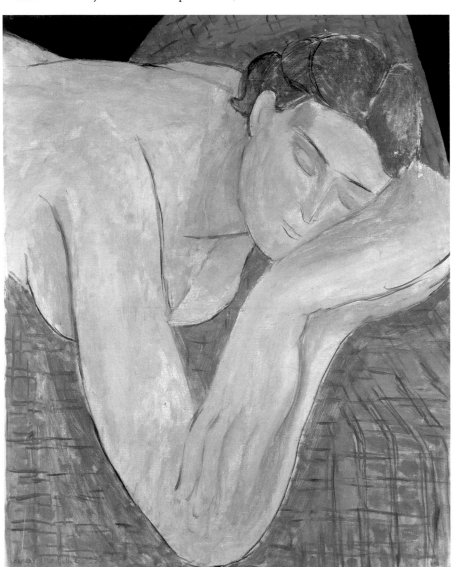

84 *The Dream*, 1935, oil on canvas, Musée National d'Art Moderne, Paris

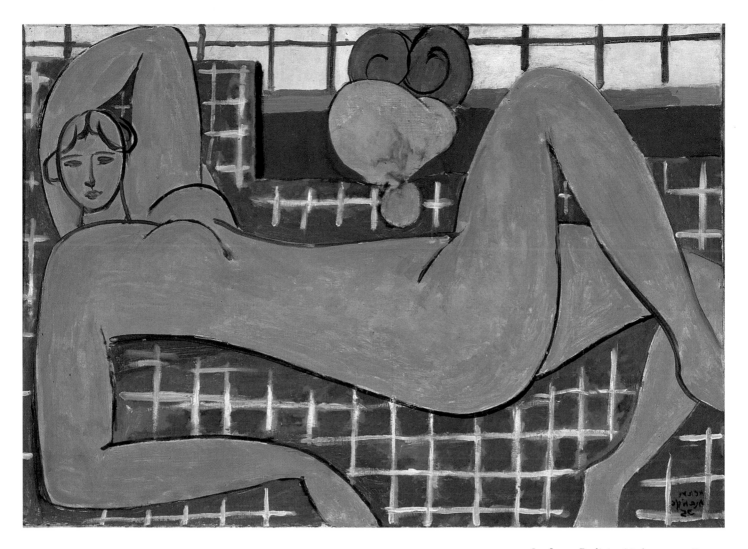

85 *Large Reclining Nude*, 1935, oil
on canvas, Cone Collection, The
Baltimore Museum of Art

flesh colour rather than body form that makes her so. The figure in *The
Dream*, also of 1935 (Pl. 84), is equally a victim of the artist's formal
distortion, yet she remains within a human and erotic universe, by
virtue of the curve of her forearm, the undulation of her fingers, and
the evident weight of her breasts. The distortion of form in *The Dream*
is ambiguous enough to suggest as a possibility the simple nearness of
the artist to that gigantic arm, as though he were viewing the woman
close-up in bed. On the other hand, no imagined location could
account for the distortions of the *Large Reclining Nude*, which is thus as
reality-free and therefore morality-free as a work for which there exists
no human model.★

★ In the midst of the normally technical and formalist language Matisse used about
his work with the model, there are occasional oases of moral usage. For example: 'The
sittings continue in the same spirit, probably without these two becoming substantially
more informed about each other than on the first day. Something has come into being,
however, an interaction of feeling which makes each sense the warmth of the other's
heart; the outcome of this can be the painted portrait, or the possibility of expressing in
a series of drawings that which has come to me from the model.' (Quoted in Flam,
Matisse on Art, p. 152.)

The paper cut-outs were the primary work of Matisse's last years. They were an invention born of incapacity and illness, in which the artist's gifts as a muralist, draughtsman (he called the cut-outs 'drawing with scissors'[32]), sculptor ('cutting directly into colour reminds me of a sculptor's carving in stone'[33]) and colourist were united. The cut-outs also represent the triumphant integration of liberated colour (throughout Matisse's career a sign of the expressive self) with observed form (the perceived other), and thus are, by virtue of the medium alone, a symbolic union of artist and subject. But the characteristic content of the cut-outs was of equal significance. In the large decorations, the artist once more created a larger universe, far outside the confines of his own work-/sick-room. And just as he responded to his own solitariness with pictures of fully populated natural and human worlds, so his response to his own invalidism was to create images of physical freedom and release: creatures that float, fly, swim, acrobats, dancers, birds and fish, all inhabiting a gravity-less space of pure light. The universes in the cut-out murals are both natural and sacred, the work itself a hymn to love and movement. In *Jazz*, a book of cut-outs, Matisse wrote:

> Love wants to rise, not to be held down by anything base . . .
>
> Nothing is more gentle than love, nothing stronger, nothing higher, nothing larger, nothing more pleasant, nothing more complete, nothing better — in heaven or earth — because love is born of God and cannot rest other than in God, above all living beings. He who loves, flies, runs and rejoices: he is free and nothing holds him back.[34]

These words express perfectly the ecstatic spirit of the cut-outs, works such as *The Parakeet and the Mermaid* (1952, Pl. 86), *The Swimming Pool* (1952), *Polynesia, the Sky* (1946, Pl. 87), where the artist both praises the Creator and offers thanks for a life-time of creativity.

Aragon said Matisse's wish was 'to bequeath to posterity the story of a happy man'[35] — which is to say to perpetrate a fiction, or rather a truth that could be sustained only in moments of revelation, through communion with the thing outside oneself, with beauty. ('From a certain moment what takes place is a kind of revelation — It's no longer me. I no longer know what I'm doing, I identify with the model.')[36]

The image of happiness that Aragon speaks of was Matisse's gift, and his invention. In his last decades Matisse endured frequent periods of pain and fatigue, from which he found release in his art, a 'self-defence' as he described it.[37] And elsewhere: 'I too have said one wouldn't paint if one were happy. I'm in agreement with Picasso on that one. We have to live over a volcano.'[38]

'From La Joie de vivre till now — I was thirty-five then — to this cut-out — I am eighty-two — I have not changed . . . because all the time I have looked for the same things, which perhaps I have realised by different means.'[39] The constant image of Matisse's art, whether the version is Arcadian or domestic, was Earthly Paradise; the constant

86 *The Parakeet and the Mermaid*, 1952, paper cut-out on canvas, Stedelijk Museum, Amsterdam

goal as an artist was to move closer inside it, to fuse with it by identification with the model, until he could disappear (to paint himself into and then, in De Kooning's phrase, 'out of the picture'). In the cutouts, Matisse stepped back from his one-to-one relation with the model and gave her freedom and multiplicity on a field as large as, and far more exuberant than, any Paradise of which he had yet conceived. In the first of these ideal worlds, *La Joie de vivre*, the artist is not yet inside — the empty spaces of the canvas almost evoke his absence. In the studio Paradises, on the other hand, the universe consists entirely of the painter and his works. He is God the Creator in this sense: 'My drawings and canvases are pieces of myself. Their totality constitutes Henri Matisse. I could also say that my drawings and my canvases are my real children.'[40] When in the Nice period he returned the living female to this artist's Eden, she was partly a projection of himself, partly a companion for his solitude. But his relation to her was again that of God, God rather than Adam, who on the day of creation makes an erotic, sensuous world, but does not partake of it.

For Matisse, desire was an apprehension of beauty which fulfilled itself in communication. His was an art of presentation, of giving rather than judgment, or (as in Picasso, say) the demonstration of power over and possession of the subject. Unlike Picasso, Matisse was not a jealous God, but one motivated by the wish to give pleasure, by love. 'Is not love the origin of all creation?' he once asked.[41]

'I believe my role is to provide calm,' he wrote in 1951. 'Because I myself have need of peace.' But there are different kinds of peace, and different routes to it. Matisse's was essentially religious in nature, the product of a spiritual union, involving the loss of self in the invented other. 'It's only that I tend towards what I feel, towards a kind of ecstasy,' he told Alfred Barr. 'And then I find tranquility.'[42] The sacred universe that Matisse created with the cut-outs was a world made of

87 *Polynesia, the Sky*, 1946, paper
cut-out on canvas, Musée
National d'Art Moderne, Paris

such tendencies, identifications and affinities: forms of flowers evoke
those of birds, fish, shells, expressing rapport through the common
language of kindred shapes and colours. In *The Parakeet and the
Mermaid*, for example, the arched female torso calls across a world of
undulating plant-life to the breast of the bird. Matisse feels the nature of
both these subjects, and his own nature in them. 'It is by entering into
the object that one finds oneself. There was a parakeet I had decided to
make out of colored paper. So I became the parakeet. And I found
myself in the work.'[43] In the cut-outs Matisse is the medium through
which both the Creator and his creatures express themselves, a two-
way door, and thus invisible. In the last work, the artist found himself
not only in the model, the mermaid or the parakeet. When he was
working on the chapel at Vence, he told one of the nuns: 'I am doing it
for myself.' 'But you told me you were doing it for God,' she said.
'Yes,' Matisse replied, 'but I *am* God.'[44]

NOTES

1 'Interview with Verdet', in Jack D. Flam, *Matisse on Art*, E. P. Dutton, New York, 1978 (paperback edn), p. 147.

2 Quoted in Pierre Schneider, *Matisse*, Rizzoli, New York, 1984, pp. 367–8.

3 Quoted in Louis Aragon, *Henri Matisse, a Novel*, Harcourt Brace Jovanovich, New York, 1971, vol. 1, p. 120.

4 *Jazz*, in Flam, op. cit., p. 112.

5 Quoted in Pierre Schneider, op. cit., pp. 675, 582, 716, respectively.

6 Ibid., p. 582.

7 Ibid., p. 734.

8 Ibid., p. 10.

9 For example, Aragon: 'Have you noticed that among all the human figures he depicted, all his life long, there is not one that betrays pain?' Louis Aragon, op. cit., vol. 1, p. 167.

10 Quoted in Pierre Schneider, op. cit., p. 215.

11 Ibid., p. 353.

12 'Notes of a Painter', in Flam, op. cit., p. 38.

13 Alfred H. Barr, jr, *Matisse, His Art and His Public*, Museum of Modern Art, New York, 1951, p. 94.

14 Marguette Bouvier, 'Henri-Matisse at Home', in Flam, op. cit., p. 97.

15 'As for the odalisques, I had seen them in Morocco, and so was able to put them in my pictures back in France without playing make-believe,' from 'Matisse Speaks', in Flam, op. cit., p. 135.

16 'Interview with Charbonnier', in Flam, op. cit., p. 140.

17 Quoted in Louis Aragon, op. cit., vol. 1, p. 240 (margin).

18 'Statements to Tériade', in Flam, op. cit., p. 59.

19 'Notes of a Painter', ibid., p. 38.

20 Quoted in Pierre Schneider, op. cit., p. 675.

21 'Notes of a Painter on his Drawing', in Flam, op. cit., p. 82.

22 Aragon quoted by Alfred H. Barr, op. cit., p. 212.

23 Quoted in Pierre Schneider, op. cit., p. 506.

24 Quoted in Louis Aragon, op. cit., vol. 1, p. 236 (margin).

25 Ibid., p. 173 (margin).

26 Quoted in Pierre Schneider, op. cit., p. 620.

27 Ibid., p. 632.

28 Ibid., pp. 357–8.

29 Ibid., pp. 558, 358, 358, respectively.

30 'Testimonial', in Flam, op. cit., p. 136.

31 'Interview with Verdet', ibid., p. 143.

32 *Jazz*, ibid., p. 112.

33 Ibid.

34 Ibid., p. 113.

35 Louis Aragon, op. cit., vol. 1, p. 285 (margin).

36 Quoted in Pierre Schneider, op. cit., p. 582.

37 Louis Aragon, op. cit., p. 285.

38 Quoted in Schneider, op. cit., p. 734.

39 'Testimonial', in Flam, op. cit., p. 136.

40 'Interview with Verdet', in Flam, op. cit., p. 144.

41 'Looking at Life with the Eyes of a Child', in Flam, op. cit., p. 149.

42 Alfred H. Barr, op. cit., p. 160.

43 Pierre Schneider, op. cit., p. 358.

44 Ibid., p. 675.

PABLO PICASSO

There is no twentieth-century artist about whom we have been told so much and yet know so little as Pablo Picasso. In photographs and full-length films, in critical and biographical studies, in memoirs both hagiographic and spiteful, the artist has been documented. He is quite likely the most documented of modern artists, the most universally renowned and, until his death in 1973, among the most visible. He was a celebrity from his first days at the Bateau-Lavoir until his last years on the Côte d'Azur, and there are accounts of him through eight decades of a peculiarly art- and fame-obsessed century. We know not only the variously reproduced body of works (a fraction, however, of the total output — but that we know, too), we probably also know some of the names of his dogs and mistresses, the addresses of his studios, the nature of his tastes and whims, tantrums and table-manners. The most famous photographers of several eras have fixed him for us, inside his different homes, or on the streets of Paris, or parading by the shores of the Mediterranean. We have seen him in working-man's overalls and flowered beachwear, in evening dress and matador costume. And we could recognise the artist from a close-up of one fierce eye, or by his naked boxer's torso or striped matelot shirt, even beneath a papier-mâché mask or the skull and horns of a bull. Again and again he has been presented to us, whole or in pieces, but always bearing the solidity of a monument. And yet underneath the monument, which is a monument to the obfuscating nature of celebrity itself, the true character of the man and artist remains as inaccessible and vague as the documents of the life and work are overwhelming and precise.

This paradoxical obscurity is Picasso's freedom, the urge to which lies at the heart of his work and spurred its changing styles — those exercises in contradiction that enabled him to evade capture and comprehension,★ yielding only, and for much of his life with

★ 'Basically I am perhaps a painter without style,' he said to André Verdet in 1963. 'Style is often something which locks the painter into the same vision, the same technique, the same formula during years and years, sometimes during one's whole lifetime . . . I myself thrash around too much, move too much. You see me here and yet I'm already changed, I'm already elsewhere. I'm never fixed and that's why I have no style.' (Dore Ashton, ed., *Picasso on Art*, pp. 95–6.)

phenomenal success, to the self-imposed imperative to amaze, the obligation to astonish. The distance between Picasso and us is the distance imposed by the performer, the conjurer who serves his audience while yet demonstrating his power and separateness. In the end it is Picasso's showmanship which keeps him safe and unknowable, and which explains the lack of intimacy in his work, even that work pertaining to 'intimate' things. Because he never takes us into his confidence as an artist, never speaks of himself except in the least open of manners (Picasso, when he is not being wildly rhetorical, is alternatively 'poetical' and unbelievable or analytic and remote), we are never overwhelmed by a presence behind the art. Ever willing to display his skills, he nevertheless refuses to go without the mask and placard 'artist' or to emerge — but for the shortest periods — from under cover. There is something both boastful and suspicious in his manner, so that our admiration for the master technician and paragon of creative and physical energy fails to extend to the private man. He is one of those artists everyone acknowledges to be great, yet few are moved by. Perhaps the constant shout in the work of 'look at me' raises resistance. Or perhaps merely the myth and weight of reputation have buried him and there need to be some years of silence and obscurity before Picasso can function again as an artist, which is to say as a communicator. Picasso himself might have agreed with these priorities: 'It's not what an artist *does* that counts,' he said in 1935, 'but what he *is*. Cézanne would never have interested me a bit if he had lived and thought like Jacques Émile Blanche, even if the apple he painted had been ten times as beautiful. What forces our interest is Cézanne's anxiety —that's Cézanne's lesson; the torments of Van Gogh — that is the actual drama of the man. The rest is sham.'[1]

Picasso's own voice and drama ought to be easier to recognise. After all, the preoccupations of his art were consistent: sex, death, war, procreation and creativity. And one could stage a Picasso play without once mentioning the artist's name, merely by presenting the familiar cast of characters: harlequin, acrobat, minotaur, nude, ape, horse, owl, goat, male child in Pierrot suit, female child with bouquet, a dwarf, a crone, Rembrandt, a prostitute in an African mask, Gertrude Stein, Apollinaire, a shepherd, a guitar-player, a bullfighter, a pipe-smoker, a circus bareback-rider, and, in their various guises and art-historical manners, of course, Fernande, Olga, Marie-Thérèse, Dora, Françoise and Jacqueline.

The work itself is theatrical — symbolically and poetically scenic in the Blue Period, augustly dramatic in the Rose, where the figures have the frozen-narrative or tableau quality of neoclassical history painting. Posing, staging, is a characteristic of Picasso's art whether the subject is human or still-life (what are those bottles confronting guitars if not actors in a theatrical moment?), whether the manner is cubist, neoclassical or surrealist. Throughout, and particularly in the later work, there is a tendency to combine elements of action with mystery, ritual or myth.

There is a preponderance of masks and costumes, 'scenes' from the worlds of performance: the circus and the ballet, the corrida, the public life of the beach. There are platforms and raised curtains (in, for example, *Les Demoiselles d'Avignon* and *The Women of Algiers*), dramatic lighting and stylised gestures. The artist does not just offer himself as performer, but also his figures and favourite objects. As with performers, we feel the presence of the mask or costume in the sheer rhetoric of the paint that comes between them and us. Picasso's subjects have the artist's desire to perform, that is, simultaneously to hide and display. The presentation is a demand for a particular kind of attention, which insists that we see, and applaud, but not get too close. Few of Picasso's paintings allow us across the barrier of footlights. The images are icons for the worship of, spectacles for the admiration of. Intimacy is not on offer. We are asked to remain in our seats.

Picasso presents and displays, but does not reveal; he analyses with precision, yet his comments can be crude. It is all large-scale — projected, as over a distance. His emotions are projected too, amplified: the extremes of lust, anger, ferocities of vision or expression, and these alongside paintings that seem coolly cerebral and detached. This

88 *The Charnel House*, 1944–5, oil and charcoal on canvas, Museum of Modern Art, New York

89 (opposite) *The Three Dancers*, 1925, oil on canvas, Tate Gallery, London

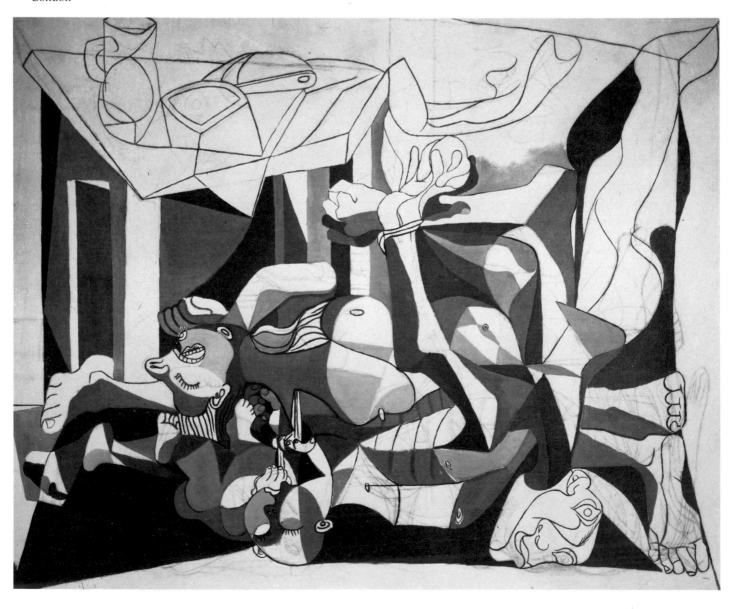

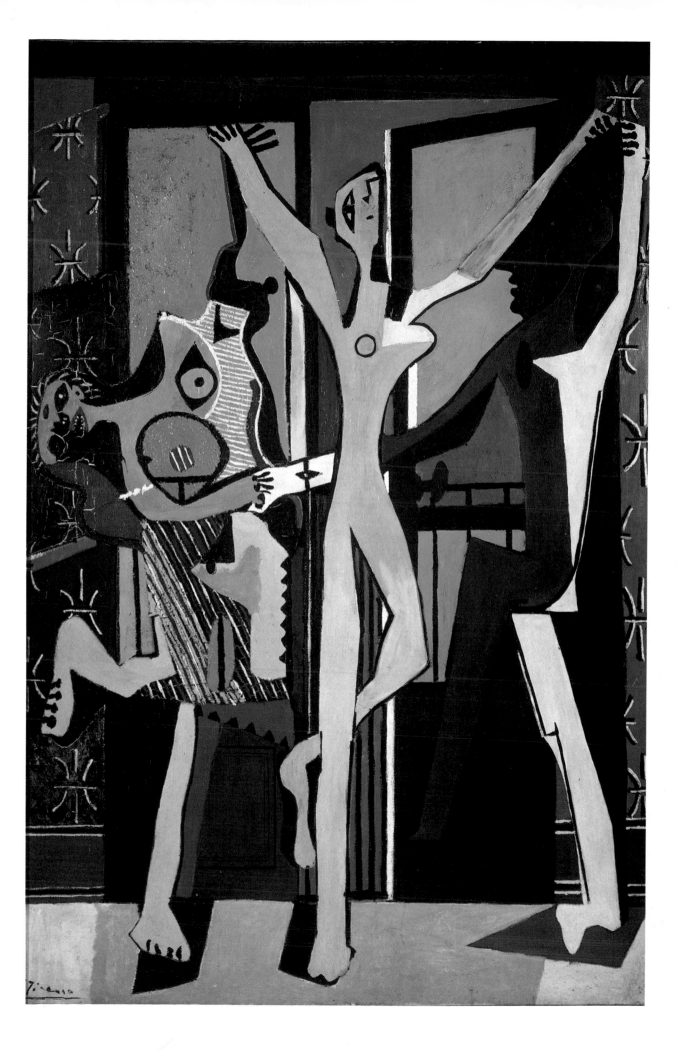

curious combination runs through his work unintegrated — on the one hand, the theatrical, whether violent and ritualistic or poetic and fantastical, on the other, the dispassionately investigated and set-down.

'Americans . . . are like Spaniards,' Stein wrote. 'They are abstract and cruel. They are not brutal they are cruel. They have no contact with the earth such as most Europeans have. Their materialism is not the materialism of existence, of possession [that is, does not derive from empirical knowledge], it is the materialism of action and abstraction.'[2]

What Stein calls cruelty and abstraction are qualities that underlie Picasso's detachment, and that are basic to the two strands in his work: the theatrical and violent ('the materialism of action') and the coolly analytical. A certain heartlessness was necessary to make a conceptual leap of the kind cubism represents, and beyond that, to push the cubist discoveries in otherwise taboo areas: the human body, for example, which in cubism is chopped up and rearranged with chilling if by now familiar determination. In later work it enabled Picasso to pursue his basically analogical mode of thought, in which not only objects and figures appear in the guise (or costume) of other objects and figures (bathers look like squids, guitars like vaginas and so on), but in which situations themselves can shift their emotional content and significance with unnerving ease: scenes of love-making become scenes of carnage, and vice versa (see, for example, *The Charnel House*, 1944–5, Pl. 88). 'Cruelty' and 'abstraction' granted Picasso the freedom to violate not only the accepted forms for representing appearance, but equally our notions of what must be good and what bad, as in his refusal to differentiate between a rape and an embrace (passim), a dance and a crucifixion (see *The Three Dancers*, 1925, Pl. 89). But notions of cruelty and abstraction also explain that other streak in Picasso's work, the frankly sentimental and poetic, since these are only further versions of heartlessness — the kinds of expression where love of the real is absent. Both the cruel/detached and the poeticised/sentimental come from a lack of faith in conventionally perceived reality. Picasso's art disdains this reality, whether of form or emotion, not because it is conventional but because it feels unreal, merely notional, and therefore violable.

In the same way that Picasso loves costume, mask and symbols, he loves appearance; but that is not the same as loving the real, of which his art is highly suspicious. He is continually announcing his independence from the world of phenomena, his contempt for first impressions, by irony, by demonstrations of his freedom to challenge and rearrange the given. 'Painting isn't a question of sensibility,' he once remarked, 'it's a matter of seizing the power, taking over from nature, not expecting her to supply you with information and good advice.'[3] And elsewhere he has said: 'They speak of naturalism in opposition to modern painting. I would like to know if anyone has seen a natural work of art. Nature and art, being two different things, cannot be the same thing. Through art we express our conception of what nature is not.'[4]

Picasso's detachment is really a kind of high-handedness. It is totally different, for example, from the detachment of an artist like Matisse, who sought through his art to submerge the ego in an expression of the other. With Picasso, typically, the opposite was the case: his art tends to submerge the other in expression of the self. Perhaps this says only that Picasso's art moved towards expressionism while Matisse's moved progressively away from it. Picasso's work of the 1960s bears close resemblance to the work of a painter like de Kooning, particularly in its speed, urgency and imagery. Matisse, on the other hand, ecstatic a painter as he was, could be called 'expressionist' only for one short, early period in his art, when he was part of the fauve group.

Except for a kind of weak-pulsed fraternalism in the work of the Blue Period, there isn't really much love of the other in Picasso's art — eroticism, physical and aesthetic rapture, occasional tenderness and humour, but not that overwhelming love of the world that informed Matisse's vision and led him to define his art as a gift. In fact, there isn't much giving in Picasso's oeuvre. His art is too conscious of the gulf between self and others. Nor is there any reverence for the subject — only the intellectual curiosity of the brilliant child, as willing to pull wings off flies as to construct an aeroplane, the showiness of an autocratic ego, the 'detachment' of the tyrant.★

What Gertrude Stein viewed as the Spanish attitude to reality — 'abstraction' and 'cruelty' — marked Picasso's treatment of the nude, generally speaking a genre where the more conventional and 'reality'-respecting art manners obtain; generally, too, the most self-revealing part of an artist's oeuvre, a form of sometimes involuntary autobiography. But here, as throughout Picasso's work, the public manner dominates, and the bravado presentation. Françoise Gilot said that Picasso had only two ways of treating women, as 'goddesses or doormats',[5] and this extremism and double disconnection characterised his treatment of women in paint (actually, 'goddesses and landmines' would be a closer description). His most famous nudes, whether the style is allegorical or mechanistic, poetical or grossly material (that is, invested/augmented on the one hand, or reduced/deconstructed on the other), are all of them finished statements and public icons (this is true

★ . . . or of the merchant: 'You know,' Picasso told Hélène Parmelin, '[painting the nude] is just like being a peddler. You want two breasts? Well, here you are — two breasts . . . ' And to Brassaï he quoted 'an old Spanish proverb: "If it has a beard it's a man; if it doesn't have a beard it's a woman."' (Dore Ashton, ed., *Picasso on Art*, pp. 101, 107.) Perhaps it should be emphasised here that it was Picasso's detachment which enabled him to create profound re-visions of the female form, not just in celebratedly astounding works like *Les Demoiselles d'Avignon*, but in those later works which acceptance of the proto-cubist masterpiece made more readily accessible, works that permanently affect our perceptions of a female body, notably *Woman in an Armchair* (1913), *Nude in an Armchair* (1929, Pl. 102), *Woman by the Sea* (1929), *Figures by the Sea* (1931, Pl. 104), *Woman with Stiletto (Death of Marat)* (1931, Pl. 103), *Bather with a Beach Ball* (1932), creatures from the series of *Figures Making Love* and *An Anatomy* (Pl. 98), both of 1933, *Woman Dressing her Hair* (1940, Pl. 110), and many others.

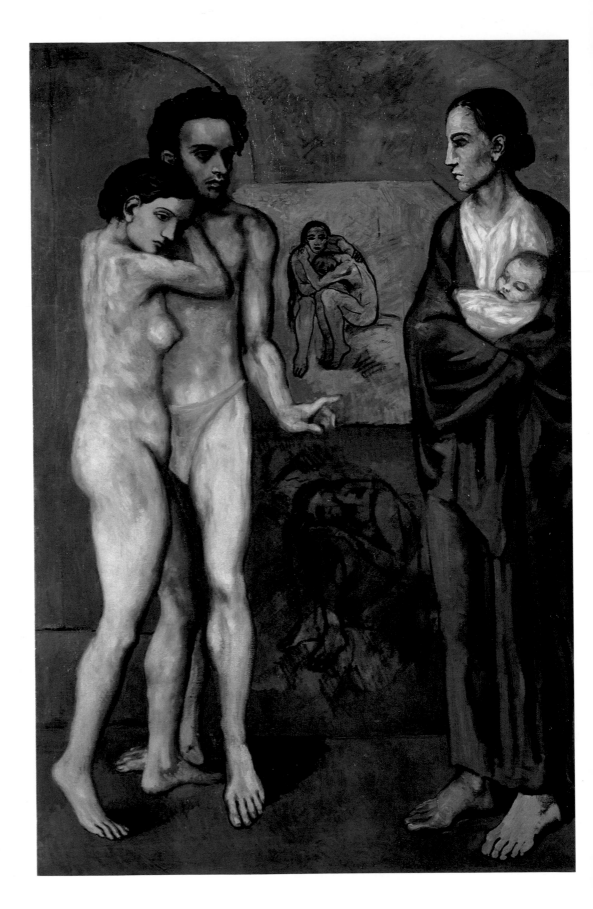

90 *La Vie*, 1903, oil on
canvas, Cleveland
Museum of Art, Ohio

even of the diary-like drawings of *347*, for example). They are divas and show-stoppers, Trilbys behind whom the Spanish Svengali lurks, jealous, protected and invisible.

Whatever the size of the canvas, Picasso's nudes feel monumental, like public statements (and often they were: announcements of solutions to the artistic ringside crowd by whom, from his earliest days in Paris, he seems to have been both cheered and taunted). An early work like *La Vie* of 1903 (Pl. 90), painted when the artist was 22, is nothing if not grand in its presentation and rhetoric. An obscure symbolism, a sense of weighty and final understandings, adheres to the image. The figures relate to one another, and of course to the title, like characters in a morality play. The painting is concerned not so much with physical realities as with the suggested psychological and allegorical themes. Mystery enhances the power of the work, together with the artist's apparent sympathy for the undisclosed plight of his figures. In this early treatment of the nude, Picasso presents nakedness almost as a costume for a masque. Although we feel the physical attributes of nudity — above all the vulnerability to cold — through the colour of the painting, the woman's pose and the presence of the second woman's cloak, we are also aware that nakedness here is part of the allegorical rendering, and helps to represent the qualities of youth, sexuality or virginity, qualities that are troubled or doomed, as the accompanying sketches on the wall of naked, sorrowful and huddling figures make clear. The work is said to have been inspired by events in the life of Picasso's close friend Carlos Casagemas, whose death in 1901 had already been the subject of several earlier paintings. Picasso was deeply affected by Casagemas's suicide and its cause — an unhappy love affair thwarted by impotence.

Sexual tension, which is here barely suggested, was a consistent element in Picasso's depiction of couples in the Blue and Rose Periods, particularly in those family groups of saltimbanques where figures sit at odd physical and psychological distances from one another, and where often the image of an ape is included like an emblem of animal nature and uninhibited sexuality from which the human subjects refrain. It is, too, in this Rose Period that the theme of disconnection and longing first enters Picasso's work in the form of images of dressed males appraising sleeping or indifferent, mostly naked, females. (See, for example, the pen and watercolour studies of 1904, *Sleeping Nude* and *Meditation* (*Contemplation*, Pl. 91), and the gouache of 1905, *The Harlequin's Family*, where a clown-costumed man gazes at a naked woman, who looks only at the mirrored reflection of herself.) Such images were to reappear in Picasso's work of the 1930s, where the male figure may be a faun or a minotaur, and later, in the 1940s, where the sleeper is male and the watcher female. Perhaps it is worth noting that the nocturnal gazing may have had its origins in the economic arrangements of the impoverished young painter. In his early days at the Bateau-Lavoir, Picasso shared a studio with Max Jacob, sleeping in the only bed when Max went to work in the

91 *Meditation (Contemplation)*, 1904, watercolour and pen, Collection of Mrs Bertram Smith, New York

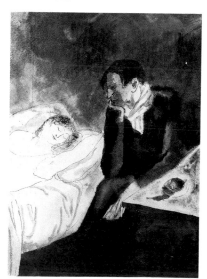

daytime and painting by artificial light when Max was asleep. It is likely that when, not long afterwards, he moved in with Fernande Olivier, he continued his night-time work habits* and had frequent occasion to watch his mistress as she slept. In any case, Picasso always preferred to be awake at night, and often took long walks through the city. Roland Penrose refers to 'these nocturnal wanderings' as a life-long habit: 'Picasso enjoyed the sensation of being conscious when others were asleep; it felt like a triumph over death.'[6] It probably also felt like a physical assertion of the artist's role to be conscious when and where others were not, and by that consciousness to know himself separate from them.

Despite the associations with its name, there is nothing particularly cheerful about the Rose Period paintings, except the frequency of circus costumes and the pastel colouring. In works where groups of figures are presented, the mood is of disconnection, every bit as bleak as that suffered by the hungrier and colder figures of the preceding Blue Period. Even where the subjects are solitary, there is a deadly stillness about them, frozen gestures and a kind of petrified dignity as in Egyptian tomb-painting — a fact which reminds us of Rousseau's remark to Picasso, which caused much mirth among the advanced-art crowd: 'Picasso, you and I are the greatest painters of our time, you in the Egyptian style, I in the modern.'[7] The designation seems true enough, in relation not just to the Cleopatra-eyed primitives of Picasso's 1907 work, but even to such earlier figures as the mysteriously gesturing, hieratic woman in profile, the *Lady with a Fan* of 1905 (Pl. 92).

It was about this time that Picasso stopped telling stories in his painting,† however imbued with mystery, and began to concentrate on non-psychological, non-poetic aspects of his female figures. Female appearance rather than behaviour or literary association begins to be the subject of his paintings of women, and in particular aspects of size: body mass and weight, rendered as solid fields of flesh. No longer underfed, vulnerable, or even seductive, the nudes of 1905–6 are dauntingly, even comically, sturdy. Although Picasso had painted at least one unusually ample nude by this time, the very Flemishly pink and iridescent *Dutch Girl* (*La Belle Hollandaise*) of 1905 (Pl. 93), it wasn't until after the *Portrait of Gertrude Stein* (Pl. 94) that the physical characteristics of his nudes changed markedly. According to the portrait's subject, Picasso hadn't used a model for eight years when he

* 'I like to work in the afternoons,' Picasso said in 1945, 'but best of all at night . . . artificial light suits me a great deal better . . . ' (Dore Ashton, ed., *Picasso on Art*, p. 98.)

† Picasso never renounced story-telling as such in painting, and his later work is full of narrative and scenic elements. Claude Roy quotes Picasso in 1956 speaking about Bonnard: 'I like him best when he isn't thinking of being a painter, when he painted pictures full of anecdotes, literature, "told stories" . . . Actually, that's the best part, pictures full of literature, rotten with anecdotes, that tell stories.' (Dore Ashton, ed., *Picasso on Art*, p. 161.)

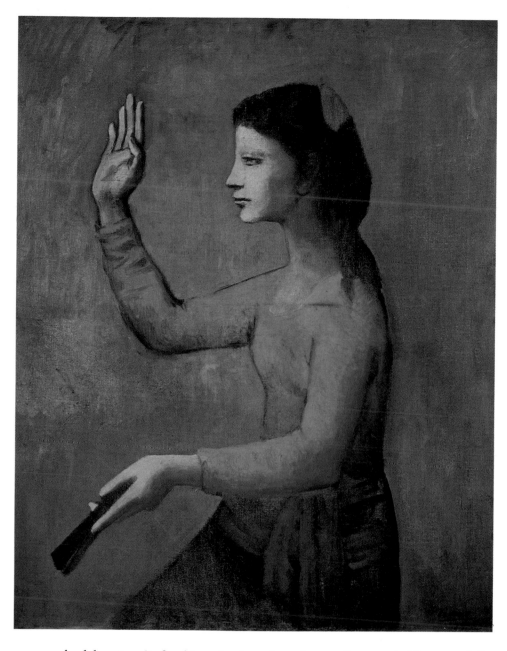

92 *Lady with a Fan*, 1905, oil on canvas, National Gallery of Art, Washington

asked her to sit for him during the winter of 1905–6. She posed for him, she claimed, some ninety times before the summer of 1906 when Picasso, in exasperation, painted out the features of her face and went off to Gosol in Spain. On his return to Paris that autumn, he resumed his portrait of her and imposed on the blank face the mask features he had seen on Iberian statues during his time away. The importance of Stein's mask-featured portrait as a forerunner for elements in *Les Demoiselles d'Avignon*, and therefore as a herald of cubism, has tended to overshadow the possibility of any other significance in the work. But it seems to me highly possible that the actual size, bulk and character of his subject, stared at ninety times over an entire winter and spring, might also have affected the painter's vision.

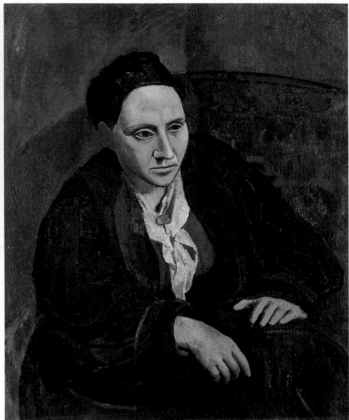

93 *Dutch Girl (La Belle Hollandaise)*, 1905, oil and gouache on cardboard, mounted on wood, Queensland Art Gallery, Brisbane

94 *Portrait of Gertrude Stein*, 1906, oil on canvas, Metropolitan Museum of Art, New York

Gertrude Stein was a central part of Picasso's world at this time. Not just a friend and fellow artist, and one noisily engaged like himself on the frontiers of modernism, she and her brother Leo were enthusiastic supporters and collectors of his work. Furthermore, Gertrude and Picasso had certain things in common, being both foreigners in Paris, both dark-eyed and short — in fact they were the same height, five foot two inches tall — both dominating and aggressive in manner. Even if none of these things impressed Picasso about Gertrude Stein, it is likely her physical presence did. Here is Mabel Dodge's description of Picasso's subject:

> Gertrude Stein was prodigious. Pounds and pounds and pounds piled up on her skeleton — not the billowing kind, but massive, heavy fat . . . [all beneath] a jolly, intelligent face . . . Yet with all this she was not repulsive. On the contrary, she was positively, richly attractive in her grand *ampleur*. She always seemed to like her own fat anyway and that usually helps other people to accept it. She had none of the funny embarrassments Anglo-Saxons have about flesh. She gloried in hers.[8]

And Picasso seems to have gloried with her. I see the influence of her body (even her head and face) in a work like *Seated Female Nude with Crossed Legs* (1906, Pl. 95), in those figures whose squat firmness has

114

95 *Seated Female Nude with Crossed Legs*, 1906, oil on canvas, National Gallery, Prague

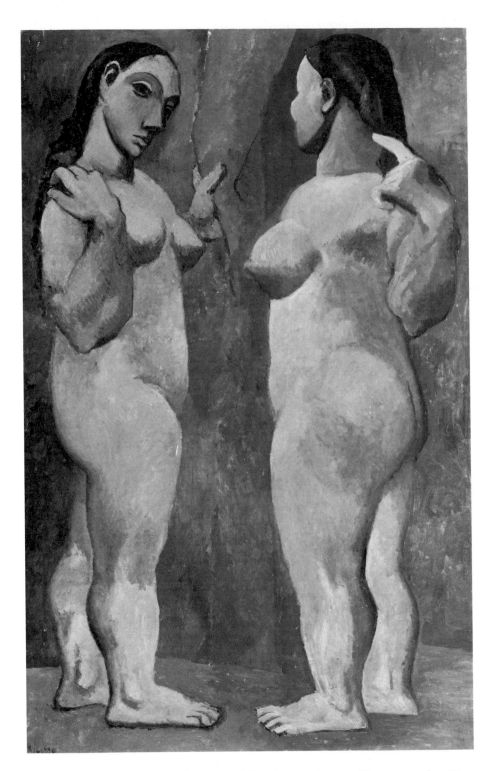

96 *Two Nudes*, 1906, oil on canvas, Museum of Modern Art, New York

been attributed to the influence of Iberian sculpture (for example, *Two Nudes*, 1906, Pl. 96), even in what looks like a Picasso self-portrait as Gertrude Stein, the *Young Nude Boy* of 1906. None of the female figures is voluptuous in the Rubens or Courbet manner. The massive flesh is asexual, as solid and monumental as a boulder, and it seems to me that the body type of Gertrude Stein, and perhaps also her unselfconscious

and androgynous character,* lies behind these emanations in the nudes that Picasso painted immediately after her portrait.

The depictions of huge female body mass did not end at this point in Picasso's art. There are giantesses with doey, Raphael eyes in the work of the early 1920s (see Pl. 100), and a decade later bathers as blown up as their beach balls, and further experiments to see how far female flesh could be stretched before it lost its female recognisability. But the line of squat deities possibly influenced by Gertrude Stein ends around 1907, as Picasso goes on with a different kind of female description and proceeds towards *Les Demoiselles d'Avignon* and the ladies of cubism, abandoning images of solidity for investigations into what Gertrude Stein, referring to her own work, called 'inner and outer reality'.

An interest in primitive art, and in African masks in particular, had been current among the Paris avant garde for some time when, around 1907, Picasso began to adopt certain of their formal properties for his painting. Unlike the sombre Iberian facial features of the *Portrait of Gertrude Stein*, the peculiarities of the African mask served to unleash in Picasso's art elements of both ferocity and playfulness. In the studies for, as well as in the finished version of, *Les Demoiselles d'Avignon*, these seemingly contradictory qualities are present for the first time. Their combination in the large work gives it some kinship with the comically horrific jungle paintings of Rousseau, works which also share with Picasso's something of the same sensationalism and brutal directness.

The emotional tone of the *Demoiselles* (1907, Pl. 97) has never been easy to read. The title itself was the result of an off-hand remark, and survived as a kind of joke, being a reference to a street in the red-light district of Barcelona, the Carrer d'Avinyo (Avignon Street). About prostitutes, and particularly such immodest and demanding creatures as these, there is a reflex and tradition of dismissive name-calling. But the joke itself indicates the presence in the work of a kind of sexual threat which, thanks to the startling formal innovations, has largely been overlooked. It is worth noting, however, that unlike the asexual beings immediately preceding this great composition of nudes, the figures here are flamboyantly and unnervingly erotic. The extreme left-hand *demoiselle* is 'Egyptian' in Rousseau's sense, hieratic and clearly emanating from some house of the dead. But the two ladies in the centre, lifting their arms behind their heads the better to display their breasts, engage in traditional gestures of sexual enticement. On the right, however, the dishevelled sirens are past such genteel and ritualised erotic behaviour. The standing figure looks quite undone and seems about to hurtle into the room like a messenger with bad tidings, while the crouching figure squats in the posture of defecation, and twists her head over one shoulder to stare at the viewer.

* After his first exposure to Gertrude Stein and some of her friends, Picasso is said to have commented to Fernande: 'Ils sont pas des hommes, ils sont pas des femmes. Ils sont des Américains.'

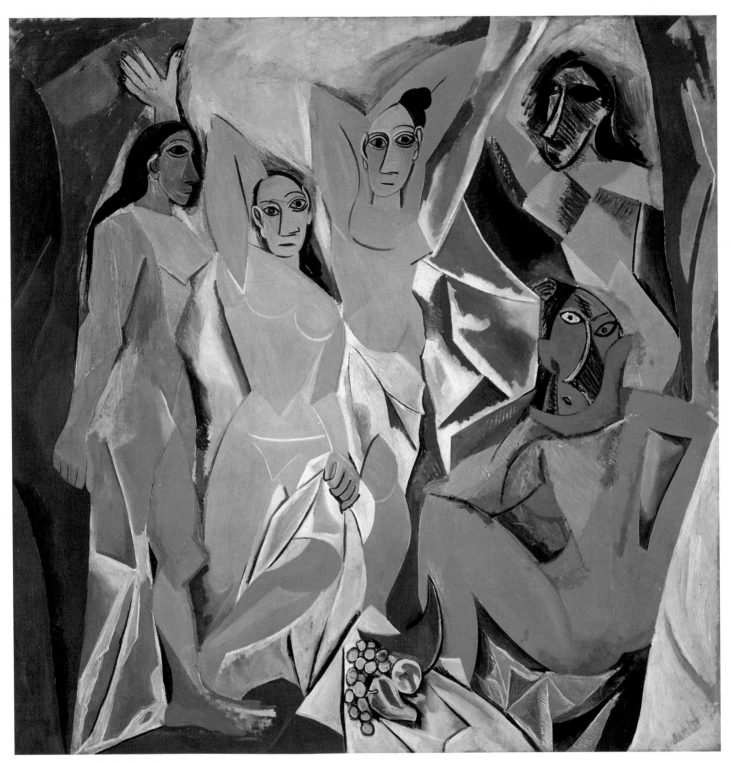

97 *Les Demoiselles d'Avignon*,
1907, oil on canvas, Museum of
Modern Art, New York

In Picasso's private collection is a group of Degas etchings[9] that
present informal views of brothel life: women lying on couches, legs
apart, or bending over, self-preoccupied and somewhat grotesque, as
indifferent as cats to the eye of the viewer. But the *Demoiselles* is not

such a brothel snapshot. Rather, it is something closer to a formal portrait, but one with such a mixture of crude and genteel posing that the viewer is uncertain whether he is being challenged, seduced or ignored. At the time, most of the painting's first viewers were simply alarmed — and that may still be an appropriate response. *Les Demoiselles d'Avignon* has a kind of circus bravado about it, a savage theatricality in its raised curtains and erotic flaunting, huge staring eyes, even in its blatant (shocking) pinkness, which makes this work, perhaps more than the Rose Period images of saltimbanques, the true product and memento of Picasso's evening excursions to the Cirque Médrano.

Les Demoiselles d'Avignon was Picasso's first depiction of — and, more important, artistic response to — female sexual aggression. With the advent of cubism, the emphasis in Picasso's art shifts from what is being looked at to who is doing the looking, and how. The object, particularly the female object, becomes a kind of provocation in the assertion of its integrity and inviolability. (According to the cubist dealer Daniel-Henry Kahnweiler, the significance of cubism lay in its invasion of the object. By 1910, he said, Picasso had 'taken the great step, he had pierced the closed form . . .')[10] With cubism, Picasso literally squared off and took the measure of what was in front of him, in order to penetrate, reduce, deconstruct and then reassemble the object to suit his own vision of reality. ('The goal I proposed myself in making cubism?' he asked in 1932. 'To paint and nothing more. And to paint seeking a new expression, divested of useless realism, with a method linked only to my thought — without enslaving myself or associating myself with objective reality. Neither the good or the true; neither the useful or the useless. It is my will that takes form outside of all extrinsic schemes, without considering what the public or the critics will say.')[11]

Initially, the cubist researches were made in a spirit of scientific investigation.* Gradually, however, Picasso's stance towards the object became increasingly combative, and his painting, as he called it, 'a sum of destructions'.[12] Power over the object, and more than that the demonstration of Picasso's ability to overpower it (without destroying

* Leo Stein gives this account of the early days of cubism: 'There was a friend of the Montmartre crowd, interested in mathematics, who talked about infinities and fourth dimensions. Picasso began to have opinions about what was real and what was not real, though as he understood nothing of these matters the opinions were childishly silly. He would stand before a Cézanne or a Renoir picture and say contemptuously, "Is that a nose? No, this is a nose," and then he would draw a pyramidal diagram. "Is this a glass?" he would say, drawing a perspective view of a glass. "No, this is a glass," and he would draw a diagram with two circles connected by crossed lines. I would explain to him that what Plato and other philosophers meant by "real thing" [sic] were not diagrams, that diagrams were abstract simplifications and not a whit more real than things with all their complexities, that Platonic ideas were worlds away from abstractions and couldn't be pictured, but he was bent now on doing something important — reality was important whatever else it might be, and so Picasso was off.' (Leo Stein, *Appreciation*, pp. 175–6.)

its recognisability or essential nature), became the focus of his art, as the importance of what was depicted took second place to the manner of its perception.

Assertion of the primacy of vision, with all its vulnerabilities and contingencies, over the immutability of form was Picasso's response to the menacing solidity of the 'other'. In this respect, it is interesting that the period of opening up and reconstruction of the object (among which were several female nudes) should follow on such monumental and monolithically conceived icons as the 1906 *Seated Female Nude with Crossed Legs*, and even the post-*Demoiselles* block women of 1908 (see, for example, *Three Women*) which have the colour, shape and solidity of piles abandoned at a site of construction. It was almost as though Picasso needed to see what he was up against before he could begin the demolitions of which a work like the 1910 *Woman in an Armchair* and the more legible and poetic (that ever-useful musical instrument) *Girl With a Mandolin* (also 1910) are examples. It is part of the process of art history — and perhaps of making art — but nevertheless ironic that the creation of a modernist aesthetic, with all its subservience to notions of the contingent and the momentary, should result only in further icons, made all the more sacred and indestructible by their fixed place in our cultural heritage, our need for the inviolability of the masterpiece that is to be handed down. One cannot bequeath an ephemeral vision, though to some extent that is what early practitioners of cubism attempted. It is by its inherent qualities rather than its observations (whether pseudo-scientific or legitimate) that the

98 *Three Women, X* (from the suite *An Anatomy*), 1933, pencil on vellum, Musée Picasso, Paris

art work survives. Though the cubist masterpiece asserts perishability, it does not enact it: Picasso's cubist women are as solid as any of the icons that preceded and to some degree provoked them.

The cubist experiment, with the indecisiveness of appearance, the shifting of forms, and the inequality of parts, was eventually to serve Picasso's analogical (proto-surrealist) vision, and above all its wit and playfulness. The 1913 *Woman in an Armchair* (Pl. 99), invaded, deconstructed, reduced and disrespectfully reassembled though she is, seems to me to be one of the great nudes of this century, and one of the finest of Picasso's inventions. The lady is an assemblage of part-objects, and not all of them hers — her sex or *cache-sexe* (there is both a pun and a violation of modesty at work here) is made up of buttoned fabric. Breasts, hair, navel and ribs are exposed to us as the significant female signifiers. The breasts themselves are pegged ambiguously with what might be a second pair of nipples, her lower parts conveyed both by the wrinkled fabric and the hair-like fringe of the chair. She has herself partly disappeared into the curving form of the wing-back. Deceptively upright and inviting, the upholstered chair together with its knobbed, jagged and generally protuberant occupant suggest some kind of erotic booby-trap. Picasso was to make similar observations about quietly waiting women in armchairs throughout his career, and in few of them does he convey much confidence in the apparent offer of affability or comfort.

'In poetry interest will be born of the doubt between reality and imagination,' Max Jacob wrote in his *Correspondance*. '. . . Doubt, that is art.'[13] After cubism, Picasso put the expression of this doubt at the service of his own sexual ambivalence, and in his work depicted the female as a primary 'anxious object'.

99 *Woman in an Armchair*, 1913, oil on canvas, Collection of Mr and Mrs Victor W. Ganz, New York

In 1918, Picasso married the dancer Olga Koklova, and began to enjoy the virtuous and orderly life of a bourgeois husband and family man. A time of domestic contentment coincided with a neoclassical period in his art, an affirmation and return to the grand traditions of Western painting in Ingres-like portraits, fine-lined scenes of classical life — both idyllic gatherings and abductions — and a series of grand nudes, virginal and somewhat pastoral in conception, with gentle Italianate eyes (Picasso had been 'overwhelmed' by the *stanze* of Raphael in the Vatican during a trip to Rome in 1917, when working on his sets for *Parade*[14]) and large, soft and amiably conceived bodies (see, for example, *Large Bather*, 1921–2, Pl. 100, and *Nude Seated on a Rock*, 1921). The acts of reparation and declarations of faith in female goodness (they are both *madonne* — images of virtuous fertility — and goddesses) made through these images were to be as short-lived as Picasso's marital contentment. By the mid-1920s, his preoccupation with the ambiguities of his response to women and the anxieties of erotic life had returned. *The Three Dancers* of 1925 suggests a crucifixion as much as a farandole, and is a far cry from the loving (and somewhat saccharine) depictions of ballerinas

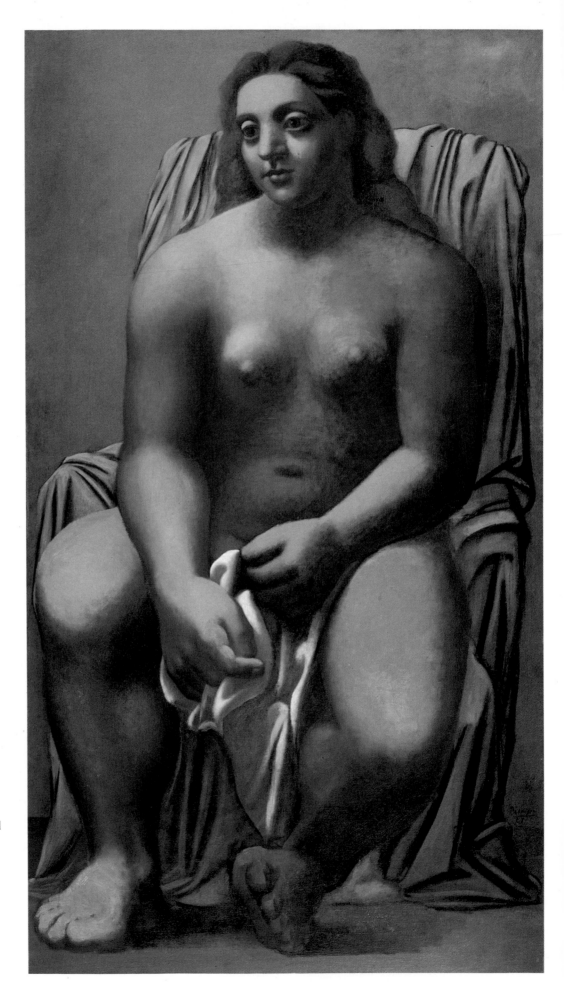

100 *Large Bather*, 1921–2, oil
on canvas, Musée de
l'Orangerie, Paris

done some six years previously when Picasso was in his first enchantment with Olga and the Ballets Russes. We are back in the world of the *Demoiselles*, of alarming sirens in the guise of seduction. Once again, the image of female exuberance provokes Picasso's hostile and dismembering art. And as previously, a period of whole and larger-than-life nudes leads to one in which the integrity of the icon is belligerently challenged.

Sexual anxiety and aggression seem likewise part of the series of rather surrealist and fetishistic 'Guitars' of 1926, constructions in which female private parts are conceived of not just in terms of musical instruments, but as lethal traps and targets for sadistic impulses.

Surrealism, with its erotic obsessions and love of puns, its streak of sadism, encouraged the hostile turning which Picasso's portrayal of women took in the 1920s. Robert Rosenblum notes that 'the image of female sexuality as a monstrous threat dominates the work of the late-20s; especially in paintings that juxtapose a male profile of classical beauty with a female head of grotesque ugliness'.[15] But there were, too, in this period, sweeter descriptions of sexual life in which a very abstractly rendered bather, a changing cabin and a key are the symbolic components. These are gently delivered sexual jokes, punning on the lock and key as shorthand for male and female genitals, rather than misogynist attacks. (As Rosenblum says, ' . . . the sexual connotation

101 *Bather Unlocking a Cabin*, 1928, oil on canvas, Musée Picasso, Paris

102 *Nude in an Armchair*, 1929, oil on canvas, Musée Picasso, Paris

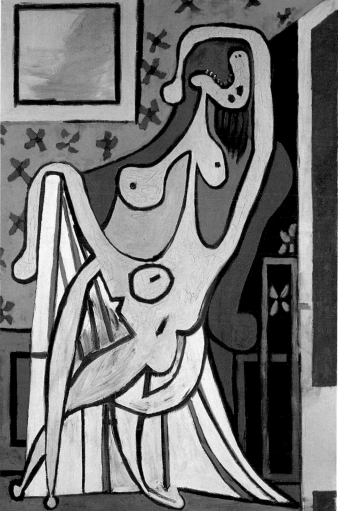

of inserting a key in a lock is so basic that the Italian slang word for copulate is *chiavare* [to unlock]'.[16]) These bathers, if less than reverentially conceived, have their own abstract charms (see, for example, *Bather Unlocking a Cabin*, 1928, Pl. 101) and are certainly sweet–natured creations when compared with the 1929 *Nude in an Armchair* (Pl. 102). Here, the mousetrap is in full operation. The female signifiers have changed markedly since the 1913 version. This seated nude is all teeth and tentacles, a vision all at once of sprawling immodesty, hysteria and entrapment, and endowed with a sex that is simultaneously a sharp instrument and a gaping wound.

It gets worse, and more emphatic. *Seated Bather* (1930) has all the poise of an Ingres odalisque — and the head and mandibles of a praying mantis. *Woman with Stiletto (Death of Marat)* (1931, Pl. 103) is a child's fantasy of being overpowered and consumed, as a huge amorphous female, with breasts and teeth, jaws apart in primal scream, takes the life of the tinier, flattened male who is depicted in an act of creation. Blood gushes from his wound to his manuscript, and he himself seems about to be eaten by the monster that looms above him. The paintings of this period are rife with such sexual paranoia. Even mutually agreed-upon intercourse looks like a mixture of combat and gluttony in the 1931 *Figures by the Sea* (Pl. 104). Humour and playfulness are barely evident in such images. They have the urgency and power of a very real and shrill cry of pain.

In 1927 Picasso had met and begun an affair with Marie-Thérèse Walter, a pretty, blonde student of 17. Her face appears in several

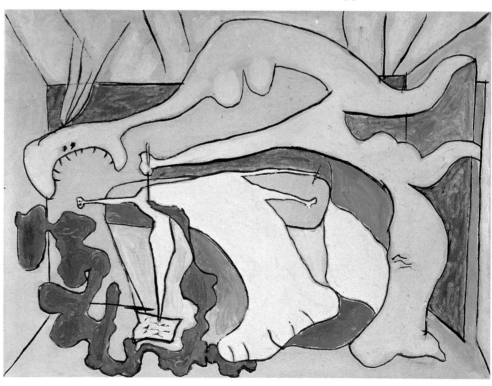

103 *Woman with Stiletto*, 1931, oil on canvas, Musée Picasso, Paris

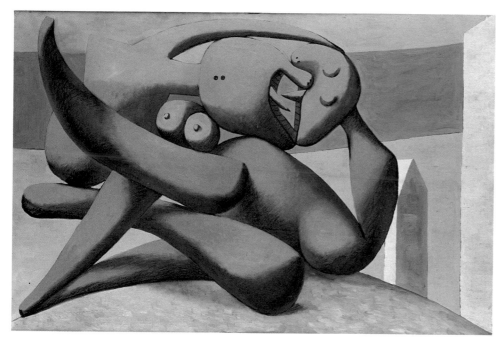

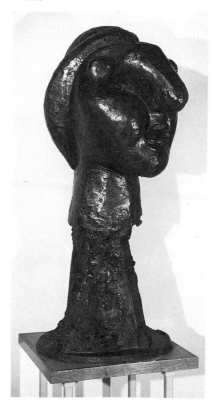

104 *Figures by the Sea*, 1931, oil on canvas, Musée Picasso, Paris

105 *Head of a Woman*, 1932, bronze, Galerie Louise Leiris, Paris

works during the following years, and most notably in a series of sculptured heads executed between 1931 and 1933, in which her soft but distinctive profile lends itself to the shape of male genitals (see Pl. 105).[17] Her figure and nature also feature in paintings of the early 1930s, in the most benign and creaturely images of women Picasso ever made. Unlike the entangling and fractured malignities of *Nude in an Armchair* and *Woman with Stiletto (Death of Marat)* — images that have been ascribed to tensions in Picasso's marriage with Olga[18] — the nudes inspired by Picasso's young mistress are all contained and placid, whole and wholesome. The discrete forms enclosed in sleep in *The Dream*, *The Dream (Reading)*, *Sleeping Nude*, *Nude on a Black Couch*, *The Mirror* (all of 1932) and *Nude Asleep in a Landscape* (1934) are each conceived as safe, silent, and above all, still (see Pl. 106). These are images of a harmless and innocent creature, desirable and, significantly, unconscious. Picasso depicts his child-mistress as a ripe fruit, an oval cleft like a peach, or as a plump arabesque — all contained forms that speak of a kind of natural perfection, of something desired but not activated, nor acted upon. The nude's discreteness is a part of her beauty. Enclosed, but yielding, she may be woken at the artist's bidding. And there is not a sharp edge or tentacle on her.

With the advent of Marie-Thérèse, joy returns to Picasso's images of women. *Bather with a Beach Ball* (1932), grotesque as its pneumatic forms might be, is nevertheless benignly and affectionately conceived. Part dirty joke (her head and hair are inspired by certain anatomical details of the penis), part tribute to Picasso's sexual fulfilment (the bathing hut stands behind her unlocked), it is also a wonderful picture of an innocent but sexually mature female child at play. Likewise, in *Woman Sitting on the Beach* and *Bathers with a Toy Boat* (Pl. 107), both of 1937, fully developed females are endowed with a childlike innocence

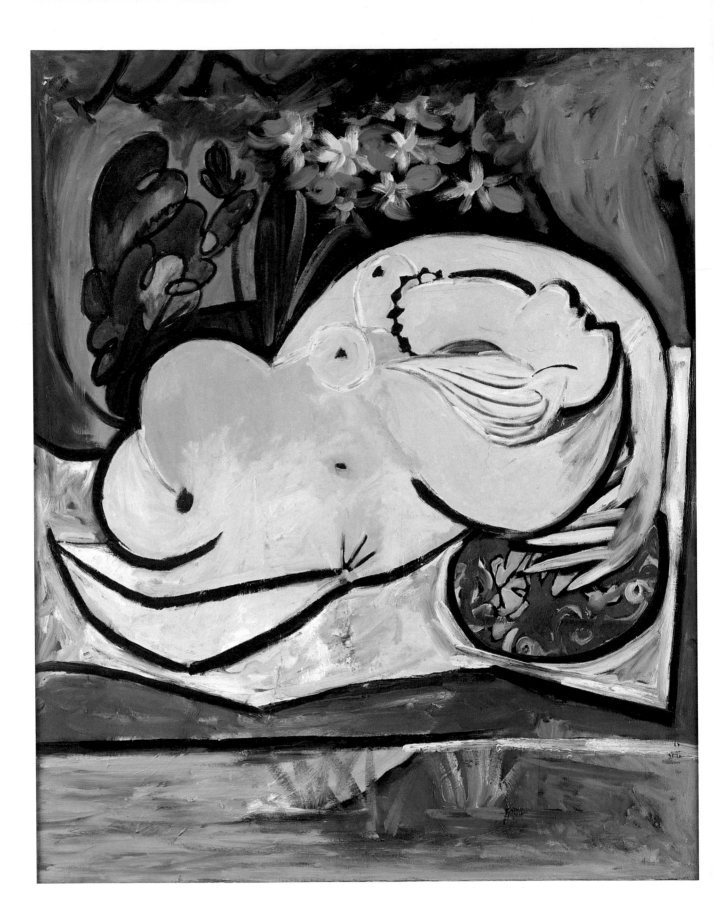

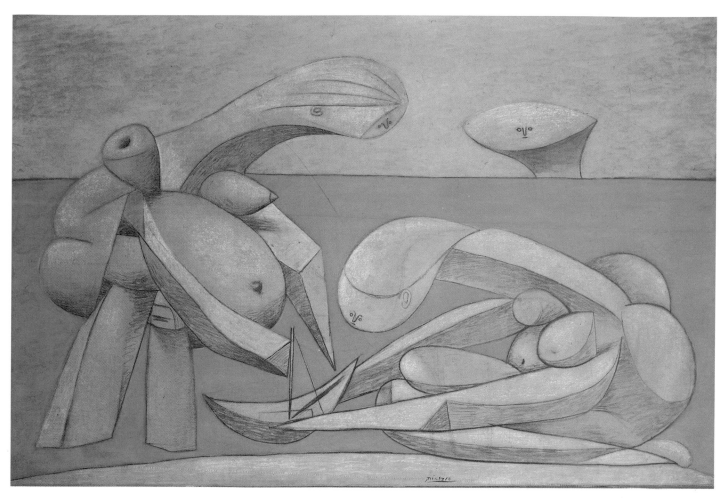

and love of play. Even the more cerebral and emotionally neutral creatures from *An Anatomy* of 1933 (see Pl. 98) are wittily conceived and affectively irreproachable. In *Figures Making Love* (1933), despite the description of apparent disconnection (the points of contact are few and crudely specific), Picasso's vision of male/female relations is set down without anguish. Aware of the grotesque and visually curious aspects of sex, the artist is nevertheless once more in humorous mood.

Between 1930 and 1937 Picasso made a series of etchings which were collected and published as the *Vollard Suite*. Here, poetry, mythology and narrative are once more given full expression in his art (see Pl. 108). There are beautiful nudes, asleep and awake, handsome artists and Greek gods, minotaurs, horses, ladies in distress, abductions and heroes, models and sculptures in artists' studios. The whole work is one in which Picasso in his various guises is the hero, but the women are his peers and sources of inspiration. The book is about love, love fulfilled and re-created in art. It has a lyrical quality unlike anything in his work since his first associations with the Ballets Russes, when neo-classical imagery and a theatre of magic and delight absorbed him. In this fantastical world, part autobiographical, part universal day-dream, Picasso abandoned the realities of his domestic entanglements and escaped to purer air.

106 (opposite) *Nude Asleep in a Landscape*, 1934, oil on canvas, Musée Picasso, Paris

107 *Bathers with a Toy Boat*, 1937, oil on canvas, Peggy Guggenheim Collection, Venice

127

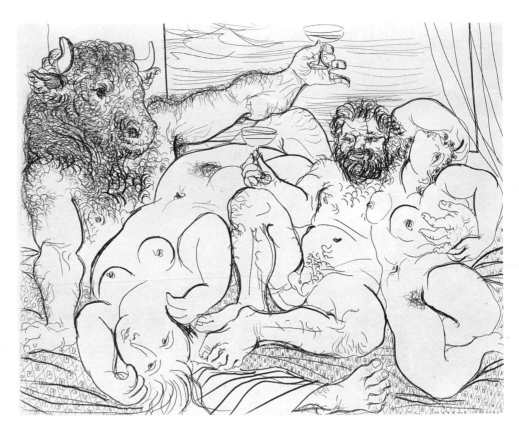

108 *Bachanal with Minotaur*, 1933, etching, Museum of Modern Art, New York

109 (opposite) *Nude Before a Vanity*, 1936, pencil, Musée Picasso, Paris

By the second half of the 1930s, and particularly around 1937, the time of *Guernica*, Picasso's painted women are no longer either still or unconscious. Images of weeping women, their features cracked or swollen by tears, dominate his art. In 1935, Picasso, by then the father of Marie-Thérèse's daughter Maia, separated from Olga. A year later he began his affair with Dora Maar, a photographer friend of the surrealist crowd with whom Picasso was then closely associated. Though the grieving women in his work may have been inspired by real reactions to his domestic upheavals, they seem to have a more universal aspect. By 1937, Picasso was using the figures of such women as expressions of outraged and violated humanity — as such they appear, howling, at far left and right in *Guernica* and in various parts of *The Dream and Lie of Franco: II*. By June 1940, when war was closer to home, the figure of woman was used in *Woman Dressing her Hair* (Pl. 110) as an image of humanity reduced, by anxiety and deprivation. She is no longer a sexual presence, although she has been endowed with breasts, belly and painted lips, and bears some resemblance (in the breasts and right-side ribs, particularly) to her highly sexual predecessor, the *Woman in an Armchair* of 1913. But this woman, cross-eyed with worry, splay-footed and deathly pale, is as erotic as hanging poultry — which in these early days of shortages may have been somewhere on Picasso's mind. The subject and title of the work are ironic, given the series of dressing women which preceded it (for example, the great image of female self-preoccupation in the Rose Period, *La Toilette*, 1906, or the later *Nude Before a Vanity*, 1936, Pl. 109, where a pea-brained beauty

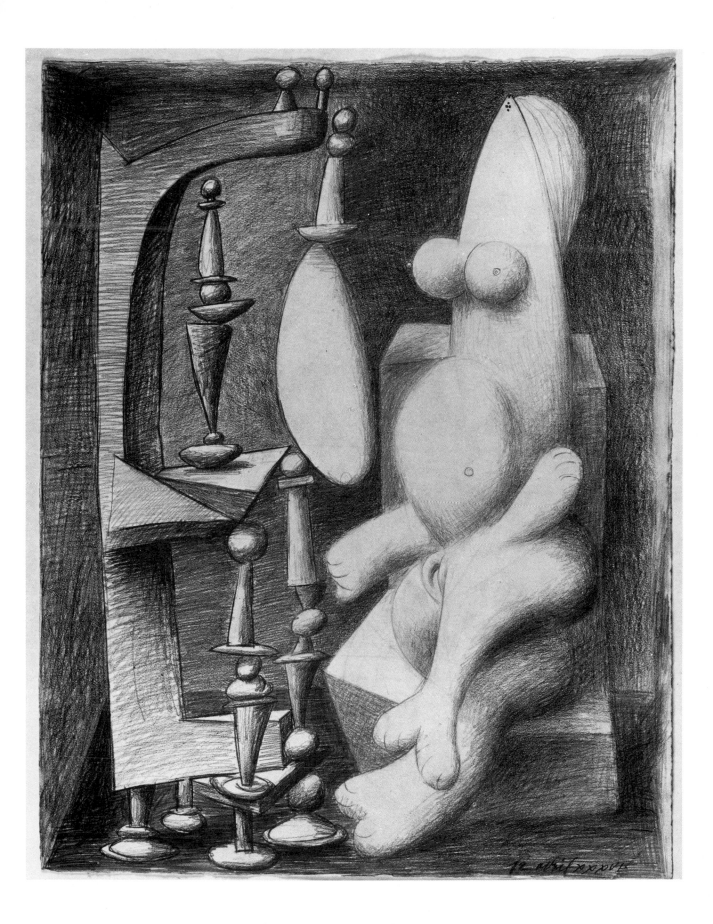

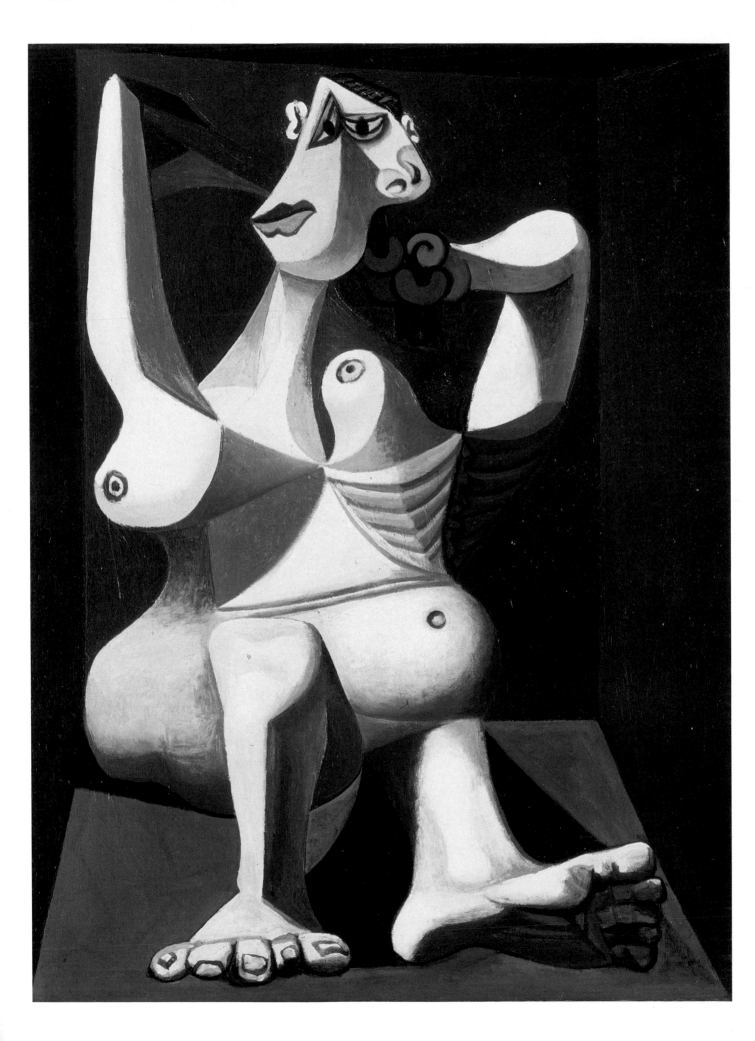

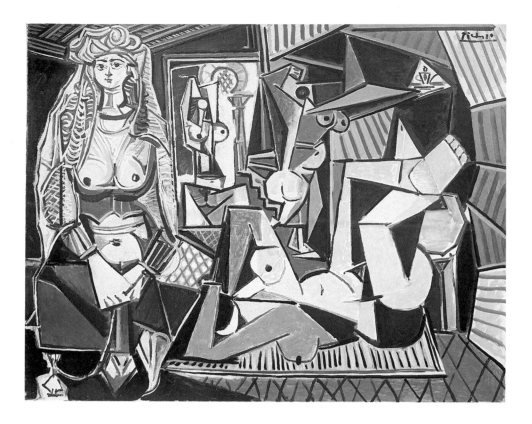

110 (opposite) *Woman Dressing her Hair*, 1940, oil on canvas, Collection of Mrs Bertram Smith, New York

111 *Women of Algiers, after Delacroix (O, Final Version)*, 1955, oil on canvas, Collection of Mr and Mrs Victor W. Ganz, New York

appreciates her charms in a parodically (though less attractively) knobbed and perhaps somewhat carnivorous mirrored dresser. In this image of the icon in war-time, the hair-dressing seems an anxious and pathetic reflex, as though ritual and self were all that were left to hold on to. Two years later, there is not much difference, in Picasso's vision, between a reclining nude and a trussed corpse (as in *L'Aubade* (*The Dawn Serenade*) and *Sleeping Nude* of 1942) — an ambiguity of appearance emphasised in *The Charnel House*, 1944–5 (Pl. 88).

Not until long after the war did Picasso endow his nudes with their traditional female charms, and he turned to tradition to do so. In the great series of *Women of Algiers, after Delacroix* (1955, Pl. 111) and in *Luncheon on the Grass, after Manet* (1960–1, and taken up again in 1971), Picasso reaffirms the stature of the female nude and quite consciously asserts his own place in a hundred-year-old artistic tradition. Regarding the *Women of Algiers*, he specifically referred to the influence of Matisse ('. . . when Matisse died he left his odalisques to me as a legacy, and this is my idea of the Orient, though I have never been there'[19]), but behind Matisse there were, as always, other predecessors and rivals. No longer challenged by the icon, or the actual female presence behind it, Picasso in such paintings seems to be reaching over her head to his fellow artists in the grand tradition, 'taking on' them rather than 'nature' in the contest of his old age.

'I paint just as I breathe,' Picasso told an interviewer in 1968, when he was 86 years old. 'When I work, I relax; not doing anything or entertaining visitors makes me tired. It's still often 3.00 a.m. when I switch off my light . . . Where do I get this power of creating and

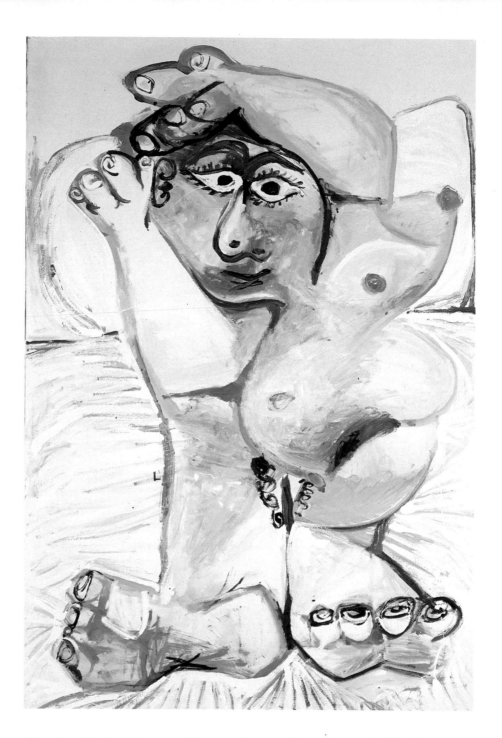

112 *Sleeping Nude*, 1967, oil on
canvas, Musée Picasso, Paris

forming? I don't know. I have only one thought: work.'[20] The output
of Picasso's old age has an energy, drive and speed which are
astounding, even in terms of the standards he set for himself as a
younger man. The imagery is obsessive and repetitive. As Picasso told
Brassaï in 1966:

I'm always saying to myself: 'That's not right yet. You can do
better.' It's rare when I can prevent myself from taking a thing up
again . . . *x* number of times, the same thing. Sometimes, it becomes

an absolute obsession. But for that matter, why would anyone work, if not for that? To express the same thing, but express it better. It's always necessary to seek for perfection. Obviously, for us, this word no longer has the same meaning. To me, it means: from one canvas to the next, always go further, further . . . [21]

The output and intensity in Picasso's late work have often been attributed to the artist's notorious fear of death. If so, the image he contacted again and again as a source of energy and safety from mortal threat was emphatically female and sexual. The erotic content is unlike anything else in his art, in its insistence, urgency and power. All reference to himself and his work is made in terms of the female, who seems to be endowed with the properties of creativity and immortality. In drawing after drawing in the mid-1950s and the late 1960s, Picasso repeats the image of the nude, both as an art-historical abstraction (he depicts himself as artist, too, in the guise of clown, winged and masked Cupid, grotesque dwarf or old man, even as ape, always admiring or wooing the lady), and, less grandly and equally abstract, as a sexual presence, evoked in scrawls and diagrams that often take on the appearance of men's-room graffiti. These latter images of women are not made as intellectual or visual jokes. Instead they are almost primitively urgent evocations of sexual power — an attempt to contact as much as describe it — rendered by gestures or marks that reduce the female form to a system of erotic signs. The sexual parts are always emphasised and may be given by a series of quick, decisive lines: a vertical below a horizontal, like a fractured T-bar, or else a short vertical punctuated by a dot below it and edged with acute and grave accents of pubic hair. In the late work such drawings proliferate, along with more detailed renderings of women masturbating, or of the male and female genitals in the act of copulation. In hundreds of drawings woman is a primitive deity, crudely evoked and simply worshipped. Her sex, repeatedly set down by brutal markings, is seen as the essence of a sacred force, as though this place were the central site of power in the universe.

Picasso's last painted nudes (see Pl. 112) are less intensely rendered than those he scrawled in drawings. They are notably comic, treated with affection and detachment, but they are none the less erotic icons, since sex remained the central and most essential act in Picasso's last vision of human life. Sex here is clearly also an activity akin to art,* something through which human life take place, just as the life of the image is born of the contact between the painter and his subject. In the last works, woman is the subject, and becomes the essence of life itself, that thing outside the painter that was not him nor created by him, and which he could not give up.

* 'Art is never chaste,' Picasso once said: ' . . . if it's chaste it isn't art.' (Said to Antonina Vallentin, 1957; quoted in Dore Ashton, ed., *Picasso on Art*, p. 15.)

NOTES

1 In conversation with Christian Zervos, 1935, quoted in Dore Ashton, ed., *Picasso on Art: A Selection of Views*, Viking Press, New York, 1972, p. 45.

2 Gertrude Stein, *The Autobiography of Alice B. Toklas*, in Carl Van Vechten, ed., *Selected Writings of Gertrude Stein*, Vintage Books (Random House), New York, 1972, p. 86.

3 Quoted in Françoise Gilot and Carlton Lake, *Life With Picasso*, McGraw-Hill, New York, 1964, p. 198.

4 Quoted in Dore Ashton, op. cit., p. 4.

5 Quoted in John Richardson, 'Picasso: A Retrospective View', in Marilyn McCully, ed., *A Picasso Anthology: Documents, Criticism, Reminiscences*, Princeton University Press, Princeton, New Jersey, 1982, p. 283.

6 Roland Penrose, *Picasso: his Life and Work*, University of California Press, Berkeley and Los Angeles, 3rd edn, 1981, pp. 208–9.

7 Quoted ibid., p. 145.

8 Mabel Dodge Luhan, *European Experiences* (vol. ii of *Intimate Memories*), Harcourt, Brace, New York, 1935, pp. 324, 327, respectively.

9 See pp. 240–2 in the *Musée Picasso catalogue des collections*, Paris, 1985.

10 Quoted in Roland Penrose, op. cit., p. 167.

11 In conversation with Felipe Cossio Del Pomar, 1932, quoted in Dore Ashton, op. cit., pp. 59–60.

12 In conversation with Christian Zervos, 1935, quoted ibid., p. 38.

13 Quoted in Roland Penrose, op. cit., p. 175.

14 See Marilyn McCully, ed., op. cit., pp. 122–4.

15 Robert Rosenblum, 'Picasso and the Anatomy of Eroticism', in T. Bowie and C. Christensen, eds, *Studies in Erotic Art*, Basic Books, London and New York, 1970, p. 339.

16 Ibid., p. 342, note.

17 The pun on noses and penises is also universal. In Picasso's drawings of the late 1920s, details of the penis are used frequently as facial features. There are a series of penis-nosed female figures in several drawings. (See Christian Zervos, *Pablo Picasso*, Éditions 'Cahiers d'art', Paris, 1956, nos 279–83 (1929), pp. 114–16.

18 See, for example, John Richardson, 'Picasso and L'Amour Fou', *New York Review of Books*, 19 December 1985, pp. 59–69.

19 Roland Penrose, op. cit., p. 351.

20 In conversation with Ernst Beyeler; quoted in Dore Ashton, op. cit., p. 49.

21 Quoted ibid., p. 80.

AMEDEO MODIGLIANI

Of the famous meeting in Cagnes in 1919 between Modigliani and the aged Renoir, Osterlind's account is as follows:

The master lay crumpled in an armchair, shrivelled up, a little shawl over his shoulders, wearing a cap, his whole face covered with a mosquito net, two piercing eyes behind the veil.

It was a delicate thing putting these two face to face: Renoir with his past, the other with his youth and confidence; on the one side joy, light, pleasure and a work without peer, on the other, Modigliani and all his suffering.[1]

It was Modigliani who had asked his host Osterlind to arrange the meeting, yet once there he was awkward with Renoir. For a while Osterlind and his famous neighbour spoke. The artist had some paintings taken from the wall to be examined, and then he addressed himself to his visitor:

. . . A grim, sombre Modigliani listened to him speak.
'So you're a painter too then, eh, young man?' he said to Modigliani, who was looking at the paintings.
'—'
'Paint with joy, with the same joy with which you make love.'
'—'
'Do you caress your canvases a long time?'
'—'
'I stroke the buttocks for days and days before finishing a painting.'
It seemed to me that Modigliani was suffering [Osterlind says] and that a catastrophe was imminent. It happened. Modigliani got up brusquely and, his hand on the doorknob, said brutally, 'I don't like buttocks, monsieur.'[1]

A host's nightmare, but a perfect expression of aesthetic incompatibility, and a summing up of artistic position as much by Modigliani as by Renoir.
That Modigliani *did* like buttocks is clear from several of his

paintings. What he didn't like, despite his admiration of Renoir's work ('The Parisiennes as seen by Renoir are *so* Parisian. They have all the charm and natural grace of a real Parisienne. And especially the femininity that one sees in a woman only in Paris — no one has painted it like Renoir . . . '[2]), was what he took to be an old lecher's irreverence to, and misreading of the nature of, the act of painting itself.

It might have been worse, for Renoir is said to have put his views more bluntly to another visitor when asked how, his hands crippled by arthritis, he nevertheless managed to paint. 'With my prick,' Renoir replied, a remark his son and biographer describes as 'one of those rare testimonies, so seldom expressed in the history of the world, to the miracle of the transformation of matter into spirit'.[3]

While Renoir refused to, or simply did not, divorce the sexual impulse from his painting, for Modigliani it was only the first and not the most important of several stages in the creation of the nudes. For Renoir, his nudes were part of the world, caressable, and themselves an extension — for that is the implication of his remark — of himself. Renoir's nudes are painted as though the paint *were* skin, and their flesh is rendered lumpy, iridescent, half-smeared, as though the painter had literally been fondling them, as though (in the spirit of the later claims of the abstract expressionists) he had been himself inside the painting, rolling around with the girls.

Nothing could be further from Modigliani's method. Not only did he not 'caress' his nudes or linger over them — he painted in rapt, intense sessions, feverishly, as has been reported, his fevers abetted by drink, and quickly: one hour, two hours and he was done — but Modigliani is not the least interested in description of flesh (the reason, as de Kooning once remarked, that oil painting was invented). His nudes are normally monotonously and uniformly coloured, the skin weirdly orange, or greeny-brown, like hillscapes of his native Tuscany. Characteristically the body of a Modigliani nude is coloured almost as a piece, the parts distinguished by drawing rather than tone. In some instances the colouring of head and body do not match: naturalism was not what he was after.

The uniform surfaces of Modigliani's nudes owe a great deal to his work as a sculptor. It is known that the painter thought of himself primarily as a sculptor, though he was barred for most of his life from that work because of the high cost of material and the strain on his health. (Modigliani was tubercular; the stone dust made him cough, and the stones themselves were often too heavy for him to manoeuvre.) However, between 1909 and 1914 Modigliani worked almost exclusively as a sculptor, and for two of those years lived in the Cité Falguière, next door to the sculptor Brancusi, with whom he had a close and important relationship.

Under the Rumanian's tutelage Modigliani learned to redefine his art in sculptural terms. With Brancusi he shared a contempt for the then-dominant art of Rodin — like Renoir, an artist of impassioned surfaces — whom Brancusi called 'a maker of beefsteak'. For Brancusi and

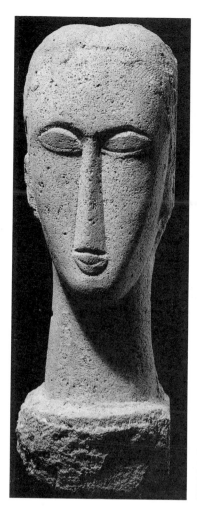
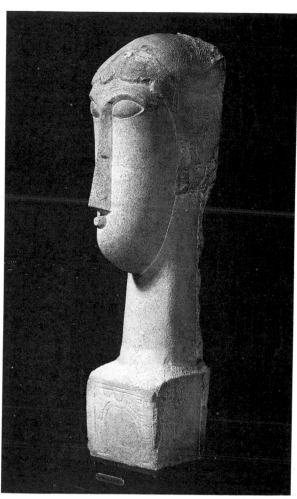

113 *Head of a Woman*, 1911, stone, courtesy of Perls Galleries, New York

114 *Stone Head*, c.1911, stone, Philadelphia Museum of Art, Pennsylvania

Modigliani, finish was the thing, polish, and the creation of discrete objects, wholly divorced from the hand of the maker. For both, the secret lay in the difference between modelling and carving. Carving frees the essential image from the stone (takes it out of its environment, the way, later, Modigliani's nudes were to seem removed from theirs), while modelling keeps the image in constant (caressed) contact with the hand and emotions of the sculptor.

Since in modelling the artist has not freed the figure from the rock, the resulting object, being only an extension of the artist, has no life of its own; such art (according to Modigliani and Brancusi) is dead matter which can only mimic the appearance of life. 'What good is the practice of modelling?' Brancusi asked. 'It leads to sculpturing cadavers.'[4] That Modigliani subscribed to Brancusi's views is well documented. The sculptor Jacques Lipchitz remembers a conversation of the period when Modigliani described modelling as playing with 'mud' and stated that the only hope was for artists to begin carving again, directly in stone. 'We had many heated discussions about this, for I did not for one moment believe that sculpture was sick . . . But Modigliani could not be budged; he held firmly to his deep conviction . . . When we talked of different kinds of stone — hard and soft — Modigliani said that the

137

stone itself made very little difference; the important thing was to give the carved stone the feeling of hardness . . . '[5]

From his work with Brancusi, Modigliani derived not only a definition of art as the creation of discrete objects, intended to exist outside the artist's reach, and outside the circumstances of his life, but also — something he could not take simply from Picasso and cubism — a contempt for mere resemblance. For Picasso, naturalism was simply a banal and incorrect expression of outer reality; for Brancusi, and bearing far more significance for the tubercularly doomed Modigliani, it was an aesthetic that had ('sculpturing cadavers') affinities with death.

In any case, it was as a sculptor that Modigliani first began to understand and make figures as objects outside the self, idols to be contemplated — even worshipped. During the period of sculpture, this was literally the case. Of the giant heads that Modigliani carved then, Epstein wrote, 'At night he would place candles on top of each one and the effect was that of a primitive temple. A legend of the quarter said that Modigliani, when under the influence of hashish, embraced these sculptures.'[6]

So it was with his nudes: icons to be worshipped. And yet, not quite, for the nudes differ in one important respect from the carved figures:

115 *Nude*, 1917, oil on canvas, Solomon R. Guggenheim Museum, New York

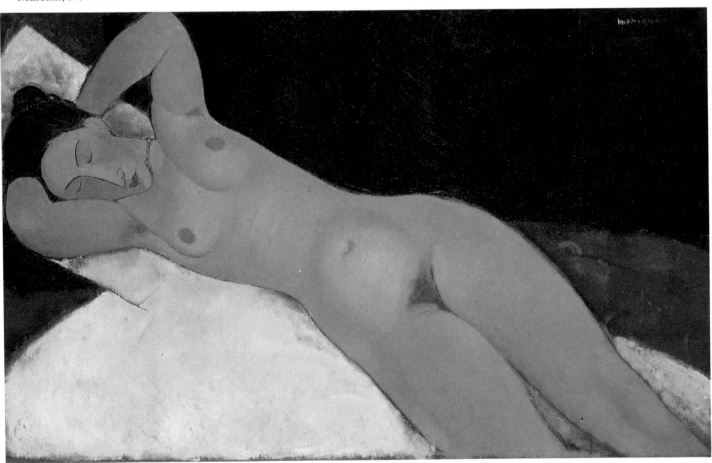

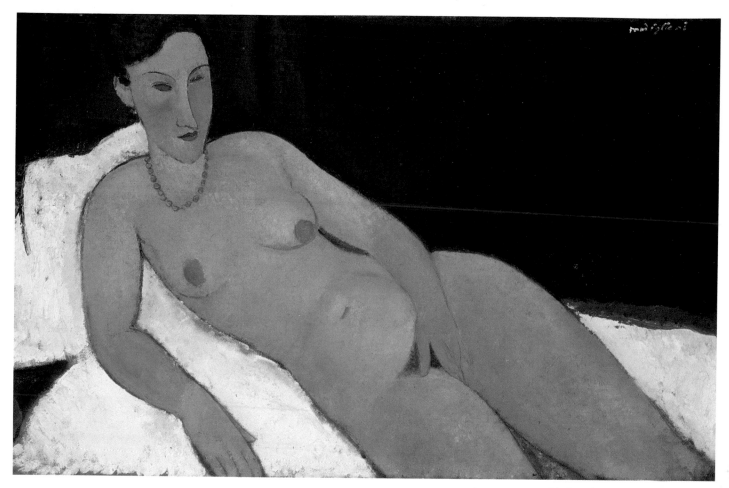

116 *Nude with Coral Necklace*, 1917, oil on canvas, Allen Memorial Art Museum, Ohio

they are overwhelmingly blatantly sensual. Like the stone idols, the nudes are beings set outside the artist's world, removed both by the absence of setting and by the distortions of Modigliani's art. Nor are they portraits. But while the stylised simplifications of the sculptures move them into the realm of things to be worshipped, in the nudes such simplifications read as a kind of crudeness, primitive, emphatically (as though obsessively) erotic, like pin-ups on prisoners' walls.

That they were found to be obscene we know. The Paris police closed Modigliani's only one-man show in 1917, when a crowd, drawn by a nude in the window, blocked the pavement outside the Berthe Weill gallery. Investigating the complaints, a police inspector examined the work, and declared it obscene: the artist shows pubic hair. For similar reasons, a rock was thrown through a gallery window in Toulouse in 1919, and in the same year, when Modigliani's work was shown in London, the press objected to an art 'glorying in prostitution'. A benighted age, one might think. But thirty years later subscriptions were cancelled when *Life* reproduced a Modigliani nude among its pages, and more recently still the Guggenheim Museum was obliged to withdraw from its postcard counter the reproduction of a Modigliani nude that the US postal authorities refused to allow through the mail.

The Modigliani nudes *are* disturbing, despite the apparent straight-

forwardness, the sweet simplicity of presentation, and the Paris police inspector had a point: there is something about the hair that isn't right, or the teeth, or the posture. A Modigliani nude is not a million miles from the porno cliché: the kittenish pose with lascivious intent, and similarly jarring thanks to the characteristic emphasis of incongruous detail: some sharp sign of the real (the hair, for example), brought like a trophy from another world and set on a form stylised to a point of abstraction. Such juxtapositions work in Modigliani's nudes as disruptively as the moustache on Duchamp's Mona Lisa. Except that the moustaches in Modigliani's art are all sexual, and the art itself absolutely unfrivolous.

The characteristic of a Modigliani nude is to hold a tension between the abstract and the real. The abstract qualities of his nudes, which tell us that they are not of this world, include non-naturalistic colouring, distortions and simplifications of form, vagueness of setting: Modigliani's nudes are neither integrated with their settings — as are those of Bonnard, say, where the nude lies emphatically *in* her bath, or of Matisse, where she exists in an ornately decorated room, part of the decoration of the room — nor, like some cubist subjects, are they invaded and dismembered by their surroundings. Some of the nudes, sitting, have no chairs to support them; some, standing, have no feet to ground them. At times they exist at a double remove from the viewer, as though they were paintings not of women, but of images of women.

And then, suddenly, on these unreal beings, the most specific and sexually evocative detail: armpit hair, pubic hair, teeth, and, typically, along the horizontal profile, interrupting the sweet abstract line, an unambiguously erect, naturalistically coloured nipple: invasions of the real and notably tactile detail into the emotionally detached and formally pure image. The disturbing qualities of Modigliani's nudes derive, I think, from this: that they work on two levels at once, or rather, not at once, but with a sudden interruption as the intellectual contemplation is violated, broken into by fragments from the realm of the senses, the fragments isolated inside the image — as though in the midst of the aesthetic geometry we were suddenly offered things to be touched: a coral necklace, hair, teeth, nipple.

There are other ways that Modigliani forces the real into his spectral figures: the difficult poses, for example, contorted hips and twists of torso, poses that cannot be maintained by the model without strain (and therefore introduce the element of time and endurance into apparently timeless images). The poses are both ideally and actually erotic, combining (in the pin-up format) what is desired with what has been experienced, as though the images had been abstracted like stills from a flow of sexual movements.

In other pictures, Modigliani manipulates the proximity of the viewer so that he is unnaturally near (with *Nude on a Cushion*, 1917–18, and *Nude Resting*, 1918, he is not only close but on his knees) and, no matter where he stands *vis-à-vis* the canvas, forced in upon the image, too close for contemplative ease. Modigliani's trick is to unbalance,

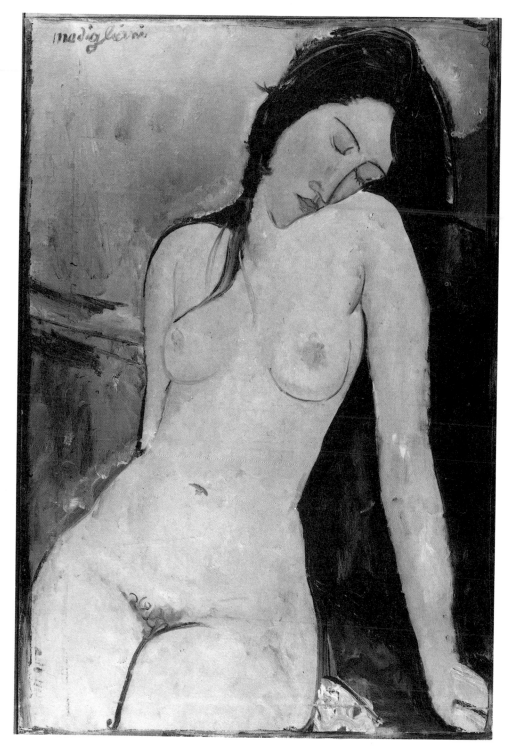

117 *Seated Nude*, *c.*1912, oil on canvas, Courtauld Institute Galleries, London

118 (overleaf) *Seated Nude*, 1917, oil on canvas, Koninklijk Museum, Antwerp

119 (overleaf) *Seated Nude with Blouse*, 1916–17, oil on canvas, Musée d'Art Moderne du Nord, Lille

disturb, and such paintings, whether for model or viewer, are literally uncomfortable.

But they are not 'real'. In *Seated Nude* (*c.*1912, Pl. 117) head and body do not match, a pale torso bears a dark brown face. In both *Seated Nude* (1917, Pl. 118) and *Nude on a Cushion* the features of the face are heavily drawn, the features of the body only lightly sketched. Though the

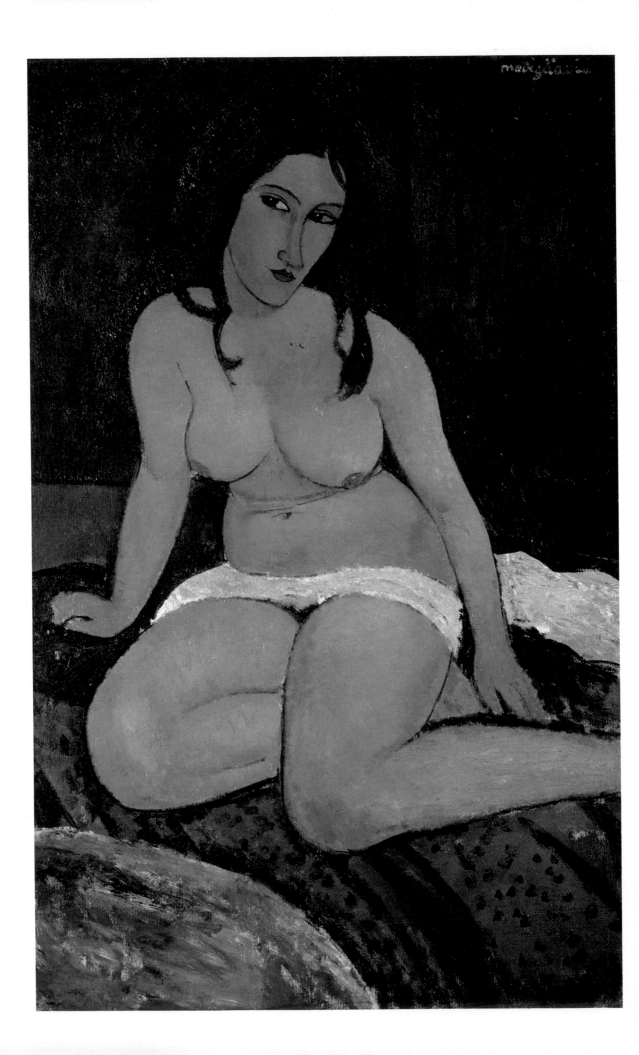

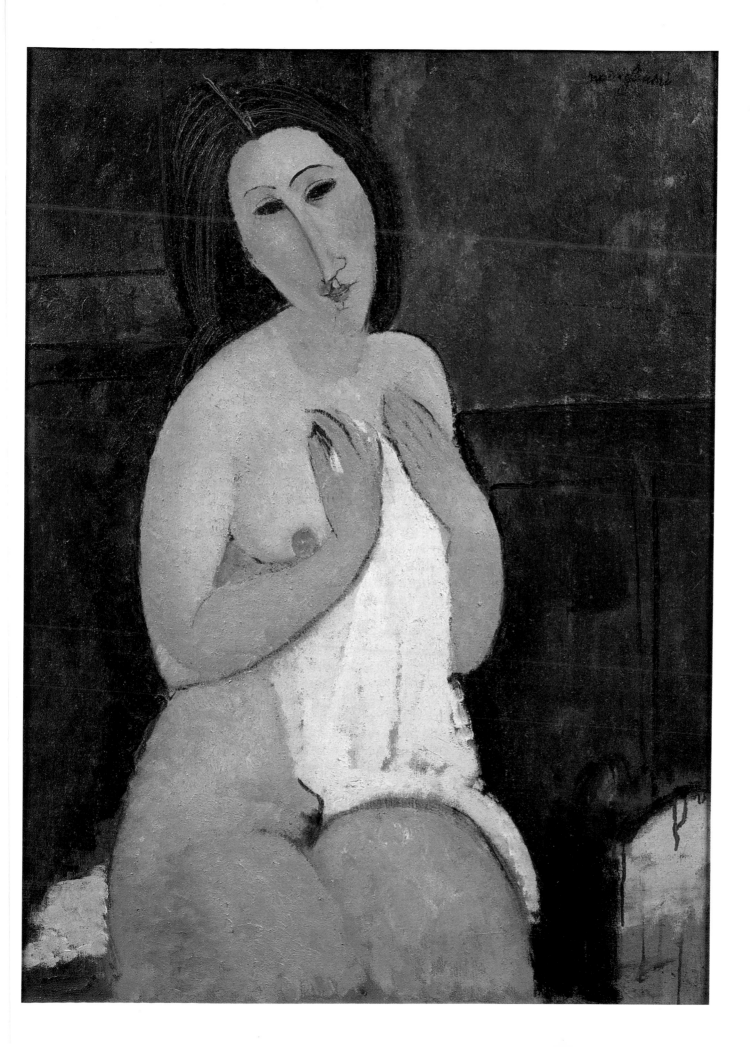

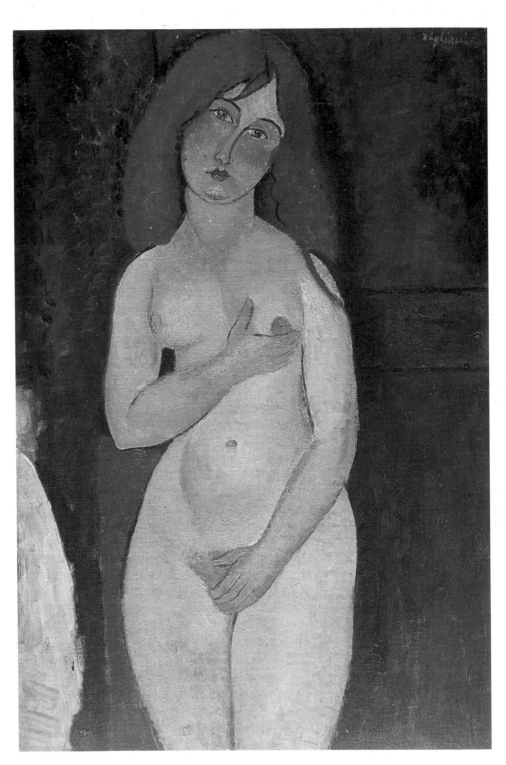

120 *Venus*, 1918, oil on canvas, courtesy of Perls Galleries, New York

the artist, and consequently little of this first, darkly mooded work rings true. Later, when through drugs, alcohol and the approach of death Modigliani was truly *maudit*, his art became correspondingly pure. As his own life became darker, he infused his work with innocence, painted portraits of children and blue-eyed milkmaids and gave to even the most sensuous nudes madonna-like graces. Beatrice

Hastings, with whom Modigliani lived between 1914 and 1916, remembers that in great distinction to the erotic excesses of their actual life, Modigliani's 1916 drawing of her nude made her into 'the best type of Virgin Mary, without worldly accessories as it were'.[11]

And in contrast to his early choice of models, for the later nudes Modigliani could be brutally choosy. 'On one occasion, a rich society girl offered to pose for him. He told her to undress, looked her up and down like a farmer buying an animal, declared briefly "trop putain" (too prostitute) and told her to get dressed and go.'[12]

Modigliani progressed in his work from an early art that recorded the world through the inherited glances of Toulouse-Lautrec, Steinlen and Baudelaire. When, through Cézanne's influence, he learned to break down appearance into structure, for Cézanne a way of penetrating reality, Modigliani found himself able, paradoxically, to free his art of the look of the world, and, more important, of the taint of the world. Eventually, he was able to work the one independently of the other, even able, through his own stylisations, to test the incorruptibility of his art. So far from using it to record a corrupt world, Modigliani developed his art to keep as much of that world as he liked at a distance,

121 *Reclining Nude*, 1918, oil on canvas, courtesy of Perls Galleries, New York

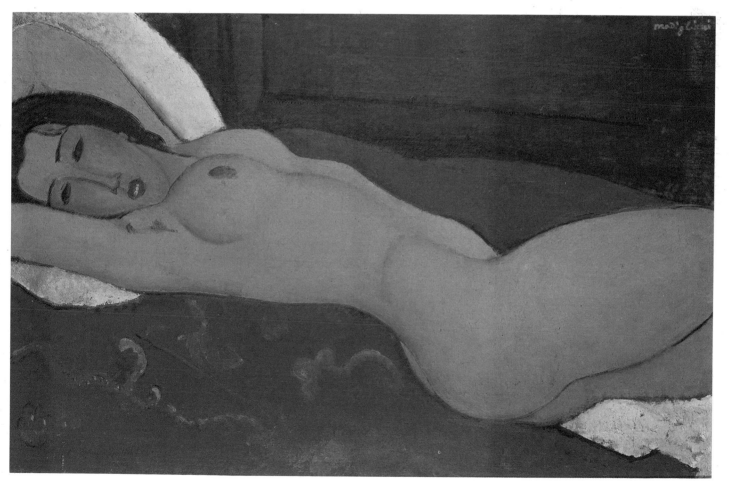

as though to protect himself and *it* from the things he preferred not to have to see. 'Dedo was to the last degree a purist,' Max Jacob wrote of him. 'His mania for purity went so far as to make him seek out Negroes, jail-birds, tramps, to record the purity of the lines of his drawings.'[13]

During his early years, and reflected in his early work, Modigliani was out of touch with himself and with others. Anna Akhmatova, with whom Modigliani had a brief affair in 1911, described him then as ' . . . enclosed in a ring of solitude. Never mentioned the name of a friend, never joked, never spoke of past loves, never mundane things . . . He saw things differently from others — Cubism remained strange to him. "I am another of Picasso's victims", he said. Everything in fashion, called fashionable, he did not notice.'[14]

For Modigliani, it was not simply a matter of not joining up, though his refusal in 1910 to sign the Futurist Manifesto when asked by Severini is interesting, because that, at least in nationalistic terms, was a possible outlet for his opposition to Picasso. He was an Italian chauvinist, but of the old school, having studied for years in Venice and Florence, and keeping Old Master reproductions on the walls of his rooms. He was, perhaps, unlikely to subscribe either to a programme of burning down museums or, more relevant here, to the futurist declaration: 'We fight . . . against the nude in painting, as nauseous and as tedious as adultery in literature . . . We demand, for ten years, the total suppression of the nude in painting.'[15]

That Modigliani did not join the cubist bandwagon is perhaps more surprising, for he truly admired Picasso; 'He is always ten years ahead of the rest of us,'[16] he once said. But his natural pride went against movements. When asked in 1913, the high point of cubist-futurist notoriety, what 'manner' he worked in, he answered, 'Modigliani! . . . when an artist has need to stick on a label, he's lost.'[17] And besides, he was always something of an outsider with the chic *gang à Picasso*, forming his close friendships with outcasts like Soutine and Utrillo, wild men and disreputes on a scale Picasso would never have condoned for himself. When Beatrice Hastings asked Picasso to introduce her to Modigliani in 1914, he said: 'Beatrice Hastings, poet. Amedeo Modigliani, drunkard.'[18] Years later Picasso confessed to having once, when canvas was scarce, painted over a Modigliani portrait, 'the one crime,' Picasso said, 'I have ever committed'.[19]

But if there was always an uneasy relationship between the two men, disdainful on Picasso's part, a mixture of admiration and jealousy on Modigliani's — his remark to Anna Akhmatova that he was one of Picasso's victims refers, I think, to his sense that the dominance of cubism made it impossible for buyers to value his work — there were also aesthetic and ideological grounds for Modigliani's independence of cubism.

The cubist experiment was an attempt to break through the conventionally accepted description of the world because the conventionality itself acted as a veil over 'reality', hiding what actually is

behind what is already known, that is, presumed to be known. In experimenting with three-dimensional forms, Picasso and Braque not only intended to present objects in a new and hence more visible manner, they also implied their belief that things and persons *could* be known, and not only by surface appearance, but through and through. The world for the cubists is unmysterious, finite and measurable; it can be tipped on its side, seen from 360 degrees at once, X-rayed, broken up and weighed. It is the materialist view of the world, *par excellence*.

Modigliani was not a materialist, neither politically nor aesthetically. In 1917, just after the Russian Revolution, he attacked the optimism of his socialist friends, and to Léger — a denouncement as much of Léger's cubism as his politics — declared, 'You want to organise the world. But the world can't be measured with a ruler.'[20]

There is little of the 'world' in Modigliani's art. He painted no still-lifes, certainly none of the guitar-and-bottle compositions of the day, and only three landscapes. His subjects are people, real and, connected with these, imaginary. Where they come from, how they live, never interests him. A contemporary of Modigliani's remembers a dispute between 'Modi' and Diego Rivera: 'Modi insisted that only people mattered in painting; Rivera, just as insistently, that landscape and nature were important. Modi regarded these as meaningless background. "Landscape!" he shouted. "My God, don't make me laugh. Landscape simply does not exist!"'

It was an epistemological, not simply aesthetic, discussion, with a fine audience in Picasso, effectively described by the witness as in ' . . . the attitude of a gentleman waiting for a train, his beret jammed down on his head to his shoulder, resting on his stick as if he were a fisherman patiently waiting for a bite'.[21]

As the description implies, Picasso is all-seeing, all-knowing (even Modigliani's drawing of Picasso includes the tribute 'SAVOIR'); Modigliani is not all-knowing. He is not interested in such 'knowledge' of the world; it is not 'really' important.

Modigliani did, of course, take some things from cubism, a style of inscription on drawings, the use of abstract shapes to break the picture plane, but what he took came from cubism's later, synthetic phase, when the forms discovered in the first, analytic period were separated from their descriptive-investigative function and used in their own right, playfully, for the visual pleasure of abstractions.

As a positivist aesthetic, cubism remained antithetical to Modigliani. Three-dimensionality to him meant something very different. On his drawings are a variety of inscriptions, some his own, some from Dante, some from Nostradamus and the Talmud. On one he writes:

3 designs
3 worlds
three dimensions.

And on another: 'What is true — is equally true in three worlds.'[22]

122 (overleaf) *Reclining Nude*, 1917, oil on canvas, Staatsgalerie, Stuttgart

149

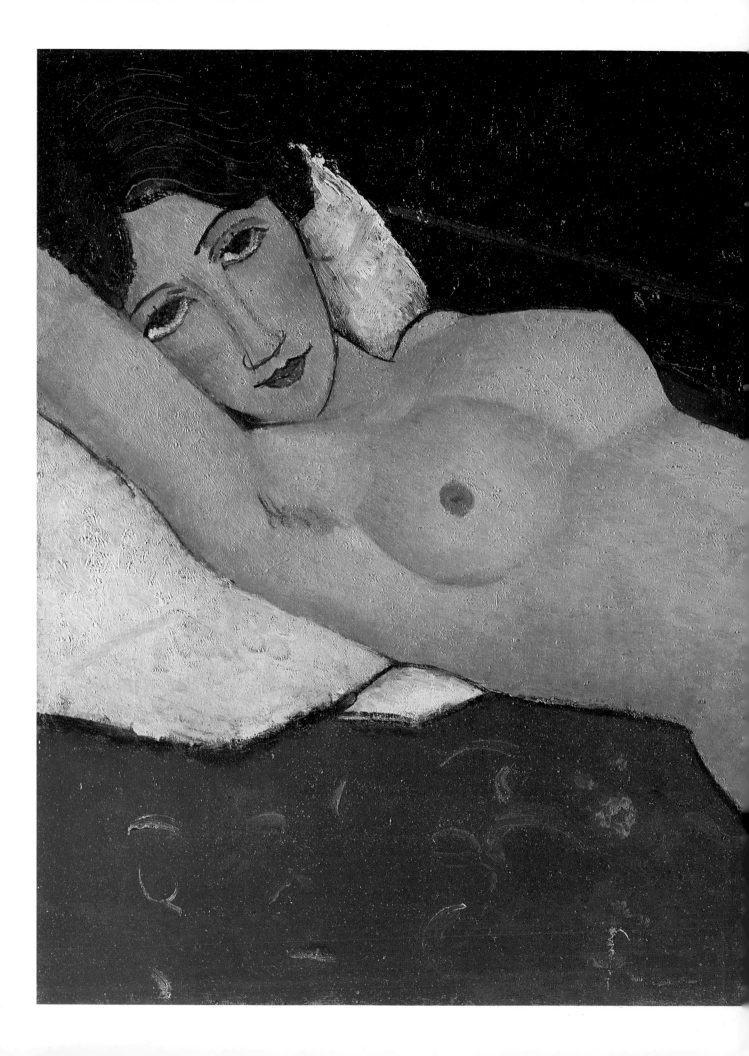

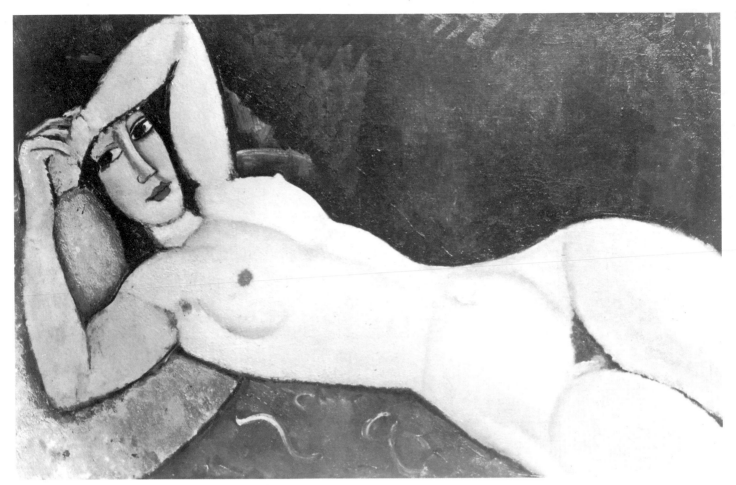

123 *Reclining Nude, One Arm Across her Forehead*, 1917, oil on canvas, Collection of Mr Richard Zeisler, New York

Modigliani's love of esotericism, his claims to be a medium, his belief in ecstatic experiences, his use of hashish and absinthe to induce truer 'realities', all run counter to the optimistic materialism of cubism. 'Life is a gift,' he wrote on one of his drawings, 'from the few to the many; from those who Know and Have, to those who do not Know and do not Have.'[23] The voguish free-for-all of cubism was silly, and possibly even irreverent.

For Modigliani, the world of appearances was a distraction, getting in the way of more important things. One of these was people, but even in his portraits he is only mildly interested in appearances. The café drawings which he made daily during different periods of his life, which provided him with quick cash, drink, and contact during periods of poverty or isolation, are, whether the subjects are friends or strangers, rapid simplifications, almost caricatures. Features are distorted or ignored, yet the character of the sitter is manifest — or rather the character the sitter wears like a costume and presents to the world: his self-regard, modesty, dandyism, his sense of himself and his position in society. The aspects Modigliani emphasises in his portraits are those his sitters display to him; the manner by which they signal, whether welcoming, unwelcoming, at home or alienated. Modigliani used the café drawings and the finished portraits as a contact between himself

and others, but he also used the sessions to describe the way in which others contacted him. Later, when he painted the nudes, the element of expressiveness is similarly pronounced, the features emphasised are those that elicit contact. There, as much as in the portraits, Modigliani's art is about communication: the journey of the inner world to the outer.

Ilya Ehrenburg, who knew Modigliani in 1917, and knew his friends, described the portraits in his memoirs:

> He was never distracted by any trappings or anything external; his canvases reveal the nature of the person. Diego Rivera, for instance, is large and heavy, almost savage; Soutine retains his tragic expression of incomprehension, the constant yearning for suicide. But what is extraordinary is that Modigliani's models resemble each other; it is not a matter of an assumed style or some superficial trick of painting, but of the artist's view of the world . . . An old man, a model, somebody with a moustache; all are like hurt children, albeit some of these children have beards or grey hair. I believe that the world seemed to Modigliani like an enormous kindergarten run by very unkind adults.[24]

124 *Two Women in a Café*, 1906–9, watercolour, Museum of Fine Arts, Boston

What Ehrenburg describes as the imposition of Modigliani's own view of the world on to his portraits and his use of the painting to make sympathetic contact between himself and others, is even more true of the nudes, where the limitations of portraiture, even such limitations as Modigliani's portraiture accepts, do not apply. But the act of painting others, and connecting by that process with the other (unknowable except as the other chooses to be known, to project himself), was an important stage in the process that culminates in the late paintings of the nude. Disbelieving in simple appearance as a source of knowledge (if other people don't significantly exist, as they largely did not for the isolated Modigliani, then recognisability has no function), and needing to make therefore a sympathetic effort to 'know', Modigliani came closer to the point where he would use his art to entirely imagine another human being, and, further, to imagine another human being that would respond to and connect with him.

Modigliani was not part of the dominant world of the cubists, neither socially nor philosophically; nor was he really part of anyone's world ('a child of the stars,' his dealer wrote after his death, 'for whom reality did not exist'[25]), thanks to the effects of hashish and alcohol as much as personality. And though his art documents a wide circle of acquaintances, he was intimate with few of them. He was rough and changeable with friends, he used his women in the old-fashioned Italian way, and he suffered intense isolation. His street-life and his party-going were frantic and, as his own death became more real to him, desperate activities. He was not at home in the world, and the subjects of the portraits, like the nudes, shared his alienation. Like Modigliani, too, most portrait subjects have (when the artist decides to bestow the poetic gifts upon them) access to two realities, with one eye closed

153

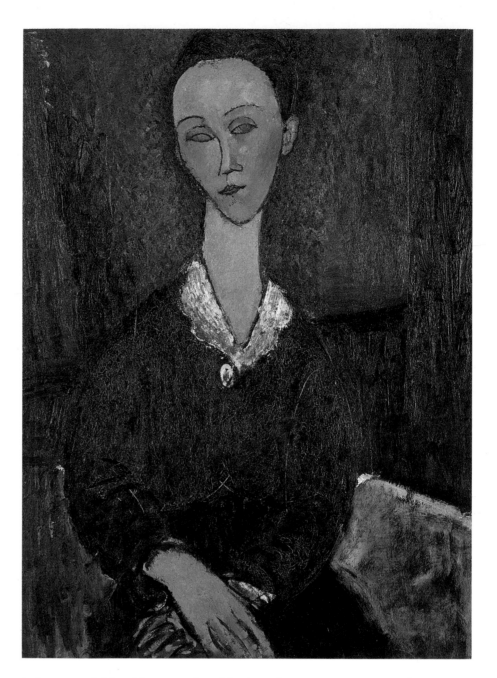

125 *Portrait of Lunia Czechowska,*
1916, oil on canvas, Musée de
Peinture, Grenoble

(often overlaid with cross-hatching) and one eye open ('with one eye
you look outside, with the other you look inside,'[26] he wrote on one of
the drawings). Thus the subjects of the portraits are given something of
the artist's situation, or perhaps, simply, the artist's intuition about the
human condition. Later, in the nudes, he was to find a better vessel for
his feelings about himself and the world and the possibility of
connecting inside it. He was quite explicit about this; he wrote, 'I will
forge a cup and this cup will be the receptacle of my Passion.'[27]

There are certain indications that Modigliani's distortions of his
sitters' appearance related to his use of drugs and alcohol. The sculptor
Epstein says that when he knew him around 1912, Modigliani believed

that 'hashish would lend him help in his work . . . Certainly the use of it affected his vision, so that he actually saw his models as he drew them';[28] and Charles Beadle 'once flippantly observed to Modi, and meant it flippantly, that he got his "swan neck" inspiration from glimpsing a mistress through the neck of an absinthe bottle — empty of course, as the absinthe would be inside him!'[29] But if this was a joke, it was one to which Modigliani occasionally contributed. When working on a painting, he 'invariably demanded a bottle of brandy . . . That was his medium he insisted with a laugh that ended in a coughing fit . . . '[30]

By 1912, Modigliani was dependent on alcohol (and often hashish) as a stimulant for his art. In 1913–14, the dealer Chéron had, in order to get regular work from the artist, to lock him in his basement, provide him with paint, brushes, model (usually Chéron's maid) and a bottle of *marc*. In the open-air drawings the dependence was the same. The sculptor Chana Orloff remembers watching him at a café around 1916:

It seemed to me that in Modigliani the subconscious had taken the place of the conscious. To work well he had to have two or three glasses of wine. After the first it didn't work; after the second things

126 *Nude on a Blue Cushion*, 1917, oil on canvas, National Gallery of Art, Washington

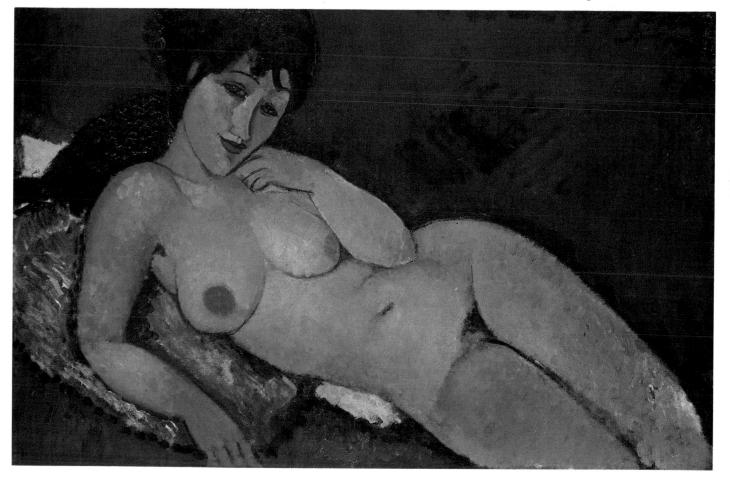

were a little better; after the third his hand worked on its own . . . He threw away sketches when he was sober. He drew with incredible facility when he was intoxicated.[31]

And this was not simply because Modigliani was by then a drunkard who could not work without his fix. It was rather an aesthetic choice, stemming from Modigliani's belief that his art needed unimpeded connection with the unconscious. Even before his arrival in Paris, when he was still abstemious, bourgeois, correct, hopeful of painting romantically decadent life, he counselled such artistic manipulations with the Nietzschean declaration:

> We have rights denied to others because our needs are different and place us — this we must say and believe — above their moral code . . . Your real duty is to save your dream . . . You must hold sacred all that might exalt and excite your intelligence. Try to provide and multiply all such stimuli, because these alone can drive our brain to its utmost creative power . . . [32]

Later, as the bizarre elements around him came to seem less important to his art, he freed his imagination to work its unique visions on ordinary subjects.[33] One such sitter was Lunia Czechowska, who in late 1916 or early 1917 sat for the first of several portraits by Modigliani. Later she wrote:

> I can see him still in shirtsleeves, his hair all ruffled, trying to fix my features on the canvas. From time to time he extended his hand towards a bottle of cheap raw brandy (*vieux marc*). I could see the alcohol taking effect: he was so excited he was talking to me in Italian. He painted with such violence that the painting fell over on his head as he leaned forward to see me better. I was terrified. Ashamed of having frightened me, he looked at me sweetly and began to sing Italian songs to make me forget the incident.[34]

And the portrait? Lunia as Sienese madonna, utterly still, hands folded on lap in the Tuscan manner, a long, impossibly elegant neck, on which rests a tilted head, wistful, the blue eyes blank, poetically unseeing. (See Pl. 125.) It is the critical paradox of Modigliani's art that no matter how wild his ecstasies while painting, nor how violent and passionate his life, he made the images arise calm and eternal.

It was not in order to alter the appearance of the outside world that Modigliani resorted to drugs and alcohol, but to unblock himself to connect with it. 'There is but one aim in all things,' his mentor Brancusi said, 'to get there one must get out of oneself.'[35] The distortions of Modigliani's art express not a mannerist sensibility, but a yearning to get out of what was increasingly a terrible mortal limitation. Making the connection between longing and elongation, Modigliani's swan necks and lengthened bodies express the artist's own desire to escape the laws of gravity and human time.

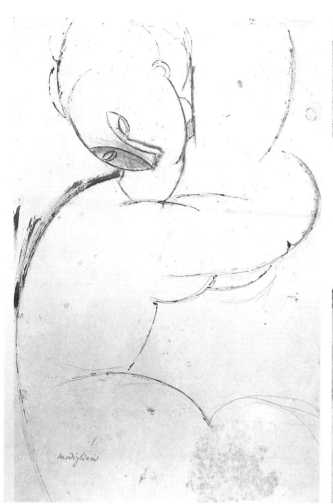

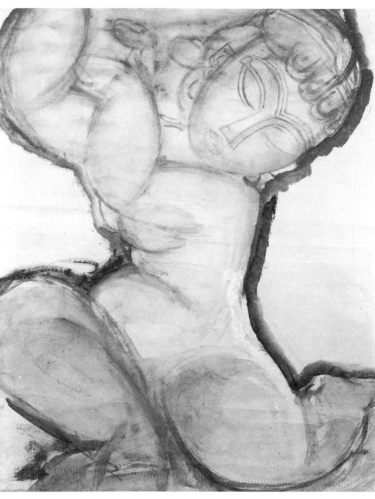

127 *Caryatid*, c.1913, ink, pencil and pastel, McNay Art Institute, San Antonio

128 *Rose Caryatid with Blue Border*, c.1913, watercolour, courtesy of Perls Galleries, New York

The group of drawings of caryatids, and the sculpture that relates to it (from the period 1909–1914, when Modigliani worked primarily as a sculptor) may seem, since these are imaginative studies of naked women, more relevant to the late nudes than the portrait sketches and finished paintings we have been discussing. The twenty-six drawings of caryatids are also among the most formally advanced and beautiful of Modigliani's works; and had only these survived, his art would be securely valued as a triumphant expression of the modernist spirit. The caryatid sculpture for which the drawings are preparatory studies survives only in one example, now at the Museum of Modern Art in New York. The piece was intended for an architectural setting, a temple, Modigliani said, for the glory of man, not God. The female figures were meant to be 'colonnes de tendresse'. The other caryatid carvings were either never completed or simply have not survived (a group of sculpture was lost in 1912 when thrown, at the advice of friends, into the river at Livorno when Modigliani was there and working with Carrara marble).

Until the First World War, when the shortage of material (together with his own poor health) forced him to abandon sculpture altogether,

157

Modigliani bought or stole his stones from local masons. (He also took, on one occasion, a wooden tie from the track of the Paris métro.) According to his stated intent, and evident in the surviving sculptures, Modigliani wanted to preserve the shape of the stone (and wooden tie) in his carving.*

The single surviving standing figure preserves the pillar shape. The parts are not discrete, but form a staggered solid bar, its length emphasised by the figure's long stripe of nose and the line that divides the legs. The breasts are shallow cups, matched in shape by the larger circle of belly and echoed on the right leg by the disc of kneecap. In the drawings of the standing figures, the unarticulated pillar shape is even more pronounced. Like the heads, the standing figures have an other-worldly feel, static and calm.

The caryatids, on the other hand, are very unstatic. Crouching under some weight, or pushing upwards against it, they are images of energy, sprung, or contorted and about to spring. Unlike the drawings of the standing figures, those of the caryatids are locked into the page, encompassing the space and struggling with it, twisting and contorting against the weight they bear. Similarly, the one surviving caryatid sculpture fills its stone space. Gone is the mass/surface discrepancy of the heads, where the etched characterisations sit lightly on the surface of the stone. The caryatid informs the whole stone; there is no part of the material that is not activated by the energy of the crouched figure.

The caryatids seem to me less studies of women than visual metaphors for the creative process. This may be another reason why these drawings seem, more than most of Modigliani's work, in touch with a modernist spirit, being about effort and process and, like much twentieth-century art, suggesting the creation of art itself.

The drawings, whether pillar-shaped or crouching, are also suggest-ively phallic. The standing figures are female, I think, only because male genitalia would interfere with the formal demands of the column (the Hollywood Oscar's coy bump would not have appealed to Modigliani). Such indications of femininity as are present are greatly reduced to signs: a bikini-like triangle, geometric breasts. At best the drawings are androgynous, or female in the way that all proper Italian abstractions are. But in the crouching figures the manipulations are greater: knees are bent, arms are raised and curved at the elbow so that

* In the twenty or so stone heads that still exist, the material seems curiously over-preserved, as if the artist were afraid of hurting the image. The lines are superficially drawn, the features in delicate relief, often wholly outbalanced by the mass of stone, as though the stone were a large canvas the artist cannot or will not fill, and as though the artist cannot penetrate the image more than this. The features themselves are simple signs merely, inspired by the African masks or Khmer temple sculptures Modigliani admired, long razor noses, tiny geometric mouths, almond eyes. These stone heads are the gods of Modigliani's temple, lightly drawn upon by a reverent artist, fearful of chipping away too much power. For the heads, Modigliani served as simple midwife for the images inside the stone.

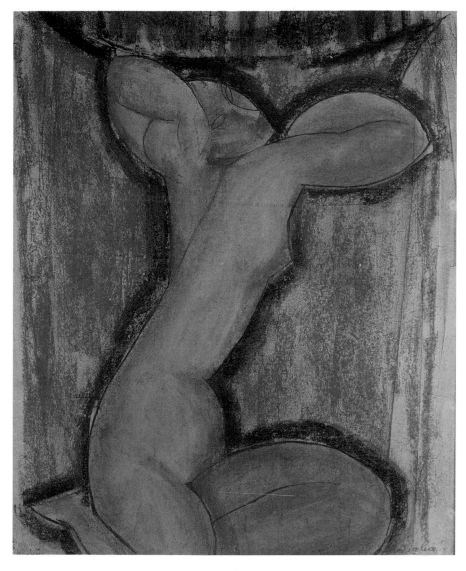

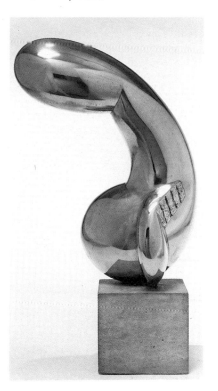

129 *Caryatid*, c. 1913–14, pastel and watercolour, Musée d'Art Moderne de la Ville de Paris

130 BRANCUSI, *Princess X*, 1916, bronze, Philadelphia Museum of Art, Pennsylvania

the figures may be bunched at hips and leg, rising smoothly with torso and bent arms to form a longish bulbed tube which grows from a cluster. That Modigliani may have seen the female form in the guise of his own genitalia will seem far-fetched until one compares Brancusi's notorious *Princesse X* of 1916 with one of Modigliani's caryatids, the silhouette of which is startlingly similar. (See Pls 130, 129.)

And what else is a 'colonne de tendresse'? Woman as creative principle is an old concept, but phallus as engendering one will serve just as well. I do not mean to suggest that Modigliani's caryatids are explicit puns in the way Brancusi's 'portrait' is. Nor are the phallic properties of the caryatids consistent. In some drawings the bent figure holds the pillar, and in one the double arcs of breasts as the figure clutches the phallic shape read ambiguously as the lower part of the genitals (see Pl. 127). But in all cases the drawings are sexual, and the sex, I think, is the artist's own. It may be worth saying, too, that the period of caryatid sculpture and drawing coincided with a time of

159

intense exhibitionism when, according to several accounts, Modigliani would at the drop of a hat unwind himself from his thirteen-foot red cummerbund, strip off, and, no matter whether at a party or on the street, perform his ecstatic and self-adoring dance.

If the standing figures and burdened, crouching maidens are narcissistic projections of Modigliani's self and artistic aspirations on to the female form, then they are very different in spirit from the externalised, worshippable (and worshipping) images of the late nudes. The important nudes were all painted during the last three years of Modigliani's life, between 1917 and January 1920, when he died of tubercular meningitis at the age of thirty-five. It was a period when, except for a few important sales during the last months, no one was interested in his work. He was acutely aware that the international stature and financial security attained by most of his companions of the 'heroic age' of modern art were not going to be his, certainly nothing like the wealth and renown now accorded Picasso and Matisse. He had worked hard since his arrival in Paris in 1906, yet by 1917 he was still existing through money from the café portraits, his dealer Zborowski's generous but inadequate patronage, and funds that his mother continued to send him from Livorno, most of which he quickly spent on drink. In 1917 he met and began to live with a young art student, who was to have his child in November 1918. Though the relationship was very different from his stormy 1914–16 affair with Beatrice Hastings, there were certain similarities: Modigliani out all night drinking, ranting; Jeanne Hébuterne at the police station the morning after, collecting. Unlike Beatrice, who was a journalist and something of Modigliani's match in intellect and temperament, Jeanne was an innocent, a virgin when he met her, from a difficult, petit-bourgeois family. She was also, to some degree, his ideal madonna — pure, passive and mysterious. A contemporary described her as ' . . . strange . . . [with] a queer, almost mystic expression in her brooding eyes . . . She talked little and never smiled . . . her lack of gaiety and her silence were the result of her life with her unsympathetic, narrow, bourgeois family . . . [She was] driven inwards, repressed to the point of perpetual melancholy.'[36]

It may be said that Modigliani found in Jeanne the woman he had always painted in portraits of others. There were even those who thought she looked like a Modigliani, with her extraordinarily long neck and almond eyes. But there was to be some cost to Modigliani in actually living with this child-bride invention of his:

It has been said that [Modigliani] was violent to her, even in public and despite the fact that she was pregnant most of the time; yet she never reacted, never protested, but according to Paulette Jourdain, would sulk like a child for hours and she would often ask Paulette — who was fourteen at the time, but often felt more mature than her — to take her hand as if to still her ever-recurring fears. Her child-like

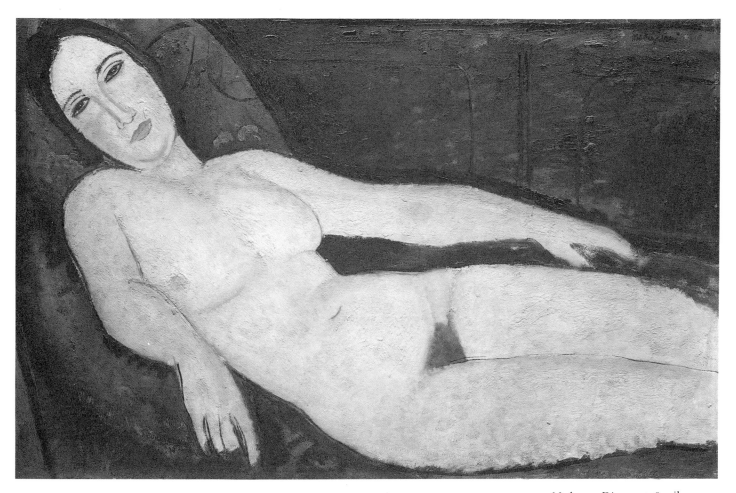

131 *Nude on a Divan*, 1918, oil on canvas, National Gallery of Art, Washington

conduct extended into irresponsibility; not only did she not take any interest in her daughter — of the two, Modigliani was far more of a parent — but also when he was dying, she never once thought of calling in a doctor but watched his agony, as desperately helpless as he was. Jeanne seemed to have reached such mental numbness that even the most elementary reactions were stunted . . .[37]

— a cautionary tale for those who have stood before the canvas and dreamed of life with a Modigliani dream woman.

There was another companion, who may have seemed more real to Modigliani in the last years than this spectral wife. Friends heard him speak of his own death on morbid jaunts to cemeteries and late at night. They may have thought it simply another of his *fin de siècle* poses. When Nina Hamnett saw him for the last time during the First World War he was still playing with an apparently strictly literary sense of himself as *maudit*:

The bed was unmade and had a copy of *Les Liaisons dangereuses* and *Les Chants de Maldoror* upon it. Modigliani said that this book was the one that had ruined or made his life. Attached to the end of the bed was an enormous spider. He explained that he could not

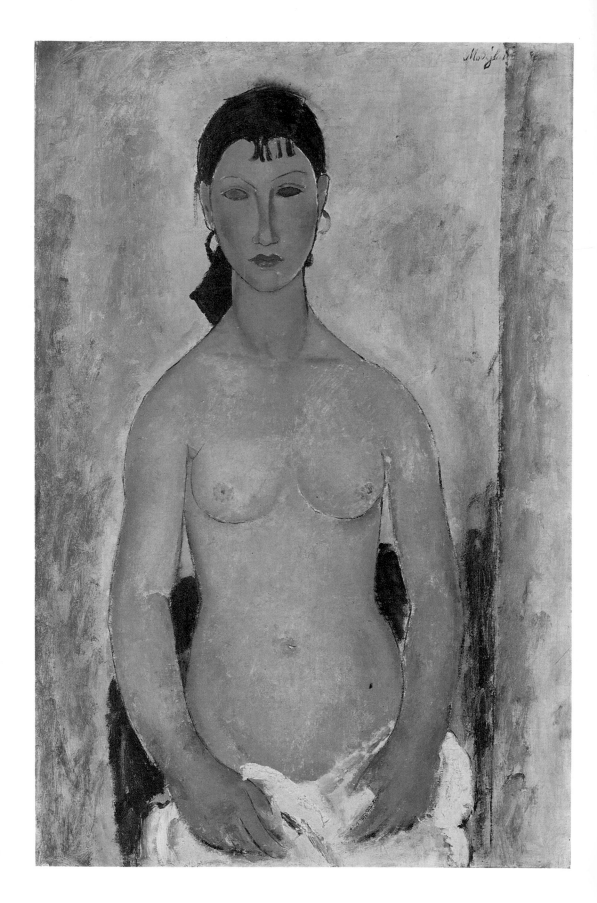

132 *Standing Nude
(Elvira)*, 1918, oil on
canvas, Kunstmuseum,
Bern

make the bed as he had grown very much attached to the spider and was afraid of disturbing it.[38]

Until the very last months, when he began to spit blood ('I always aim at the light,' he said), to lose his teeth and, according to certain ex-lovers, his looks, Modigliani remained the god-like figure he had always seemed, the self-punishing but indestructible 'Prince of Mont-parnasse'. Though he was not yet the tragic hero that the circumstances of his death and Jeanne's subsequent suicide would make him, he was aware of his own doom. 'My fairest mistress / Is laziness,' he wrote in a poem, 'In the hallway / There's a man bearing me a deadly grudge [qui m'en veut à mort]'.[39]

Laziness, or rather having time to spare, would have seemed fair to Modigliani in the last years, when he was working under great pressure and with noticeable intensity. Foujita, with whom his friend and dealer Zborowski took him on a work holiday in Nice in 1918 (when his consumption was already raging), remembers him painting in an 'orgiastic' manner: '. . . he went through all sorts of gesticulations . . . his shoulders heaved. He panted. He made grimaces and cried out. You couldn't come near.'[40]

Modigliani had always painted in short, intense sessions, but the

133 *Reclining Nude*, c. 1919, oil on canvas, Museum of Modern Art, New York

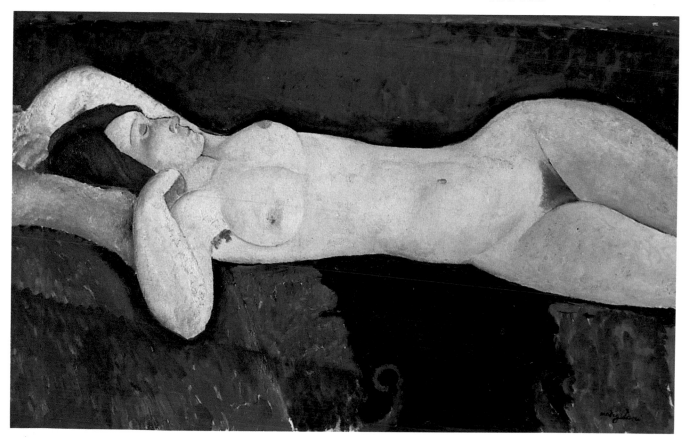

urgency of the last work was something different, and prompted most likely by a sense of his own suddenly finite time. Perhaps this is why the figures in Modigliani's late nude paintings are also so solid, sculpturally so, their forms carved out of the darkness, their gaze straight, as though their determined presence could compensate for the increasing doubtfulness of his own.

Though he did many portraits of Jeanne in the last years, he never painted her naked. This may not simply have been because he regarded his wife as too pure to be the subject of a nude painting (when his friend Kisling asked his permission to paint Beatrice Hastings in the nude, Modigliani had refused on the grounds that 'when a woman poses for a painter, she gives herself to him'[41]). If anything, Jeanne was not pure enough; she was known and loved and tainted with the real circumstances of his life with her, and could not have served the spiritual purposes of the paintings.

In contrast to the desperate public life of Modigliani — hours on the street, intense quick drawings of people in cafés, grasping at likenesses, getting *other* people down on paper, making contact with them — the painting of the nudes was a private and sacred act:

> Lunia Czechowska reports that his dealer, Leopold Zborowski, could never understand why Modi would not allow him to enter his studio when a model was posing for him in the nude: 'Modigliani detested these intrusions. For him it was violation of a sanctuary.' She even used to guard his door, to protect his privacy. One day, however, Zborowski managed to enter. Madame Czechowska notes both the girl and the dealer had to flee in a hurry from the angry artist: 'He was delivering furious blows of the brush on to the canvas; I had enormous difficulties in making him believe that Zbo had entered by chance and in convincing him not to destroy his canvas.'[42]

The model, as this story indicates, was not important, but the girl on the canvas was. It is possible that Modigliani, as self-described medium, attributed to her a rarefied nature that any disturbance by the outside world threatened to destroy.

In painting the nudes, Modigliani turned his back not only on the reality of his life with Jeanne, with his dealer and friends, on the real world with its promise of his own death, but he turned away, too, from his own experience of modernism in Paris. That is why these late paintings of Modigliani's often seem so dated, so out of touch with contemporary art experiment in France, with his own experiment in the caryatid drawings and certain of the finished portraits. By the last years, Modigliani was not interested in contemporaneity but in immortality; the nudes are not only the most naturalistic of Modigliani's art, they are also closest in tradition to an art he knew to be immortal. Behind the nudes, in specific gestures and poses, and in general fellowship, is the art of Giorgione, Titian and Goya.

I do not wish to make too much of the immortality aspect of the late

nudes. They are clearly sensual beings, earthy and, moreover, depicted as sexually responsive to the artist. Though they do not sit according to the law of gravity (*Reclining Nude, c.* 1919, Pl. 133, seems to be suspended over a chasm), and seem to emerge out of a vague darkness, and though they are never entirely drawn, what is drawn, and emphasised (as though only these parts were 'real'), are those aspects of the image that relate to (entice, beseech, are conscious of) the artist: eyes that meet the artist's own, and, besides the eyes, hips, breasts, pelvis, the parts that would be engaged (contacted) during an act of love.

Yet the pronounced and paradoxical innocence of the nudes is also bound up with their apparent sexual engagement: they aren't just anybody's; their open relationship is with the artist and, through him, the viewer. The eroticism is sanctified by its truthfulness, emphasised always by the expression and expressiveness of the eyes.

There is something obsessive in this emphasis on eyes and sex in Modigliani's nudes. As with his caricaturing portraits, these details are singled out in a manner as direct as a prisoner's scrawls. Like those scrawls, Modigliani's late nudes express urgency, contact desired, rather than the memory of contact had. Modigliani's relation to the image, like the prisoner's, is one of plea, and he projects that on to his fantasies, to imagine their contact with him. His own isolation and the nearness of his death made him helpless, created the trap from which he needed these erotic and power-endowed creatures to save him.

NOTES

1 Quoted in E. Brummer, 'Modigliani chez Renoir', in *Paris-Montparnasse*, special issue of February 1930, pp. 15–16; cited in Pierre Sichel, *Modigliani*, W. H. Allen, London, 1967, p. 413.
2 Quoted in Pierre Sichel, op. cit., p. 296.
3 Quoted ibid., p. 414.
4 Quoted ibid., p. 159.
5 Quoted in Alfred Werner, *Modigliani the Sculptor*, Arts, Inc. (a Golden Griffin book), New York, 1962, p. xxiii.
6 Ibid., p. xxii.
7 William Fifield, *Modigliani: the Biography*, Morrow, New York, 1976, p. 67.
8 André Utter, quoted in Charles Douglas [Charles Beadle and Douglas Goldring], *Artists' Quarter: Reminiscences*, Faber & Faber Ltd., London, 1941, p. 89.
9 Ibid., p. 76. And on this subject, see Jean Cocteau, *Modigliani*, Eng. trans. by F. A. McFarland, Zwemmer, London, 1950 (20pp., n.p.), second page.
10 Quoted in Pierre Sichel, op. cit., p. 182.
11 Quoted ibid., p. 281.
12 R. W. Howe, 'Modigliani', *Apollo*, vol. 60, no. 356, October 1954, p. 94.
13 Quoted in Charles Douglas, op. cit., pp. 112–13.

14 Quoted in William Fifield, op. cit., pp. 15–16.
15 'Futurist Painting: Technical Manifesto', 11 April 1910, in Herschel B. Chipp, ed., *Theories of Modern Art: a Source Book by Artists and Critics*, University of California Press, Berkeley and Los Angeles, 1968, p. 293.
16 Quoted in Alfred Werner, 'The Inward Life of Modigliani', *Arts Magazine*, vol. 35, January 1961, p. 36.
17 Quoted in Pierre Sichel, op. cit., p. 222.
18 Quoted in R. W. Howe, loc. cit., p. 92.
19 Ibid.
20 Quoted in Ilya Ehrenburg, *People and Life: Memoirs of 1891–1917*, Eng. trans. by Anna Bostock and Yvonne Kapp, MacGibbon & Kee, London, 1961, p. 194.
21 Ramón Gómez de la Serna, quoted in Pierre Sichel, op. cit., p. 370.
22 Pierre Sichel, op. cit., p. 291.
23 Quoted in Alfred Werner, 'Nudest of Nudes', *Arts Magazine*, vol. 41, no. 1, November 1966, p. 36.
24 Ilya Ehrenburg, op. cit., pp. 151–2, and cf. Jean Cocteau: 'If in the end, all his models look alike, it is in the same way as Renoir's girls. He reduced us all to his type, to the vision within him, and he usually preferred to paint faces conforming to the physiognomy he required.' (*Modigliani*, loc. cit., fifth page.)
25 Zborowski in 1920, quoted in Pierre Sichel, op. cit., p. 545.
26 On his portrait of Survage, 1919.
27 Quoted in Pierre Sichel, op. cit., p. 291.
28 Ibid., p. 200.
29 Charles Douglas, op. cit., p. 97.
30 Ibid., p. 198.
31 Quoted in Frederick S. Wright, Introduction to *Modigliani: Paintings and Drawings* (catalogue of an exhibition held at Los Angeles in 1961), Los Angeles, University of California, Committee of Fine Arts Productions, p. 20.
32 Quoted by W. S. Lieberman in his Foreword to the Los Angeles exhibition catalogue, loc. cit., p. 11.
33 However, even in later years, Modigliani kept a taste for the bizarre. Nina Hamnett writes of the artist's approach 'to a woman with an exceptionally ugly but interesting face. He said, *Madame, votre figure m'intéresse énormément: C'est la gueule la plus monstrueuse que je n'ai jamais vu mais intéressante, admirrrable* [sic] *du point de vue du dessin et je voudrais bien vous dessiner.* [Madame, your face interests me enormously: It's the most monstrous mug I've ever seen, but interesting, admirable, from a drawing point of view, and I would love to draw you.] The poor lady was very embarrassed, but later, I think, when she found out who he was, she sat for him.' (*Laughing Torso*, Constable, London, 1932, p. 60.)
34 Quoted in Pierre Sichel, op. cit., p. 328.
35 Ibid., p. 159.
36 Fritz Sandahl, quoted in Pierre Sichel, op. cit., p. 360.
37 Carol Mann, 'Amedeo Modigliani and Jeanne Hébuterne', *Connoisseur*, vol. 203, no. 818, April 1980, p. 291.
38 Nina Hamnett, op. cit., pp. 78–9.
39 Quoted in Pierre Sichel, op. cit., p. 484.
40 Ibid., p. 410.
41 Ibid., p. 298.
42 Alfred Werner, 'Nudest of Nudes', loc. cit., p. 37.

JULES PASCIN

The myth is there to tint the work, casting shadows nearly as purple as those admiring rumours and death-omens that colour the life of Modigliani. Obscure and exotic birth helped, and the constant wandering, and the famous parties mentioned in so many memoirs of Paris in the 1920s. Most of all, the subject-matter of Pascin's art lends itself to speculation about his life and its ending, as though there has to be punishment for so much pleasure — or perhaps, rather, that such pursuit as Pascin's art describes argues an implacable demon in the drive to shelter in the flesh, ever-changing, younger, newer, girl after girl until the suicide, an ending which somehow begs to be seen as consequential to so much futile escape into escapade, the inevitable conclusion to what the tongue-clucking commentaries report as moral and physical exhaustion.

It is hard to know to what extent the suicide affected recollections of the artist. Hemingway, by his own account not easily impressed, was struck by Pascin's urbanity, a lightness of manner that had little resemblance to the desperation reported by other contemporaries. For Hemingway, Pascin's gift for jest revealed a true *savoir faire*: 'They say the seeds of what we will do are in all of us, but it always seemed to me that in those that make jokes in life the seeds are covered with better soil and with a higher grade of manure.'[1]

Perhaps the agrarian imagery suggests disguise rather than fortitude. Pascin's biographer, Gaston Diehl, gives a very different picture of the artist:

> Pascin always stressed the darker side of existence . . . While Pascin was alive, those in his circle caught the fatal scent of pain, for the legend in which he draped and concealed himself was already well-established. Alas, did Pascin not create this legend himself; did he not help spread it with his nocturnal excesses?[2]

Diehl even suggests that it was the effort to maintain an appearance of merriment, rather than the pain thus disguised, that drove the artist to suicide. He describes a kind of death by running on the spot:

> Driven to the wall by his own legend, he was forced to play the role

continually, nightly making rounds of Montmartre or Montparnasse. But his body, worn out by so much excess and consumed by alcoholism, was less and less able to bear the wear and tear inflicted on it. Painful attacks would prevent him from eating and from working. To a certain Doctor Tzanck who advised moderation, he replied he could not allow his suicide to misfire.[3]

If Pascin was self-dramatising, consumed by his own legend and tragedy, nothing of this is evident in his painting. What is interesting about such descriptions of the artist is the light they may throw on the relation of man to work, the connection or apparent lack of connection between the two. Unlike the reported behaviour, Pascin's art not only reveals no urgency or theatricality, but has little evidence either of great pain or great *joie de vivre*. What is expressed is an extraordinary tolerance, for fellow creatures (Pascin's young women are often depicted with affectionate detachment, a kind of curiosity about appearance, a sense of peaceable co-existence that might be appropriate to studies of cats or cows), and seemingly for himself as well. There is little driven 'self' in the work; instead, a self which stands aside, describes without comment. Pascin's pictures have a strange passivity, rarely expressing feelings much warmer than admiration for shape and weight of limbs. This detachment may well be a mark of urbanity, but Pascin's courteous acceptance of his girls at times borders on indifference, indicates rather than passion a post-coital ennui. It is as though the placidity of the work comes not from any resolution of

134 *Character Reference*, illustration from *Simplicissimus* magazine, 3 December 1906

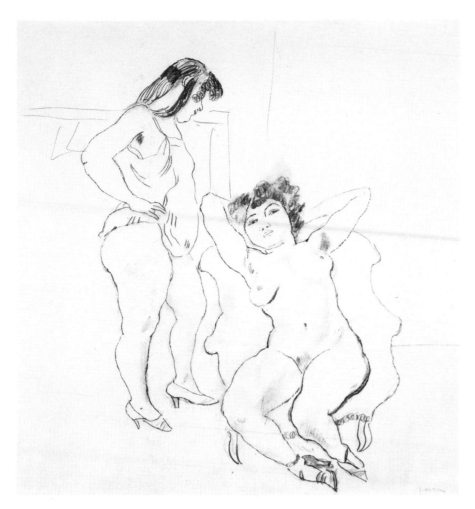

135 *Two Nudes*, 1926, pencil,
Philadelphia Museum of Art,
Pennsylvania

feeling, but from a refusal to engage with the feeling that his subjects
must inevitably arouse. These nude studies have been called lustful,
rapacious, obsessive, but the treatment of the erotic images expresses,
rather than the artist's lust, the artist's knowledge of how lust may be
provoked. The skills and relation to the images are those of a procurer
rather than a lover or epicure: sex is his merchandise, untouched by the
merchant, held in trust for the customer.

Pascin's distance from his subject may seem part of his worldliness,
an expression of appetite already sated. But there is no indication that
the artist's relation to the erotic was ever any less detached than it is in
the late work. In fact, the younger the artist, the more distant he is from
his images. His youthful drawings for *Simplicissimus*, for example, are
full of ferocious but icy rejection, cynical condescension for what he
sees (Pl. 134). The mature paintings and pastels, on the other hand (the
satirical sketches, such as *The Prodigal Son*, 1921, Pl. 136, are witty —
silly rather than horrified), are rarely other than courteous, respectful,
without falsification or idealising. There is nothing pornographic or
'complex' in the art, except the distance itself, the refusal to express
much beyond a visual, almost intellectual interest in models whom, by
all accounts, Pascin habitually took to bed.

On the evidence of the work, the artist seems never to have let the

169

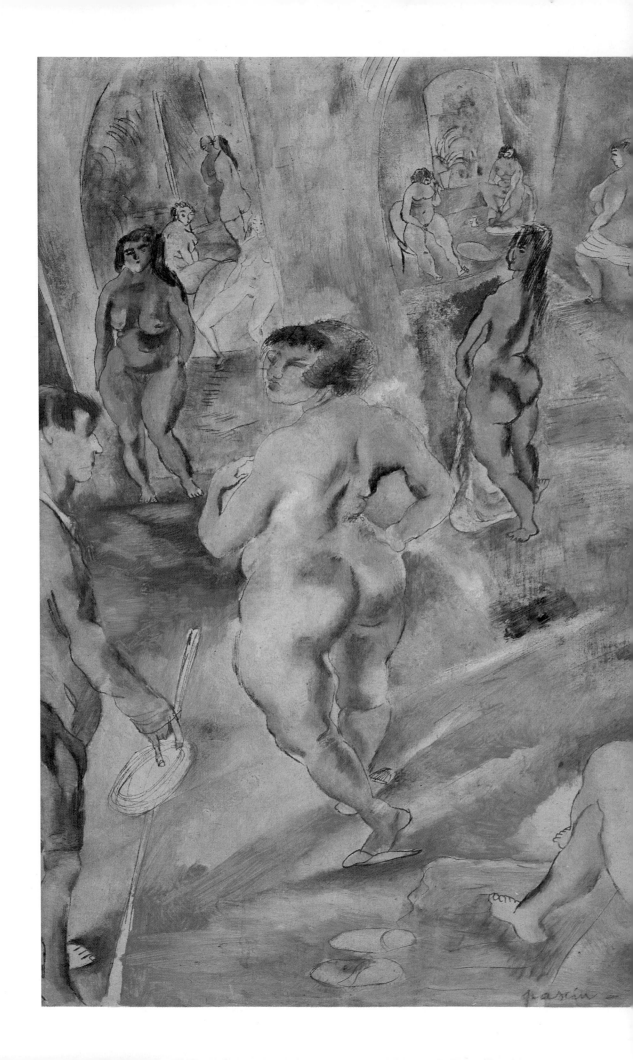

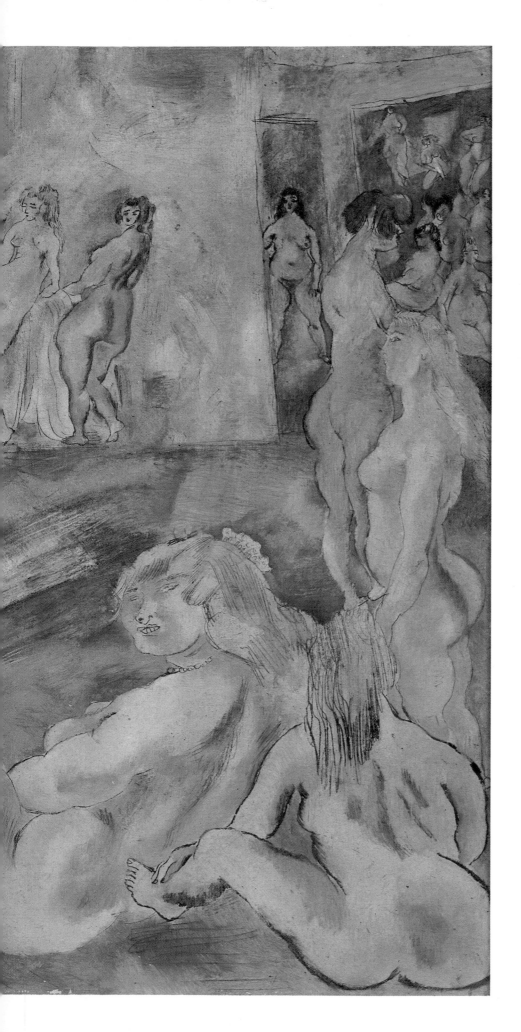

136 *The Prodigal Son*, 1921, oil on
board, Josephowitz Collection

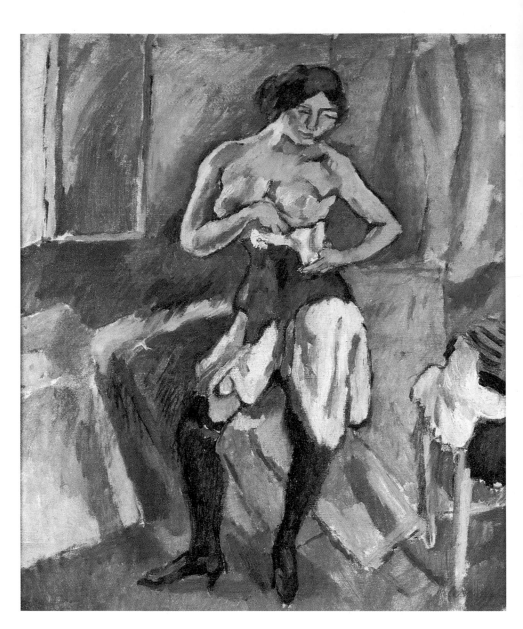

137 *Woman in a Corset*, 1909, oil on canvas, Josephowitz Collection

lives of his subjects touch his own, nor allowed his own feelings into his art. In the end, that may have been why the work could not sustain him or hold him to his life, why it stopped growing, became 'obsessive' in its repetitions of form and manner, why it failed to express more than Pascin's charm and urbanity and, finally, why it never achieved much more than its Vaseline-lensed prettiness, a fuzzy, unfocused, ambivalent connection with the real.

Pascin was born Julius Pincas in 1885, the eighth of eleven children of a Jewish merchant of the town of Vidin in Bulgaria. It seems possible that certain characteristics of his pictures of young girls (the animal familiarity, the intimacy without expressed involvement, perhaps even the non-focus on the erotic subjects: the filmy, gauzy surface of the work) have their origins in Pascin's crowded, claustrophobic and

172

138 *The Three Graces*, 1908, oil on canvas, courtesy of Perls Galleries, New York

doubtless incest-inciting and incest-prohibited childhood. In any case, Pascin remembered it in later life without affection and claimed to have escaped from it as soon as he could. His flight from the bourgeoisie took him, at a time when he was still too young to travel alone, to the house of a local madam, where he was invited to draw the occupants (further training in the art of looking without taking) and encouraged in his ambitions as an artist. The record of his formal instruction in Vienna and Munich is unclear, but by the time he was 20 (earlier by some accounts) Pascin was a salaried illustrator for the German satirical paper *Simplicissimus*. In the preferred style of the review, Pascin's work is full of sharp observations of physical and moral degeneracy, and the later tolerance is not much in evidence. But these skilful cartoons of sexual depravity, peasant and bourgeois hypocrisy, did not hold his interest or nurture his talent for very long. At the end of 1905, not yet

21, Pascin left Germany and set up as a 'real artist' in Paris.

Pascin toyed briefly with an expressionist style (as in *The Three Graces*, 1908, Pl. 138), and later there are one or two seemingly late forays into a cubist manner, as in the 1916 *Woman in a Landscape* and the 1918 *Portrait of a Woman*, but by and large his (non-humorous) painting is exceptionally uniform in style, and seems to have been executed over a twenty-year period without significant change in manner or subject.

There seems something rather terrible in the story of Pascin's career as an artist: his arrival in Paris with all his skills already developed and evident in the polished early work; his radical move from the limitations of this work to a mature manner within the first years of serious painting; and then a kind of stasis, or premature final arrival in an art which — apart from the lighter hand and more watery view of his nymphs in the late work — shows very little evidence of growth or movement.

Pascin's restlessness, his desire for sensation, escape and change, was expressed in his constant travels and household upheavals in Europe, America, North Africa; in his night-time prowls with their obsessive searches for perfect venues; in his love life, divided between (or rather

139 *Manolita*, 1929, oil on canvas, Musée d'Art Moderne de la Ville de Paris

140 *Young Woman, Standing,*
1929, oil on canvas, courtesy of
Perls Galleries, New York

multiplied by) wife and mistress and the countless affairs and one-night
stands — but *not* in the art, which, in notable contrast to the artist,
remained fixed. Beautiful though it often is, it seems never to have
provided what Pascin must have needed from it: the possibility of
development and change, a channel for expression of the whole nature
and need of the man.

The American expatriate Robert McAlmon described Pascin at his
own, notoriously wild parties as: ' . . . usually quiet, perhaps even
morbid, but he obviously liked to entertain and let people be
themselves'.[4] There is a similar live-and-let-live attitude in the mature
work, sometimes expressed by a humour that is, as Hemingway saw it,
wise and urbane (compare *The Prodigal Son* of 1921 to the *Simplicissimus*
work, for example), sometimes by a kind of animal tolerance, born of

175

familiarity with naked bodies in studio or brothel. But Pascin's good nature is too consistent to be quite believable. 'The charm of his manner,' McAlmon says later in his memoir, 'had nothing to do with the restless grief in his eyes; his urgent hospitality, so his worldliness and wit kept insisting, had no possible connection with what solitude might eventually have the power to do.'[5]

Nor does Pascin's art make the connection between manner (often pastoral, often boudoir pretty) and feeling. In the work, as in McAlmon's description of him, charm co-exists with sorrow and solitude. But there is no fusion of the two expressed as anguish or desire, no simultaneous recognition of the beautiful and its unavailability; no assertion of the fact that you can see but not *have* or that pleasure does not last, but may at best only be repeated with progressively weakening force. The art expresses knowledge of the other but not the consequence of that knowledge. It is an art about charm and appearance, surface and skin (and that characteristically fuzzily depicted). Pascin's gravity, an occasional bedroom gloom, merely colours the forms — literally, in those earth tones Pascin uses which seem so oddly contradictory to the pastoral moods in the work, yet which again and again (but not always) save it from banal sweetness (Pls 141, 142, 143). Though there is weight in Pascin's work, it is a corporeal weight, not an emotional one, expressed in plump thighs and compact, squat adolescent bodies, breasts that fall, arms and legs that rest heavily in heavy armchairs. The record is of matter and its appearance, but

141 *Two Women, Reclining*, 1928, ink and charcoal, Musée d'Art Moderne de la Ville de Paris

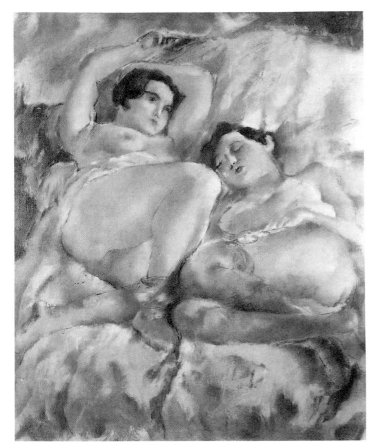

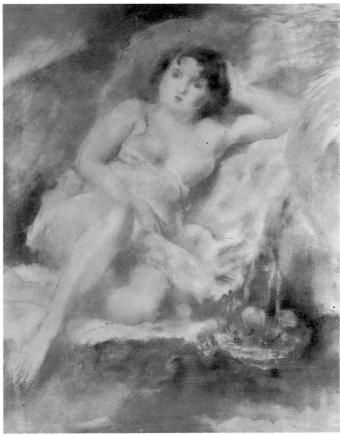

142 *Two Semi-nude Girls*, 1926, oil on canvas, courtesy of Perls Galleries, New York

143 *Alberte with a Fruit Basket*, 1928, oil on canvas, courtesy of Perls Galleries, New York

Pascin's attitude to this record, or perhaps to the 'real' itself, is at best ambivalent. The work that records naturalistically the presence of bodies is also overlaid with layers of sweetness (the pearlised or watery surfaces of the paintings), or 'brightened' by touches of prettiness: studio clichés like bouquets of flowers, parasols, brothel lamps and lingerie — cheering and pleasant 'effects' that speak more of artifice and fantasy than of art. For all its virtues, Pascin's vision seems to lack the crucial virtue of truth, to perception and to feeling, and is in the end, like the detachment of the artist, a kind of polite lie.

The curious quality of Pascin's art, which is both wistful and indifferent, all-accepting and remote, comes from the artist's refusal to take anything for himself, while yet signalling vague longing (by, for example, the gauzy effects of the surface of the work, hazy as in hazy memory, indistinct as in yearning). Because of the lack of urgency in the evocation of desire (in images of naked girls with their clothes dropped around their ankles, for example), a jadedness has been perceived, as though the pictures were memory-prompters of an old lecher. But satiety does not seem to be behind the work as much as unresolvable isolation.

The arbitrariness, lack of indication why Pascin is making *these* pictures rather than any others (the work convinces us that the models are attractive, but not that Pascin, in particular, finds them so), the

177

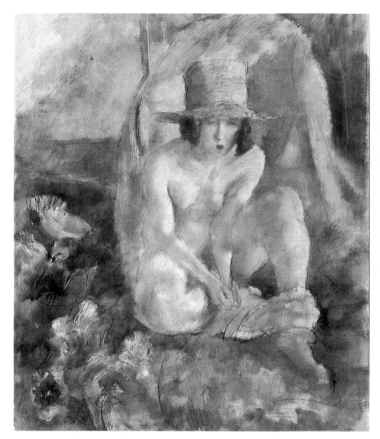

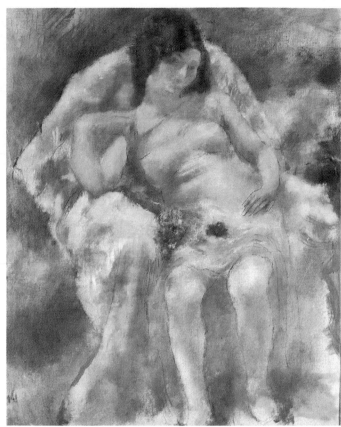

144 *Nude with Green Hat*, *c.*1925, oil on canvas, Cincinnati Art Museum, Ohio

145 *Seated Girl with Flowers*, *c.*1929, oil on canvas, Musée d'Art Moderne de la Ville de Paris

characteristic lightness of mood and apparent ease of effort (the unfinished look and swift brushwork in so much of the painting), are found also in Pascin's only other major subject apart from the portraits, the travel sketches. There is the same sense of recording a kind of passing-through, a different inability to settle, to engage with what is in front of him, to commit his art to connection with place or feeling.

Fervour, desire are for others: thus the eternal host among his noisy, dancing guests, witty, generous, immensely skilled in pleasing, separate, observant. Pascin does not participate. In the light of his suicide, it is not the erotic and obsessive subject-matter that seems significant but, on the contrary, Pascin's detachment from it.

Pascin's work in Paris never led him much beyond the talent he arrived with. As Picasso said, it is fatal for an artist to imitate himself, and perhaps for Pascin, the word 'fatal' was exact. What changes are evident in the late work are along the lines of a letting-go, almost a weakening of grip on his subject. Wistfulness increases, together with the now more pronounced blur of surface (see *Young Girl Seated*, *c.* 1929, Pl. 145) which makes a reading of the subject's features more difficult, as though from a distance either of time or space. The element of fantasy increases, as well, but it is fantasy in a trite and rather millinery sense (especially in a work like *Alberte with a Fruit Basket*, 1928, Pl. 143, with its all-too-pretty props of straw basket and fruit, its dreamy subject's pose and the vague draping of skirts, and filmy, pastel

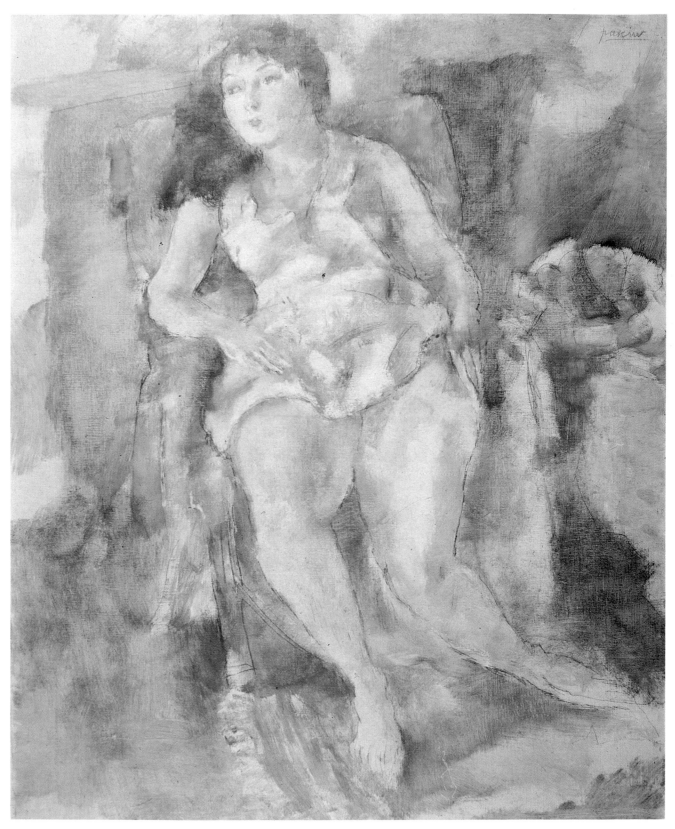

146 *Hilda*, *c.*1927, oil on canvas, Sheldon Memorial Art Gallery, University of Nebraska

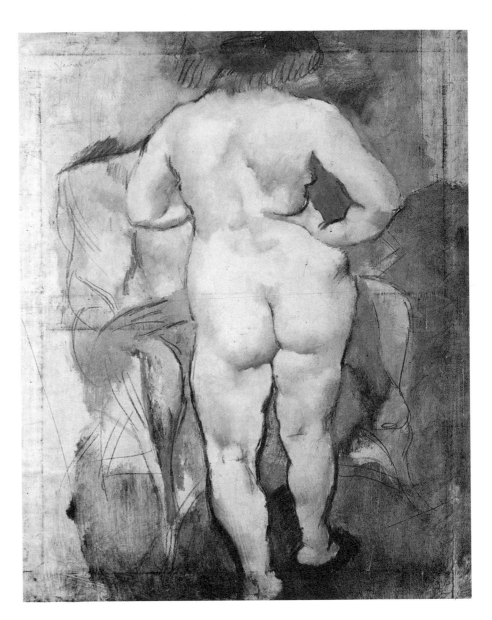

147 *Back View of Venus*, 1924–5, oil on canvas, Musée d'Art Moderne de la Ville de Paris

colorations). Compared with the earthiness of the 1924–5 *Back View of Venus* (Pl. 147), where the colours describe flesh and are an important part of the assertion of the beauty of matter in the work, Pascin's late colours hide and disguise, 'colour-over', make, with the faintness of touch, a kind of contradiction of the real. In *Hilda* (*c.* 1927, Pl. 146), for example, the effect of Pascin's watery surface on the depiction of heavy flesh renders the great slabs of the girl's legs — so heavy they seem to be falling downward in the picture — dream-light and sylphic, leavened by the fairy dust of the late style. Out of this argument between matter and manner comes Pascin's peculiar lyricism, not tragic like that of Watteau, whom Pascin very much admired, but almost joyless, and at times coyly vulgar, like lace covers on a soiled and dirty armchair.

Pascin chose to concentrate more and more on surface effects in the late work, while allowing his subjects to become increasingly faint, as though weakly perceived. The amoral little animals of Pascin's best

pictures, and especially the drawings — solid creatures of a real world with real personalities — have become sugary fairies of remotest provenance, vague of feature, barely presented, perhaps now barely visualised by the artist. Conviction in things of the world seems to have been surrendered, replaced by a preoccupation with making art: scumbling surfaces, mixing paints, creating the veil that seems less and less pretty, more often only a means of separating Pascin from his world, from what is in front of him, from what he knows if no longer loves.

In the end, Pascin became a kind of technician of nostalgia, a role far too cheap to keep him engaged for long. Refusing to see, literally to focus, Pascin cut off the possibility of real escape (through the work) and narrowed his artistic preoccupations to a point where they could no longer sustain him. It seems to be a measure of Pascin's tragedy that he was unable to create an art strong enough to bear up to and make full use of his great talent, or perhaps to create a vision large enough to contain all that he knew and felt. In the end, the paintings themselves seem part of the evidence that he died of boredom.

NOTES

1 Ernest Hemingway, *A Moveable Feast*, Jonathan Cape, London, 1964, p. 80.
2 Gaston Diehl, *Pascin* (Eng. trans. by Rosalie Siegal), Crown Publishers, New York, 1968, pp. 5, 6.
3 Ibid., p. 78.
4 Robert McAlmon, *Being Geniuses Together, 1920–1930*, Doubleday, Garden City, New York, 1968, p. 123.
5 Ibid., p. 300.

GASTON LACHAISE

Imagine you are seeing the work of Gaston Lachaise for the first time: a standing or reclining nude from the 1920s, one of the acrobats, or the bronze *Mountain*; an isolated piece, out of context, a small sculpture in a contemporary gallery. You glance at the artist's name, surely a comic invention, Gaston Lachaise. You look at the proportions of the female form, and you think you get it, a not very sophisticated joke, a little arch. As humour, it hardly holds you — a small exercise in misogyny. You are likely to register the irony briefly and move on.

On the other hand, let us say you know something of the legend of Gaston Lachaise, how in Paris at the turn of the century a 20-year-old Beaux-Arts sculptor met a Boston matron some ten years his senior, fell in love, decided to follow her to America, and there, waiting years until they could be married, devoted his art to immortalising her, made her the almost exclusive subject of a life's work, and was in 1935, on the occasion of his retrospective at the Museum of Modern Art, finally honoured as 'the greatest living sculptor' by the critic Henry McBride. Knowing this, and bowing to the reputation and the romance, you are likely to suspect either that something is very wrong with the story as told — since the work is the oddest devotional art you are likely to have seen — or, given that the story is true, that there is something highly peculiar about the nature of the devotion.

In descriptions of Gaston Lachaise, what is always stressed, because to every contemporary who admired the art it was crucial that this be understood, was the absolute ingenuousness of the sculptor. 'Three things Lachaise, to anyone who knows him, is,' e. e. cummings wrote in 1920, 'and is beyond the shadow of a doubt: inherently naïf, fearlessly intelligent, utterly sincere. It is accurate to say that his two greatest hates are the hate of insincerity and the hate of superficiality.'[1] '. . . You felt the tumult of his ardours and his idealistic ideas in every look and movement of him', Marsden Hartley wrote in 1939. He was alive with passion for art and the pure expression of it, he was inordinately simple as well, like a child yet in no way childish, he believed in his personal star and to him it was the most radiant of all, and he left the world outside himself to its own ridiculous or sublime devices, and it mattered not at all which it was.'[2]

And yet the first question that is asked in front of his work is: Is he serious? And the second: If serious, is this a wholly conscious art? Surely he can have had no perfect idea of what the effect of this work would be. It remains essentially grotesque, and even now, despite contemporary saturation with all manner of erotic imagery, provocative and, in its very last manifestations, shocking.

Gaston Lachaise was born in 1882 in Paris, the son of a decorator and cabinet maker who is remembered as the designer of the apartment inside the Eiffel Tower. He began to study sculpture at the age of 13, and was admitted three years later to the Académie Nationale des Beaux-Arts. There he received the formal classical training, entered his work in the Salon des Artistes and competed for the great Prix de Rome. A prominent career as a sculptor seemed certain when, some time between 1901 and 1903, he encountered Mrs Isabel Nagle. Writing some thirty years later, Lachaise described the event: 'One Spring day . . . as I was coming out through the beautifull [sic] formal garden and the beautifull gate of the School, I passed a majestic woman that was walking slowly by the bank of the Seine. I succeeded to meet the majestic woman later — through her the splendour of life was uncovered for me and the road of wonder beguin [sic] widening and far out reaching.'[3] She ' . . . became the primary inspiration which awakened my vision and the leading influence that has directed my forces. Throughout my career as an artist, I refer to this person by the word "Woman".'[4]

Thus, on the completion of a classical training, and at one stroke, Lachaise was given the subject-matter of his art for the next thirty years. His dedication to Isabel was absolute. Not only did he pursue her in Paris, he also made the decision to abandon his already distinguished career and follow her — despite her refusal to divorce her husband until her son was of an age to be abandoned (not until 1917) — to the cultural wilderness of Boston.

To get there, Lachaise apprenticed himself to the workshop of René Lalique, saved his money, and bought a passage to America. He arrived at Boston in 1906. He was 24.

Isabel Nagle was a short, buxom woman, small-waisted, large-breasted, with slender legs. Almost all Lachaise's sculpted women have this body; his works reproduce and play with its eccentricities (the contrast of scale, for example, between torso and limbs). Its deviation from ideal proportions fascinated Lachaise, as did its ambiguities of size: Isabel's was a monumental body, yet a small one; heroic, yet coquettish. Its parts do not agree: the ankles have a fashionable youthfulness, a frivolous charm; the torso is matronly. In his early sculpture, Lachaise does not manipulate the natural forms of his subject but reproduces them faithfully, responding to the appealing idiosyncrasies and seeming distortions that nature has provided him with in his model. Later, taking the clue from this first response, his work will do its own playing, distorting and manipulation, and, much later still, its own violence to the subject.

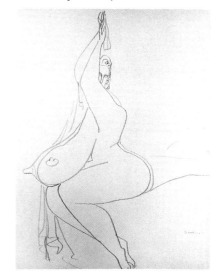

148 *Seated Nude with Arms Up*, undated, pencil, courtesy of The Lachaise Foundation/Robert Schoelkopf Gallery, New York

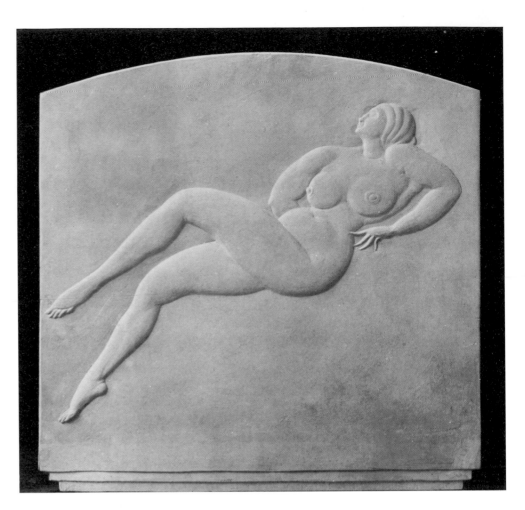

149 *Reclining Woman, c.*1917,
plaster relief, courtesy of The
Lachaise Foundation/Robert
Schoelkopf Gallery, New York

Lachaise's response to Isabel's body celebrates a tension between
grace and clumsiness. The artist's decorative training — the Lalique
line, the art-nouveau curve and lightness of touch — is present in the
outline of a monumental work like *Elevation* (1912–27), accentuated by
the thrust of flesh-covered hip and bent arm. There is something
extraneously graceful in the coy arch of the foot, the mannerist elegance
of the hands and feet, the strange gesture of the arms, which acts as a
kind of commentary — humorous in one possible reading — on the
dignity and bulk of the lady. There is a hint of the ludicrous, in the
depiction of so much weight held up on such delicate toes and in the
nearness of hand to mouth, that suggests, contrary to the intentions of
the piece, the affected gestures of an over-large, girlish, but no longer
young society matron. Solidity competes with lightness in a coup of
gravity-defiance, a conjunction of impossibilities Lachaise plays with
elsewhere, most specifically in his sculptures of 'floating' acrobats —
belly-sagging but air-borne — and in his studies of the heavier bodied
mammals swimming or leaping, where he chooses the bulkiest
creatures (seals, dolphins) and shows them aerodynamic. Had he ever
sculpted cows he would have emphasised the beef tonnage above their
slender ankles and cloven hooves and shown how they jump over the
moon.

Lachaise wanted his standing figures capable of movement. Eternal grounded images interested him less than images of flesh alive, performing, contradicting its own weight by its *joie de vivre*.

In certain early works, Lachaise describes this female grace and movement in the simplest fashion, using a deco manner as a kind of shorthand, expressing the female form as an instant flash of beauty, held by line, reduced to a sinuous aphorism of grace. In the early reliefs, such as *Reclining Woman* (c.1917, Pl. 149) and *Dusk* (1917), neoclassical elongations combine with the floating postures to suggest weightlessness and, by extension, timelessness: Isabel as water sprite, vaguely Greek, vaguely immortal. But this aspiration to elegance does not altogether succeed, seeming contrived and at odds with other, merely implied elements in the work. In *Reclining Woman*, the delicate feet, stretching away from the body, disappearing from head and torso as these tilt arched and sensual, have something of a brothel elegance about them, an artificial and sickly charm. They lie remote and precious at the end of the form, like a coiffed poodle at the foot of a courtesan's bed. In such works the idea of 'Woman' is subordinated to a notion of design; line is all. Flesh, its weight and density, is not described. Only later will Lachaise's work celebrate this flesh, when his goddess returns to earth and becomes unequivocally (for some, a little too unequivocally) matter.

In other early versions of the nude, Lachaise attempts to convey Isabel's beauty less as a triumph of design than as a description of spiritual force. By means of a contrary convention, romantic rather than neoclassical, he presents her flesh in heroic terms. In the many small standing nudes executed from 1910 onwards, Isabel is seen in the manner of Rodin's *Balzac*, her top-heaviness translated into his: a huge torso, draped or bursting unbuttoned over a plinth of limbs (Pl. 157). These works, though they can be held in the hand, are monumental and, like Rodin's *Balzac* (an art-world *cause célèbre* when Lachaise was a student in Paris), suggest the spiritual and moral qualities of the subject as they are expressed in the physical presence. By 1921 (*Standing Nude*, Pl. 150) the same form is unwrapped, naked, and it speaks more plainly. The legs no longer lift the torso into the realms of romantic emotion, but support simply the full, heavy forms of the physical animal. Lachaise no longer has to describe what he finds desirable in terms other than his own. He needs neither Rodin nor the conventions of art deco to state the case of Isabel's peculiar beauty for him: he begins to find the courage of his appetite.

As Lachaise's work developed, it increasingly conveyed less the look of Isabel than the experience of loving her. Because for so much of the time, even after Isabel divorced her husband and moved to New York City, they lived apart, the work became a kind of surrogate object for Lachaise's passion for his mistress. Remembering how the work evolved, Lachaise wrote about it years later: 'After my days work as an assistant [in Boston] I would work at night in a small studio of my own to my own work [sic] — Slowly personal expression came out of what

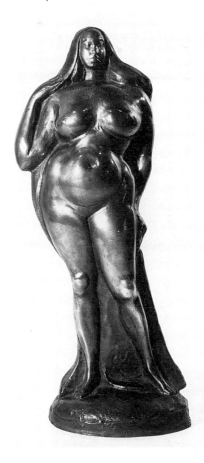

150 *Standing Nude*, 1921, bronze, courtesy of The Lachaise Foundation/Robert Schoelkopf Gallery, New York

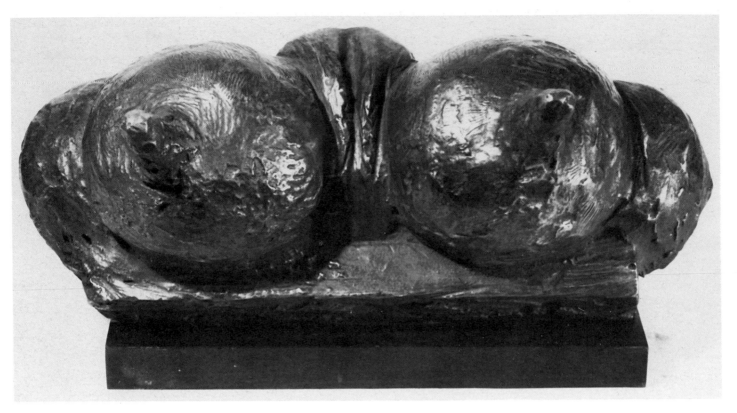

151 *Breasts with Female Organ Between*, 1930–2, bronze, courtesy of The Lachaise Foundation/Robert Schoelkopf Gallery, New York

152 *Nude with Four Breasts*, undated, pencil, courtesy of The Lachaise Foundation/Robert Schoelkopf Gallery, New York

I was so intensely living. This is where as reverently and with all the genuine simplicity possible I will express my profound gratitude to the leading inspiration which still leads me to day, my wife — the majestic woman [who] passed by once years ago by the Bank of the Seine.'[5]

In an undated letter to Isabel he conveys more clearly the direct connection between his feeling for her and the process of his art: '. . . I worked from you all afternoon expressing your body — expressing your thoughts — your body is your thought. It has been burning hot in the studio — it is good atmosphere around me — I am all aflame — a flame which burns of you. The heat, the light in the studio, the work, the little slippers, the 4 corners of the studio close me in with you.'[6] These words suggest, as do the later, more expressionist, flesh-manipulated sculptures — of which *In Extremis* (c.1934, Pl. 168) and *Breasts with Female Organ Between* (1930–2, Pl. 151) are perhaps the most sensational examples — the degree to which Lachaise used his art for a kind of long-distance ravishment of his somewhat autocratic, often remote, mistress. His art was, as he wrote to Isabel in a New Year's letter in 1926, 'The best of ALL Me all Over you IN and Out.'[7]

As these passages suggest, the first works are devotional offerings; gradually, as the manipulations of the work increased, they seem to become the locus of a great range of feeling, from lust to a rage which Lachaise expresses elsewhere only in the drawings, which sketch out the kinds of distortion explored in the late sculpture, for example the huge and multiple breasts (see Pl. 152). Here Lachaise's work is oddly Beardsleyesque, in both style and tone: the drawings are scornful,

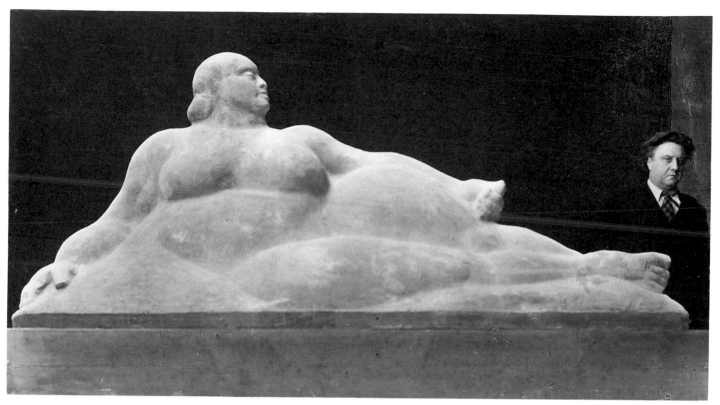

153 *The Mountain*, 1934–5, cement, Private Collection

fearful, a sophisticated version of English seaside postcards with their grotesque women and tiny, sniggering men (Pl. 148).[8]

Neither fear nor anger is hinted at in any of the letters to Isabel, which are uniformly worshipful and describe what one critic called Lachaise's 'thralldom'[9] to her, and the public statements about his art are similarly restrained. In the latter category, for example, is his description of the monumental version of *The Mountain* (1934–5, Pl. 153), a description which both compliments his wife and wraps the work, via something of a contradiction, in the veils of heroic symbolism: 'You may say that the model is my wife. It is a large generous figure of great placidity, great tranquility. Whatever I have of tranquility I get from my wife . . . What I am aiming to express is the glorification of the human being, of the human body, of the human spirit with all there is of daring, magnificence . . .'[10]

The subtitle of this work — some nine feet long, made of a few tons of cement, and intended for life outdoors, where today (in Lenox, Massachusetts) it lies rain-eroded and moss-covered — is *La Montagne héroïque*. It differs from other versions of *The Mountain* not only in size and intention, but in its uncharacteristic pomposity. The rhetoric of Lachaise's description of it matches that of the piece, but it cannot be said that the work lives up to its aspirations of 'daring, magnificence' etc., despite the horizon-gazing pose of the head. Perhaps Isabel's 'tranquility' was not the characteristic that inspired Lachaise most. The other versions of *The Mountain* symbolise less and describe more. They are views of Isabel neither as tranquillity nor as daring humanity, but as

187

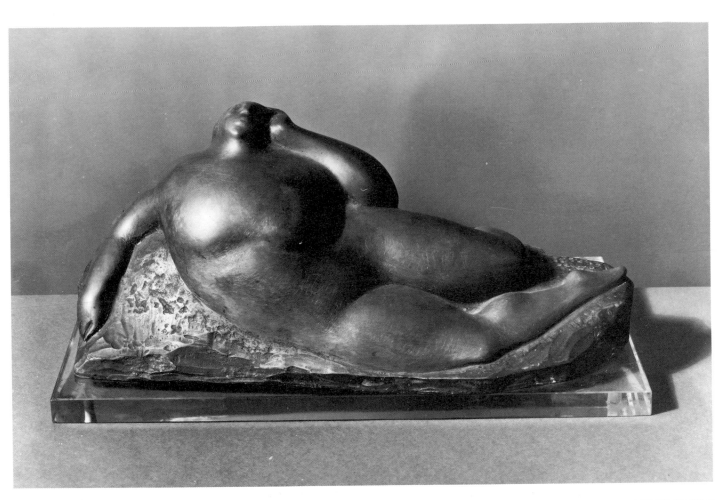

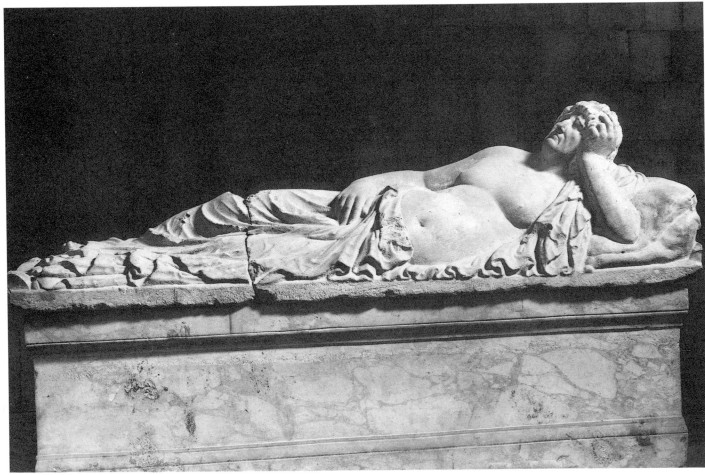

mountainous flesh. In the versions of 1921 and 1924 (Pl. 154), she lies fat, full, content in the pose of a satiated Roman emperor. There is, in fact, a satiated Roman that may have been the inspiration for the 1924 version. Called *Il obeso* (no mincing with words in this title), the Etruscan tomb sculpture which is reproduced as plate 7 of Kenneth Clark's book on the nude bears an uncanny resemblance to the Mountain/Isabel (Pl. 155).

Lachaise is happiest when he can render flesh as flesh, when he can freely express his sensuality. e. e. cummings remembers the artist's irritation with one gallery-owner's coy naming of a sculpture. According to the poet, Lachaise said 'Ai don lai kit ai hay tit "pudeur" dat means something to me dirty . . .'.[11] In the wonderful *Woman with Beads* of 1917 (Pl. 157), the beads act like a zipper on the dress from which Isabel bursts, belly and bosom, like a giant pea splitting its pod. In the 1921 *Standing Nude* (Pl. 150) the full form emerges entirely from its encasement (though the drape of hair suggests the remnants of closure).

Lachaise uses clothing in his sculpture as well as any choreographer of striptease, an art form of which he was a frequent patron and admirer. Robes, skirts, cloaks are used to erotic as well as aesthetic effect. Entirely clothed, as in *Standing Woman with Pleated Skirt* (1926, Pl. 158) or the high-heeled *Woman on a Couch* (1918–23, Pl. 156), the figures take on a folk-art manner and innocence; flesh becomes mere fullness, like the characteristic stuffing of a children's toy.

Lachaise loves the weight of flesh and the force of gravity, loves like an infant scientist turning Isabel upside down to see how she will look. Later he will examine what she looks like with two sets of breasts, the feet removed, legs splayed, up-ended, and with her parts isolated or

154 (opposite) *The Mountain*, 1924, bronze with glass base, The Metropolitan Museum of Art, New York

155 (opposite) *Il obeso*, Etruscan tomb sculpture, Tarquinia Museum, Rome

156 *Woman on a Couch*, 1918–23, bronze, Hirshhorn Museum and Sculpture Garden, Washington

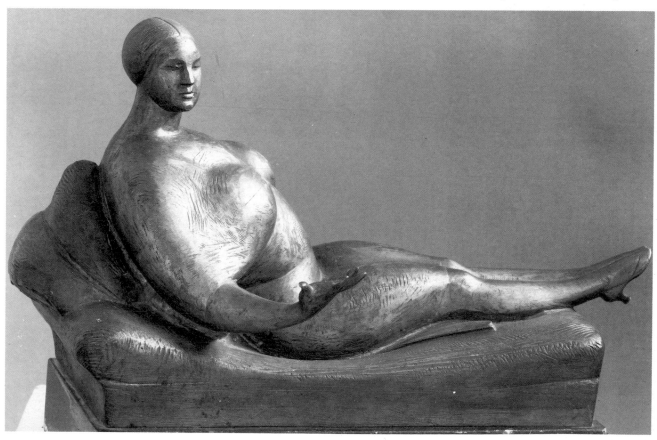

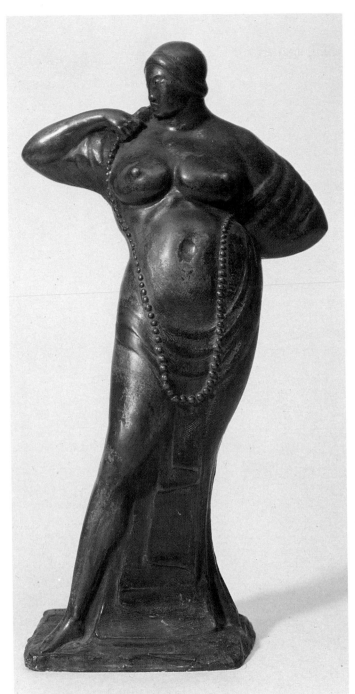

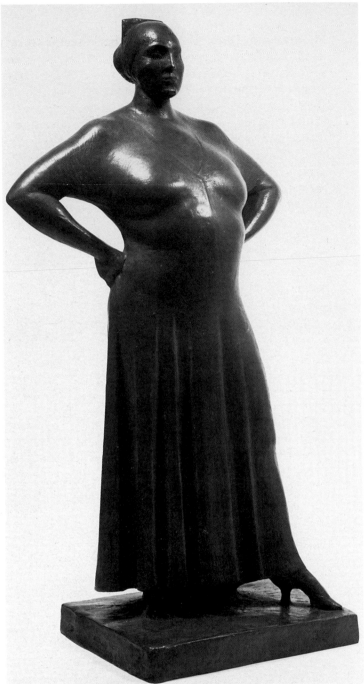

157 *Eternal Force (Woman with Beads)*, 1917, bronze, Smith College Museum of Art, Massachusetts

158 *Standing Woman with Pleated Skirt*, 1926, bronze, courtesy of The Lachaise Foundation/Robert Schoelkopf Gallery, New York

reorganised. In *Acrobat: Upside Down Figure* (1927), she looks graceful, comfortable, pleased with herself and her up-ended beauty. By 1935, in *Female Acrobat* (Pl. 159), both she and the art work seem less happy. Some time between the late 1920s and the mid-1930s an element of excessive manipulation enters Lachaise's work, hinting at obsession, coercion, and certainly not always either reverential (as he continued to claim) or benign. In his examination of what is beautiful and what grotesque (see, for example, two torsos executed in 1928, *Classic Torso*,

Pl. 162, and *Torso*, Pl. 161), Lachaise seems to be pushing against the edges of ideal form, seeing how far it can go without surrendering its aesthetic power or becoming simply idiosyncratic or grotesque. In works like the 1930 *Torso*, or that of 1933 (Pl. 163), distortion is the means to a powerful and economic statement of beauty. But in *Torso with Pendulous Breasts* (1930–2, Pl. 160) and the 1928 *Torso* (Pl. 161) something else is being essayed. Here Lachaise is unhampered by

159 *Female Acrobat, c.*1935, bronze, courtesy of The Lachaise Foundation/Robert Schoelkopf Gallery, New York

notions of the acceptable, let alone ideal, form, but pushes over the borders of the grotesque, with a kind of insistence on his rights as artist to use such force. There is a near-aggressive assertion of independence from nature in the late works that seems to amount to a re-definition of his art in terms of the relative power of artist over subject. Isabel is no longer either the adorable folk-art toy of *The Mountain*, say, nor the dominatrix of *Standing Woman (Heroic Woman)* (1932, Pl. 164), but has become something of Lachaise's experimental victim, at times his performing animal.

One of Lachaise's earliest memories was of a trip to the circus in 1887, which he recalled in a fragmentary memoir: 'These were trills [sic] to a little boy five years old — the profusion of light and music — the smell of parfum mingled with the ammonia of the stables — and also trilling — the wonderful round bossomed and round heaped lady [sic, sic] — tossing herself up and down from a beautifully decorated big horse galloping gently in circles.'[12] He loved the sight of flesh bouncing even then, and where, later, the facts of sculpture denied him the pleasure of re-creating movement, he insisted at least on recording its effects. The eccentric spelling of Lachaise's memoir suggests one of the ways he chose to delineate and express the impact (both erotic and formal) in his late work. In *Burlesque* of 1930, for example, he did make hips into heaps, padding the body beyond nature, forcing its forms hyperbolically. Here and elsewhere, particularly in his many drawings,

 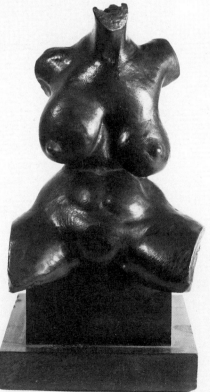

160 *Torso with Pendulous Breasts*, 1930–3, plaster, courtesy of The Lachaise Foundation/Robert Schoelkopf Gallery, New York

161 *Torso*, 1928, bronze, courtesy of The Lachaise Foundation/ Robert Schoelkopf Gallery, New York

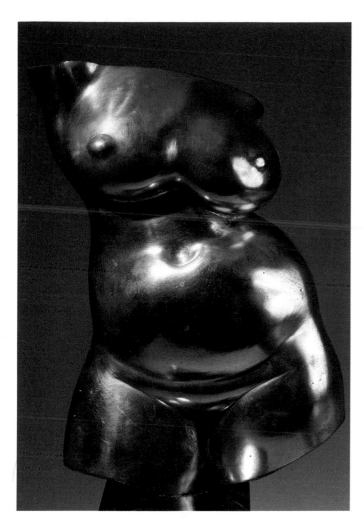

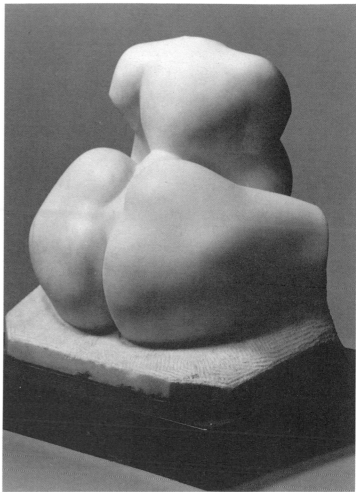

162 *Classic Torso*, 1928, bronze, The Santa Barbara Museum of Art, California

163 *Torso*, 1933, marble, Smith College Museum of Art, Massachusetts

he depicts woman as a burlesque queen, faintly lewd, outrageous, and self-parodying. For all his proclaimed purity (about Isadora Duncan, another form of bouncing nude, he wrote in a letter of 1909, 'This good modest city Boston plans to prohibit her when she returns because she dances a bit too nude. As for myself I feel that completely nude would be a beautiful thing too. It's phenomenal how these virtuous and chaste people see nothing but sexes . . . '[13]), he himself is not beyond the dirty joke, however humourlessly delivered.

Lachaise's late art is concerned more with coming to terms with Isabel's sexual power, and with his own sexuality, than it is with making a convincing statement of her beauty. Through a process of strangely joyless, but playful experiment (see *Seated Woman Holding Breasts*, 1931) with parts of the body, Lachaise seems to be trying to take Isabel apart to analyse (and perhaps master) the source of her power over him. Out of this analysis come the many quite wonderful sculptures of parts, fragments conceived as wholes, as though the magical design were inherent in every part of the model, as though like a mysterious snake Isabel could be sliced anywhere and still retain her special nature and life.

In this category are the *Knees* (1933, Pl. 165), as formal, and

193

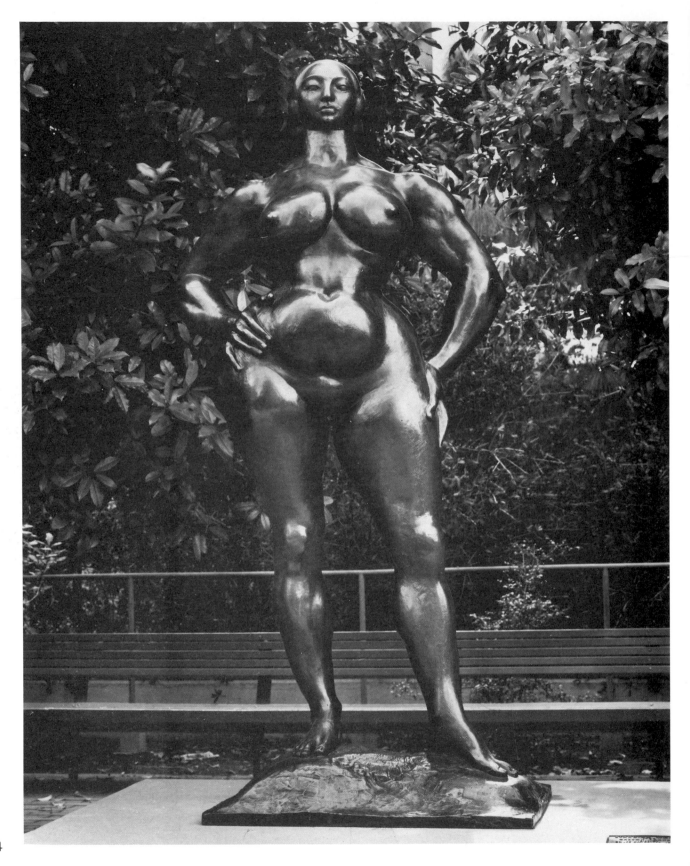

194

sensuous, as anything in Brancusi, and, just as beautiful, the strangely divided sculpture, the front and back of the 1933 *Torso*. But other 'part' works succeed less well. The study of breasts and arms of 1935 called *Torso with Arms Raised* (Pl. 166) simply suggests a large (headless) female simian conducting an orchestra. The truly bizarre fragment, or violent conjunction of fragments, *Breasts with Female Organ Between* (Pl. 151), is another case; but it has the peculiar success of a surrealist found-object, and the deadpan simplicity of a work like Jasper Johns's 1964 *Painted Bronze II* (*Cans of Ale*).

'All art is a confession,' Lachaise wrote in his 1931 memoir; and earlier, 'One can conceal nothing of one's weakness.'[14] I think this was the success of his art, that he arrived by precisely this means, working through weakness, through his 'thralldom', acknowledging appetite and obsession, to make, in a work like the 1935 *Nude with Hat* (Pl. 167), triumphant acknowledgment of his passion for Isabel. His art moved away from its first tendency to make things acceptable (using the

164 (opposite) *Standing Woman (Heroic Woman)*, 1932, bronze, Franklin D. Murphy Sculpture Garden, UCLA, California

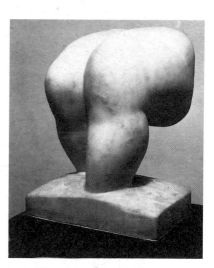

165 *Knees*, 1933, marble, Museum of Modern Art, New York

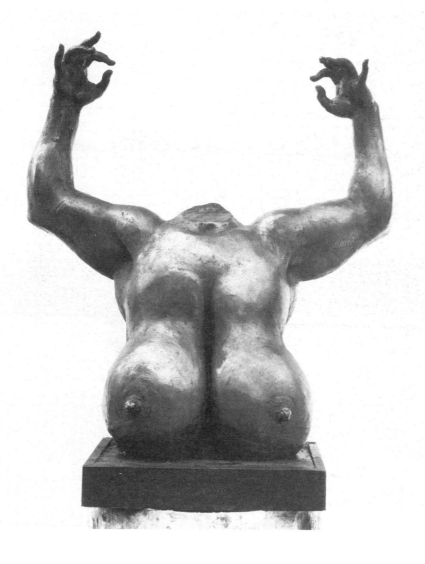

166 *Torso with Arms Raised*, 1935, bronze, courtesy of The Lachaise Foundation/Robert Schoelkopf Gallery, New York

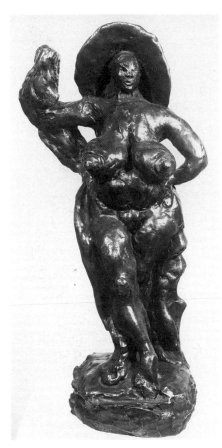

167 *Nude with Hat*, 1935, bronze, courtesy of The Lachaise Foundation/Robert Schoelkopf Gallery, New York

168 *In Extremis*, c. 1934, bronze, courtesy of The Lachaise Foundation/Robert Schoelkopf Gallery, New York

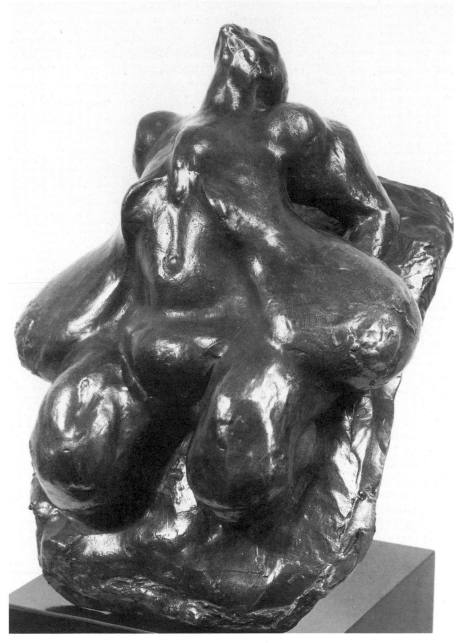

smoothing–over style of deco/Lalique) or grandiose (via Rodin and the monumental studies) to confront the nature of his feelings for women and restate them in terms of his own obsession. In a late work like *Dynamo Mother* (1933), and more so in *In Extremis* (Pl. 168), the image seems to arise from the fusion of erotic subject-matter and the sensations of the artist. The violent expressionism of the latter piece derives from the artist — the 'extremism' is his, not his subject's; it may be, as has been suggested, a study of a woman dying, or coming, but it is also an invented form, created to express the sexual overpowering of both subject and artist. All the elements of Lachaise's late work can be seen in a piece like this, the themes of power, domination, ecstasy, rage. Using distortion, and describing a body torn by feeling, he

arrives at a genuinely heroic image, tragic and powerful, yet locked into its own mortality. In such a work the two directions of Lachaise's art — towards the eternal, through ideal form, and towards the grotesque, through the specifics of flesh — perfectly come together.

NOTES

1 Quoted in Gerald Nordland, *Gaston Lachaise: The Man and His Work*, George Braziller, New York, 1974, p. 23.
2 From a reprint of Marsden Hartley's essay on Lachaise, originally published in *Twice a Year*, Fall–Winter 1939, in *The Sculpture of Gaston Lachaise*, Eakins Press, New York, 1967, p. 28; also includes an essay by Hilton Kramer, and appreciations by Hart Crane, e. e. cummings, Marsden Hartley, Lincoln Kirstein, A. Hyatt Mayor and Henry McBride.
3 From an unpublished, 35-page (handwritten) 'autobiography' by Gaston Lachaise written in 1931, held at the Beineke Rare Book Library, Yale University, New Haven, Conn.; reprinted in Gerald Nordland, op. cit., p. 8.
4 From Gaston Lachaise, 'A Comment on My Sculpture', *Creative Art*, vol. 3, no. 2, August 1928, p. xxiii, and quoted ibid., p. 8.
5 From Lachaise's 'autobiography', quoted ibid., pp. 13–14.
6 From an undated letter from Lachaise to Isabel Nagle at the Beineke Rare Book Library, quoted ibid., pp. 17–18.
7 In the Beineke Rare Book Library, quoted ibid., p. 50.
8 Some of the head-dresses of Lachaise's drawings, as well as the body proportions and, frequently, the tone, suggest the Beardsley of, say, the *Lysistrata* illustrations. Lachaise admired Beardsley; in a letter of 1908, (quoted ibid., p. 13), he calls the English artist, 'Extraordinary, really great'.
9 Hilton Kramer, 'Gaston Lachaise', in *The Sculpture of Gaston Lachaise*, p. 10.
10 Gaston Lachaise in an article in *Arts Digest*, 1 February 1935, quoted in Gerald Nordland, op. cit., p. 50.
11 e. e. cummings in a letter to his mother dated 4 July 1918, quoted ibid., p. 22.
12 From Lachaise's 'autobiography', quoted ibid., op. cit., p. 4.
13 From a letter to Pierre Christophe, 17 May 1909, in the Beineke Rare Book Library, quoted ibid., p. 13.
14 Gaston Lachaise, Preface to the catalogue for 'Exhibition of American Sculptures', Bourgeois Galleries, January–February 1919, quoted ibid., p. 166.

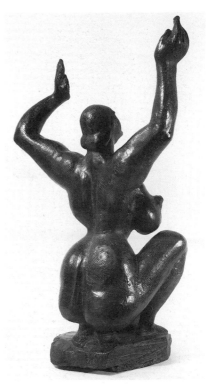

169 *Kneeling Nude*, undated, bronze, courtesy of The Lachaise Foundation/Robert Schoelkopf Gallery, New York

STANLEY SPENCER AND LUCIAN FREUD

There is a point in adolescence when consciousness of the body of the opposite sex arrives with such suddenness and stays with such insistence that the only verbal defence is to deal with the intrusion by means of analogy. For children, obsession and novelty demand a special vocabulary: familiar, yet distancing. A breast is a 'balloon', a 'bag', a 'melon' or a 'pear'. The alien body is a 'carcase', a 'cow' or a 'dog', a 'sack', a 'stick', a piece of 'fluff'. Analogy defuses the otherness of the other, as at the same time — by calling attention to the difficulty of self-explanation — it prolongs it.

Both Stanley Spencer and Lucian Freud seem to me to be artists that maintain this kind of adolescent looking and work it to a point of eccentricity. Both paint the female nude in a manner that emphasises its strangeness; and, though oddness has menace in Freud's work but is simply a divine attribute in Spencer's, both use similar techniques to point it out, juxtaposing the familiar with the peculiar, and making analogies between aspects of the body and elements of another world: of clothing, animals, food. But whereas each conveys the 'innocence' and intensity of the first looking, Freud, it seems, also hangs on to the squeamishness.

Initially, this may not seem true. What, for example, could appear more squeamish, body-fearing, female-disdaining than the 'Leg of Mutton Nude', Spencer's most sensational painted simile? My reading, from Spencer's other work and from what has been written by and about him, is that such an image acts less as analogy than as narrative, as a document of a surprising conjunction of beings. But even as simile, look at it next to Lucian Freud's *Girl with a White Dog* (1951–2, Pl. 170), a painting which seems to be genuinely — and with horror — making comparisons in the guise of simple description, in this case between the exposed breast of the sitter and the woeful countenance and disturbing (a most Freudian★ adjective) skin formations of the dog. The dog and breast conjunction is faintly obscene, humourlessly malign, despite Freud's habitual deadpan manner in this period of his art; ugliness, the

★ In both senses. Lucian is a grandson of Sigmund Freud.

198

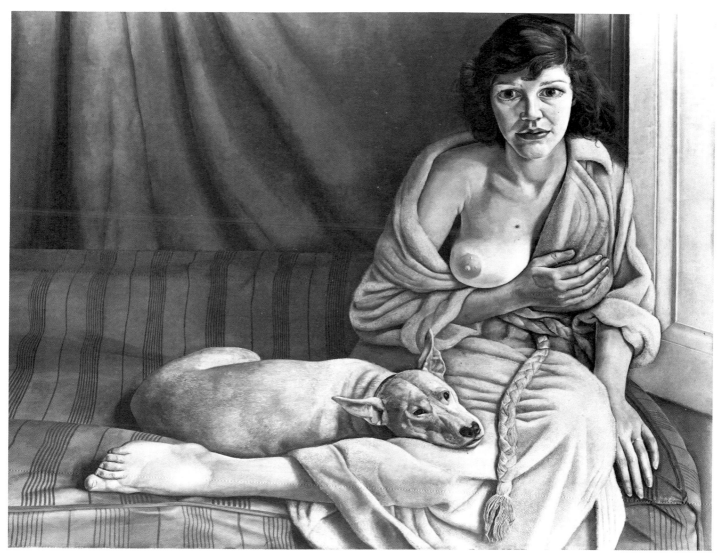

170 FREUD, *Girl with a White Dog*, 1951–2, oil on canvas, Tate Gallery, London

grotesque, is more than hinted at. We feel the artist's sense of the peculiar look of things and of the body in particular. Characteristically ambivalent about his subject, Freud has it both ways: the girl is sweet, young, sad, beautiful, and she is exposed, animal-like, horrific. The artist denies responsibility for the double reading; he simply points it out — not sniggering, but apparently as remote from his subject as a collector of specimens.

In Spencer's 'Leg of Mutton Nude', known more formally as *Double Nude Portrait: The Artist and his Second Wife* (1937, Pl. 171), there is no logic, no apparent narrative 'sense' to the composition. In the hands of another painter, the presence of the uncooked pieces of lamb (leg plus chop) in such proximity to the two naked bodies would imply absurdity. But in Spencer's great painting the figures are sheltered by the artist's peculiar pity, and even that uncooked meal is served with what amounts to compassion, to make an odd but convincing statement of common fleshly fate. It is part of Spencer's genius that he can so often describe what is potentially blasphemous or ridiculous and

199

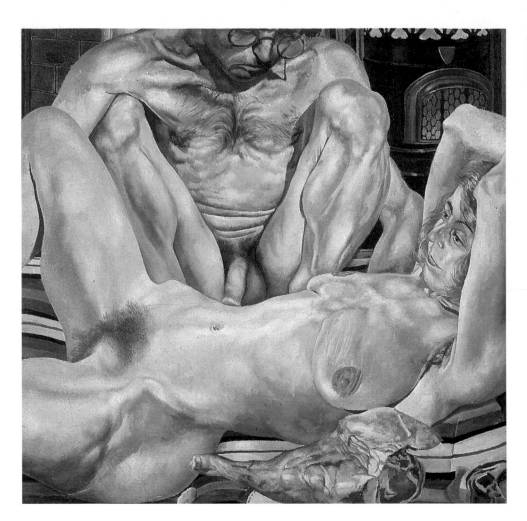

yet make us accept his utter sincerity. Here he does so, despite the implied comparisons between the lardy streaks of meat and the brutally coloured human flesh. The common ugliness, rawness (the fire in the background might cook them all), only suggests the frailty of the flesh, its precariousness and corruptibility, what it may come to rather than simply how it appears. Patricia Preece, the artist's second wife, is already over-ripe, already mutton, not lamb. But the artist depicts himself bending over her, looking, not judging, here implying a different kind of love and awe than in earlier work, where visions both sexual and religious are set down with a sort of Holy-Cow ecstasy. He expresses detached compassion, a melancholy pensiveness, about himself as much as his wife. The painting of the bodies does not distinguish between him and her, or between them and the lamb; they are all naked, ageing, fallibly present, and most lovingly rendered.

Spencer accepted and was as enchanted by his own body as by anyone else's, and in the two nude self-portraits this directness and reverence is important to our reading of his tone. 'I wish you could see me as well as I see you duckie,' he wrote to his first wife, Hilda, 'because I am sure I am very nice to look at.' And, he went on, 'I feel my shape physically being such a complementary shape to yours somehow reveals to me something about our spiritual complemen-

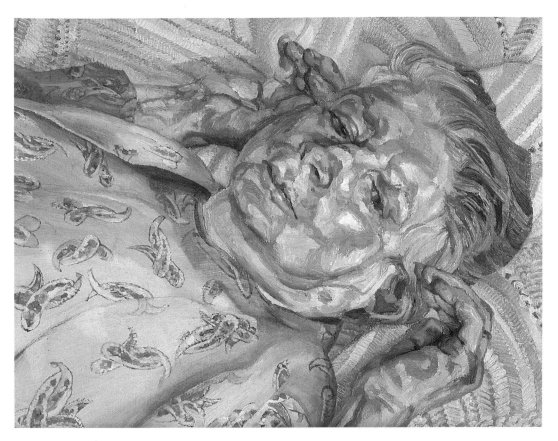

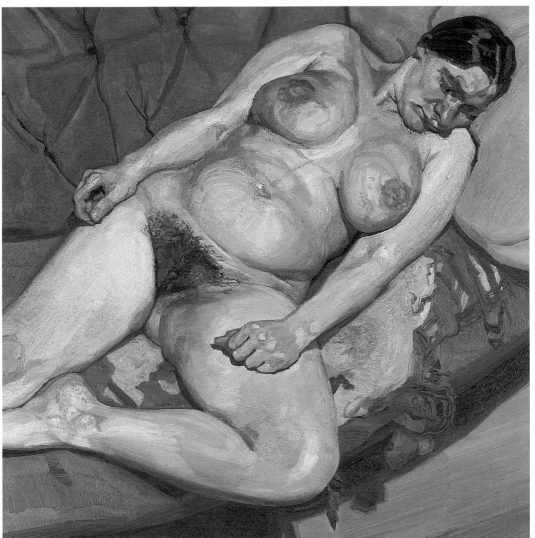

201

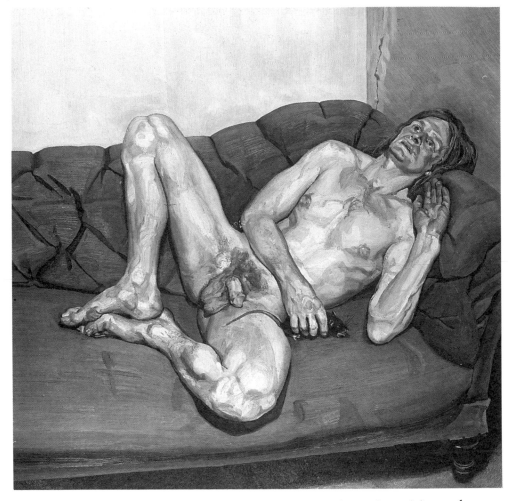

174 FREUD, *Naked Man with Rat*, 1977, oil on canvas, Private Collection

175 FREUD, *Hotel Bedroom*, 1954, oil on canvas, The Beaverbrook Foundation, New Brunswick

tariness.'[1] Spencer saw himself as blessed, in body as in spirit, and that conviction he painted into his nudes.

And yet there is something very sad about this painting. It suggests isolation as much as common ground. Spencer had an unhappy time with his second wife. It is said she refused to sleep with him. Something of this is hinted at in the picture, which separates the two figures as observer and observed, and may have suggested its imagery: the meat, after all, is in an inedible (raw) state, and slowly decomposing — it is not a feast.

Freud's response to the body is far more complex than Spencer's, full of ambivalence, hesitation and bravado. But there is a similar compassion for human flesh in the later works, an energetic sympathy that seems to have developed through the portraiture. We see it best, perhaps, in the paintings of his mother in old age. The artist began to paint her after her attempted suicide, when bedridden, only half-wishing to be alive, she is no longer entirely 'herself', no longer his mother, partly a 'thing', the thing that contains and imprisons the person who chose to be elsewhere. Freud's paintings of her show her rendered harmless, and his art approaches her, can be tender almost because of her helpless state. In *The Painter's Mother Resting: II* (1976–7,

Pl. 172) — a painting whose title characteristically seems to announce the artist's relationship to the subject so that the art itself can demonstrate its independence from it — Freud shows his mother strangely up-ended on her bed, as helpless as an overturned turtle, her hands curled towards herself in a gesture of defencelessness and pain. The painting is both cool and affecting. Freud has seen what is horrifying about his mother's suffering and set it down as though the suffering were a thing, objectively visible. In this work, as in others of this later period, Freud triggers our pity without declaring his own. *Naked Man with Rat* (1977, Pl. 174), for example, makes the analogy between rodent and genital with a horror that yet has room for compassion, or which, naming the grotesque, cannot choose between the two responses. It is as though Freud wants us to be moved but doesn't want to get too close himself. There is a fearfulness *of* and *for* the flesh in the powerful and horrific 'Pregnant Nude' (*Naked Portrait: II*, 1980–1, Pl. 173), painted with such force that we feel Freud's greed for true rendering, a need for painting that can account for the worst and still pronounce it beautiful.

In the earlier work, such as *Girl with a White Dog*, there seems, rather than compassion, a recoiling from the facts of flesh. Yet this first expression of horror may be the source of the later feeling — horror of what the body is and must endure. Mortality is expressed in all of Freud's work, a subject implied in the early work by the characteristic greenish hue of the skin, by those enormous eyes that stare as though imprisoned and seem to insist on the divorce between matter and spirit, body and soul. Freud seems always, even in his portraits, to be bidding his subjects adieu. Whereas in Spencer we feel the joy of greeting, the celebration of the other's existence, there is in Freud a death-bed fascination, as though painting itself were a vigil. Those huge eyes, whether Freud's own in the self-portraits, or those of his sitters, see terrible things, and what they seem to see (in *Ill in Paris*, 1948, and *Hotel Bedroom*, 1954, Pl. 175, as well as in *Naked Man with Rat* and *The Painter's Mother Resting: II*) are endings.

Mortality is connected with a shame of the body in Freud's work; it is the developed statement of the adolescent's first discovery of what is grotesque, fascinating or terrible. His early work is full of dead animals; his nudes often lie in the posture of the dying or terminally ill.

With Spencer, on the other hand, there is never any shame, nor any horror of death. He believed in the Resurrection — sometimes a literal and entire resurrection of the body (he changed his views on this during his life), sometimes simply a transformation of matter into spirit — and his religious views kept his painting untouched by a sense of either the grotesque or the tragic. In Spencer, there is nothing ever to grieve about. Nor is there anything about the body to make one ashamed. In the Astor Collection, for example, there are wonderful drawings, as ecstatically rendered as any of his heavenly visions, of himself and his first wife, Hilda, as they sit on adjoining loo seats and Spencer displays his erection to his wife. The intention is to charm Hilda (and us), not to

176 and 177 SPENCER, *Lavatory Composition*, pencil, from volume 1 (1939–43) of the scrapbook drawings in the Collection of Viscount Astor, Oxon

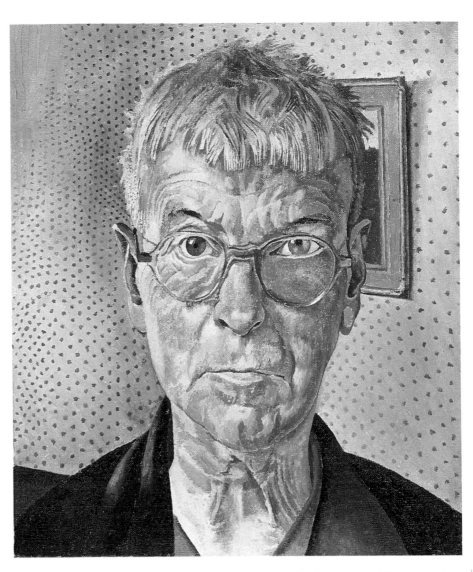

178 SPENCER, *Self-portrait*, 1959,
oil on canvas, Tate Gallery,
London

shock. The pictures are cosy, not smutty, the humour childish rather
than adolescent (see Pls 176, 177).

But Freud feels shock, and wants to express it in images that will
shock in turn. A sense of the horror of the flesh is always present in his
work. It is an important part of his fascination with the nude. Almost
indifferent to shape, line, the classical formal interests of the genre, it is
flesh he wants to paint. 'I want paint to work *as flesh*,' he has said,[2] to
use skin and pigment to describe skin and pigment. And so he looks
skin-deep, at the colouring, the lumps, swellings, bruises. He paints
less the presence of flesh than its contingency: its responses to tem-
perature and to illness. He paints its striations and flushes, its purpling
and stretching in pregnancy, its paling and desiccation in old age.

There is absolutely nothing of the icon/idol in Freud's vision of the
nude, an *ir*reverence reinforced by the surprising smallness of some of
his paintings, as though other people's bodies were remote, had to be
peered at, to be shown as curiosities in the form of miniatures. What
motivates him in the nudes is not longing (a desire to have) but a need

— almost intellectual, and demanding courage — to look and really see.

In the work of both Spencer and Freud the fact of seeing is given as much weight as are the facts of what is seen. The subject-matter of both artists' work is recorded as though the artist didn't so much choose what he was going to paint as allow himself to be chosen. Freud subjects himself to what he sees; Spencer is the grateful, God-chosen witness. As visionaries, intense starers — wide-eyed, both of them, in front of the extraordinary and the alien — both act as registering instruments for what presents itself to their view, colouring that view only with the shock of seeing. In Spencer's case this shock is often set down ecstatically as religiously received, and his work is a record of the miracles of the visible world. In Freud, on the other hand, particularly in the early work, the shock comes as something perpetrated on a young and sensitive bystander. He paints as though he were wounded by what he sees; until the late work, his art seems a protestation against

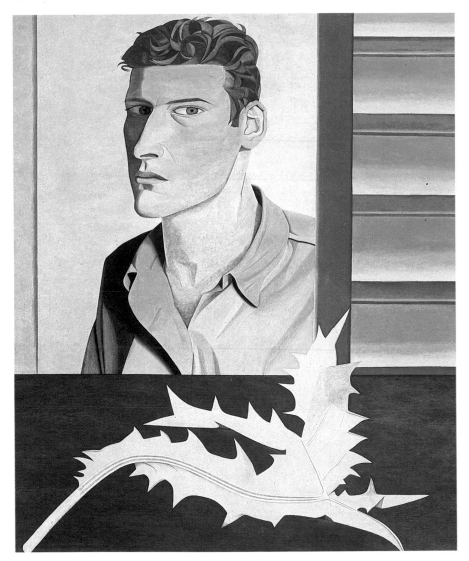

179 FREUD, *Self-portrait*, 1946, oil on canvas, Tate Gallery, London

assault by the other on the eye of the self.

From their self-portraits, it is clear that both artists saw themselves as visionaries. Spencer's last (1959) *Self-portrait* (Pl. 178) shows him in ferocious, unflinching stare, hardly the benign and dotty old eccentric he allowed others to imagine him, but a seer, in fierce possession of the truth. Truth, rather than description, is what his realism is about. 'There are certain things where I can see & recognise clearly this spiritual identity in something, but if I am drawing & dont see this clearly, its all up,' he wrote in 1926. 'In fact the only impulse I have to draw or paint is that I know somewhere in all these things there is that miraculous spiritual meaning that just in a flash of a second could change boredom of drawing into a tremendous experience . . . '[3] (In the same letter he wrote, 'I feel that everything in one that is *not vision* is mainly vulgarity.'[4])

Lucian Freud's stare is equally unflinching, familiar to us from, among other works, the 1946 *Self-portrait* (Pl. 179), a painting he later came to dislike (it is not reproduced in Lawrence Gowing's official monograph on the artist), perhaps because it claimed too much for the eyes, for their courage and experience of pain. But the same unblinking, wounded eyes are given by Freud to his sitters in works like *Girl with White Dress* (1947), *Girl with Roses* (1947–8, Pl. 180) and *Girl with a Kitten* (1947, Pl. 181), where the intensity of the stare is matched by a hand so tight around the neck of the kitten that the animal seems in danger of being strangled. The eyes seem to exist independently of the subject, and here, as throughout Freud's portraits, suggest how separate the artist feels minds and bodies to be, as though the spirit of the sitter were simply (and rather medievally) housed by the body, and that only temporarily. In Freud's work, flesh is nothing to be counted on; its future betrayals are always seen and set down.

For Spencer, as for Freud, the nude was a form of portraiture. Both artists described their nudes as such, and freighted them with psychological characterisation. But in Spencer's work the body never seems incidental to, nor to be guarding the secrets of, the soul. The two are integrated in his vision: spirit is made known through flesh; truth *is* revealed; mysteries *are* visible. (Spencer was very matter-of-fact about all this: 'As he was falling to sleep he would say to himself, "Tomorrow I will see God." When he woke he knew he could paint.'[5]) Freud's view is that the other will never wholly be revealed. The eyes speak of isolation, express pain; and the artist himself respects the distance his subjects seem to insist on. Unlike Spencer, Freud knows anxiety, puts his honesty at the service of doubt; he gives no assurance, visionary though he is, that what can be seen is the same as what can be known.

Comparison of the work of these two painters is likely to throw less light on Spencer's achievement than on that of Lucian Freud. Spencer, after all, is a fairly self-contained phenomenon in the great line of English eccentric/visionary artists like Blake and Palmer, though if Spencer saw himself continuing any tradition it would have been that of the Italian Renaissance, with its crowded compositions and angelic

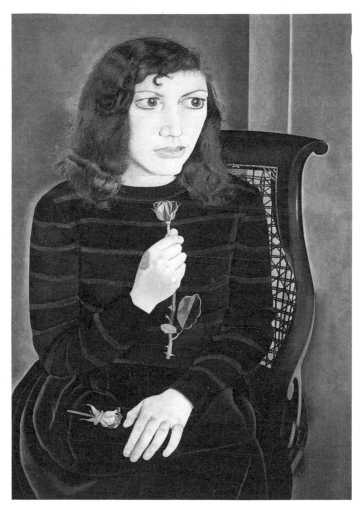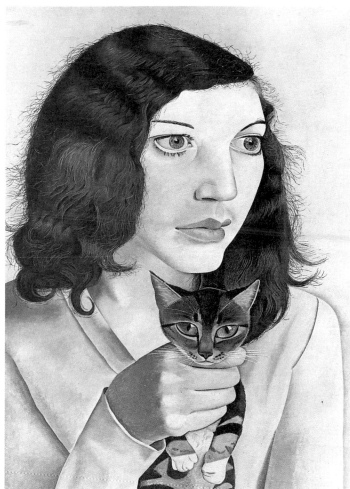

flocks, its delight in the grouped forms of naked bodies, its optimism about what art can express, its sense of its importance and its public.

Nor, despite his two great double-nude portraits, can Spencer be considered a major painter of the nude. The handful of nudes in Spencer's work exist as part of an autobiographical and religious record: his image of village life in Cookham, work-day life, cat-and-dog life, all good expressions of the daily miracle.

What does link Freud's and Spencer's nudes is their peculiarly similar intensity of vision, their insistence on the 'other' as extraordinary, and their indifference to nude 'portraiture' as a rendering of mere likeness. 'I would wish my portraits to be *of* the people, not *like* them,' Freud has said. 'Not having a look of the sitter, *being* them. I didn't want to get just a likeness like a mimic, but to *portray* them, like an actor . . . As far as I am concerned the paint *is* the person. I want it to work for me just as flesh does.'[6]

In a letter to Hilda, Spencer writes:

This difficulty I seem to have of being able to retain as clear a vision of you when you are here or with me, that I can when you are away is rather, in fact exactly like the difficulty I have about painting from objects; with the object in front of me I mean.

180 FREUD, *Girl with Roses*, 1947–8, oil on canvas, Collection of The British Council

181 FREUD, *Girl with a Kitten*, 1947, oil on canvas, Private Collection

207

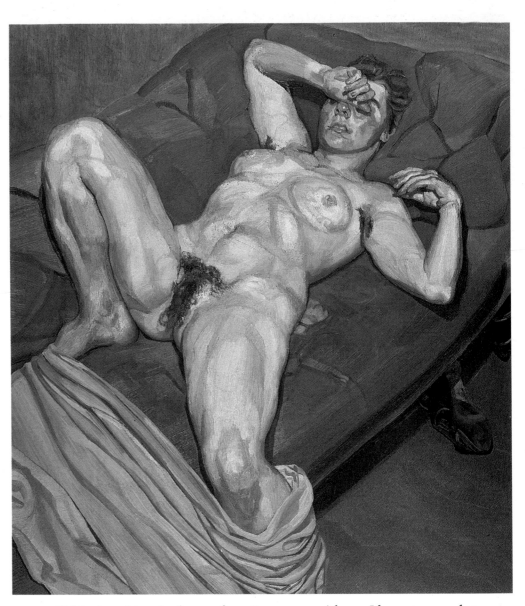

182 FREUD, *Rose*, 1978–9, oil on canvas, Private Collection

With the object in front of me & w. you with me I have to see a lot of things that I have not imaginatively comprehended & don't like & the remedy required in each case is identicle [sic]; confidence, that one can see only perfection wherever one looks . . . [7]

And in another letter he writes, 'When I see you and feel in your presence the same gladness as when I find myself back in my empty room, I do not really need your presence because it does not make me happier than I am without it.'[8]

For both artists, portrayal of the other person required a certain amount of not looking to retain a sense of first impact, novelty or oddness, whatever quality first disturbed the painter into the desire to paint. In order to similarly disturb the person who will see the painting, Freud, at least, needs to import into the work elements extrinsic to simple description of the subject, to add analogous or mysterious

objects, or the suggestions of a story.

Like Spencer in the double-nude portraits, Freud relies on hints of narrative, or on props which will act to dislocate the image from simple statement of appearance, and throw the viewer into a version of the artist's own first quizzical stance in front of it. His props can be dramatic, even melodramatic, as in *Naked Man with Rat*, or *Naked Girl with Egg* (1980–1, Pl. 191), or more subtle, such as the old shoe in *Rose* (1978–9, Pl. 182). Even propless, his best nudes rely on something strange or special in the composition, subject or setting of the painting, or in the condition of the model: see, for example, the pregnant nudes in *Pregnant Nude* (1980–1) and in *Annie and Alice* (1975, Pl. 183). Without such hints of narrative (of peculiar tales told and stopped mid-sentence) or strange props which demand explanation (by a willing viewer), Freud's nudes do not always manage to avoid the look of the academic, and for all the impastoed intensity of the late style can become, in Spencer's sense, vulgarity, not vision.

Freud's first mature painting of the female nude (*Sleeping Nude*, 1950, Pl. 184) has a neoclassicism unlike anything in the later work, and

183 FREUD, *Annie and Alice*, 1975, oil on canvas, Private Collection

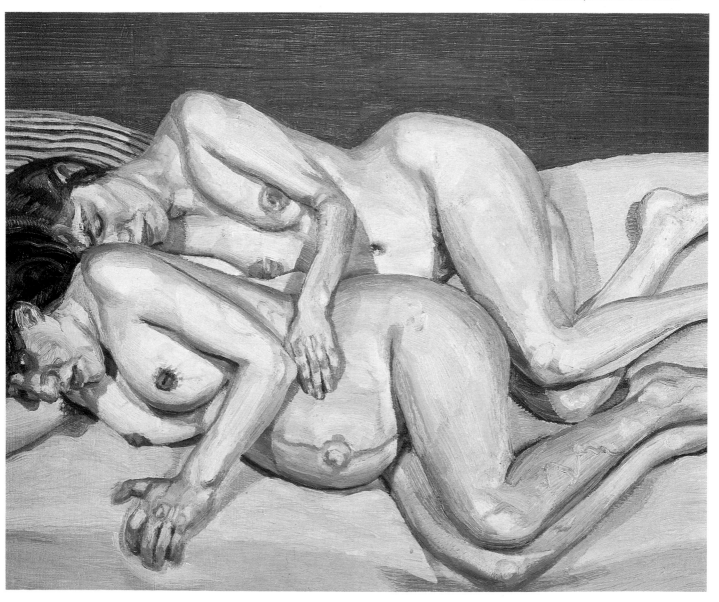

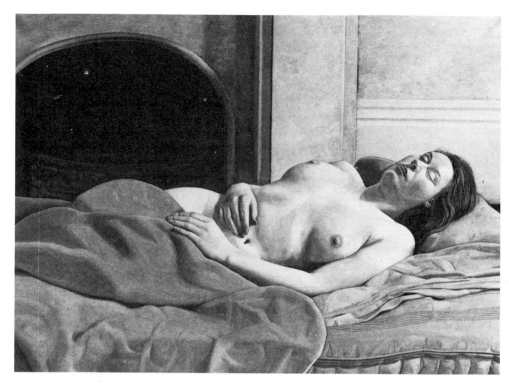

184 FREUD, *Sleeping Nude*, 1950, oil on canvas, Private Collection

185 FREUD, *Portrait Fragment* (detail), 1971, oil on canvas, Private Collection

suggests (in colour and imagery) the possible influence of Magritte or Delvaux. His model, however, is heavier than any of the surrealists' dreaming nymphs, and one can feel already in this work the contradicting pulls between the conceptual and the physical that characterise in different form most of Freud's painting of the nude. The grossness of flesh, its presence in his art, will eventually triumph in the late work over the more intellectual elements — the tendency he has towards symbols and tales. But even when Freud is at his most 'literary', his touch is far too delicate to make his aims seem surrealist; and it is the simplest, most Courbet-like statement of the body which triumphs in the late work (see particularly *Portrait Fragment*, 1971, Pl. 185). In *Sleeping Nude* there is a contradiction, not quite successful, between the unearthly elements — the dream, the pale, dead colour of skin, the lifeless greys — and those parts of the picture that really seem to interest Freud: the heavy hands and breasts, the slack and fleshy mouth, the weight of the model as she lies on her dipping mattress.

Freud's painting of the nude underwent a process in which emphasis seems to have shifted from the artist to his model, or at least to have closed the distance between them. The bridge may be compassion or desire, and in the late nudes it pushes through the artist's characteristic ambivalence. The body no longer shuts the artist out, but becomes a way in. The late nudes are neither whimsical, nor remote, nor 'fascinating', like the work of the 1950s, but often brutally and triumphantly erotic. *Rose*, for example, is a powerful painting, where Freud uses 'ugliness', rawness, crude and reddened features, and yet shows these things to be attributes of a sexual desirability. In the early work, the artist's stance is often that of someone who has entered a room too suddenly, not yet able to adjust to the sight of what's there.

In *Rose*, it is as though the artist has been with the model over a long period of time and is now describing one moment among many jointly experienced. The portrait trails a residue of tender interaction; the 'ugliness' is only a part of the story, referring to recent emotion, body change in a sexual context. The late nudes seem to be offered as parts of narratives: love stories, no longer the gothic stage-sets of the early work.

In *Rose*, there is a suggestion of recent sex not just in the exhausted pose of the model and the colouring of her face, but in the tangle of sheets at the end of the studio couch. The sheets themselves suggest the recent existence of movement and of someone other than the model, their twists and tension echoing the arching of the model's body and of other bodies that can twist and entwine. It is a painting curiously about sexuality, and not desire. Freud totally accepts his subject, yet remains away and above her, in a state of objectivity. His tenderness is dispassionate, embracing the old shoe beneath the couch and the couch itself as warmly as it does the model.

Freud's close-on engagement with his subject, a kind of undefended (by irony or anecdote) confrontation, of which his most powerful and erotic nudes are examples (*Rose*, *Portrait Fragment*, *Pregnant Nude*),

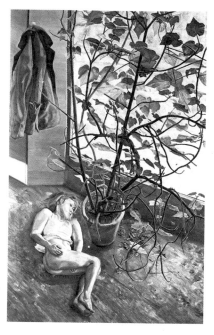

186 FREUD, *Large Interior, Paddington*, 1968–9, oil on canvas, Private Collection

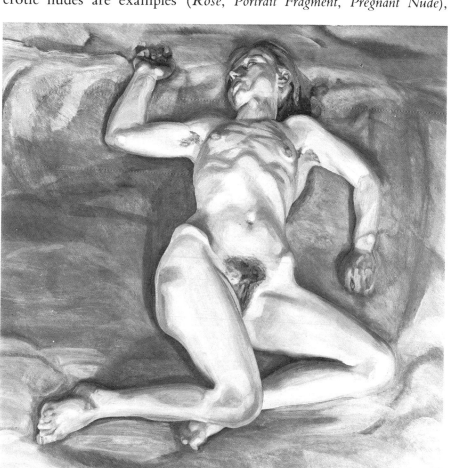

187 FREUD, *Naked Girl Asleep: II*, 1968, oil on canvas, Private Collection

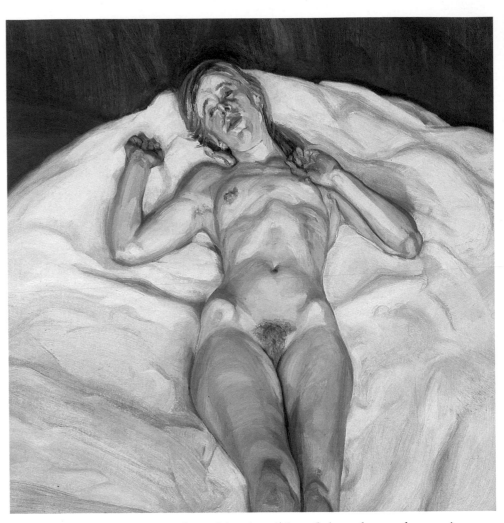

188 FREUD, *Naked Girl*, 1966, oil on canvas, Private Collection

always declare something brutal in the sight of the other and meet it with the artist's own brutal, unflinching, seeing and acceptance. But there is another line which runs through Freud's work at odds with this, and which shows his taste for the pathetic, or rather for that edge the pathetic shares with the grotesque, where the artist refuses to decide between pity and horror. This ambivalence, with its near-expressionist dealings in the pathetic/grotesque, runs consistently in Freud's work from the many early studies of dead animals and birds, of sick or disturbed children, and it often characterises his nudes. There is a built-in ambiguity in the postures of his reclining nudes; it is not always easy to tell a sleeper from an invalid or a casualty (*Large Interior, Paddington*, 1968–9, for example, Pl. 187). In *Naked Girl Asleep: I* and *II* (1967, and 1968, Pl. 186), a woman seems to be lying in pain among twisted sheets, bony, writhing, exhausted. The same model in *Naked Girl* (1966, Pl. 188) lies helpless, unhappy, her face expressing either yearning *or* sickness, so that it is hard to tell whether the peculiar perspective of the painting describes the view of a lover or a doctor.

In *Large Interior, W9* (1973, Pl. 189), an old woman (the artist's mother) sits in a chair under which a mortar and pestle has been placed. Behind her on a bed a strangely foreshortened woman lies under a

212

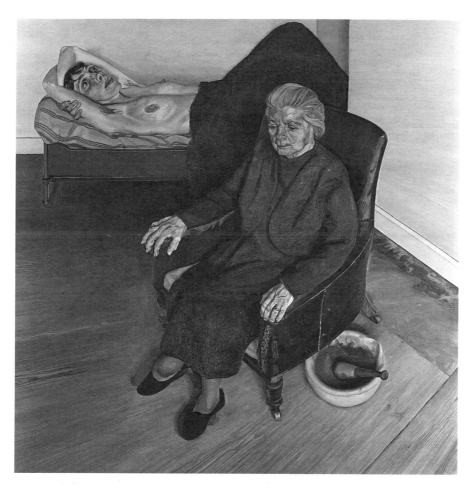

189 FREUD, *Large Interior, W9*, 1973, oil on canvas, Private Collection

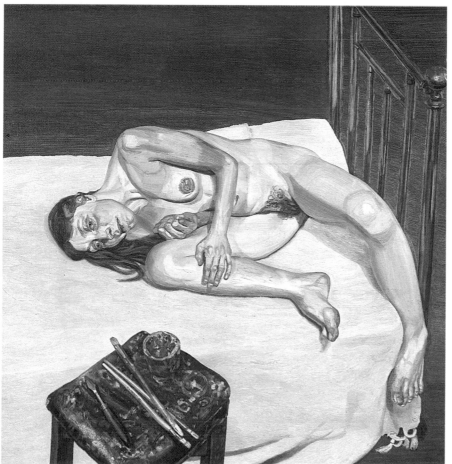

190 FREUD, *Naked Portrait*, 1972–3, oil on canvas, Tate Gallery, London

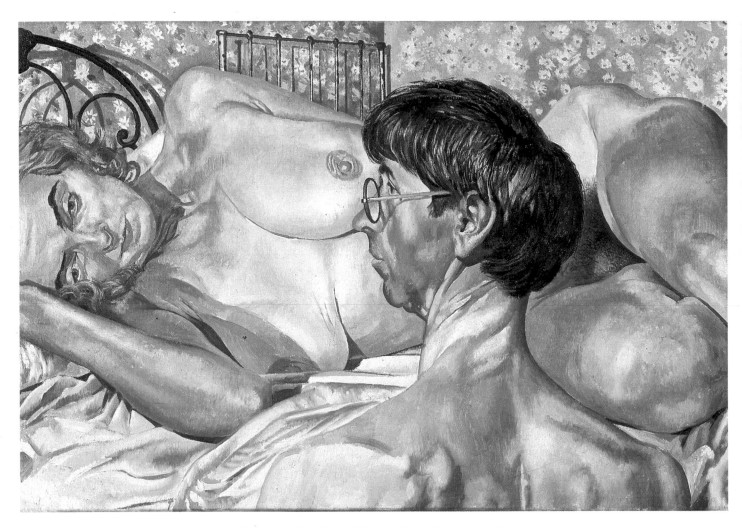

193 SPENCER, *Self-portrait with Patricia Preece*, 1937, oil on canvas, Fitzwilliam Museum, Cambridge

heartlessly, Freud keeps his observer's distance.

This distance is of course one of the great differences between Freud and Spencer. In both Spencer's double-nude portraits, but particularly in *Self-portrait with Patricia Preece* (1937, Pl. 193), the artist forces himself into the picture, posed kneeling by the bed, almost awkwardly close to his second wife. Renouncing the traditional relation of artist to model, Spencer paints himself with Patricia as though his subject were their simultaneous concurrence. It is their proximity that thrills him. The paintings have the urgency of snapshots — the need to document his own presence in a special place (likewise he paints himself among the crowds in the religious visions of Christ at Cookham). In these two double nudes Spencer insists on the specialness of the occasion, the extraordinariness of an ordinary moment: Isn't it wonderful, the leg of lamb, me and Patricia, all in the same space? All three heads lean together for the camera, the camera itself prompting the reunion.

Perhaps, for Spencer, it wasn't the extraordinariness of an ordinary moment that was celebrated by his art, but its reverse. After all, there wasn't anything ordinary about the conjunction of lamb, self and Patricia — nor, I suspect, about him and Patricia together in the nude. Perhaps more than documenting them, the paintings express Spencer's

216

194 SPENCER, detail from *Christ Preaching at Cookham Regatta*, 1953–9 (unfinished), Collection of Viscount Astor, Oxon

wishing himself next to her, a fantasy of how an extraordinary event might be were it ordinary as, for example, Christ in a boater in *Christ Preaching at Cookham Regatta* (1953–9, Pl. 194).

And this really is the difference between Spencer and Freud, the degree to which for Spencer all 'visions', whether sacred or profane, could be expressed through the ordinary events and objects of daily life, whereas for Freud ordinary things — plates of eggs, dog's muzzle, girl's breast — never quite fall into place with the everyday, nor inhabit the same space as the self; for Freud, the other never entirely loses its 'otherness', nor ceases to seem, to the intense observer, eternally separate and peculiar.

NOTES

1 Quoted in John Rothenstein, ed., *Stanley Spencer the Man: Correspondence and Reminiscences*, Paul Elek, London, 1979, p. 42.
2 Quoted in Lawrence Gowing, *Lucian Freud*, Thames and Hudson, London, 1982, p. 190.
3 Quoted in John Rothenstein, op. cit., p. 22.
4 Ibid., p. 21.
5 Elizabeth Rothenstein, quoted in John Rothenstein, op. cit., p. 100.
6 Quoted in Lawrence Gowing, op. cit., p. 190.
7 Quoted in John Rothenstein, op. cit., p. 37.
8 Ibid., p. 67.

BALTHUS

(Count Balthazar Klossowski de Rola)

Balthus is a generous transcriber of appearances, pedantically exact in the details, insistent about where objects begin and end, what light does to colours, what gravity does to forms. Here you are, his paintings tell you, exactly here; this is what it looks like. Yet for all the apparent accessibility, Balthus's world feels both remote and unfamiliar, somewhat staged and a little unsafe.

Dislocation seems intended. Embracing the obvious with apparent urgency, his art forces us to confront and admit to the secrecy of the phenomenal world. By its exactitude and clarity, his work proclaims a suddenness, the brightness of the present moment. And yet something other than the present is offered: an odour of recent events or, more potently, a prognosis of events to come.

The characteristic stillness of Balthus's work endures no longer than a first glance. Quickly his pictures begin to vibrate, objects come apart. As in an earth tremor, we see the glass that is about to shatter, a mirror that is about to crack; this is the moment Balthus prolongs, to make us tense, as a fish is watched too intently by a cat, a nymph sleeps too deeply, lies too vulnerably exposed. The moment, eternalised by Balthus's art, none the less hangs on to its connection with real time, precisely in order to play upon the nerves. There is a consistent double-dealing in Balthus's presentation of time and place. Violence is in the air, and under the clearest of skies.

Balthus paints menace by the most subtle means; he clues obliquely, barely suggests. The burden of interpretation, inventions of narrative, he unshoulders elegantly. Other people, he has said, and with convincing disdain for the vulgarity, insist on reading into the work elements (and particularly erotic elements) which simply are not there. You can see for yourself . . . [1]

Through his not very willing comments on his art, and more so through the rigorous delicacy of his mature work, Balthus discourages interpretation of his images, perhaps because he believes that once a thing is translated, decoded, it is dead. He is enough of a surrealist to believe in the potency of images, the life to come of mysterious forms.

195 *The Street*, 1933, oil on canvas, Museum of Modern Art, New York

But he does not use either of the favourite surrealist manners — neither ambiguity of shapes, nor the conjunction of disparate objects (as in Lautréamont's famous description of the chance meeting of an umbrella and a sewing machine on an operating table) that will mate in surreal dream space. In Balthus's world, both objects and place are real but their condition is perilous, their permanence in doubt. Transformation (breakage, rather than metamorphosis) is latent in images presented as solid in the context of real life, eternal in the context of art. This is the source of the characteristic quiet of Balthus's work, which is nevertheless nothing if not disquieting.

Balthus's subject comes from an ontological bestiary. He paints the thing that is both eternal and transitory, both real and non-existent. His subject is edges, of both objects and states, and the borders between objects that will suggest (occasionally, especially in the earliest work, even a little crudely, symbolise) those in-between states of both body and mind. He paints: a jug too close to the edge of a mantel; open windows and window-frames, doors, thresholds; the state between childhood and maturity; the moment between sleep and waking, or between desire and action; the edge between the inner and the outer world, between innocence and experience.

Time is also seen as an edge in Balthus's art. Characteristically, things are *about* to happen, although in some works the mysterious event may be one that has just passed. A typical Balthus model's pose is one with the leg pushed out, head and arm thrown unnaturally backwards, as though a fatal shot had just been fired, as though the

219

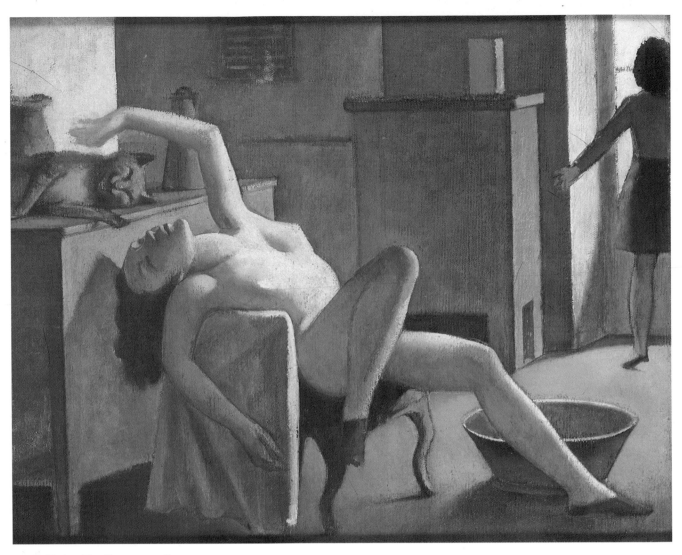

196 *Nude with a Cat*, 1949, oil on
canvas, National Gallery of
Victoria, Melbourne

moment of the painting were the moment of discovery — of a crime
without any clue but the corpse (see, for example, *Nude with a Cat*,
1949, Pl. 196). There is, in fact, an early nude as 'innocent' and
wholesome as anything later and less indelicately named: a little too
reclining, but by no means any more obviously abused, it is called *The
Victim* (1939–46). And in more recent work (*Japanese Girl with Black
Mirror*, Pl. 197, and *Japanese Girl with Red Table*, both 1967–76), a
Japanese model is depicted crawling like someone wounded trying to
reach a phone. Sadism pervades the work like an exotic waft.

Balthus imagines disaster, violence and violation. But with the
exception of some early paintings (such as *The Guitar Lesson*, 1934) he
does not depict it directly. Instead he makes his laconic and elegant
suggestion, preserves the refinement of his sensibility by the delicacy of
his art, allowing us to translate those vibrations in the work into our
own shudder, to make (if we insist) our own grosser response to what
his art pretends to deny is there at all. And this is another of Balthus's
borders between desire and action, good and evil, where his is the

desire, and *ours* the evil. Firmly marking the edge in his work, he allows us to cross it, to complete his thought and, in a sense, the painting, and the transgression it almost names.

Why is it that we insist on arguing with the given in one of Balthus's scenes, or at least in bringing our own contribution to images that seem to proffer completeness, silence, aspire to a kind of frozen perfection — an aspiration which is clearest in his orientally remote landscapes and in such other-world romantic compositions as the Friedrich-like *Girl at the Window* (1955)? How does the artist manage to invite both contemplation of the fixed moment and, at the same time, our interference with it? Part of an explanation has to do with the inherent drama of many of his scenes, theatrical set-pieces like *The Room* (1947–8, Pl. 199), *The Room* (1952–4), *The Moth* (1959–60) and *The Window* (1933, Pl. 198), which use rhetorical gesture and stage lighting, to the point of melodrama. These works, even the 'stillest' of them, suggest narrative, at the very least acts which, if not yet played, are certainly conceived. In other works, relationships are set up among the figures where meaning seems tantalisingly available, yet provocatively withheld, as in those newspaper contests where captionless cartoons promise certain and instant understanding once the crucial text is provided.

197 *Japanese Girl with Black Mirror*, 1967–76, oil on canvas, Private Collection

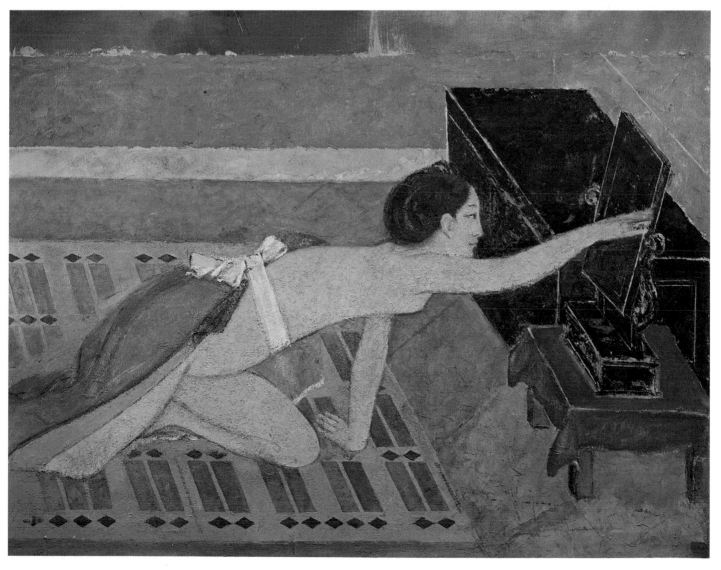

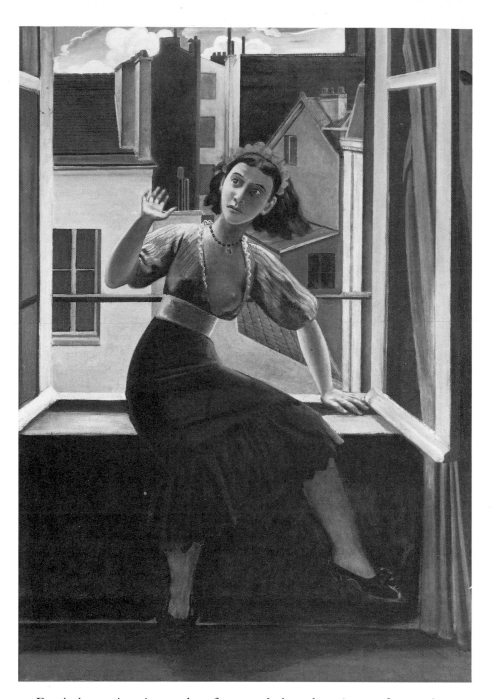

198 *The Window*, 1933, oil on
canvas, Indiana University Art
Museum, Bloomington

But it is not just in works of suspended explanation or frozen theatre
(as especially in the great street scenes like *Passage du Commerce St-
André*, 1952–4, *The Street*, 1929, and *The Street*, 1933, Pl. 195) that we
feel the instability implanted in Balthus's work. It exists throughout the
oeuvre, even in the places where it would seem to have been most
consciously excised.

In *Nude in Front of a Mantel* (1955, Pl. 200), a plump adolescent girl
stands in front of a mirror, lifting her hair with her left hand and gazing
at her reflection. She is seen in profile, and she stands with one foot in
front of the other, like those dead walkers in Egyptian tombs, as tall
and discrete from her surroundings, as bathed in silence as the vertical

figures of Seurat, to whom, in pose and line and softness of colour, she bears evident kinship. The picture is, in more than a punning sense, 'about' a moment of reflection. The stillness, the element of contemplation (by both artist and subject), is reinforced by the picture's setting, built of perpendiculars that describe the architectural details of the elegant room (in 1961 Balthus, then 53, was appointed Director of the Académie de France in Rome, and the formal rooms of the Villa Medici, where the Académie is housed, make their appearance in the late work). Because nothing is firmer than a perpendicular, where opposing forces meet and cancel each other out, these details also create stasis in the picture, and the kind of imposing grandeur and exactitude of placement, the measured separation between foreground and background for which Balthus was indebted to his much-admired Piero della Francesca.[2]

Initially, nothing could be stiller than this image with its pale,

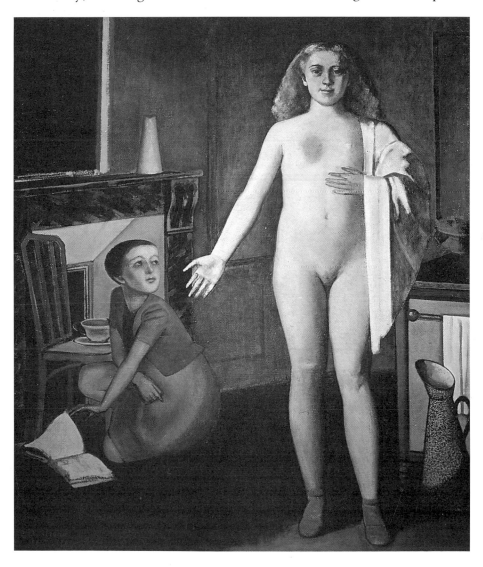

199 *The Room*, 1947–8, oil on canvas, Hirshhorn Museum and Sculpture Garden, Washington

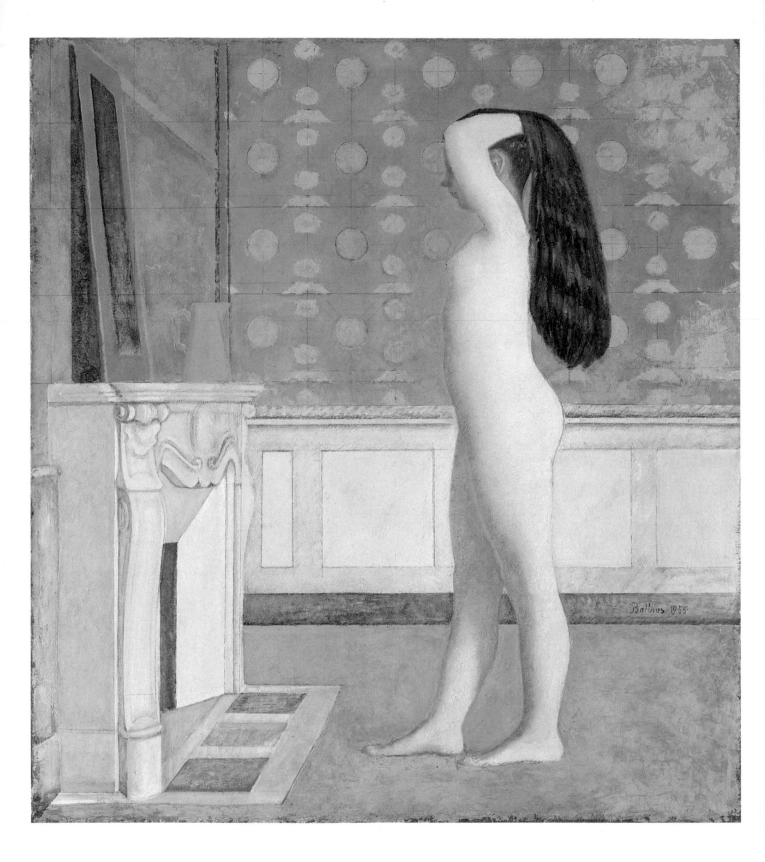

200 *Nude in Front of a Mantel*, 1955, oil on canvas, Metropolitan Museum of Art, New York

201 *Girl with Goldfish*, 1948, oil on canvas, Private Collection

neoclassical colouring, the static geometry of the background and the hieratic stance of the foreground figure, plump, weighted, motionless, gazing. And yet, very quickly, the picture begins the characteristic Balthus quavering as we note the gentle undulating line of the girl's body, the ripples in the heavy fall of hair, the oblique tilts and shadows around mirror and fireplace, the dance of circles on the wall patterns, and the lines of force that escape from the squared-off under-drawing and suggest (as in a diagram) push and direction of movement. We can now see the cracks that disrupt the pattern of the wallpaper, the non-alignment of the stencilled forms. And we soon notice the jug on the mantelpiece, distinct and discordant in its colouring, an electric and unstable blue that vibrates a little dangerously in the colourless room, and seems, now as we look at it, to be sitting perilously close to the edge of the mantel, breakable, like the mirror, and like the moment.

In earlier works the suggestion of imminent breakage is more clearly made. This is particularly true of near-narrative works like *The Greedy Child* of 1937–8, or the series of goldfish paintings done in the late 1940s. In *Goldfish and Candle* (1949), infant, cat and fish in bowl seem to be held in a moment before disaster. In *Girl with Goldfish* (1948, Pl. 201) and *Girl with Goldfish* (1949), the infant and cat are joined

225

around the fish by a young and glassy-eyed woman. The attraction to the goldfish and the hint of imminent catastrophe are, by the addition of the hypnotically staring female figure, lent a suggestion of the erotic.

Adolescent greed is one of Balthus's consistent subjects. It is a greed for experience, an impatience for life to begin. By so often implying calamity in the work, Balthus seems to prize, above all, the moments of desire as yet innocent of action. As in the sensational *Room* of 1952–4, his work often hints at allegory on the themes of innocence and experience; at times an intense preoccupation with virginity and sin seem at the heart of his presentations of calm and disaster.

Rarely in the late work is he as openly symbolic as he is in *Still Life with a Figure* (*Le Goûter*, 1940). Here a young girl stares at a table on whose crumpled white cloth are presented a bowl of fruit (with short leaves and branches still attached), a glass of red wine, and a loaf of spotless white bread, into which a brutally large and sharp knife has been thrust. And a similar table (minus contemplating virgin) is shown in the 1937 *Still Life* (Pl. 202), where to the suggested drama of knife thrust in virgin bread and rumpled white cloth is added a shattered wine carafe.

It is not that Balthus is sentimental about his virgins or about virginity; rather that he sees the state from their point of view. This is the extraordinary perspective of the work, and one which makes plausible his insistence that he is not a painter of erotic subjects. He does not look wolfishly on at his models, remorseful in advance, and in gourmet fashion, for their loss of innocence, but deals with that imminent loss as though from a point inside their bodies, projecting

symbolically on to the physical world the desires and anxieties appropriate to beings on the brink of change. While the objects around the adolescents take on a potent force, Balthus records the fact from a double perspective: the view of the child and the view of the observer, an impartial but knowing being, often symbolised in the work by a cat, a creature with whom Balthus elsewhere identifies.[3]

Balthus's memories of his own childhood, spent in Paris and then in Geneva, are strong. His parents were highly cultured Poles, his mother a painter, his father an art critic, and among the family friends were Rilke (who wrote an introduction to cat drawings by the 11-year-old artist), Bonnard, Derain and Ambroise Vollard. Balthus's brother, Pierre Klossowski, himself an artist, remembers from their childhood the importance of certain books like *Alice in Wonderland*, the sadistic children's tale *Struwwelpeter* and, of course, *Wuthering Heights*, for which Balthus later made a series of illustrations (Pl. 203). He describes their early life as full of Edwardian nursery ritual, regulations and prohibitions, servants, both desirable and authoritarian, and a great deal

203 'Cathy and I escaped from the wash-house to have a ramble at liberty', illustration for *Wuthering Heights*, 1933, ink, Private Collection

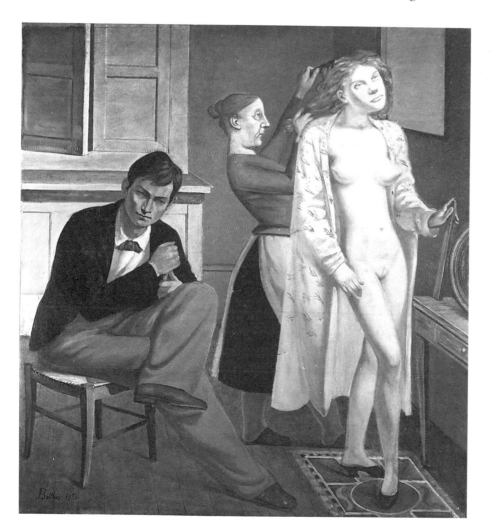

204 *Cathy Dressing*, 1933, oil on canvas, Musée National d'Art Moderne, Paris

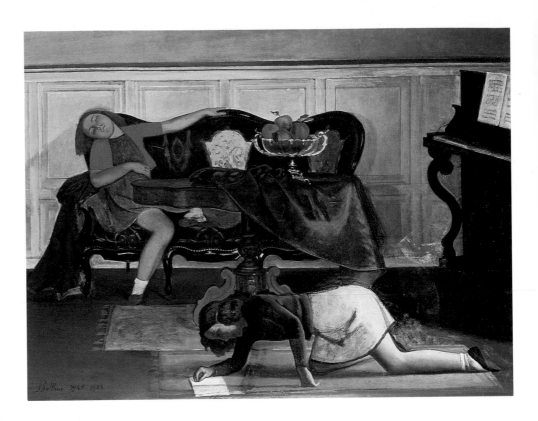

of reading: 'Balthus says that he has never stopped seeing things as he saw them in his childhood.'[4]

Balthus knows the adolescent state of mind intimately, particularly the disconnection between body and consciousness that so often characterises it, and which links it in dreaminess, 'other-worldliness', to that of the artist. Balthus's adolescents are not always aware of their bodies; they lean heavily, gauchely, on tables, sprawl in chairs, kneel clumsily on the floor, reading, head down, body askew; their socks droop around their ankles, their skirts slide upwards; they sit among objects in dangerous inattentiveness. (See *The Children*, 1937, and *The Living Room*, 1941–3, Pl. 205.) Above all, they dream, half hanging out of windows, or half-asleep in chairs. They are often bored, seem eternally to be waiting, and what they wait for sometimes frightens them.

But whereas the little girls in Balthus's work, taking their adventures from books, gazing out of windows, speculating in mirrors on their own desirability, generally long vaguely and ignorantly for experience, Balthus the artist distrusts it. The art itself is only in small part about experience, and that diluted, as the memory of this adolescent desire for it. A larger element is concerned less with life than with art, an obsession evident not just in the numerous quotations in the work from other art (and largely an art of a particularly intellectual, austere kind: Chinese landscape, Seurat, Poussin, Piero della Francesca), but also in its preferences for permanence and artifice, and in its philosophy. His art is about those things which, like art, keep life at one remove, and at a safe distance — mirrors, windows, books, dreams, adolescence, desire itself.

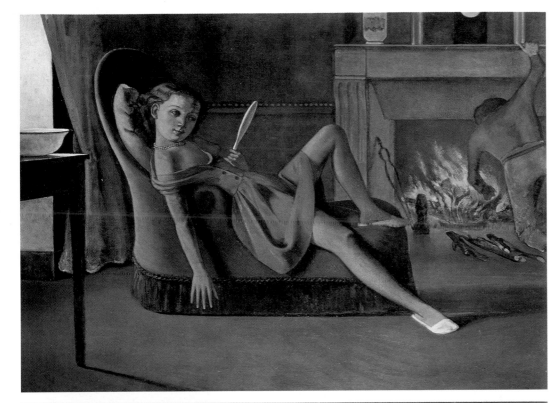

206 *The Golden Days*, 1944–6, oil on canvas, Hirshhorn Museum and Sculpture Garden, Washington

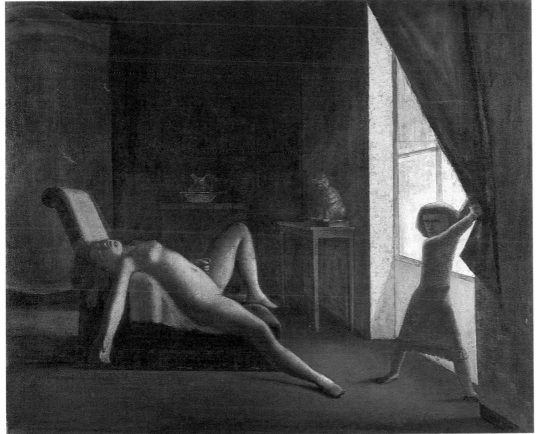

207 *The Room*, 1952, oil on canvas, Private Collection

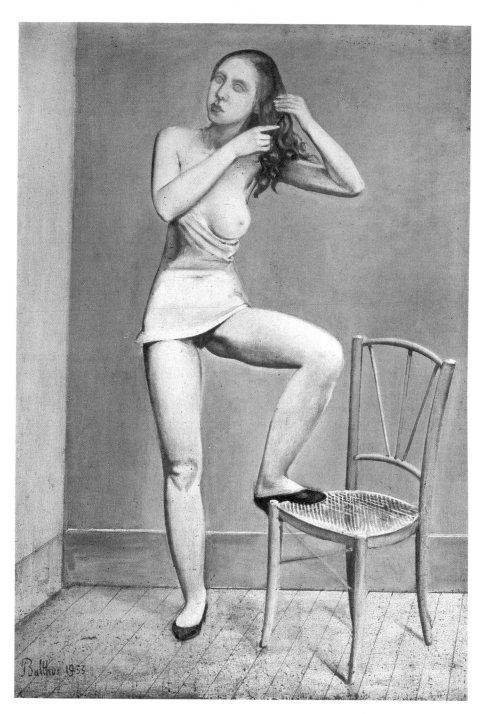

208 *Alice*, 1933, oil on canvas,
Private Collection

Balthus is too subtle a painter, too self-censoring a symbolist, to
make his disappointment with life, or his distrust of it — its violence,
its spoiling — the central subject of his painting; it seems rather to lie
behind his figures as a kind of near-allegorical backdrop, or is expressed
symbolically in more 'neutral' works, such as the 1937 *Still Life*, which
offer themselves as a kind of marginal exegesis on the more important
texts.

In the pictures of dreaming or reading adolescents, the world of
action or experience may be represented by another figure in the scene,

230

such as the grown man stoking a fire in the right-hand corner of *The Golden Days* (1944–6, Pl. 206), where the foreground figure, a pre-pubescent female, sprawls in *déshabillé* and regards her image in a mirror. In such compositions, where Balthus presents one figure inactive (asleep, or reading) and one engaged in action, the deeds of the latter seem often to express a desired or feared projection of the dreamer. This may be dramatically (and, as ever, inexplicitly) rendered as a kind of rape, as in *The Room*, where an enraged and evil-looking child violently draws aside the curtains to expose to bright light a seemingly ravished, certainly ravishable, young nude, defenceless in her deep and luxurious sleep, yet receptive to the light, abandoned to it, in a manner which suggests one inspiration for the work in depictions of mythological women seduced by showers of gold. Or the desired/feared experience may be hinted at less dramatically, as in *Thérèse Dreaming* (1938), where a cat laps greedily at a bowl of milk, placed in the painting just beneath the open legs of the erotically dreaming nymphet above. The sins of these dreamers, if they commit them, are sins of thought only, just as the adventures of those readers of books take place in their minds alone. Again and again one senses in Balthus a tenderness for this time in his own life, when he knew less and desired more, when he perched on the perilous edge of life, like one of his empty containers on a mantel, before the Fall.[5]

In the context of the whole work, and particularly its seeming ambivalence towards life, it is hard not to feel that the peculiar look of Balthus's painting has its source here: that the stillness in the art is an expression of a refusal or fear of action, and, on the other hand, that its peculiar vibration speaks of a desire for it. That desire is both ambivalent and anxious, representing thoughts that for Balthus cannot or should not be completed; and yet, by the many hints and directions, the 'unfinished' symbolism, he seems to ask us to name the thoughts for him, while he remains absolved and art-protected inside the work. There is a sense, too, that however much Balthus, by sheer sophistication, refinement and delicacy, forbids us to make this kind of reading of his art, the art itself prompts it, welcomes it, not just as a means to completion of his thought by our guess but as a kind of rescue. Enclosed by his art, Balthus makes his half-hearted but audible communication with us, who live (presumably) in the real world and in the present.

What about those paintings in which there are neither secondary figures who may be seen as acting out the dreams of his young girls, nor objects that may be taken as symbols, infused by the adolescent mind with qualities of menace or desirability? Where Balthus neither empathises with nor projects feeling on to, but simply observes and records the young female form? When they are undressed and undreaming, Balthus's girls are markedly chaste, graceful, almost asexual in their lack of self-awareness; there is no pose that is either false or provocative, and, where their sensuality is clear, it is shown to be unconscious, merely latent as yet in bodies that have not reached adult

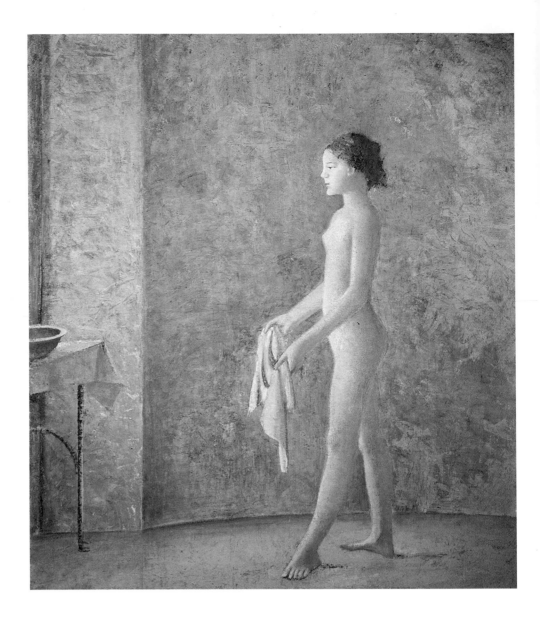

209 *Nude in Profile*, 1977, oil on canvas, Private Collection

210 (opposite) *Nude Resting*, 1973–7, oil on canvas, courtesy of Galerie Claude Bernard, Paris

form. His models do not flirt, nor do they seem self-involved; though they may regard themselves in mirrors, it seems to be with the same objectivity as the artist. These are not temptresses in any sense, but 'nice', matter-of-fact, wholly un-Lolita-ish children, not even old enough, most of them, to have body hair, and hardly even the beginnings of breasts. In *Nude in Profile* (1977, Pl. 209), the subject might as easily have been male as female, and seems more pagan than modern in her total indifference to nudity. It is a painting of a young, not especially 'pretty' girl, standing tall and self-possessed, dignified in bearing, her body in harmony with itself and her light-filled surroundings. Nor does a work like the lovely Degas-esque *Nude Girl with Raised Arms* (1951), for all the animal sensuousness of pose, have the least eroticism about it. The model shows neither self-love nor shame, and not a hint of an intent to seduce. In themselves, individually portrayed, these Balthus girls on the edge of sexual awakening are

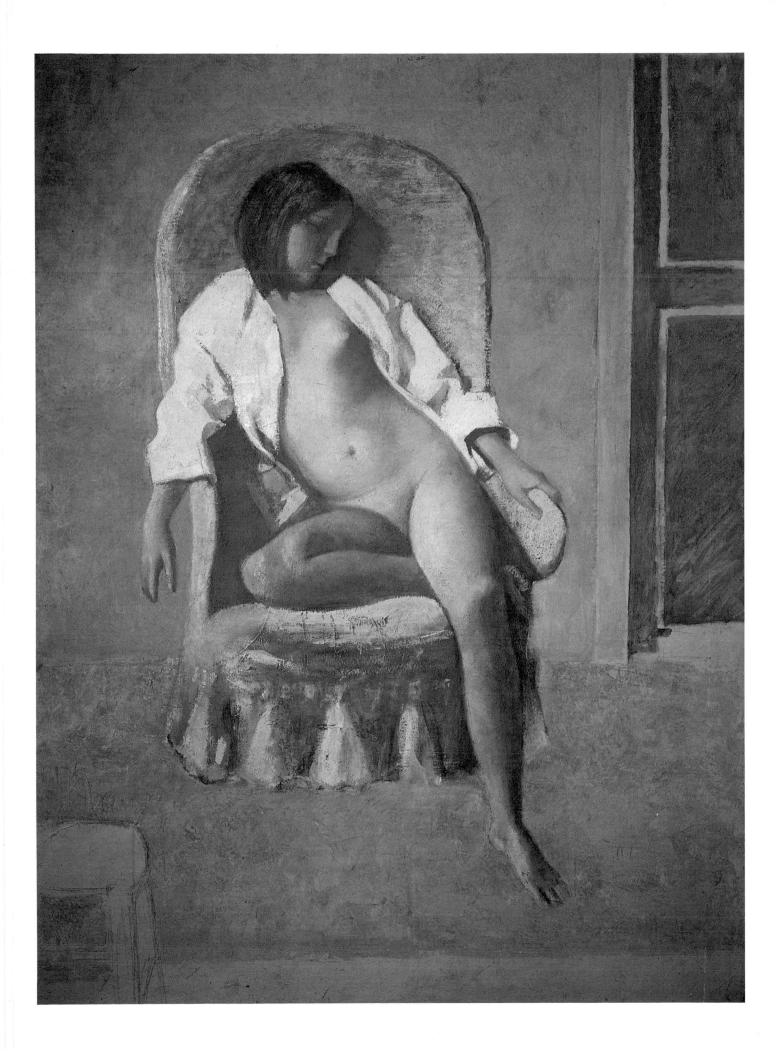

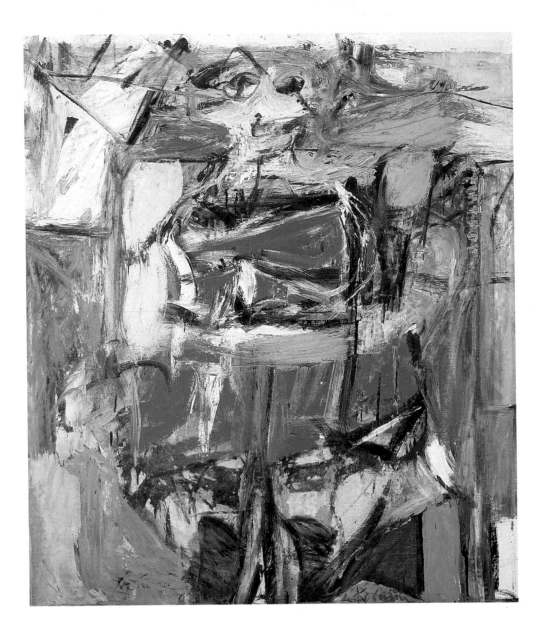

214 *Woman VI*, 1953, oil on canvas, Carnegie Museum of Art, Pittsburgh

Besides, it wasn't just a question of not wishing to be 'ordered around' as an artist; abstractions *per se* were boring to him. Reality, limited by his own perceptions, was enough for him: man was the measure, and only those things a man felt and saw could be the legitimate subject of art:

That space of science — the space of the physicists — I am truly bored with by now. Their lenses are so thick that seen through them, the space gets more and more melancholy. There seems to be no end to the misery of the scientists' space. All that it contains is billions and billions of hunks of matter, hot or cold, floating around in darkness according to a great design of aimlessness. The stars *I* think about, if I could fly, I could reach in a few old-fashioned days. But physicists' stars I use as buttons, buttoning up curtains of emptiness.

If I stretch my arms next to the rest of myself and wonder where my fingers are — that is all the space I need as a painter.[11]

Despite these warnings, however, de Kooning's apparent defection from the non-figurative-art camp, announced by his 1953 exhibition of 'Women' (some six large paintings and related drawings and pastels), was greeted with cries of alarm and accusations of backsliding. His previous one-man show of two years earlier (coincidental with his lecture at the Museum of Modern Art quoted above) had shown the large black and white abstractions that had been heralded as one more step into the future of art, leading, by implication, towards the triumph

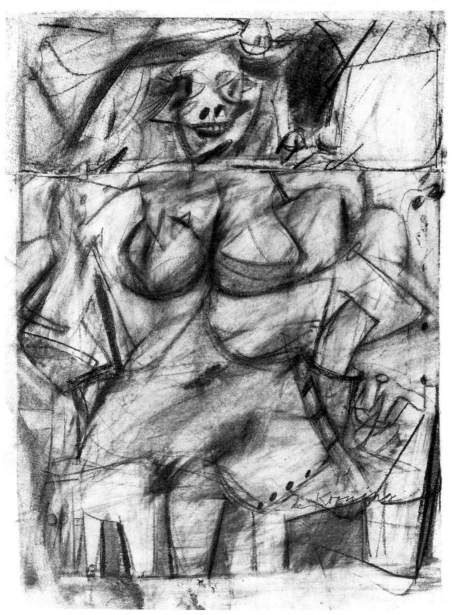

215 *Standing Woman*, 1952, pastel and pencil on cut and pasted paper, Museum of Modern Art, New York

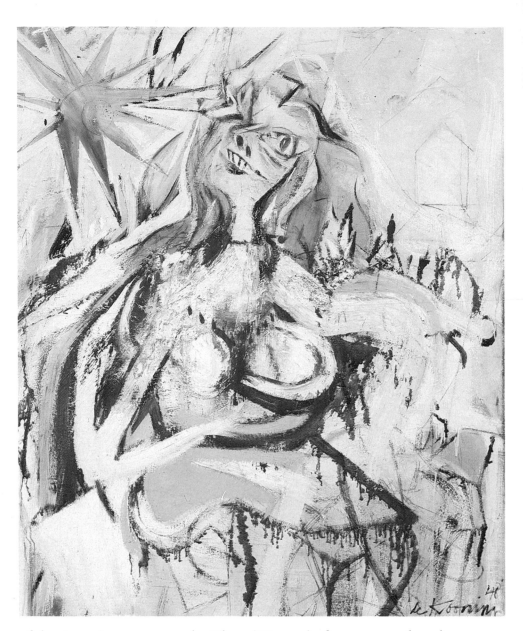

216 *Woman*, 1948, oil and enamel on fibre-board, Hirshhorn Museum and Sculpture Garden, Washington

of the American avant garde. These 'Women' of 1953 seemed to show de Kooning taking a grievous side-step away from the manifest destiny of the home team. The general question, asked in a tone of bewilderment as well as scorn, was: Where does he think he's going?

Ten years later, de Kooning was still defensive about his move from abstraction. In 1963 he told David Sylvester in an interview for the BBC: 'It's really absurd to make an image, like a human image, with paint, today, when you think about it, since we have the problem of doing or not doing it. But then all of a sudden it was even more absurd not to do it. So I fear that I have to follow my desires.'[12] There is a degree to which de Kooning's 'Women' have been seen as simple counters in an art-historical game, a characteristic and dramatic bid for artistic freedom. This is a view de Kooning has always encouraged: 'It may be that it fascinates me, that it isn't supposed to be done,'[13] he told

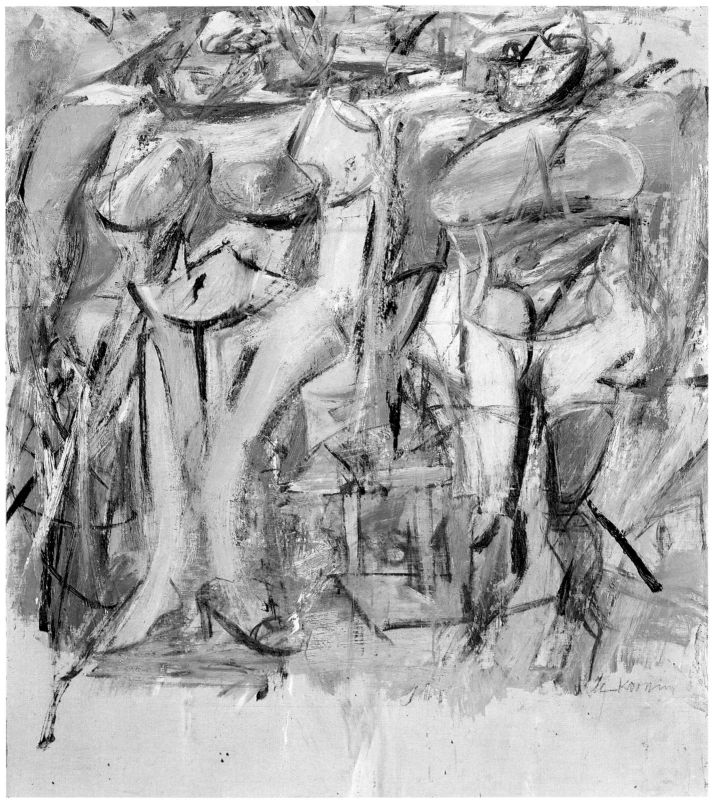

217 *Two Women in the Country*, 1954, oil, enamel and charcoal on canvas, Hirshhorn Museum and Sculpture Garden, Washington

Sylvester. And in 1956, speaking about the 'Women', he told an interviewer: 'Maybe Rembrandt's subject-matter — the beggars and Jews that he liked to go around with or observe — were just as "usual", as cut-and-dried, as Vermeer's interiors or Rubens's fleshy nudes or our swirls of color. They were what happened to be around, what one naturally painted when one got up in the morning and painted simply in order "to paint".'[14]

This was not the way it looked to people who saw the first 'Women' exhibition in 1953. There didn't seem to be much neutrality in the images, those scrawled, blowsy dames about whom Hess said 'you could name a hurricane after any one of them'.[15] They are potent and highly 'expressionistic' renderings in which the wildness of the brush-stroke seems anything but inconsequentially related to the images 'underneath'. As de Kooning himself said in that same interview of 1956: 'About my Woman series — they say that I hate women, that I am a homosexual, that I got the idea from Philip Wylie's book on Momism . . . I like beautiful women,' he insisted. 'In the flesh; even the models in magazines. Women irritate me sometimes. I painted that irritation in the "Woman" series. That's all.'[16] And, rather in the spirit of Flaubert's 'Madame Bovary, c'est moi', de Kooning adds, 'Maybe . . . I was painting the Woman in me.'[17]

Our speculation about de Kooning's relationship to his subject-matter is part of our understanding and response to his art. The art itself establishes the relationship as problematic and important, in its expressionism, in the degree to which the evidence of the act of painting is left inside or on top of the image (de Kooning's 'Women', unlike Rembrandt's, or Flaubert's for that matter, do not exist as creatures perfectly separate from their maker, but bear the scars and bruises of their making). De Kooning incorporates his feelings during the painting into the figures painted, and therefore sets up as relevant (part of the very subject-matter) the question of what these feelings are. In his celebrated essay on Action Painting, Harold Rosenberg stated, 'A painting that is an act is inseparable from the biography of an artist . . . The act/painting is of the same metaphysical substance as the artist's existence. The new painting has broken down every distinction between art and life.'[18] In the case of de Kooning's 'Women', the 'act/painting' has broken down the expected distinction between the final image and the painter's affective life. These disaster girls are victims of a hit and run artist; his tyre marks are still upon them. Their final look is not simply a frenzied depiction, but a record of the artist's tango/entanglement, from which the artist escapes not quite intact, leaving a trail behind him.

De Kooning's is a narrative art, describing events in which he has taken part, and as though they were still happening. The painter does not depict aftermaths but the violent processes themselves — in this way, his art lies closest to the futurism of Boccioni or Duchamp, with its descriptions of passage from virgin to bride, almost a kinetic art in its incorporation of time and process. This involvement with the

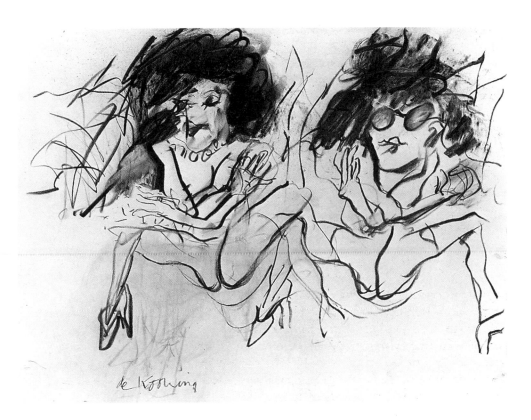

de Kooning

218 Untitled drawing, *c.*1968,
charcoal, Stedelijk Museum,
Amsterdam

process of art-making, recorded as part of the painting, is characteristic of a large body of the work and lends to our sense that these are mysterious stories being told, rather than descriptions of appearance. In the early abstractions that 'look like' corpses, such as *Attic* and *Excavation*, or those of the mid-1970s that look like Rubens compositions seen from the corner of an eye or at too close range, as well as in the more recognisable bodies of women (made of abstracted body parts, as though one were the macrocosm of the other), we perceive that something has happened to the figures, though part of the ambiguity of de Kooning's work derives from our never knowing clearly what that is. In the later 'Women', however, particularly those depicted with most revulsion, those of the 1960s, the narrative element is not present and the painter is far and satirically removed from his subject, and with that distance, surrenders his normal and more interesting ambiguity.

De Kooning himself has described this process of involvement in his work as his getting in and out of a painting, and Rosenberg in his famous description puts it metaphorically as a kind of one-to-one armed combat: 'The painter no longer approached his easel with an image in his mind; he went up to it with material in his hand to do something to that other piece of material in front of him. The image would be the result of this encounter.'[19]

Rosenberg's account seems an accurate description of the making of de Kooning's abstractions, or of Pollock's painting, but in the 'Women' series the image seems, rather than the result of an encounter, the survivor of it. In de Kooning's version of figurative abstract

245

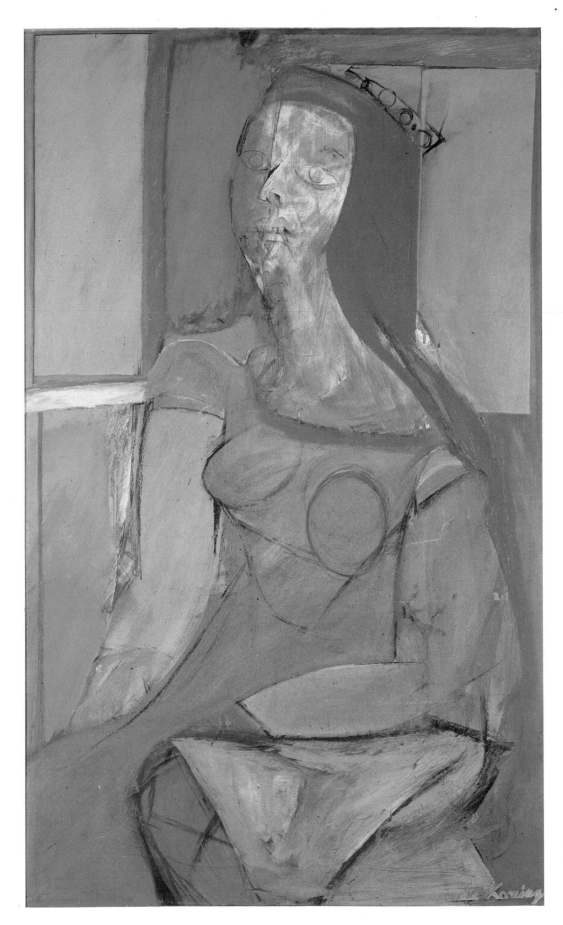

219 *Queen of Hearts*, 1943–6, oil and charcoal on fibreboard, Hirshhorn Museum and Sculpture Garden, Washington

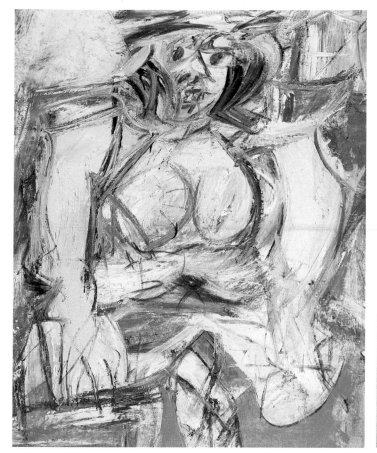

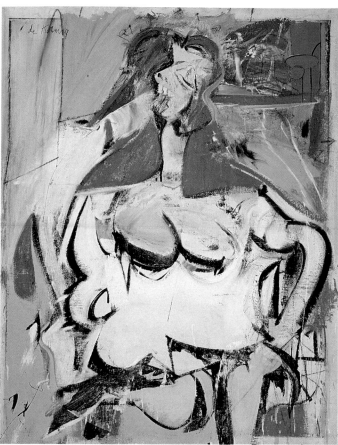

220 *Woman IV*, 1952–3, oil on canvas, Nelson-Atkins Museum of Art, Kansas City

221 *Woman*, 1949, oil, enamel and charcoal on canvas, Collection of Mr and Mrs Boris Leavitt, on loan to the National Gallery of Art, Washington

expressionism, the two elements of figure and feeling do not ever totally adhere; what is done seems *done to*. Expressionism reads as a form of aggression. And because the subject-matter is human — and not still-life, or marine life, or botanical life — this aggressive element is provocative and an ineradicable part of our response to the pictures, no matter with what other elements, comic, art historical, self-cancelling or ambiguous, the image is also endowed.

In the 1940s, de Kooning made portraits of women in which parts of the body were delineated and gently rearranged in the manner of late cubism, the backgrounds similarly cut and recomposed in polite and 'reflective' manner. (In his 1951 talk at the Museum of Modern Art, de Kooning spoke of his admiration for cubism, detecting in the movement 'that wonderful unsure atmosphere of reflection'.[20]) Despite the example of Picasso's recent paintings of women, in which the artist's rage was clearly expressed, de Kooning's female studies at this time are curiously neutral images, without the later work's anger or anxiety. They share with his portraits of men a quality of alienation, remoteness and stillness (see, for example, *Queen of Hearts*, 1943–6, Pl. 219).

In the works of the 1950s, however, the dignity of the female subjects is under attack: gently, as in *Woman I, Woman II* (both 1952)

247

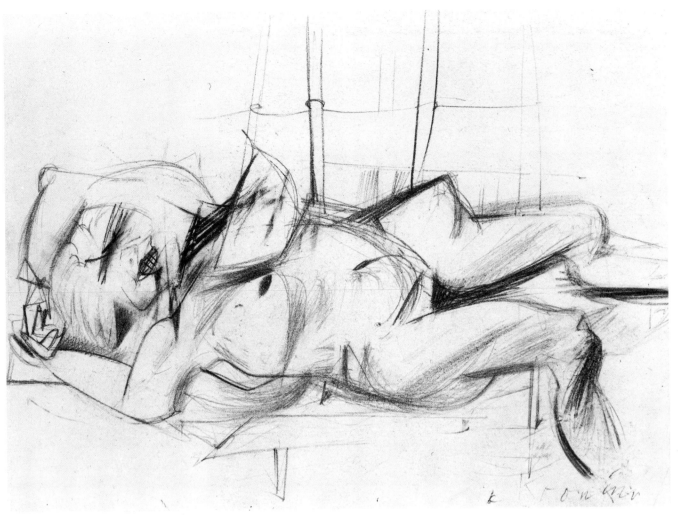

222 *Reclining Woman*, 1951, pencil on paper, Private Collection

and *Woman IV* (1952–3, Pl. 220) (the lady is dumb but good-natured; that slippered kicking foot in the bottom right-hand corner sets the tone); or savagely, as in *Woman* of 1949 (Pl. 221) and in many of the drawings connected with the larger works. In one of these early drawings, *Reclining Woman* of 1951 (Pl. 222), de Kooning offers a monster of swollen breasts and belly, up-ended as on an operating table, with predatory teeth and lascivious grin. The drawing is unusually ferocious, unredeemed by the ambivalence and sweet temper (however superficial) that characterise and confuse the artist's images of women in the 1950s. Its icier directness and its cruelty link it to the drawings of the 1960s.

Between the good-natured dumb-bells and the *sirena dentata* of the 1950s, there is a range of ladies who may be both at the same time. *Woman and Bicycle* (1952–3, Pl. 223) is one of these, a burlesqued burlesque queen with zombie stare and tits flying, right foot coyly arched, a welcoming smile and beneath that, in ferocious repetition, a necklace of grinning teeth.

The 'Women' of de Kooning's 1953 exhibition are ambiguous

248

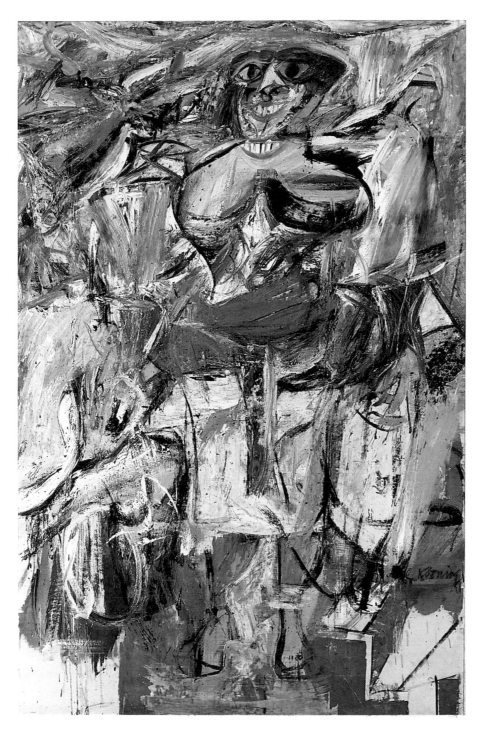

223 *Woman and Bicycle*, 1952–3, oil on canvas, Whitney Museum of American Art, New York

images, grotesque because they are both funny and horrifying (or neither, or nerve-rackingly both at the same time). Their double nature is often concentrated in the grins, the mouths that de Kooning confessed he was obsessed with and for a period of time cut out of magazines and worked into his pictures.[21] These grins can express, as in animal life, both aggression and greeting; they trigger without guiding our own reaction.

249

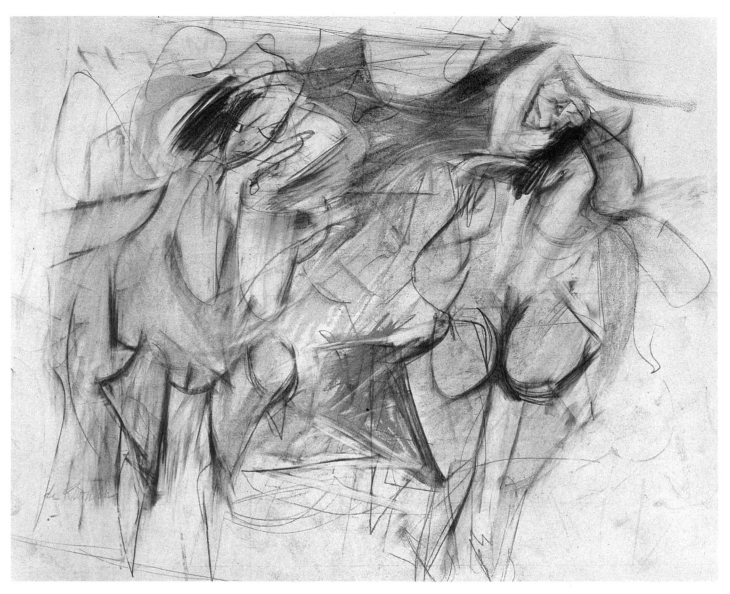

224 *Two Women III*, 1952, pastel, charcoal and graphite on paper, Allen Memorial Art Museum, Ohio

The difficulty of reading the 'Women', as well as our difficulty in finding a single emotional response to them, also comes from the non-figurative part of the painting. The pure drawing, fast and possibly furious, is a kind of scribbling over, suggesting as it mocks the force of the images underneath — as though, as in scrawled-over photographs of a mother or headmistress, it were an expression of disobedience, a feeble revenge against their authority. For all the playfulness in these images, there is an edginess that seems an important part of the artist's response.

Most critics, both hostile and sympathetic, have seen in the 1950s 'Women' misogynist depictions of female power. Hess, in his discussion of them, speaks of the artist's hatred of his mother;[22] Andrew Forge has claimed the paintings can induce 'real genital panic';[23] and Robert Hughes calls them 'one of the most memorable

250

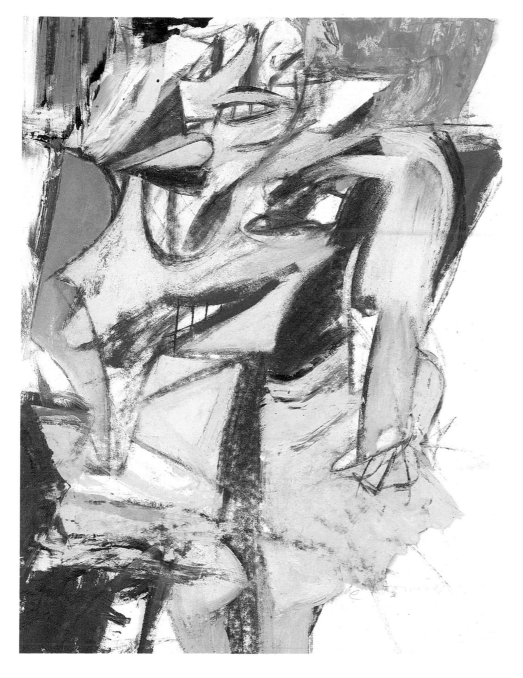

225 *Woman*, 1953, oil and charcoal on paper, mounted on canvas, Hirshhorn Museum and Sculpture Garden, Washington

images of sexual insecurity in American culture'.[24] Even de Kooning has said, 'They have a jungle innocence. The Goddesses — that grin they have. They really scare the pants off me.'[25]

But a simple misogynist reading is not really appropriate for the 1950s 'Women', not just because of the ambiguities with which de Kooning loads the paintings, but because of the power with which he endows them. These are not nice little girls hacked to pieces à la Bellmer, nor wives punished as in certain late-twenties Picassos, but creatures of a supernatural order. Here, de Kooning responds to something other than the factual females — whether mother or lovers

— in his life, moving away from the personal towards the icons of art history, towards Mesopotamian idols and the great nudes of Western art. Part of the ambivalence, and the game of doubly bestowing and removing power, praising and desecrating the images, has to do with their reference to a world that de Kooning addresses again and again elsewhere, and to which his art continually announces its relation: the long past of Western art. 'I was possessed,' he said, speaking of the 'Women' of the 1950s, 'by the idols of art.'[26]

Given that the 'Women' have reference to the traditional imagery of Western art ('The Women had to do with the female painted through the ages . . . the idol, Venus, the nude'[27]), de Kooning's desecrations take on new meaning. Since the scribbling and non-referential brush-strokes are the parts of the work that express him, his feelings, his biographical existence during the act of painting, and since it is with these elements that de Kooning plays his characteristic end-games (scribbling up to a point of muddiness, illegibility and total destruction of the image), they set up a challenge: How much can de Kooning 'express' himself, his feelings — in the parlance of the day, his authenticity — without actually destroying the image? Or, how American abstract expressionist, how progressive, can he be without having to bid farewell to the world of Rubens, Rembrandt, the painters of the Renaissance — all those Europeans and Academicians he left when he quit the Rotterdam Academy of Fine Arts and emigrated at 22 as a stowaway on a ship to New York?[28]

Compared with the all-over structures of de Kooning's previously exhibited abstractions, the 'Women' are traditional in format and presentation, their modernism all on the surface. Years later, Pollock detected the same disguised rear-guard element in de Kooning's abstract works, calling him 'a French painter . . . You know what French painting is . . . All those pictures in his last show [of 1956] start with an image. You can see it even though he's covered it up, or tried to . . . Style — that's the French part of it. He has to cover it up with style.'[29] Actually, the French part of it was the construction underneath; the American stuff lay on top in the wild brush-strokes and cancellations with which he made his public declaration of modernism.

De Kooning's painting refuses to choose between the old and the new. He did not believe that art was a question of progress, but of accumulation. He had praised cubism in 1951, rather against the evidence, as a movement that 'didn't want to get rid of what went before. Instead it added something to it'.[30] Like Gorky, de Kooning's close friend, and at one time an important influence on his art (see, for example, the very Gorky-like portrait of Elaine de Kooning, 1940), and unlike the other abstract expressionists with whom he was linked in the public mind, de Kooning was a European, educated at the Art Academy in Rotterdam, raised inside a Western art culture which he never chose to ignore. For an artist like Pollock, art could be made out of the self, born in a form of parthenogenesis, unfertilised by too much of the old painting. Most modern movements needed to destroy

museums (as Marinetti phrased it) in order to proceed with anything
new, in order really to continue the tradition of making art; but before
this the old had to be experienced as something from which you could
push off. For de Kooning, it was part of the definition of an artist that
what he made related to what went before. It is in this respect that de
Kooning is as ambitious as Pollock, who was more open in his aim to
outdo Picasso. De Kooning takes on whole museums full of nudes with
his 1950s 'Women', whole temples full of female icons; within his own
art he splits himself in two, both the maker of beautiful images and the
desecrater of them. His work is a struggle against his museum/ Midas
touch, and he has used all sorts of tricks (such as left-handed and
blindfolded drawing) to fight against the natural lyricism of his gift. In
the nervy game he plays with his art, he sets up his own oppositions,
creates his own obstacles, cancels his own progress. More than Picasso,
de Kooning is the minotaur, a bull-headed wanderer in a maze of his
own creation.

De Kooning's art plays the kind of game a cat plays with a mouse, of
how long he can maul the image before it goes dead. Despite the
natural elegance of his strokes and the almost unerring sense of
structure in his paintings, it is a game he does not always bring off.
There are some very dead and decomposing women in his harem, and
many that have simply vanished under the brush-strokes. In some of
the 1950s work the element of desecration outweighs the presence of
the icon and the pictures look simply muddy, or deteriorate into what
reads no more clearly than a frenzied scrawl.

The survival of the under–image, even in the more abstract works,
was important to de Kooning. In the anthropomorphic terminology he
often used about his art, he calls the surviving image the 'face' or the
'countenance' of a painting, and describes his encounter with the
picture in terms that suggest how dangerous to it he thought his own
expressionist presence could be:

> I paint myself out of the picture, and when I have done that I either
> throw it away or keep it. I am always in the picture somewhere. The
> amount of space I use I am always in, I seem to move around in it,
> and there seems to be a time when I lose sight of what I wanted to do,
> and then I am out of it. If a picture has a countenance, I keep it. If it
> hasn't, I throw it away.[31]

In his 1963 interview with David Sylvester, de Kooning again insists
that his 'Women' are not intended to be read as discrete images but as
the end results of his game, the dance/combat with art itself:

> I never was interested in making a good painting. I didn't want to pin
> it down at all . . . I didn't work on it with the idea of perfection, but
> to see how far one could go — but not with the idea of really doing
> it. With anxiousness and dedication or fright maybe, or ecstasy, like
> the *Divine Comedy*, to be like a performer: to see how long you can
> stay with that imaginary audience.[32]

253

226 *Woman, Accabonac*, 1966, oil
on paper on canvas, Whitney
Museum of American Art, New
York

227 *Woman, Sag Harbour*, 1964,
oil on wood, Hirshhorn Museum
and Sculpture Garden,
Washington

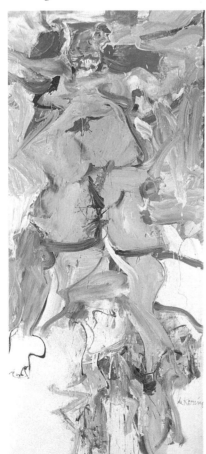

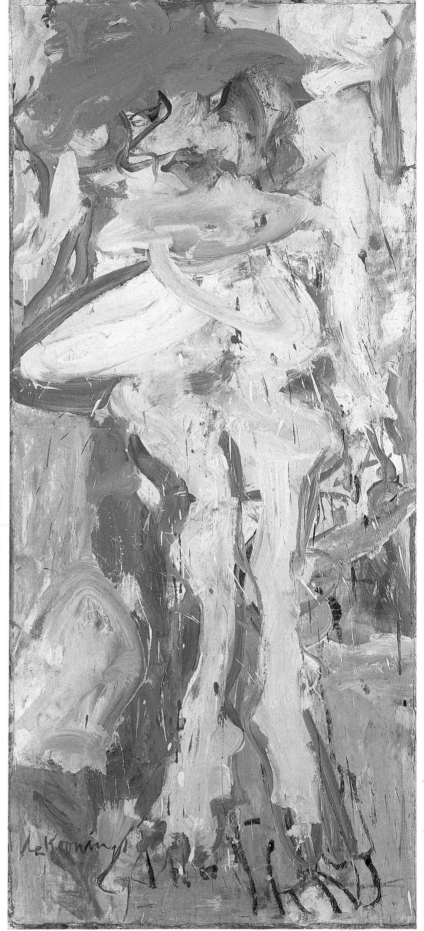

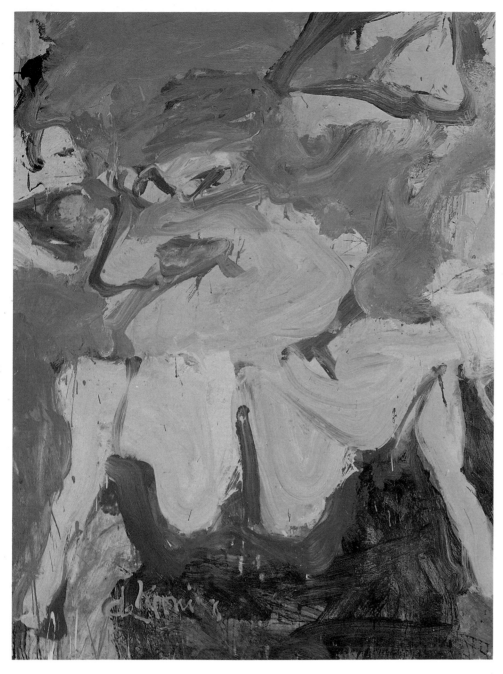

228 *Woman on a Sign II*, 1967, oil on canvas, courtesy of Allan Stone Gallery, New York

In the women that de Kooning painted in the 1960s the element of desecration is clearer. These are less ambiguous and more 'misogynist' images. The goddesses have become harpies, having less to do with art-historical deities than with the art-world groupies de Kooning was increasingly surrounded by. In 1963 the artist left his New York studio to move to Springs, East Hampton, in an attempt to avoid the worst effects of his exceptional fame. Pictures like *Woman, Sag Harbor*, 1964 (Pl. 227), and *Woman, Accabonac*, 1966 (Pl. 226), are vengeful scrawlings, sometimes nearly masochistic in their announced revulsion. In *Woman, Sag Harbor*, the grin of greeting, the offered presence of the

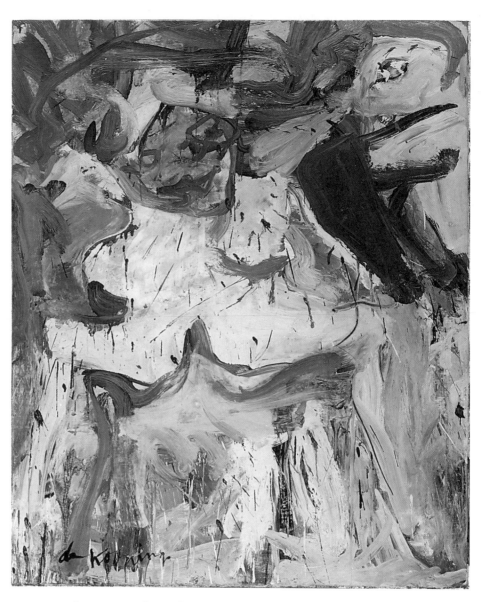

229 *The Visit*, 1967, oil on canvas, Tate Gallery, London

woman, is seen as horrific, as it might be to a man who was now constantly offered such grins of greeting, such sexual hospitality. In works like these the women are unambiguously naked, but with no museum-reverential nudity. These are menacingly undignified girls, nightmarishly available, extravagantly undesired.

When clothed, the 1960s women — floozies and urban week-enders, ridiculous in their short skirts and bouffant hair-dos, parading their 1960s sexuality — are equally ludicrous in de Kooning's vision. And unlike the displaced, 'no-environment' women of the 1950s, de Kooning's abstracted nudes from nowhere, these ladies are firmly linked to the real environment of the Hamptons, and to real time. This seems to allow greater scope for mockery. In a drawing of 1968 (Pl. 230), an expressionist image (a combination of Munch/Nolde screaming head and Schiele exposed genitals) is viciously parodied by the contemporary figure that stands next to it, mini-skirted and high-heeled, echoing the expressionist howl of pain with a cocktail party hysteria.

256

With these ladies, de Kooning does not get into the picture and dance, but looks on, appalled, noting appearances and brutally satirising. There is not much good nature here, though some of his bathers (*Clamdiggers*, 1964, for example) are no worse than the Gold-Diggers of 33, 'today's cuties',[33] in Rosenberg's patronising description, the granddaughters of the Brighton Beach peroxide blondes of Reginald Marsh. Other bathers are less benignly rendered, butchered in the manner of Soutine or Bacon, both of whom de Kooning very much admired. In these later paintings the sexual ferocity his audience first detected in the 'Women' of the 1950s becomes explicit. *The Visit* of 1967 (Pl. 229) shows a harpy in frog squat, a nightmare visitation recorded without the least welcome by the visited. This creature (a descendant of one of the *Demoiselles d'Avignon*) reappears frequently in the paintings of the period — in *Woman on a Sign II* and *Woman in the Dune*, both of 1967, a rough year for de Kooning ladies, and in drawings such as the 'double-acts' of 1967 and 1968 (Pl. 218 and Pl. 231), like some obsessive porno image, part pin-up (split-beaver shot), part candid-camera snap of women caught in the undignified posture of outdoor defecation.

In the late works, the image moves further and further from the artist, recorded at a horrified or amused distance, pinned in all its grotesqueness like some hideous biological specimen, vaguely amphibian, to be found by the shores of Long Island. In the long process of de Kooning's dealings with 'Women' (the last of which may

230 Untitled drawing, 1968, charcoal on paper, courtesy of Xavier Fourcade Inc., New York

231 Untitled drawing, 1967, charcoal, Collection of Gianluigi Gabetti, Turin

232 *Hostess*, 1973, bronze,
courtesy of Xavier Fourcade Inc.,
New York

233 *Seated Woman*, 1969–80,
bronze, courtesy of Xavier
Fourcade Inc., New York

be the sculptures of the 1970s★), the image has moved circularly from the first fellow-alienated being in the works of the 1940s, through the participations and 'encountering' of the 1950s, gradually spewed out in the 1960s with the marks of the artist's digestive tract still upon her. In her last, sculptured, manifestation, *Bar Girl* (retitled *Hostess*) of 1973 (Pl. 232), for example, she bears recognisable kinship with the rippled, water-reflecting painted women of the 1960s, but as a three-dimensional object she is rendered as clearly remote, more literally an 'other'. These final sculptures are the solid, battered and, as in the case of the *Seated Woman* of 1969–80 (Pl. 233), not entirely reconstituted remains of the artist's process of putting himself in and taking himself out of his art. They are recognisably survivors, and what they have survived — slumped, gouged, pushed and punchy, fatigued, greatly aged — is their long, punishing encounter with de Kooning.

★ De Kooning began to make sculptures only in 1969.

NOTES

1 'Content is a Glimpse', interview with David Sylvester, 1963; reprinted in edited form in *Location*, vol. 1, no. 1, Spring 1963, and quoted in Thomas B. Hess, *Willem de Kooning*, exhibition catalogue, Museum of Modern Art, New York, 1968, p. 15.
2 Script of Time-Life film on the artist, *Sketchbook: Three Americans*, Time-Life Books, 1960.
3 Harold Rosenberg, 'The American Action Painters', *Art News*, vol. 51, no. 8, December 1952, pp. 22–3, 48–50; reprinted in Rosenberg's *The Tradition of the New*, Horizon Press, New York, 1959, pp. 25–8.
4 Quoted in Thomas B. Hess, op. cit., p. 15.
5 Interview with Harold Rosenberg, quoted in de Kooning retrospective exhibition catalogue, Stedelijk Museum, Amsterdam, 1968.
6 Ibid.
7 *Sketchbook: Three Americans*, loc. cit.
8 Selden Rodman, *Conversations with Artists*, Devin-Adair, New York, 1957, pp. 101–2.
9 Quoted in Thomas B. Hess, op. cit., p. 100.
10 'What Abstract Art Means to Me', written for symposium, Museum of Modern Art, 5 Feb. 1951; reprinted in Thomas B. Hess, op. cit., p. 144.
11 Ibid., p. 146.
12 'Content is a Glimpse', loc. cit., p. 148.
13 Ibid.
14 Selden Rodman, op. cit., pp. 102–3.
15 Thomas B. Hess, op. cit., p. 79.
16 Selden Rodman, op. cit., p. 102, and in *Scrapbook*, notes for exhibition catalogue, Museum of Modern Art, 1968.
17 Selden Rodman, ibid.
18 Harold Rosenberg, op. cit., reprinted in Maurice Tuchman, *New York School: The First Generation*, New York Graphic Society, Greenwich, Connecticut, 1965, pp. 18–19.
19 Ibid., p. 18.

20 Thomas B. Hess, op. cit., p. 146.

21 Interview with David Sylvester, in Thomas B. Hess, op. cit., p. 149.

22 Thomas B. Hess, op. cit., pp. 12, 75.

23 Andrew Forge, 'De Kooning's "Women"', *Studio International*, vol. 179, no. 906, December 1968, p. 246.

24 Robert Hughes, *The Shock of the New*, Alfred A. Knopf, New York, 1981, p. 296.

25 *Sketchbook: Three Americans*, loc. cit.

26 Ibid. See also de Kooning's essay, 'On the Renaissance and Order', written in 1950 for an artists' lecture at Studio 35 on Eighth Street, New York, and reprinted in Thomas B. Hess, op. cit., pp. 141–3.

27 Thomas B. Hess, op. cit., p. 148.

28 In 'The Renaissance and Order' de Kooning spoke of the 'train track in the history of art that goes way back to Mesopotamia. Duchamp is on it,' he says. 'Cézanne is on it. Picasso and the Cubists are on it; Giacometti, Mondrian and so many, many more — whole civilizations . . . I have some feeling about all these people — millions of them — on this enormous track, way into history. They had a peculiar way of measuring. They seemed to measure with a length similar to their own height. For that reason they could imagine themselves in almost any proportions. That is why I think Giacometti's figures are like real people. The idea that the thing that the artist is making can come to know for itself, how high it is, how wide and how deep it is, is a historical one — a traditional one I think. It comes from man's own image.' And: 'I do feel rather horrified when I hear people talk about Renaissance painting as if it were some kind of buck-eye painting good only for kitchen calendars . . . When I think of painting today, I find myself always thinking of that part which is connected with the Renaissance. It is the vulgarity and fleshy part of it which seems to make it particularly Western. Well, you could say, "Why should it be Western?" Well, I'm not saying it should.

'But, it is because of Western civilization that we can travel now all over the world and I, myself, am completely grateful for being able to sit in this ever-moving observation car, able to look in so many directions.' Quoted in Thomas B. Hess, op. cit., pp. 142–3.

About the pressures on de Kooning of both Americanness and notoriety, he says, 'It is a certain burden, this American-ness. If you come from a small nation, you don't have that. When I went to the Academy and I was drawing from the nude, *I* was making the drawing, not Holland. I feel sometimes an American artist must feel like a baseball player or something — a member of a team writing American history . . . I think it is kind of nice that at least part of the public is proud that they have their own sports and things like that — and why not their own art? I think it's wonderful that you know where you came from — I mean you know, if you are an American, you are an American.' Interview with David Sylvester, Thomas B. Hess, op. cit., pp. 147–8.

29 Quoted in B. H. Friedman, *Jackson Pollock*, Weidenfeld & Nicolson, London, 1973.

30 'What Abstract Art Means To Me', Thomas B. Hess, op. cit., p. 146.

31 'Artists' Sessions at Studio 35 (1950)', in *Modern Artists in America*, first series, Wittenborn, Schultz, New York, 1951, reprinted in Maurice Tuchman, op. cit., p. 25.

32 Thomas B. Hess, op. cit., p. 149.

33 Harold Rosenberg, *De Kooning*, Harry N. Abrams, New York (c.1974), p. 35.

PHILIP PEARLSTEIN

Periodically, Pearlstein issues edicts about what may and what may not be read into his nudes: no imported drapery, please, of expectation, neither from years of familiarity with art history nor from notions of human nature (all our mean and ignorant suppositions of what an artist must feel about naked bodies). No guesswork, please; the painting is to be seen as it has been painted. Pearlstein is very strict about this, hanging on to the paintings far longer than most artists feel they have a right to: beyond his own involvement, right up and into the brain of the viewer. Bear in mind, he says, that what you think you see is not there. Less is more, says this emperor of closed nudes.

'I chose the artist's model, the naked person, as the subject of my re-education as a painter because of convenience,' Pearlstein says.[1] But one could say the reverse of this was truer, that the naked person was chosen precisely for inconvenience. Pearlstein's art fights (which is not the same as ignoring) the viewer's tendency — indeed, the artist's tendency — to ascribe emotional, psychological, erotic significance to the human subject-matter of the work. Such instinctive readings Pearlstein dismisses as 'literary', i.e. irrelevant to the artistic endeavour and, beyond that, by implication, low-brow, vulgar. 'I only care about the visual aspects of the painting,' he complains. 'I don't want the burden of literature thrust upon me when I only want to use my eyes.'[2] Ducking this burden is the nature of the exercise. In fine (perverse) abstract expressionist tradition, Pearlstein wants his game as tough as he can make it. For this inheritor of abstract expressionist rhetoric and method (which is to paint where it is impossible, act when it is impossible, move where there are no exits), bouncing between no-go areas is the only way to proceed.[3] And Pearlstein does paint the impossible, or at least the endlessly debatable: 'things as they are', as he has claimed. His ambition is no less than to have us see the human form as though observed by the non-human observer. His nudes, in fact, are the nymphs of Bishop Berkeley's forest.

Such a conditional subject requires a subjunctive mode. But this Pearlstein shirks. His art states not 'this is as I might see', but 'this is as it is'. It is the declarative stance of Pearlstein's work that may make us unwilling to co-operate, that may make us balk a little at his revelations. The doubt inherent in the abstract expressionist vision irritates him;

understandably, he prefers to accept their procedures without the apparent masochism. 'An abstract expressionist painting like a Cézanne is never complete,' he wrote in 'A Realist Artist in an Abstract World'.[4] 'The artist is always in doubt. "Does it work?" is the question he always asks himself, and to demonstrate his moral integrity he must always answer "no" and try again.' But Pearlstein has found a better way: 'As I concentrate on detail after detail pulled by my eyes from the setup in front of me there is no room for existential doubt. [But there is always room!] When working from life everything is instantly verifiable, measurable . . . I deny myself the luxury of emotional anxiety and indecision . . . '[5]

This, in art-world terms, is out-Luthering Luther, and not altogether to be believed. For all Pearlstein's no-nonsense approach ('My aim is to be the mechanic of art. How a picture is put together is all I'm interested in. Content is not interesting. What is interesting to me is how the page is divided . . . '[6]), his stance and aims seem little short of missionary. He has something far grander in mind than the icy minimalism attributed to him, than his own puritanical professionalism seems to endorse. Under the shop-talk, a nearly theological discourse lurks. His subject is really not the nudes so much as the facts and nature of seeing; but it is a very special kind of seeing, cleansed of human error, the baggage of the ego: poetry, romance, eroticism, fear and

234 *Two Female Models on Eames Chair and Stool*, 1976–7, oil on canvas, Private Collection

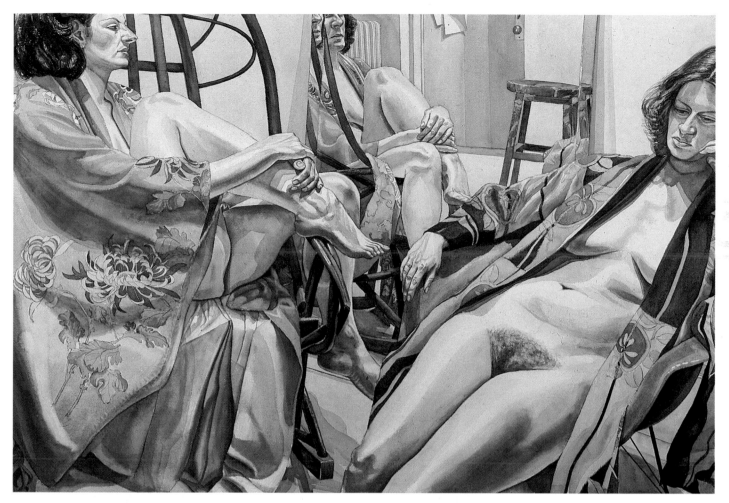

expectation. Trading a personal view — ego-blinded, habit-ridden — for something larger, he approaches the divine, the Creator's view, perhaps, that which sees all, accepts all, knows all.

Wanting nothing is the key, innocent looking (or 'dumb painting' in the artist's borrowed phrase) the method. At war with his own ego, the artist must paint himself out of the picture, ruthlessly censor those interfering signs of the painter's life and feeling in order to better *serve* the truth before him. As it was for Rothko, so for Pearlstein painting is a form of meditation, an exercise in awareness. Transcending the self, through the particulars of time and place — the model, the room, the day on which the painting is made — Pearlstein hopes to arrive at a point where (in his own Zen phrasing) 'the image and the imager become one'.

Pearlstein cultivates the discipline of 'not-seeing', or non-discriminatory seeing ('dumb painting'), and, registering neutrally, so that his consciousness opens equally to the arch of a foot or the shadows cast by a chair, he finds he is able to see and set down more, capture more of what is really there. People who find his paintings unfeeling have this complaint: that he doesn't distinguish between the human and non-human in his work but ascribes to every element an equal value. Nor are they comfortable with the unflinching clarity of a vision that seems

235 *Two Female Models in Kimonos with Mirror*, 1980, watercolour on paper, Collection of Gilda and Henry Buchbinder, Chicago

263

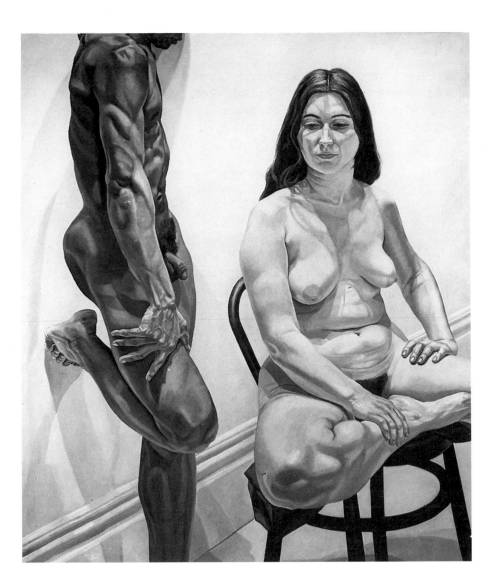

236 *Standing Male, Sitting Female Nudes*, 1969, oil on canvas, Collection of Mr and Mrs Gilbert F. Carpenter, North Carolina

neither to forgive nor to cherish. Perhaps it is his theology which is disturbing: the divine vision for which he strives may be too Eastern for us, his god too impersonal, beyond notions of compassion or forgiveness.

Yet despite the self-effacement demanded by the method, Pearlstein's work often seems immodest in its aspirations, arrogant in its refusal to acknowledge the ordinary (low-brow) associations of the subject. Arrogant and futile. For all the talk of 'things as they are', exact measurements, for all the pseudo-science and vaunted empiricism, Pearlstein's paintings reek — and happily so — with evidence of Pearlstein's self, his refusals and prejudices, his tastes (all that plain-speaking furniture: Amish rockers and Eames chairs; the Calvinist hedonism of the familiar and democratic: cheap flat weaves and silk-screened kimonos, the manufactured arabesques on furniture and fabric-decoration, more synonymous with than actually beautiful, above all, conventional, bright but banal). There is a description, too, of his milieu — artist and critic friends in the portraits, in the nudes

'middle-class America without its clothes on', as Pearlstein has described his models,[7] 'very specific types of people, New York types — university types', young black or white professionals, consistently recognisable though naked: the expressionless, middle-income occupants of an average New York City subway car on its way to the Upper West Side.

But we don't need these clues to recognise the man in the work. His print lies in every stroke of paint, making a signature that will irrevocably interfere with the pristine sight intended. Pearlstein is not, after all, a photo-realist. Nor is he a 'mechanic of art', but a passionate man hoping to arrive at higher things through the fight against human failing. Like Mahatma Gandhi, Pearlstein tests himself with naked maidens; like Elmer Gantry, he is doomed to succumb. Again and again he makes it clear how much, and for all the 'vulgar' reasons, he reveres his subject.

237 *Female Model on Ladder*, 1976, oil on canvas, John and Mabel Ringling Museum of Art, Sarasota

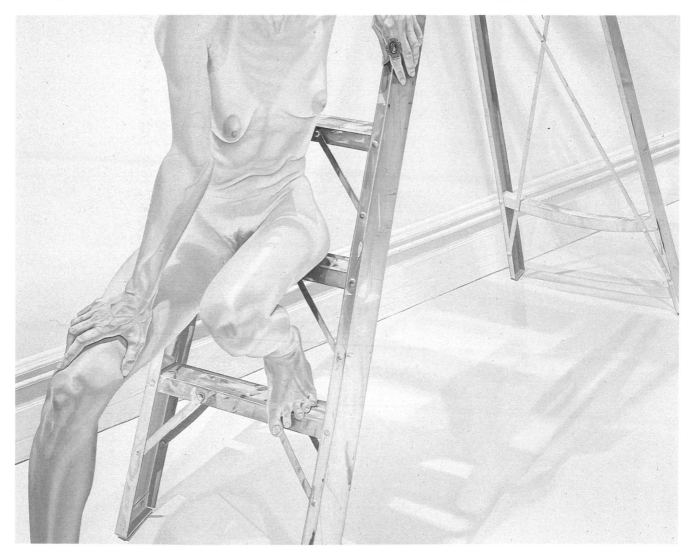

Pearlstein often manages to triumph through his own perversity, struggling to depict the (but for his intentions) erotic and psychologically fertile subject, both elaborately (every little toenail) and with constant show of indifference. Unlike de Kooning, Pearlstein does not directly set down and cancel his markings, but merely implies cancellation by the 'attitude' of the painting. For example, he presents a woman's breast but then lights it to extinction (most of the coldness of Pearlstein's work can be traced to his studio wattage), or at least to the extinction of its erotic–romantic value. Or so he thinks. Actually, many people find Pearlstein's nudes quite erotic; though many more find them, as the artist reports, 'a turn-off'. In any case, few I suppose would find them accurately stated or just 'as they are in life'. I would guess that more of us are likely to respond to the poetically described, intensely rendered body-part (the cradled breasts of Rubens's *Portrait of Hélène Fourment in Fur Coat*, for example) with a sense of absolute recognition (yes, that is precisely how it looks) than to most of what's on display in Pearlstein's car-showroom-lit studio universe. There is more to seeing than meets the eye.

Filial revolt against abstract expressionism was bound to take the route of service to subject and technique rather than to Self and Feelings. Like some philosopher's child who, irritated with his father's inability to provide, leaves home to take up a career in hardware, Pearlstein's devotion to material fact and craft often seems excessive, hints at some camouflaged grievance: 'The ultimate meaning and value of a work of art lie in the degree of technical accomplishment . . . As an artist I can accept no other basis for value judgements.'[8] ('There, dear,' we can hear the philosopher's wife consoling her husband, 'he doesn't mean what he says. He's only trying to get even with you.')

If one could divorce what he says from what he does, it would be clear how important this human subject-matter is to Pearlstein, not just in letting him use his eyes, not as 'banal' or neutral content, but for the same reason it matters to us, because the human image (however unheroically, unerotically manifested) is psychologically more potent than any other figurative form we know, as the image of the other, the living being outside ourselves that is potentially fatal, potentially saving; to be feared or loved. It is this potency that draws him, and the *mana* that he means to analyse. But he wants the power whole and unadulterated, undiluted by second-hand associations, unclouded by our habitual ways of seeing or of refusing to see.

Pearlstein's intentions are highly romantic, his mission one of restoration and rescue. Like many of the abstract expressionists, Pearlstein was shaped, as man and artist, by the Second World War. In an interview with Russell Bowman for his 1983–4 retrospective exhibition[9] he speaks of the impact of his army stay in Italy in 1944. There, during training, he took part in the restaging of local battles. The Italian landscape seemed violent to him, the hills vivid with images of struggle and the forms of recent corpses. Later, when he returned to the States, and later still on a 1958–9 Fulbright trip to Italy, he began to

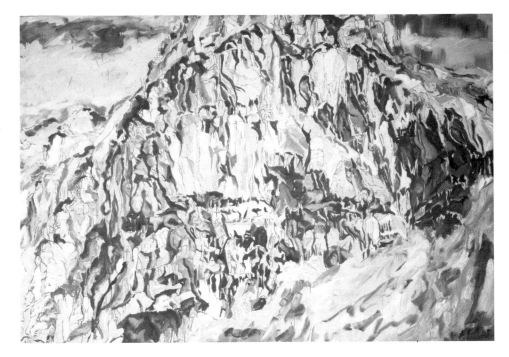

238 *Positano 1*, 1960, oil on canvas, Collection of Dorothy Pearlstein

paint cliffs and rocks as though they were human clusters, translating an abstract expressionist idiom into specific landscape descriptions. These violently named and violently depicted studies (*Shattered Hill*, 1953, *Fractured Rock*, 1955, and the later Positano paintings, Pl. 238) seethe with human life, imply heroism and tragedy, in epic visions not readily admitted to since the seventeenth century. The war churned all this up, of course, and Pearlstein's self-education in Renaissance art gave him a context of grandiose imagery, but the visions of suffering humanity endured and, I think, shaped his later art. Throughout the 1950s, a strange form of pathetic fallacy held him. In Montauk, when he went to draw the rocks by the sea, he sought out, as he says, those 'that looked like they'd had a nervous breakdown'.[10] When we wonder at the extreme effort of censorship with which Pearlstein turns his eye (and hopes to turn ours) on to the human form, we should remember that this is a man for whom, over a period of several years, at least as evidence in the work, no seaside visit was ever safe from nightmare visions: a pandemonium of fallen angels, battle scenes teeming with corpses, ghosts from the Sistine Chapel and the recent Italian campaigns.

These fractured cliff-faces, the cracked and crazed images that Pearlstein made in the 1950s before turning to the nude as the sole subject of his art, relate closely to the expressed quest for wholeness in the later compositions. That concept swims in and around much of the 'technical' description of his work. For example, he speaks of trying to challenge the hegemony of the 'roving point of view', that is, the artist-orchestrated movement of the viewer's eye through the work by means of clearly placed 'disjunctive details'. Pearlstein's answer is non-emphasis, all-overness, equality of detail (though this equality is conceptual only, in fact, and the un-equalising viewer is likely to read

267

239 *Superman*, 1952, oil on canvas, Collection of Dorothy Pearlstein

240 *Death and the Maiden (Shower Attacking Woman)*, 1950, casein tempera on masonite, Collection of Dorothy Pearlstein

disjunctively, despite the artist's precautions, because of the subject — that is, we are pulled faster to the flesh and its expressions than we are to chairs, walls, shadows). Yet however unachieved, Pearlstein's intention is clearly stated and implies a greater than technical end: 'Following Cézanne's lead the painting of fragments of casual vision became the modernist painter's mode of representing the world. I wanted to put the fragments of casual vision back together.'[11]

I see this as more than a post-war (humanist) sentiment. Pearlstein means to unsmash the cubist spectacles, so that we may once again see whole, and without anxiety. His aim is restoration: history mended, the Renaissance and its values reinstated, the human body well and whole.

Restoration, and rescue. 'Rescue' is the artist's word: 'I believe I have made a contribution to humanism in twentieth-century painting,' he wrote in 1972:

> I rescued the human figure from its tormented, agonized condition given it by the expressionist artists, and the cubist dissectors and distorters of the figure, and at the other extreme I have rescued it from the pornographers, and their easy exploitations of the figure for its sexual implications. I have presented the figure for itself, and allowed it its own dignity as a form among other forms in nature.[12]

This claim, extraordinary in itself, is all the more so in the context of

268

Philip Pearlstein

Pearlstein's usual tough-guy studio pronouncements (I just work here, 'I let the chips of interpretation fall where they will',[13] etc.).

When he returned to the States after his army life in Italy, some of Pearlstein's heroic Renaissance imagery returned with him. Notwithstanding the ironies of this early work, nor the proto-Pop images, nor the decidedly peculiar fact that Andy Warhol was for some of the time a room-mate, much of the early 1950s painting seems to play with genuinely held notions of the heroic, and in art-historically heroic terms. His imagery of this period includes the American eagle, the Statue of Liberty, the comic-book hero detective Dick Tracy and, most often reproduced, Superman (1952, Pl. 239), rising from a backdrop of urban squalor in the pose of Michelangelo's God dividing Light from Darkness. Another early work, *Shower Attacking Woman* (1950, Pl. 240), is, despite the future 'mechanic of art's mechanical drawing of a bathroom shower, spigots and all, only a smirk away from Renaissance depictions of supernatural storms and visitations, showers of gold and Danaë. In this period the references to the heroic are made by parody; later, in the nudes, they will be made by the grandeur of scale and the totally un-parodic, indeed often humourless, meticulousness of execution: the care and thoroughness that indicate with what reverence Pearlstein regards his subject-matter.

Following his 1958–9 Fulbright trip to Italy, Pearlstein began to

241 *Ridged Rock*, 1956, oil on canvas, Collection of David Lawrence Design, Chicago

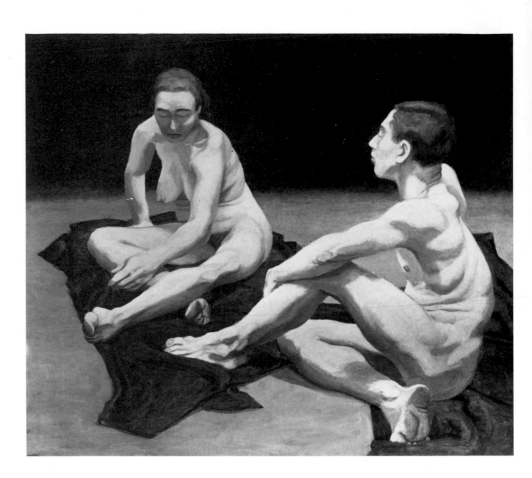

242 *Male and Female Models Sitting on Floor*, 1964, oil on canvas, Metropolitan Museum of Art, New York

attend the life-drawing classes that were held at the studio of Mercedes Matter. It was during these sessions that the artist began to see what was before him, began to learn to look *at* rather than *for*: a process of unlearning as much as its opposite, an effort of forgetting lessons of anatomy and art history. To the artist there seemed to be a 'direct connection' between the recent landscape work and the figures: the models 'looked like the boulders'. It was perhaps simply a question of turning a simile around, nudes like rocks being only another version of rocks like nudes (as, for example, the large reclining nude, an early Bonnard to be exact (see *Indolence*, p. 37), in Pearlstein's *Ridged Rock*, 1956, Pl. 241); but the connection helped Pearlstein retain a cooler vision while dealing with a 'hotter' subject.

Pearlstein exhibited the first of these nudes at the Frumkin Gallery in 1963. Compared with the later work, they seem stiff, old-fashioned, with a certain academic dowdiness, seeming to exist in no relation to the art and art issues of the time. The colouring is non-naturalistic, often chalky, suggesting remoteness, as do the models' poses. In the later work this non-connection between pairs of figures can be read neutrally: as a simple indication that the painter's descriptive interests lie elsewhere. Here, however, the distance between figures suggests a statement about alienation, too banal to have been intended. Without the later insistent precision in recording appearance, Pearlstein's images run a greater risk of extra-visual interpretation. Unclued, undirected by

the artist about where his obsessions lie, we are freer to make unwelcome assumptions about the meaning of the pictures.

This greater vagueness in the early figurative work was partly a matter of economics, since it was only much later in his career that the artist could afford to keep a model for the long sessions required by the more complex efforts of observation and execution. 'Essentially,' Pearlstein told an interviewer in 1981, 'what I now think of as the under-painting was the finished painting earlier. Starting about 1970 or 71, I just spent more time with each painting. But that means doing the paintings over and over, at least two and a half times and really indulging myself in the amount of time I spend on each detail.'[14] But the vagueness of these early figures also owed something to the greater vagueness with which the artist conceived his task. It wasn't until Pearlstein made what he called 'the biggest breakthrough of my career' that his work began to move single-mindedly in the direction of a pure setting down of what he saw in front of him. Before this could happen, he had to let go of a great deal of anxiety about the models and his relation to them as an artist. 'It took a long time,' Pearlstein says, 'until I decided that they were doing nothing but sitting there while I painted them.'[15] Once that decision was made, the whole drive of the art moved towards similar straightforwardness, involving a process of purification: fierce self-scrutiny and self-censorship over a long period

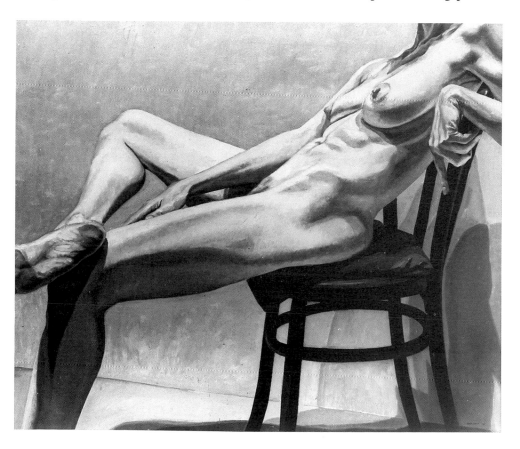

243 *Seated Model*, 1966, oil on canvas, Collection of Dr and Mrs Gerald Shapiro, New York

(so fierce in fact that the effort reaches beyond the self to where it really cannot, should not go: censorship of the viewer). Among the notions that Pearlstein must have had to surrender at this time was any lingering sense — however ghostly — of himself as Italian Renaissance painter, or at least as preserver of the Great Tradition. Here and Now was to be all he allowed himself as an artist: a great deal of course, too much for any man, but demanding the sacrifice of everything extrinsic to that slippery pure vision.

The decision to accept his situation in the studio for what it was (a decision more simply expressed than arrived at) freed Pearlstein to derive his paintings directly from the act (activity) of looking at the model. In a sense, for the artist, once the model no longer represents anything but an artist's model, she is able to disappear from the work. As a fact she becomes almost transparent, enabling the painter to see beyond the human apparition and into the peripheries (and centre) of looking. His own eye can rove, his point of view shift, his perceptions be abandoned to chance or allowed to find the under-order of a visual choreography. Skimming along the surface of the body, his eye finds more than when it systematically confronts what it meets — more, certainly, than when it is aware, even subliminally, of mythological or psychological aspects of the nude.

'I really do see more than a camera,' Pearlstein says now, 'and it takes me more time than a camera. If I look at a knee for an hour, I get conscious of every little ripple and detail.'[16] Conscious, more importantly, of consciousness — through a technique of meditation that demands the disappearance of what is meditated upon.

The problem with all this lies only in Pearlstein's expectation of how much of this process can be shared with the viewer. He wishes us to see (or rather to *not* see) exactly as he does. Or, to state it another way, he wants actively to participate in seeing while insisting we remain utterly passive, and accept the results of his seeing as though they were honestly ours. If the aggrieved, not to say peevish, tone of his pronouncements is anything to go by, he has yet to surrender control of the results of his meditative art, to truly 'let the chips of interpretation fall where they will'.

Deciding his subjects were 'just sitting there' necessarily freed Pearlstein more than his audience, for whom associations (inappropriate but inescapable) must cling to the presented bodies like fluff to Perspex. Over the shoulders of the first question, 'What do they look like?' we crane to ask, 'What do they look like when . . . ?' Stubbornly, childishly, we insist on knowing what they are doing. 'They are sitting,' Pearlstein says to himself but to us he answers: 'They are inspiring the painter to mix his colors.' Perhaps he knows that the phrase 'just sitting' begins a narrative, arouses curiosity about its subject: the fatigued, reclining hero of the tale.

People instinctively worry about Pearlstein's models, ask why they look so sad, or so tired, or so detached from their surroundings. By showing them to this degree human and responsive, Pearlstein removes

244 *Female Lying on Green Rug with Foot on Piano Stool*, 1968, oil on canvas, Collection of Mr and Mrs Joel William Harnett

245 (opposite) *Two Models, One Seated*, 1966, oil on canvas, Vassar College Art Gallery, Poughkeepsie, New York

246 (opposite) *Female Model on Eames Stool*, 1978, oil on canvas, Metropolitan Museum of Art, New York

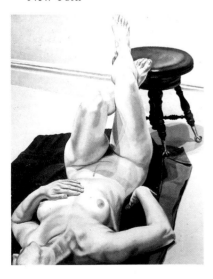

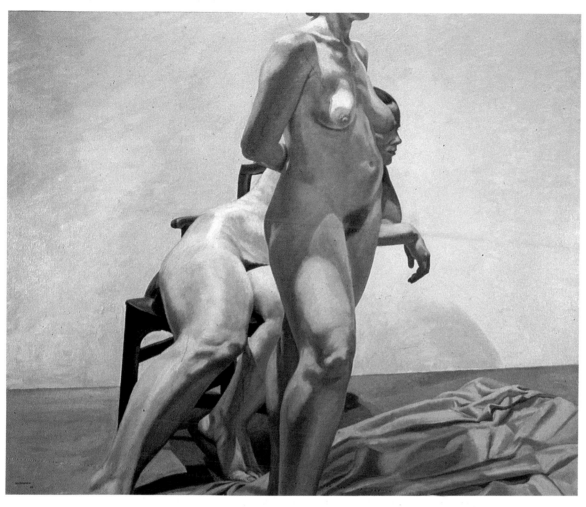

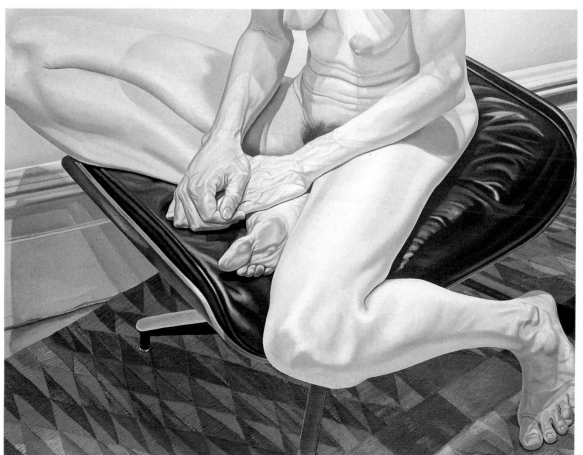

their mere objectness, returns them their persona *even as* models, and reimplicates himself in their condition. That is, since they no longer 'represent' Venus, or Judith, or Woman, but bored or worn-out models, the artist gets some blame for their distress: he is demanding, egocentric or unfeeling. Pearlstein has reaped the kind of censure suitable for a tyrant with a movie camera. As is not the case with the portraits, where we can sense something of the sitter's collaboration, feel a self-esteem and self-curiosity that matches the esteem and curiosity of the painter, with the nudes it is possible to wonder about the exchange. Never have paid models seemed so gawped at, used, 'rendered'. (The 'misogynist' Degas's women in their tubs are far more lovingly, gently handled than these.) Occasionally, we can get a glimpse of these models' lives, and their reactions seem like ours. In a recent interview Pearlstein said: 'I'm just as interested in the African stool and the little figure that's carved in it, the animal, as I am in the model. As a matter of fact the model complained that she felt upstaged by the carved figure. It has a face and she doesn't.'[17]

Not surprisingly, people have seen in these portraits of professional models scripts about alienation. The prohibitions against interpretation seem hardest to observe with the double-figure works, where the subjects seem to relate or fail to relate in more than just space. Some physical dynamic between the models, however tenuous or understated, is implied, and raises scores of questions about their psychological interconnection.

The great problem, of course, with Pearlstein's declarations about his own or the models' invisibility (invisibility as people, over-visibility as objects) is that questions pertinent to descriptions of relationships must always arise, since paintings of nudes are in themselves descriptions of relationships, the first being that between painter and model. Pearlstein's art knows and plays with this fact,★ just as it plays with the relation between the Idea of the nude and the actualities of the model. Above all, its play is with the relation between seeing and knowing. Clarity (in the precision of detail in the work) and intimacy (scale) offer legibility and imply familiarity; yet we do not know these people. Moreover, given an artist-directed reading of the work, in which other elements of the picture are equally accessible, equally 'lovingly' depicted, we are not meant, clearly, to care. Much of the drama of the work (especially in the double nudes) derives from real-life embarrassment: anxiety about bodies that are close to each other or to us and yet are not known, understood — that are not psychologically, as opposed to merely visually, legible. It is like a moment at a party before introductions as an approaching figure looms. At a touch, a clasp of the hand, at the naming of names, all will be well, but until then such moments, prolonged, can seem unendurable.

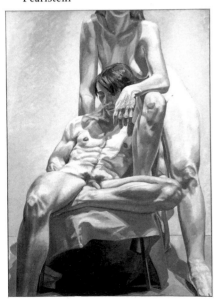

247 *Models in the Studio*, 1965, oil on canvas, Collection of Dorothy Pearlstein

★ Pearlstein was once asked whether he ever fell in love with his models. 'The love affair is with the painting, not the model,' was his characteristic reply. (Video interview with Russell Bowman, see note 9.)

This kind of edge in the work is, of course, avoided when Pearlstein decides to crop or behead his sitters, allowing us to peep without responsibility to the human element. (It is here, by the way, that Pearlstein's work has its greatest affinity with pornography in its use of persons for its own ends, though those ends seem so utterly different from simple sexual arousal. But the beauty of such works demands our contribution, our own candle-lit reading, if not museum reading: the torso as heroic and antique, as slab of humanity, rather than as headless victim of snuff-movie antics.)

Pearlstein's form of anxiety (unlike Cézanne's or Pollock's) derives from just this sort of psychological disorientation, from social and visual embarrassment. Our sense of intrusion comes from being made to feel so close to the work, because of its scale, and because of what appears to be the models' vulnerability as they sit naked for their portraits. But other kinds of awkwardness in the work feel accidental (see, for example, the way the woman appears to be staring at the male genitals in *Standing Male, Sitting Female Nudes*, 1969, Pl. 236). This is partly the result of Pearlstein's insistence on the use of bodies as still-

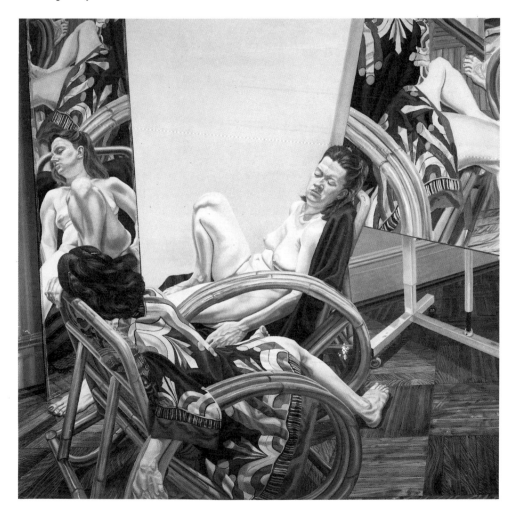

248 *Two Models with Mirror and Painting*, 1982, oil on canvas, Collection of Mr and Mrs David Pincus, Pennsylvania

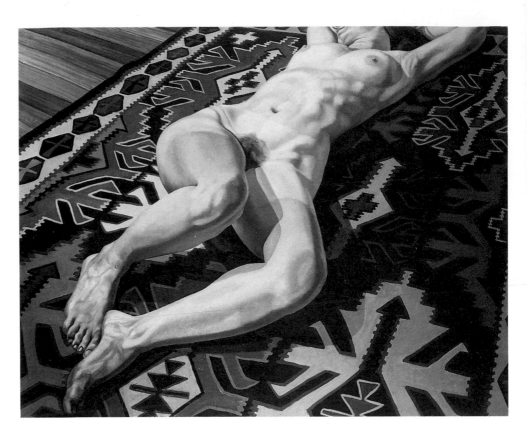

249 *Nude on Kilim Rug*, 1969, oil on canvas, Collection of Mr and Mrs Leonard A. Lauder, New York

life, allowing for collisions of body parts, potentially humorous, potentially erotic (the toe that creeps towards a nipple in *Two Female Models on Eames Chair and Stool*, 1976–7, Pl. 234, for example, or the breast that joins the more distant face in *Two Models, One Seated*, 1966, Pl. 245), sometimes simply disturbing (see the leg that connects with the armless stump in *Models in the Studio*, 1965, Pl. 247).

In the late work, awkwardness of seeing, far from being accidental, seems to be something the artist means to explore, even to push to the point of apparent aggression against his subject. Not self-effacing enough, the most recent work seems autocratic, manipulative, using perverse and distorting perspectives like a fairground mirror to make ugly noses and rubber limbs. The mannerist elegance of a work like the 1966 *Seated Model* (Pl. 243) becomes an exercise in the grotesque in such paintings as *Two Female Models in Kimonos with Mirror* (1980, Pl. 235), or *Two Models in Bamboo Chairs with Mirror* (1981), or *Two Models with Mirror and Painting* (1982, Pl. 248). The colours of the robes and rugs are now frankly garish; the high lighting now reflects so wildly as to suggest that the models have been covered in Vaseline; above all, the chosen angles of vision are such that flesh seems to swell and shrink arbitrarily: the whole seems nightmarishly vivid, loud, brutal, sharp and unreal.

Compared with the many profoundly felt and beautiful body images in the work of the late 1960s and the 1970s (see especially *Female Lying on Green Rug with Foot on Piano Stool*, 1968, Pl. 244; *Nude on Kilim Rug*, 1969, Pl. 249; *Model with Legs Up*, 1975, Pl. 250; *Female Model on Ladder*, 1976, Pl. 237; *Two Female Models on Eames Chair and Stool*,

Philip Pearlstein

1976), images which seem both heroic and erotic, the direction of the recent work seems disappointing. Our objections to it really are low-brow, moral rather than aesthetic. In the end the failure to treat the human image appropriately in either terms is what affects us, makes this work appear tricky, shallow, technically flashy but cold-hearted and ultimately uninteresting. Looking at the career, it would be natural to wonder what had become of the mission of restoration and rescue, of the notion of art as service. Or are the eccentricity and flimsiness of the

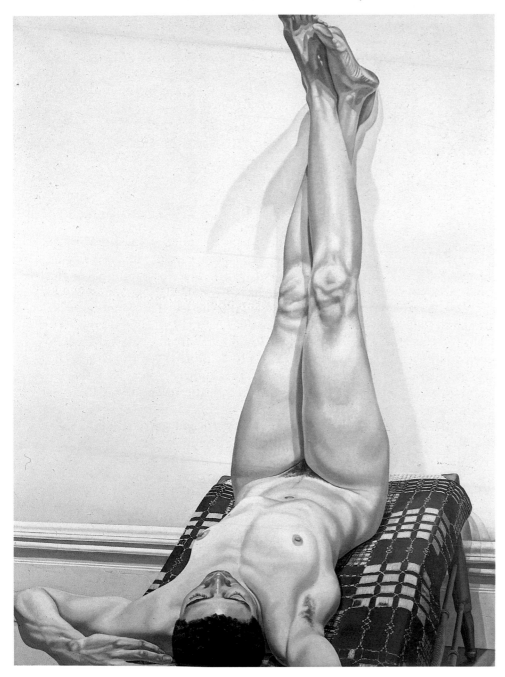

250 *Model with Legs Up*, 1975, oil on canvas, Akron Art Museum, Ohio

last work the natural result of an abstract method practised on a human subject? Perhaps it is only a sign of Pearlstein's need to break out of his own rhetorical imprisonment, the endpoint of years of stated dedication to the idea of perfecting mechanical response to the human form. The late work seems evidence that you cannot use the human body to serve an idea of art unless your response is first to the *whole* truth of that body (which may legitimately include all that it vulgarly means); evidence, just as the dead end of certain abstract expressionist work is also evidence, that there must be service to something other than an abstract notion of seeing, dedication too, to something greater than the self-censured, self-tricked purity of the one that sees. Bodies, even paid bodies, do not just 'sit there'. They suffer from artistic abuse, or they declare fatigue, endurance, desire, accessibility, above all, a long ancestry of other naked bodies — in museum rooms, in pages of books, and, beyond these, in beds and baths, and, less romantically but no less affectively, in artists' studios.

NOTES

1 Philip Pearlstein, 'A Realist Artist in an Abstract World', originally a statement for the 1978 panel discussion of 'The Conceptualization of Realism' at the annual meeting of the College Art Association; reprinted in *Philip Pearlstein: a Retrospective*, exhibition catalogue, Milwaukee Art Museum, Alpine Fine Arts Collection, New York and London, 1983, p. 13.

2 Pearlstein, from Alan Frumkin Gallery *Newsletter*, no. 7, Winter 1979, p. 6; quoted by Michael Auping in his introduction to the John and Mabel Ringling Museum of Art (Sarasota, Florida) exhibition of Pearlstein's work, 1981, p. 3.

3 In 'A Realist Artist in an Abstract World', loc. cit., Pearlstein says (p. 13), 'We were the generation of artists who built on the lessons of the art of painters like de Kooning, Kline, Rothko, etc.'; speaks (p. 14) of ' . . . a rejection of existentialism, the politically liberal middle-class philosophy of life we had grown up with'; and declares (p. 15), 'In painting existentialism manifests itself technically by allowing uncertainty to be visible.'

4 Loc. cit., p. 15.

5 Ibid.

6 Statement to the *St Louis Post Dispatch* (1977), quoted in Mathew Baigell, 'Pearlstein's People', *Art Criticism*, vol. 1, no. 1, Spring 1979, p. 9.

7 Interview with Michael Auping, Curator of the John and Mabel Ringling Museum of Art, museum catalogue *Philip Pearlstein: Painting and Watercolors*, 1981, p. 9.

8 Philip Pearlstein, 'Figure Paintings Today Are Not Made in Heaven', *Art News*, vol. 61, no. 3, Summer 1962, p. 52.

9 Video interview with Russell Bowman, Curator of the Milwaukee Art Museum, played during the retrospective exhibition of Pearlstein's work which travelled in America during 1983–4.

10 Ibid.

11 'A Realist Artist in an Abstract World', loc. cit., p. 13.
12 'Philip Pearlstein: A Statement', *Philip Pearlstein: Zeichnungen und Aquarelle: Die Druckgraphik*, exhibition catalogue, Berlin Staatliche Museum, 1972, p. 15; cited in Irving Sandler, 'Philip Pearlstein and the New Realism', Milwaukee Museum retrospective catalogue, p. 17.
13 'A Realist Artist in an Abstract World', loc. cit., p. 13.
14 Interview with Michael Auping, loc. cit., p. 11.
15 Quoted in Linda Nochlin, 'The Art of Philip Pearlstein', introduction to travelling Pearlstein exhibition, 1970–1, at the Georgia Museum of Art, in *Philip Pearlstein*, Georgia Museum of Art, Athens, Georgia, 1970, n. p.
16 Ibid.
17 Interview with Michael Auping, loc. cit., p. 11.

SELECT BIBLIOGRAPHY

Maillol

Cladel, Judith, 'Maillol and the Model', *Verve*, December 1937, p. 105.

—— *Maillol, sa vie, son oeuvre, ses idées*, Grasset, Paris, 1937.

Elsen, Albert E., *Rodin*, Museum of Modern Art, New York, 1963.

—— ed., *Auguste Rodin: Readings on his Life and Work*, Prentice Hall, Engelwood Cliffs, New Jersey, 1965.

—— ed., *Rodin Rediscovered*, catalogue of an exhibition held at the National Gallery, Washington, D.C., June 1981–May 1982.

Fry, Roger, 'The Sculptures of Maillol', *The Burlington Magazine*, vol. 17, no. 85, April 1910, pp. 26–32.

George, Waldemar, *Aristide Maillol*, New York Graphic Society, Greenwich, Conn., (no date) ?1965.

Guggenheim Museum, *Aristide Maillol: 1861–1944*, catalogue of an exhibition held at the Solomon R. Guggenheim Museum, New York, 1975.

McCaughey, Patrick, 'The Monolith and Modernist Sculpture', *Art International*, vol. 14, no. 9, November 1970, pp. 19–24.

Presson, Jean, 'Interview with Maillol', *Occident*, no. 3, February 1948, pp. 15–18.

Rewald, John, *Maillol*, Hyperion Press, London, Paris and New York, 1939.

Rodin, Auguste, *L'Art, entretiens réunis par Paul Gsell* (text 1911), Gallimard, Paris, 1967.

Ronnebeck, Arnold, 'Maillol Speaks', *The Arts*, vol. 8, no. 1, July 1925, pp. 35–7.

—— 'The Teachings of Maillol', *The Arts*, vol. 8, no. 1, July 1925, pp. 38–40.

Slatkin, Wendy, 'The Genesis of Maillol's *La Mediterranée*', *Art Journal*, vol. 38, no. 3, Spring 1979, pp. 184–9.

—— 'Reminiscences of Aristide Maillol: A Conversation with Dina Vierny', *Arts Magazine*, vol. 54, no. 1, September 1979, pp. 164–7.

Steinberg, Leo, 'Rodin', in *Other Criteria: Confrontations with Twentieth-Century Art*, Oxford University Press, London, Oxford, New York, 1976, pp. 322–402.

Bonnard

American Federation of Arts, *Bonnard: Drawings from 1893–1946*, catalogue of an exhibition held at the American Federation of Arts, New York, 1972.

Berger, John, essay on Bonnard in *The Moment of Cubism*, Pantheon, New York, 1969, pp. 117–23.

Bonnard, Pierre, notes by the painter in *Bonnard*, Éditions Beyeler, Basle, (no date).

—— notes in *Bonnard dans sa lumière*, catalogue of an exhibition held at the Fondation Maeght, Saint Paul de Vence, France, pp. 25–32.

—— *Corréspondence*, Tériade, Paris, 1945.

Bouvet, Francis, *Bonnard: The Complete Graphic Work*, Eng. trans. by Jane Brenton, Rizzoli, New York, and Thames and Hudson, London, 1981.

Dauberville, Jean and Henry, *Bonnard: Catalogue raisonné de l'oeuvre peint*, (4 vols), Éditions J. et H. Bernheim-Jeune, Paris, 1965.

Fermigier, André, *Bonnard*, Thames and Hudson, London, 1970.

Goldwater, Robert, 'Bonnard', *Lugano Review*, vol. 1, no. 1, 1965, pp. 129–37.

Heron, Patrick, essay on Bonnard in *The Changing Forms of Art*, Routledge & Kegan Paul, London, 1955, pp. 116–29.

Kozloff, Max, essay on Bonnard in *Renderings*, Simon & Schuster, New York, 1961, pp. 55–60.

Masheck, Joseph, 'Bonnard Drawings', *Artforum*, vol. 11, no. 4, December 1972, pp. 77–8.

Melville, Robert, 'The Master of Indecisions', *Architectural Review*, vol. 139, no. 830, April 1966, pp. 301–4.

Musée National d'Art Moderne, Paris, and the Phillips Collection, Washington, D.C., *Bonnard: The Late Paintings*, catalogue of an exhibition held in Paris and Washington in 1984.

Natanson, Thadée, *Peints à leur tour*, Éditions Albin Michel, Paris, 1948.

Rewald, John, *Bonnard*, Museum of Modern Art, New York, 1948.

Sylvester, David, in conversation about Bonnard with Andrew Forge and Michael Podro, *Studio International*, vol. 171, no. 874, February 1966, pp. 44–55.

Terrasse, Antoine, *Bonnard*, Eng. trans. by Stuart

Gilbert, Éditions d'Art Albert Skira, Geneva, 1971.

Terrasse, Charles, 'Recollections of Bonnard', *Apollo*, vol. 83, no. 47 (n.s.), January 1966, pp. 62–7.

Vaillant, Annette, *Bonnard: ou Le Bonheur de voir*, Éditions Ides et Calendes, Neuchâtel, 1965.

Schiele

Comini, Alessandra, *Egon Schiele*, Thames and Hudson, London, 1976.

—— *Egon Schiele's Portraits*, University of California Press, Berkeley, 1974.

—— *Schiele in Prison*, New York Graphic Society, Greenwich, Conn., 1973.

Kallir, Otto, *Egon Schiele: Catalogue Raisonné*, Crown Publishers, New York, 1966.

Leopold, Rudolph, *Egon Schiele, Paintings, Watercolours, Drawings: Catalogue Raisonné*, Phaidon, London, 1973.

Mitsch, Erwin, *The Art of Egon Schiele*, Phaidon, Oxford, 1975.

Museum of Modern Art, New York, *Vienna, 1900: Art, Architecture and Design*, catalogue of an exhibition held at the Museum of Modern Art, New York, 1986.

Vergo, Peter, *Art in Vienna 1898–1918*, Phaidon, Oxford, 1975.

Wilson, Simon, *Egon Schiele*, Phaidon, Oxford, 1980.

Matisse

Aragon, Louis, *Henri Matisse, a Novel*, (2 vols), Eng. trans. by Jean Stewart, a Helen and Kurt Wolff Book, Harcourt Brace Jovanovich, New York, 1971.

Arts Council of Great Britain, *Matisse 1869–1954*, catalogue of an exhibition held at the Hayward Gallery, London, 1968.

Baltimore Museum of Art, *Paintings, Sculpture and Drawings in the Cone Collection*, Baltimore Museum of Art, Maryland, 1967.

Barr, Alfred H., jr, *Matisse, His Art and His Public*, Museum of Modern Art, New York, 1951.

Bibliothèque Nationale, *Henri Matisse: Donation Jean Matisse*, catalogue of an exhibition held at the Bibliothèque Nationale, Paris, 18 March–21 June 1981.

Duthuit, Georges, *The Fauvist Painters*, Documents of Modern Art, Wittenborn, Schultz, New York, 1950.

Elderfield, John, *The Cut-Outs of Henri Matisse*, George Braziller, New York, and Thames and Hudson, London, 1978.

—— *The 'Wild Beasts': Fauvism and its Affinities*, catalogue of an exhibition held at the Museum of Modern Art, New York, 1976.

Elsen, Albert E., *The Sculptures of Henri Matisse*, Harry N. Abrams, New York, 1972.

Flam, Jack D., *Matisse on Art*, E. P. Dutton, New York, 1978.

—— 'Matisse in Morocco', *Connoisseur*, vol. 211, no. 846, August 1982, pp. 74–86.

—— 'Matisse in Two Keys', *Art in America*, vol. 63, no. 4, July–August 1975, pp. 83–6.

Goldin, Amy, 'Matisse and Decoration: the Late Cut-Outs', *Art in America*, vol. 63, no. 4, July–August 1975, pp. 49–59.

Goldwater, Robert, 'The Sculpture of Matisse', *Art in America*, vol. 60, no. 2, March–April 1972, pp. 40–5.

Gowing, Lawrence, *Matisse*, Oxford University Press, New York, and Thames and Hudson, London, 1979.

Monod-Fontaine, Isabelle, *Matisse: Oeuvres de Henri Matisse (1869–1954)*, Collections du Musée National d'Art Moderne, Centre Georges Pompidou, Paris, 1979.

Museum of Modern Art, New York, *Four Americans in Paris: The Collection of Gertrude Stein and her Family*, Museum of Modern Art, New York, 1970.

National Gallery of Art, Washington, D.C., *Henri Matisse: The Early Years in Nice, 1916–1930*, catalogue of an exhibition held at the National Gallery, Washington, D.C., November 1986–March 1987, National Gallery of Art, Washington D.C., and Harry N. Abrams, New York, 1986.

Schneider, Pierre, *Matisse*, Eng. trans. by Michael Taylor and Bridget Strevens Romer, Rizzoli, New York, 1984.

—— 'The Striped Pajama Icon', *Art in America*, vol. 63, no. 4, July–August 1975, pp. 76–82.

Tucker, William, Matisse chapter in *The Language of Sculpture*, Thames and Hudson, London, 1974.

—— 'Matisse's Sculpture: the Grasped and the Seen', *Art in America*, vol. 63, no. 4, July–August 1975, pp. 62–6.

Picasso

Ashton, Dore, ed., *Picasso on Art: A Selection of Views*, Viking Press, New York, 1972.

Barr, Alfred H., jr, *Picasso: Fifty Years of His Art*, Museum of Modern Art, New York, 1946.

Berger, John, *The Success and Failure of Picasso*, Pantheon, New York, 1965.

Cooper, Douglas, *The Cubist Epoch*, Phaidon, London, 1971.

—— and Gary Tinterow, *The Essential Cubism: Braque, Picasso & Their Friends, 1907–1920*, catalogue of an exhibition at the Tate Gallery, 1983, Tate Gallery Publications, London, 1983.

Gilot, Françoise and Carlton Lake, *Life With Picasso*, McGraw-Hill, New York, 1964.

Golding, John, *Cubism: a History and an Analysis, 1907–1914*, Faber & Faber, London, 1959.

Hilton, Timothy, *Picasso*, Thames and Hudson,

London, 1975.

Kahnweiler, Daniel-Henry, *My Galleries and Painters*, Eng. trans. by Helen Weaver, Documents of Modern Art, Thames and Hudson, London, 1971.

McCully, Marilyn, ed., *A Picasso Anthology: Documents, Criticism, Reminiscences*, Princeton University Press, Princeton, New Jersey, 1982.

Musée Picasso, *Catalogue des collections*, (2 vols), Éditions de la Réunion des Musées Nationaux, Paris, 1985.

Museum of Modern Art, New York, *Four Americans in Paris: The Collections of Gertrude Stein and her Family*, Museum of Modern Art, New York, 1970.

Museum of Modern Art, New York, *Pablo Picasso: A Retrospective*, catalogue of an exhibition at the Museum of Modern Art, New York, 1 May–16 September, 1980.

Olivier, Fernande, *Picasso et ses amis*, Stock, Paris, 1933.

Penrose, Roland, *Picasso: his Life and Work*, University of California Press, Berkeley and Los Angeles, (3rd edition), 1981.

—— *Portrait of Picasso*, Lund Humphries, London, 1956 and Museum of Modern Art, New York, 1980.

—— and John Golding, eds, *Picasso in Retrospect*, Harper & Row, New York, 1980, American reprint of *Picasso 1881–1973*, Paul Elek, London, 1973.

Richardson, John, 'Picasso and L'Amour Fou', *New York Review of Books*, 19 December 1985, pp. 59–69.

Schiff, Gert, *Picasso, The Last Years, 1963–73*, catalogue of an exhibition at the Solomon R. Guggenheim Museum, New York, 1983, George Braziller, New York, 1983.

Stein, Gertrude, *The Autobiography of Alice B. Toklas*, in *Selected Writings of Gertrude Stein*, ed. Carl Van Vechten, Vintage Books (Random House), New York, 1972.

—— *Everybody's Autobiography*, Random House, New York, 1937, and Virago Press, London, 1985.

Steinberg, Leo, three chapters on Picasso in *Other Criteria: Confrontations with Twentieth-Century Art*, Oxford University Press, London, Oxford, New York, 1976, pp. 93–234.

Zervos, Christian, *Pablo Picasso, Catalogue Raisonné*, (23 vols), Éditions 'Cahiers d'art', Paris, 1932–73.

Modigliani

Douglas, Charles [Charles Beadle and Douglas Goldring], *Artists' Quarter: Reminiscences of Montmartre and Montparnasse in the First Two Decades of the Twentieth Century*, Faber & Faber, London, 1941.

Fifield, William, *Modigliani: the Biography*, Morrow, New York, 1976.

Howe, R. W., 'Modigliani', *Apollo*, vol. 60, no. 356,

October 1954, pp. 92–5.

Mann, Carol, 'Amedeo Modigliani and Jeanne Hébuterne', *Connoisseur*, vol. 203, no. 818, April 1980, pp. 285–91.

—— *Modigliani*, Thames and Hudson, London, 1980.

Musée d'art moderne de la ville de Paris, *Amedeo Modigliani, 1884–1920*, catalogue of an exhibition held in Paris at the Musée d'art moderne de la ville de Paris, 26 March–28 June 1981.

Modigliani, Jeanne, *Modigliani: Man and Myth*, Eng. trans. by Esther Rowland Clifford, Orion Press, New York, 1958.

Perreault, John, 'Modigliani's Subject of Desire', *Art News*, vol. 65, no. 6, October 1966, pp. 42–3, 78.

Russell, John, 'First Facts About Modigliani', *Apollo*, vol. 78, no. 19 (n.s.), September 1963, pp. 212–15.

Russoli, Franco, *Modigliani Drawings*, Thames and Hudson, London, 1969.

Rutter, Frank, 'Modigliani', *Apollo*, vol. 9, no. 52, April 1929, pp. 216–19.

Salmon, André, Adolphe Basler, Osip Zadkine and others, *Paris-Montparnasse*, special Modigliani issue, February 1930, Paris.

Sichel, Pierre, *Modigliani*, W. H. Allen, London, 1967.

University of California, *Modigliani's Paintings and Drawings*, catalogue of an exhibition held in Los Angeles, 1961, University of California Committee of Fine Arts Productions, Los Angeles, 1961.

Werner, Alfred, 'The Inward Life of Modigliani', *Arts Magazine*, vol. 35, no. 4, January 1961, pp. 36–41.

—— 'Modigliani as Sculptor', *Art Journal*, vol. 20, no. 2, Winter 1960–1, pp. 70–8.

—— *Modigliani the Sculptor*, Arts, Inc. (a Golden Griffin book), New York, 1962.

—— 'Nudest of Nudes', *Arts Magazine*, vol. 41, no. 1, November 1966, pp. 36–8.

Pascin

Brodzky, Horace, *Jules Pascin*, Nicholson and Watson, London, 1946.

Diehl, Gaston, *Pascin*, Eng. trans by Rosalie Siegel, Crown Publishers, New York, 1968.

Fels, Florent, *Drawings by Pascin*, Eng. trans by Jean Morrison, Éditions du Colombier, Paris, 1967.

Hemingway, Ernest, *A Moveable Feast*, Jonathan Cape, London, 1964.

McAlmon, Robert, *Being Geniuses Together, 1920–30*, Doubleday, Garden City, New York, 1968.

MacOrlan, Pierre, *Tombeau de Pascin*, Textes Prétextes, Paris, 1944.

Steinberg, Leo, Pascin chapter in *Other Criteria: Confrontations with Twentieth-Century Art*, Oxford University Press, Oxford, London, New York, 1976, pp. 268–71.

Werner, Alfred, *Jules Pascin*, Harry N. Abrams, New York, 1963.

Select Bibliography

Lachaise

cummings, e. e., 'On Lachaise', *Twice a Year*, 10th Anniversary Issue, New York, 1948.

Kramer, Hilton, Hart Crane, e. e. cummings and others, *The Sculpture of Gaston Lachaise*, Eakins Press, New York, 1967.

Lachaise, Gaston, 'A Comment on My Sculpture', *Creative Art*, vol. 3, no. 2, August 1928, xxiii–xxvi.

Los Angeles County Museum of Art, *Gaston Lachaise 1882–1935, Sculpture and Drawings*, catalogue of an exhibition held at the Los Angeles County Museum of Art, 3 December 1963–19 January 1964, and at the Whitney Museum of American Art, New York, 18 February–5 April 1964.

Nordland, Gerald, *Gaston Lachaise, The Man and His Work*, George Braziller, New York, 1974.

Schwartz, Sanford, Lachaise chapter in *The Art Presence*, Horizon Press, New York, 1982, pp. 48–52.

Seldes, Gilbert, 'Hewer of Stone', profile of Lachaise in the *New Yorker*, 4 April, 1931, pp. 28–31.

Spencer

Arts Council of Great Britain, *Stanley Spencer 1891–1959*, catalogue of a travelling exhibition in England 1976–7, the Arts Council, London, 1976.

Astor Collection, The, *Stanley Spencer: the Astor Collection*, Thomas Gibson Publishing, London, 1976.

Collis, Louis, *A Private View of Stanley Spencer*, Heinemann, London, 1972.

Robinson, Duncan, *Stanley Spencer: Vision from a Berkshire Village*, Phaidon, Oxford, 1979.

Rothenstein, John, ed., *Stanley Spencer the Man: Correspondence and Reminiscences*, Paul Elek, London, 1979.

—— chapter on Spencer in *Time's Thievish Progress*, vol. III, Cassell, London, 1970, pp. 50–74.

Rothenstein, William, *Men and Memories*, vol. II, Faber & Faber, London, 1932.

Royal Academy of Arts, London, *Stanley Spencer R.A.*, catalogue of an exhibition held at the Royal Academy, 20 September–14 December 1980, Royal Academy of Arts and Weidenfeld and Nicolson, London, 1980.

Spencer, Stanley, notes to *Stanley Spencer Resurrection Pictures (1945–50)*, Faber & Faber, London, 1951.

Freud

Feaver, William, 'Lucian Freud – The Analytical Eye', *Sunday Times Magazine*, London, 3 February 1974.

—— 'A Reasonable Definition of Love', *Architectural Digest*, vol. 44, no. 7, July 1987, pp. 34–8.

Freud, Lucian, 'Some Thoughts on Painting', *Encounter*, vol. 3, no. 1, July 1954, pp. 23–4.

Gowing, Lawrence, *Lucian Freud*, Thames and Hudson, London and New York, 1982.

Hughes, Robert, *Lucian Freud Paintings*, Thames and Hudson, London and New York, 1987.

Marlborough Fine Art Ltd, *Lucian Freud, Recent Work*, catalogue of an exhibition held at the Marlborough, London, 1968.

Overy, Paul, 'Lucian Freud's Visual Autobiography', *The Times*, London, 29 January 1974.

Peppiat Michael, 'Lucian Freud', *Art International*, vol. 26, pt 1, no. 1, January–March 1983, pp. 102–6.

Russell, John, 'Lucian Freud – Clairvoyeur', *Art in America*, vol. 59, no. 1, January–February 1971, pp. 104–6.

Balthus

Arts Council of Great Britain, *Balthus*, catalogue of an exhibition held at the Tate Gallery, London, 4 October–10 November, 1968, Arts Council, London, 1968.

Bernier, Georges, 'Balthus', *L'Oeil*, no. 15, March 1956, pp. 27–33.

Brach, Paul, 'Obsession as Style: Balthus and the Figure', *Art in America*, vol. 66, no. 2, March–April 1978, pp. 118–19.

Clark, Kenneth, 'A Modern Master', *New York Review of Books*, 12 June 1980, pp. 18–20.

Gendel, Milton, 'H. M. the King of Cats, a Footnote', interview with Balthus, *Art News*, vol. 61, no. 2, April 1962, pp. 36–8, 52–4.

Hess, Thomas B., 'Balthus: Private Eye', *Vogue*, vol. 163, no. 1, January 1974, pp. 104–7.

—— 'Draughtsmanship as Dissection', *Art News*, vol. 62, no. 8, December 1963, pp. 34–5, 61–2.

Klossowski, Pierre, 'Balthus: Beyond Realism', *Art News*, vol. 55, no. 8, December 1956, pp. 26–31, 50–1.

Leymarie, Jean, *Balthus*, Eng. trans. by James Emmons, Éditions d'Art Albert Skira, Geneva, 1982.

Lord, James, 'Balthus: The Strange Case of the Count de Rola', *New Criterion*, vol. 2, no. 4, December 1983, pp. 9–25.

Mandiarges, A. Pieyre de, 'Balthus', *XXe Siècle*, no. 44 (n.s.), June 1975, pp. 61–7.

Melville, Robert, 'Extravagant Positions', *Architectural Review*, vol. 145, no. 864, February 1969, pp. 131–3.

Metropolitan Museum of Art, New York, *Balthus*, catalogue of a retrospective exhibition held at the Metropolitan, 29 February–13 May 1984, Metropolitan Museum of Art and Harry N. Abrams, New York, 1984.

Rilke, Rainer Maria, 'Lettres à un jeune peintre', *Fontaine*, no. 44, Summer 1945, pp. 526–37.

Russell, John, 'Master of the Nubile Adolescent', *Art in America*, vol. 55, no. 6, November–December 1967, pp. 98–103.

283

—— 'There Is No One Like Balthus', *Art International*, vol. 21, no. 6, pp. 42–5, 74–5.

Soby, James Thrall, 'Balthus', *Museum of Modern Art Bulletin*, vol. 24, no. 3, Winter 1956–7, pp. 3–39.

De Kooning

Alloway, Lawrence, 'Willem de Kooning', *Artforum*, vol. XIII, no. 5, January 1975, pp. 46–50.

De Kooning, Willem, essays and statements reprinted in Thomas B. Hess, *Willem de Kooning*, introduction and catalogue to an exhibition held at the Museum of Modern Art, New York, July 1968.

—— script of filmed interview in *Sketchbook: Three Americans*, Time–Life Books, New York, 1960.

—— statements in *Ramparts*, vol. 7, no. 11, April 1969, pp. 20–4.

Forge, Andrew, 'De Kooning's "Women"', *Studio International*, vol. 179, no. 906, December 1968, pp. 246–51.

Greenberg, Clement, '"American Type" Painting', in *Art and Culture*, Beacon Press, Boston, 1961; paperback edition, Beacon Press, Boston, pp. 208–29.

Guggenheim Museum, The Solomon R., *Willem de Kooning in East Hampton*, The Solomon R. Guggenheim Museum, New York, 1978.

Motherwell, Robert and Ad Reinhardt, eds, *Modern Artists in America*, documents of Modern Art, Wittenborn, Schultz, New York, 1951.

O'Doherty, Brian, chapter on de Kooning in *American Masters: The Voice and the Myth*, Random House, New York, 1974, pp. 112–49.

Rodman, Selden, *Conversations with Artists*, Devin–Adair, New York, 1957, pp. 100–5.

Rosenberg, Harold, 'The American Action Painters', reprinted in *The Tradition of the New*, Horizon Press, New York, 1959, paperback edition, Paladin, New York, pp. 35–47.

—— *De Kooning*, Harry N. Abrams, New York, (no date) ?1974.

—— two essays on De Kooning in *The Anxious Object: Art Today and Its Audience*, Horizon Press, New York, 1964, paperback edition, New American Library, New York, 1969, pp. 90–108.

Rosenblum, Robert, 'The Fatal Women of Picasso and de Kooning', *Art News*, vol. 84, no. 8, October 1985, pp. 98–103.

Sandler, Irving, *The New York School: the Painters and Sculptors of the Fifties*, Harper & Row, New York, 1978.

—— *The Triumph of American Painting*, Harper & Row, New York, 1970.

Steinberg, Leo, 'De Kooning's *Woman*' in *Other Criteria: Confrontations with Twentieth-Century Art*, Oxford University Press, London, Oxford, New York, 1978, pp. 259–62.

Walker Art Center, Minneapolis, *De Kooning Drawings and Sculptures*, catalogue of a travelling exhibition, March 1974–April 1975, E. P. Dutton, New York, 1974.

Pearlstein

Baigell, Mathew, 'Pearlstein's People', *Art Criticism*, vol. 1, no. 1, Spring 1979, pp. 3–12.

Georgia Museum of Art, *Philip Pearlstein*, catalogue of a travelling exhibition, September 1970–April 1971, Georgia Museum of Art, Athens, Georgia.

Midgette, Willard F., 'Philip Pearlstein: The Naked Truth', *Art News*, vol. 66, no. 6, October 1967, pp. 54–5, 75–8.

Milwaukee Art Museum, *Philip Pearlstein: a Retrospective*, catalogue of a travelling exhibition, April 1983–July 1984, Alpine Fine Arts Collection, New York, 1983.

Nochlin, Linda, 'The Ugly American', *Art News*, vol. 69, no. 5, September 1970, pp. 55–7, 65–70.

Pearlstein, Philip, 'A Private Myth', part of a symposium, *Art News*, vol. 60, no. 5, September 1961, pp. 42, 61.

—— 'Figure Paintings Today Are Not Made in Heaven', *Art News*, vol. 61, no. 3, Summer 1962, pp. 39ff.

—— 'The Romantic Self-Image Is Gone', *Art in America*, vol. 55, no. 1, January–February 1967, p. 53.

—— 'When Paintings Were Made in Heaven', *Art in America*, vol. 70, no. 2, February 1982, pp. 84–95.

—— 'Whose Painting Is It Anyway?', *Arts Yearbook*, no. 7, 1964, pp. 129–32.

Schwartz, Ellen, 'A Conversation with Philip Pearlstein', *Art in America*, vol. 59, no. 5, September–October 1971, pp. 50–7.

Shaman, Sanford Savitz, 'An Interview with Philip Pearlstein', *Art in America*, vol. 69, no. 7, September 1981, pp. 120–6, 213–15.

Storr, Robert, 'Pearlstein Today: Upping the Ante', *Art In America*, vol. 72, no. 2, February 1984, pp. 90–9.

Tillim, Sidney, 'A Variety of Realisms', *Artforum*, vol. 7, no. 10, Summer 1969, pp. 42–7.

—— 'Philip Pearlstein and the New Philistinism', *Artforum*, vol. 4, no. 9, May 1966, pp. 21–3.

Viola, Jerome, *The Painting and Teaching of Philip Pearlstein*, Watson–Guptill Publications, New York, 1982.

Wallin, Leland, 'The Evolution of Philip Pearlstein: Part I', *Art International*, vol. 23, no. 3–4, Summer 1979, pp. 62–7, and Pt II, *Art International*, vol. 23, no. 5–6, September 1979, pp. 54–61.

INDEX

Page references in *italics* are to illustrations.